IMPRESSIONIST DREAMS

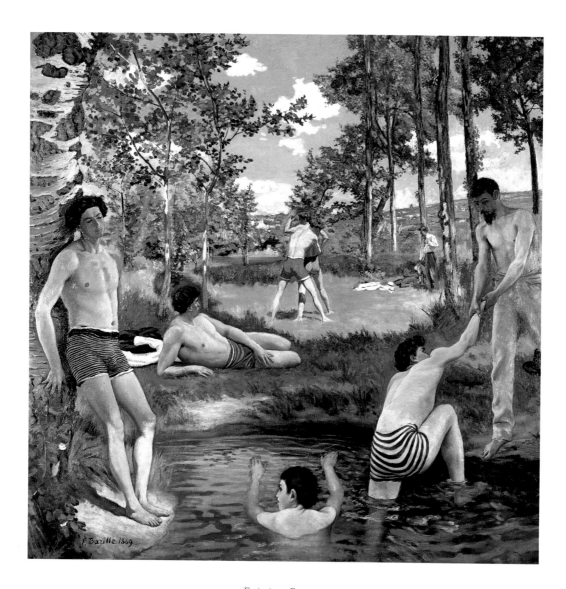

FRÉDÉRIC BAZILLE
Summer Scene

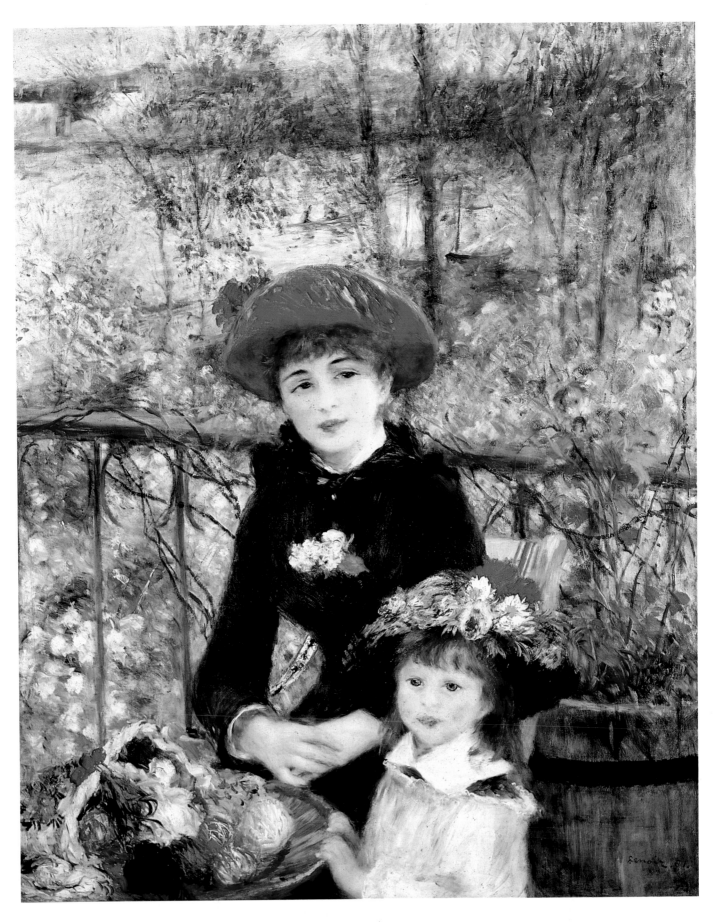

PIERRE-AUGUSTE RENOIR
On the Terrace, 1881

IMPRESSIONIST DREAMS

The Artists and the World They Painted

JOHN RUSSELL TAYLOR

BARRIE & JENKINS
LONDON

First published in Great Britain in 1990 by
Barrie & Jenkins Ltd
20 Vauxhall Bridge Road, London SW1V 2SA

British Library Cataloguing in Publication Data
Taylor, John Russell, *1935-*
Impressionist dreams: the artists and the world they
painted.
1. European paintings. Impressionism
I. Title
759.054

ISBN 0-7126-3644-7

Design by David Fordham

Typeset by SX Composing Ltd, Rayleigh, Essex
Printed and bound in Italy by Amilcare Pizzi SPA

CONTENTS

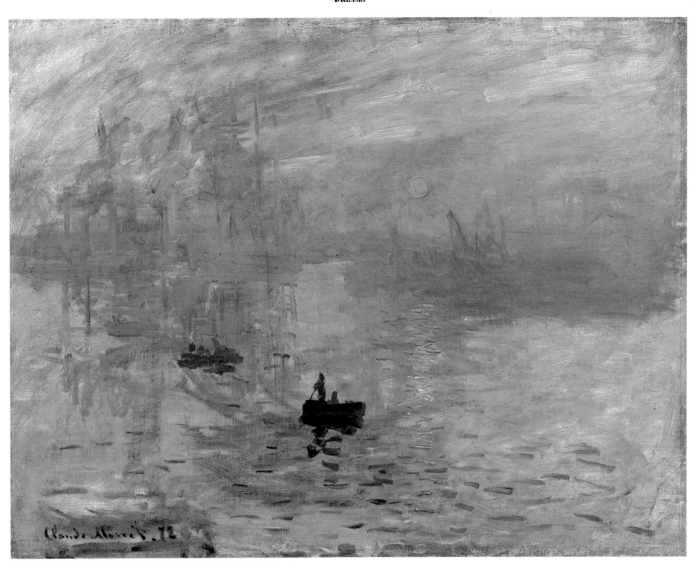

CLAUDE MONET
Impression: Sunrise, 1872
The title of this picture in the first Impressionist show encouraged Louis Leroy to
coin the mocking label "Impressionist", soon adopted by the painters themselves.

INTRODUCTION:

PAINT AND POLITICS

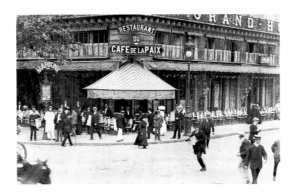

The Café de la Paix on the Place de l'Opéra, one of the bar-restaurants where so much of the Impressionists' social life took place.

WHETHER OR NOT THE FIRST IMPRESSIONIST EX-hibition in 1874 was in any real sense the 'birth of modern art', by 1974 no one had much doubt on that score. It is, of course, always useful to have a clear starting-point for something: that is why people resist so violently any attempt to revise thinking on the dates of great historic occasions like the discovery of America, or doubts raised about the significance, if any, of Magna Carta. And, in the case of the Impressionists, why not anyway? Art history is of its nature seamless, and it is largely a convention which attributes revolutionary importance to any one moment: the moment is probably only one tiny move forward in a slow and almost imperceptible evolution. Still, the first occasion the Impressionists exhibited together, and the first time they were given the name – albeit in derision – is no doubt retrospectively important, and we might as well start the history of modern art there as anywhere.

The problem is that such judgements reflect backward as well as forward. Once you allow yourself, if only for con-venience' sake, to label 1874 the birth of modern art, you com-mit yourself willy-nilly to certain assumptions: first and foremost, assumptions about the nature of modern art, and then, consequently, assumptions about what kind of thing must have happened, must have been *meant*, in order to bring

it about. For example, a revolution seems to presuppose revo-lutionaries with something coherent to fight against and some-thing coherent to fight for. Again, if you suppose that what distinguishes modern art is a rejection of convention and the academic, a radically exploratory stance in relation to ex-perience, and evolution by a continuing succession of ruptures with the styles of the past, then you may well find also that you are wishing some or all of this on to the first Impressionists, and forcing them more or less to fit into the world you have created.

All these considerations bring one back to what has been the prime question of art in the twentieth century: the subject of the art-work, and the artist's attitude towards it. Many things have been taken for granted about the Impressionists, their subject-matter and their attitudes towards it. But in fact it is very doubtful whether the first Impressionists ever saw them-selves as revolutionaries or had any recognizable body of prin-ciple according to which they acted and painted. In particular, if the academic tradition is summarily regarded as one of con-vention, keeping artists at arm's length from 'reality', then the Impressionists' supposed reaction against it should surely en-tail a substitution of 'realism', a more direct approach to the world as it was, rather than as the academics held it ought to be. This seems at first glance to make sense in terms of what we know or can see about the Impressionists. But it is already im-

Claude Monet as a young man, walking the forest in search, no doubt, of suitable subjects to paint.

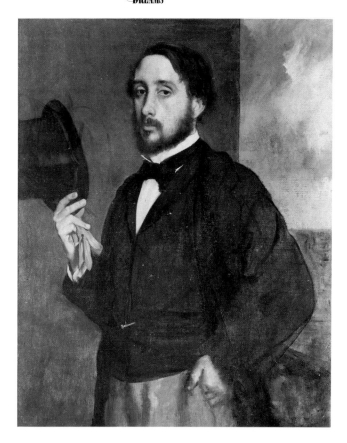

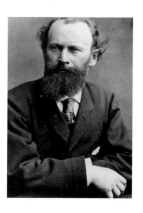

Manet depicted by the camera as a solid, if slightly fierce-looking, member of the upper bourgeoisie.

Degas's portrait of himself as a young dandy, painted around 1863, when he was in his late twenties.

possible to make any generalizations which are equally applicable to all of such a heterogeneous group. And in any case, it all depends on what you mean by 'reality'.

To look more closely at such questions, we have to look first at the social relations of the group which came to be called Impressionist, at how and why they came to be exhibiting together in a particular place at a particular time. In many respects this was a matter of exclusion from the obvious official road to artistic success and a determination to find the best alternative, rather than a wilful revolutionary gesture. By the 1850s, when most of the artists who were eventually to be known as Impressionists had had their first contacts with the Paris art world, art in France had settled into a rut. For any would-be artist, progress toward official recognition involved submission to the art establishment, which ordained that you could not do this before you had done that, that you had to have attended the right school (the Ecole des Beaux-Arts) or have been the pupil of one of the right painters. Above all, you had to have the approval of the ultimate authority, the Academy of Fine Arts, and exhibit at the Academy's biennial Salon before anyone would take you seriously and buy your work.

The Academy was at this time dominated by the great Neo-Classical painter Ingres, who insisted that everyone must more or less follow his example, with its strong emphasis on the formal organization of a picture and on traditional draughtsmanship learnt in the wearisome school of copying the masters and drawing objects and human models with a hard, clear line. A career in art, while not wholly impossible, could prove extremely difficult for painters who would not follow this line and submit to the ideas of the Academy. Ingres's great rival Delacroix, typifying the fiery, Romantic painter, replaced the cool repose of Ingres's canvases with tempestuous scenes of passion and drama painted in a free, improvisatory way to match his subjects. His work was rejected time and again by the Academy, but he persisted with his attempts to get in, since it was the only certain way to advancement. Other great nonconformists of the time were also shunned: Gustave Courbet, the master of Realism, had two important pictures rejected from the official French show of art at the 1855 Exposition Universelle in Paris.

It was a lot for young artists, still students or just starting out on their careers, to rebel against. And none of the Impressionists-to-be started in revolt against the academic establishment. Indeed, most of them may be said to have fought for as long as possible against being rebels, and to have given in to the idea of rebellion only when there seemed to be no other way. The most mature of them, Edouard Manet, came of a prosperous Paris family and sought worldly success in the conventional way, studying under one of the Beaux-Arts painter-

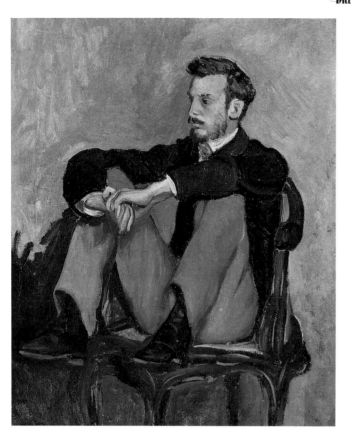

Renoir as a young man, painted by his friend and fellow-Impressionist Frédéric Bazille.

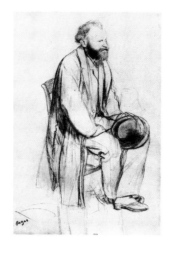

Degas's study for an etched portrait of Manet, probably made around 1866-8, when Manet was in his mid-thirties.

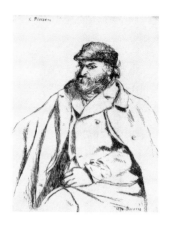

Pissarro's portrait drawing of Cézanne (1874), when Cézanne was 35 and they were regularly painting together.

instructors, Thomas Couture, for six years and aiming directly at success in the Salon, which in 1861 he achieved with his *Spanish Guitar Player*. Camille Pissarro arrived in Paris in 1855 and early on sought advice from Corot, a sensitive painter of atmospheric landscapes and one of the less controversial among the leading 'outsiders'. Edgar Degas, a young man-about-town of similar background to Manet's, two years younger and soon to be a close friend of his, enrolled in the Beaux-Arts in 1855, and carefully shunned any association with the 'unwashed' bohemian members of the artistic fraternity.

The establishment, however, seemed bent on laying up trouble for itself. In 1859, the year the precocious nineteen-year-old Claude Monet arrived in Paris from Le Havre, the Salon rejected important pictures by Manet, the flower-painter Henri Fantin-Latour and the eccentric young American James McNeill Whistler. The rejected paintings were promptly exhibited in a private studio, and created a stir. The following year the idea was pursued again, with a large-scale show of painters on the fringes of or outside the Academy, including Delacroix, Courbet, Corot, Millet and other landscape painters working around Barbizon (near Fontainebleau), who had made a principle of painting in the open air. In 1859 Pissarro befriended Monet at a private school called the Académie Suisse, where poor painters could paint from live models at little expense. Two years later Pissarro met there a rough-man-

nered young Provençal, Paul Cézanne, who rapidly joined the growing circle of friends. In 1862 Monet, after a period of military service, returned to Paris and, in order to placate his family, enrolled in the studio of one of the Beaux-Arts painters, Charles Gleyre. Here he met three other new students: Frédéric Bazille, like Cézanne a southerner of comfortable bourgeois background; Pierre-Auguste Renoir, who had managed to earn enough money for his training from painting porcelain in a factory; and Alfred Sisley, who was of British origin although born and brought up in Paris.

Thus by 1862 all the principal figures in Impressionism were already assembled in Paris, and most of them were known, at least remotely, to one another. The only one who had in any way the temperament of a rebel was Monet, who constantly expressed impatience with academic methods and disciplines. All the rest, whatever their respect for the great outsiders such as Courbet, Corot and even Delacroix (finally elected to the Academy in 1857), seemed set on conventional academic careers. But 1863 brought an important change in the Paris art scene: that year the selection committee for the Salon rejected so many works that a direct appeal was made to the Emperor. He responded by setting up a Salon des Refusés (to open two weeks after the official Salon), in which any painter whose work had been rejected could, if he chose, exhibit within a stone's throw of the Salon itself. Manet found himself

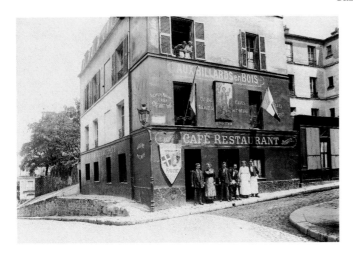

*Le Franc Buveur, a café in Montmartre where the
Impressionists and their associates hung out; Van Gogh
painted "La Guinguette" in the garden.*

*A typical bistrot in the area of Les
Halles, where artists and workmen
from the market would mix and
mingle.*

*Pissarro and Cézanne photographed together in the early
1870s, when they were neighbours in Pontoise and
constant companions.*

among these with his *Le Déjeuner sur l'Herbe* rejected by the Salon. He showed it among the refused pictures, and it created a scandal – although not at this point a very profitable one. The lesson had been learnt by the Academy, however, and the following year (1864) Manet was back in the Salon with another now-famous painting, *Olympia*. Showing alongside him were Degas, Pissarro, Renoir, Berthe Morisot and even Monet, whose sea and river scenes were very favourably received.

During the next six years or so, the selectors for the Salon followed a zigzag course, sometimes leaning towards liberalism, sometimes towards ultra-conservatism, while the critics supported now one side, now another. Although more and more voices were heard in favour of the new painters and their new approaches to colour and form, in popular estimation the Salons remained the ultimate authority. Clearly something had to be done to bring about a shift in taste. Manet, more and more dubious about the new generation's chances of shifting the Establishment of the Salons, came to be perceived as the leader of a new movement, whose members soon became known as *la bande à Manet* (Manet's gang). By the end of the decade almost all the Impressionists had got into the habit of meeting, whenever they happened to be in Paris, at the Café Guerbois (in what is now Avenue de Clichy) to pass agreeable social evenings and talk, sometimes with passion, about art and society. The Franco-Prussian War of 1870, the succeeding siege

of Paris and the short-lived Commune, which governed it between the fall of the Second Empire and the establishment of the Third Republic, drastically broke into the apparently measured, immutable progress of the Academy and the Salons. And when the scattered painters returned to Paris (minus Bazille, who had been killed in the war) they were convinced that it was time to make a new start.

What did the young painters talk about in those formative years at the Café Guerbois? No precise account seems to have survived, although there are many testimonials to the tonic effects the Thursday night get-togethers had on the participants. They must have been a curious assortment – the rather grand Parisians Manet and Degas, for instance, rubbing shoulders with the working-class Renoir and the aggressively provincial Cézanne. Nor were their politics any more consistent than their backgrounds. The gentle Pissarro, son of a Jewish-French shop-keeper, was at heart a fiery anarchist; Monet, whose father was a ship's chandler, was almost as far left of centre, as well as being an uncompromising revolutionary in artistic matters; Manet, on the contrary, inclined to political conservatism. Berthe Morisot, a grand-daughter of the painter Fragonard and a former pupil of Corot, came from a grand bureaucratic family. Sisley, born into the professional classes, had been earmarked by his father for a business career. Degas, something of a cool, ironical dandy in every area of his

The Rue des Gisons, Pontoise. Pissarro lived in or near Pontoise and obsessively painted town and nearby country from 1866 to 1884.

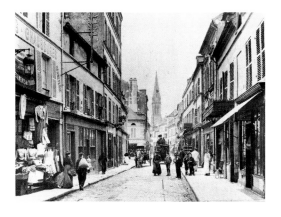

Argenteuil, with the church in the distance. Monet lived and painted there from 1871 to 1878.

Cézanne photographed near Auvers-sur-Oise, where he was living and working in 1873.

life, insisted on infuriating everyone else by adopting a lofty, patrician view of art and its public; sometimes he defended the most reactionary of the establishment painters on the grounds of their confident craftsmanship and their ability to do to perfection what they set out to do, however objectionable their artistic aims might be.

In other words, the Café Guerbois set, before and after the Franco-Prussian War, was a bunch of artists linked together by personal friendship and passionate involvement in the matter of art, rather than a narrowly doctrinaire group with a coherent and easily definable programme for changing the world. The big thing they had in their favour was their talent and their concern for the cause of art. And for all their personal differences they had, fundamentally, quite a lot in common. They were very much of an age: in 1870 Pissarro was forty, Manet thirty-eight, Degas thirty-six, Cézanne and Sisley thirty-one, Monet thirty, and Renoir and Morisot twenty-nine. They were all relative outsiders in the art world, since only Manet had up to then had anything like a critical success, let alone a commercial one. On a deeper level, they were all, at this formative period in their careers, going in much the same direction and were thinking about art in much the same way.

The great battleground among the academics, at the time when they were first feeling their way as artists, had been between the proponents of 'line' (Ingres and his followers) and

the proponents of 'colour' (Delacroix and his group). Ingres held that the basis of painting was drawing: first you got all the outlines down in detail and in their proper place, then you painted them in decorously, in subdued and harmonious colours, with as perfect a finish as possible, eliminating all evidence of individual brushstrokes and other physical processes of painting. Delacroix, on the other hand, believed that much of what was important about painting resided in the very process itself, and that hard outlines counted for little: forms in painting were built up from individual brushstrokes, and the dramatic use of colour was paramount.

In this argument the Impressionists were whole-heartedly with Delacroix, but they carried his ideas several stages further. They recognized that colour is a property of light, and that form is also created and modified by the play of light. Although they did not at this stage theorize very much about such matters (that was to come with a later generation), they were artistically fascinated, for instance, by snow and the way it reflects light and by water and the way its ripples break up light. They therefore had great areas of subject-matter in common, and would frequently paint the same scenes side by side – Monet and Renoir at La Grenouillère in Croissy, Sisley and Monet at Argenteuil, Pissarro and Cézanne at Pontoise; all three locations were dominated by rivers. They had also become aware of the development of photography, and how the camera's eye

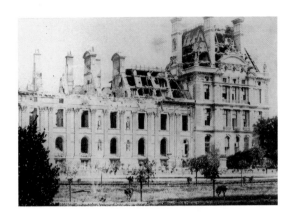

The wrecked Tuileries Palace in Paris after the Franco-Prussian
War and the Commune had done their worst.

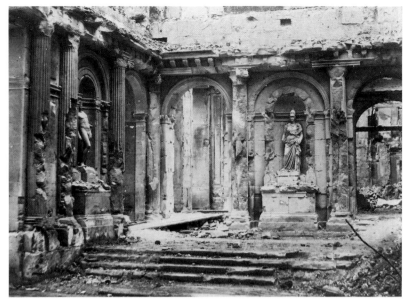

The Tuileries Palace, identified with the regime of the deposed Napoleon III, was one of the worst
sufferers from the wrath of the Commune, first wrecked, then demolished.

Alfred Sisley, Impressionist
whose British nationality
helped him to avoid the
political upheavals in Paris
around 1870.

sees objects modified by light in ways that the human viewer, his vision 'refined' or 'edited' by knowledge of the objective shape of such objects, does not normally perceive. This new visual evidence influenced the way they painted – particularly in the case of Degas.

When the friends reassembled in Paris towards the end of 1871, after scattering to the provinces or foreign parts during the war and the subsequent troubles, they were very much of one mind on the desirability, if not the absolute necessity, of painting on the spot, and of capturing the precise effects of light at a particular instant in time. (Only Degas tended in the opposite direction, preferring to sketch, or merely to observe, his favourite back-stage scenes at the Opéra and then to paint them from memory and imagination in the studio.) No one knew how the official art world of the new Republic would take shape, and while everyone was waiting to see whether the Salon of 1872 would be significantly different from those of the defunct Empire, the group met someone who was going to be important in their later careers. The dealer Paul Durand-Ruel had a gallery in London, and in 1870 Pissarro had met and received much encouragement from him there. Back in France Durand-Ruel bought Sisleys and Degas, and then, early in 1872, a considerable number of Manets. These painters and others of the group were strongly represented in his London exhibitions of 1872, 1873 and 1874.

Most of them did not try to put anything into the Salon of 1872, perhaps out of some kind of loyalty to Durand-Ruel. In any case, this was probably just as well, because the Salon proved if anything more conservative than before. Protests followed, and were intensified in 1873, only to be partially met by the organization of another Salon des Refusés, this time called an Exposition Artistique des Oeuvres Refusées. Oddly enough, that year Manet again had a considerable success within the Salon, particularly with an old-masterly portrait called *Le Bon Bock*, which most of his painter friends found disappointingly conformist. Renoir was one of the most successful in what proved to be a very well received show of the rejected. But it was becoming evident that things could not go on like this. And with even Durand-Ruel having to cut down purchases because of an economic recession, it looked as though the non-conformist painters would have to help themselves.

Thus was born the idea of putting on a show of their own. Monet, ever the rebel, seems to have been the one to push the idea through, and the more practical and diplomatic Pissarro the one who did most of the detailed organizing. It was decided that there should be a sort of joint-stock company to which each of the participating artists would contribute equally. The placing of individual pictures would be determined first of all by size, then by drawing lots. The document which made it official was dated 27 December 1873. Among the founder-

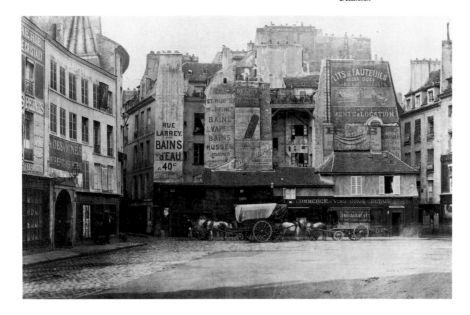

Place St André des Arts, photographed by Charles Marville in the early 1860s, around the time the Impressionists were first assembling in Paris.

Pissarro and his wife, formerly his model and mistress, though the situation was regularized in London during their exile at the time of the Commune.

members were Monet, Pissarro, Degas (although he expressed doubts about making it too narrowly based), Renoir, Sisley and Berthe Morisot. They soon acquired premises, thanks to the kindness of the photographer Nadar (Félix Tournachon), who allowed them to use free of charge the studios he had just vacated off the Boulevard des Capucines. Various other artists were persuaded to join in, among them some older, more established figures such as Eugène Boudin and the etcher Félix Bracquemond, and in all 165 works by thirty artists were assembled. The show opened on 15 April 1874, for one month. Of the major Impressionists, only Manet refused to take part, persisting in his view that a separate show was wrong, that the battle should be joined and won in the Salon. Indeed, he was not to exhibit at any of the Impressionists' shows.

In most practical terms the show was a disaster. It was reviewed savagely or jocularly in the press, the most notorious piece coming from a critic called Louis Leroy of *Le Charivari*, whose only claim to fame is that, in heading his article 'Exhibition of the Impressionists' (the term was borrowed from the title of one of Monet's paintings, *Impression: Setting Sun (fog)*), he accidentally created the label which would stick. Used at first derisively by enemies, the term was then adopted by the group with pride. Not many paintings were sold that year, and those which were fetched rather low prices. When the time came for accounting at the end of the year, the society was

found to be in debt, and a move to dissolve it at once was unanimously accepted. So it seemed as though the brave enterprise had come to an ignominious end. But the ties of friendship remained strong, and in the months following the show the Impressionist 'line' became even clearer. Monet and Renoir spent a lot of time with Manet at Argenteuil, and by their example finally converted him completely to open-air painting. And the group created another scandal when in 1875 Monet, Renoir, Sisley and Morisot arranged for an auction sale of their works (seventy-three altogether) to take place at the Hôtel Drouot in Paris. The scene here was so disorderly, and the prices fetched so derisory, that they put off plans for a new group show until 1876.

The second show had taken place in April of the previous year in Durand-Ruel's galleries, and if the attitudes of the press seemed to have changed little, at least the show did not make a loss; some of the paintings (such as Monet's *Japonnerie*, later called *La Japonaise*, a portrait of a young woman in a kimono) sold for relatively high prices, and word of this new movement in French art (although not always very favourable) had started to spread abroad. The Impressionists had also acquired a life-long patron and enthusiast – Victor Chocquet, who had a special admiration for Cézanne but also bought works by the others and tirelessly publicized them. Another wealthy friend and patron, Gustave Caillebotte (who had been a neighbour of

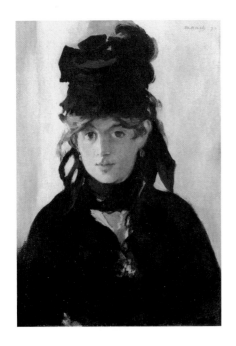

Berthe Morisot in a Black Hat (1872), Manet's
portrait of his fellow-Impressionist and future
sister-in-law.

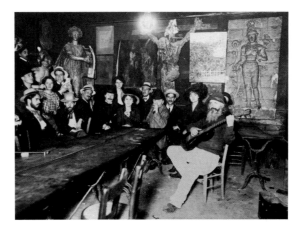

The Lapin Agile, a typical artists' haunt of the Impressionist era.

Edmond de Goncourt, with his
brother Jules an important
Naturalist novelist of the period, and
friend and apostle of the
Impressionists.

the Manet group at Argenteuil), was by profession an engineer but was also an amateur painter of no mean talent. He brought his considerable organizing abilities to bear on the problem of the next group show, which was located in the same street as Durand-Ruel's gallery, was officially called the Exposition des Impressionistes and for the first time had built into its rules the condition that exhibitors could not also exhibit at the Salon. This was in April 1877. Despite, or because of, the firm stand, the reception was little more favourable than before. But the tide was turning. In 1879 the fourth group show (tactfully dropping the word 'Impressionist' from its title) had a modest financial success and even some unreserved praise in the press. Renoir, Sisley and Cézanne were not included for various practical reasons, and Berthe Morisot was pregnant; but there were additions to the group, the most notable being the American Mary Cassatt.

The friends, however, were already beginning to go in different directions. Degas was at the centre of a lot of quarrels. Monet dropped out of the fifth exhibition (1880), although Paul Gauguin appeared there, as a pupil of Pissarro; Caillebotte dropped out of the sixth show in 1881; and by this time Monet, Renoir, Cézanne and Sisley had gone back to submitting (with variable success) to the Salon. In 1882, owing to the diplomacy of Caillebotte and the businesslike determination of Durand-Ruel, the seventh show reunited all the major Impressionists

except Degas (and of course Manet, who had never exhibited with them). Although the general public remained indifferent or hostile, they were becoming almost an accepted group within the French art establishment. In 1882 Manet, after exhibiting Un Bar aux Folies-Bergère in the Salon, was finally awarded the Légion d'honneur, the year before his death. It was really the end of Impressionism as well as its consecration. By the time of the eighth and last show in 1886, nearly all the originators had fallen away, except Degas and Pissarro (who was painting in quite a new style), while other, very different artists took part and attracted most of the attention: Gauguin again, but also Georges Seurat, Paul Signac, Pissarro's son Lucien and even the Symbolist Odilon Redon. Impressionism was giving way to Post-Impressionism, and a new era was dawning.

Even from such a summary account, it is evident that there was remarkably little unity of political opinion or artistic intention among the principal Impressionists. Often it seems that the only thing they really had in common was their general unpopularity, both in academic circles and with the sort of buyers who patronized them. It is difficult now, after some eighty years of continuous popularity for the Impressionists, to understand the nature and intensity of that unpopularity. The Impressionists seem to us, and have seemed since at least the onset of Cubism around 1910, to be the essence of visual attractiveness, uniquely unchallenging and easy to take. And

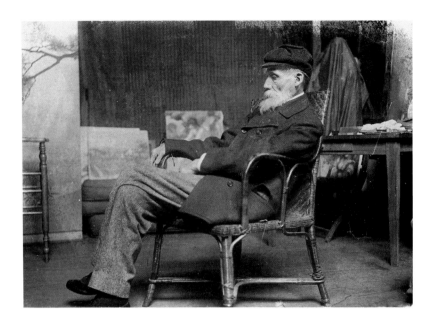

Renoir photographed by Dornac in his studio.

*Degas with his friends Albert Cavé, Léon Gandéra and Mme
Emile Straus, whom he used to accompany to the couturiers to
study the girls who worked there.*

curiously enough, that seems to have been their intention all
along: there is little or no evidence of a desire on their part to
be provocative. They wanted to be popular; they wanted to sell.
And such of them as survived the incomprehension of early
years – notably Monet and Renoir – settled down very com-
fortably to be grand old men, rich and fêted.

In a way their very directness and approachability worked
at first against them – particularly their financial approachabil-
ity. Then, as now, it was perfectly possible to be too inex-
pensive for one's own good. Many art purchasers valued what
they bought entirely according to what they paid for it. Years
later Renoir told his dealer Vollard that an early possible
patron, the banker Pillet-Will, frankly said to him that he was
too cheap to be bought: 'In my position I have to have ex-
pensive pictures. That is why I have to go to Bouguereau, at
least until I find a painter whose prices are even higher.' Of
course such purchasers were looking not only for impressive
names attached to their pictures, but also for what they con-
sidered value for money: an interesting and hopefully edifying
story told by the picture, an instantly recognizable person or
place (preferably with grand associations) and the sort of finish
which testified to long and concentrated labour on the picture,
by an artist who could achieve it only because of the years he
had spent at the right schools going through all the right dis-
ciplines.

In contrast, the Impressionists, however long they might
actually spend on painting their pictures, made them all look as
quick and casual, as much like 'impressions' of the fleeting
moment, as they possibly could. Most purchasers would not
trust their eye, and preferred their judgment to be backed up
by all sorts of outside support, guaranteeing man-hours spent.
Nor did the Impressionists' almost universal avoidance of
story-telling in pictorial form help matters. True, if there was
no 'subject' in this literary sense, there could be little important
challenge to the political or social susceptibilities of spectators
– though the way that Manet, for example, placed nude females
not in a recognizable classical or legendary context, but in the
midst of modern life, as in *Le Déjeuner sur l'Herbe*, certainly
savoured of impropriety, and moral judgements could be in-
ferred where none was implied. But the aesthetic challenge
they presented by painting what they did in the way that they
did – 'objectively' and without literary overtones – was for the
time being much more potent and damaging to them than any
mere toying with dubious literary subject-matter could ever be.

During the heyday of Impressionism's popularity, the Im-
pressionists have been almost exclusively associated with land-
scape and still-life: forms which, once you could accept or
discount the non-traditional way they were painted, proved
very easy – specially easy, perhaps – for the uninitiated to
accept. But at the time there was one broad division, both

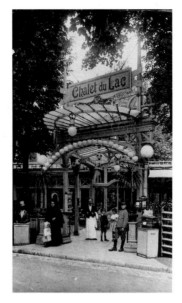

The Chalet du Lac, a café in Saint Mande, on the outskirts of Paris.

A street in Montmartre in the 1880s.

Pissarro photographed in his studio.

Cézanne at work in the open air; it is intriguing to see how formally he dresses while painting.

among the Impressionists themselves, and among their supporters, between those who saw their role as being celebrators of the timeless and unchanging, and those who thought that they should be very specifically painters of modern life. Here, oddly enough, the divide did not come, as one might expect, along political lines. The left-wingers like Monet and Pissarro were in fact precisely those who most completely eschewed any involvement with social life and social subject-matter, concentrating on pure landscape instead – and landscape, at that, of a quite escapist variety. On the other hand, the more politically conservative among the Impressionists, such as Manet and Degas (who was the only one of the group – apart from Renoir, who did it more discreetly – to side against Dreyfus in the controversy over his court-martial which divided France in

the 1890s), devoted themselves primarily to the human figure, scenes of social life and the urban scene.

Even though removal in time has made the social scenes depicted by Manet, Degas, Berthe Morisot and others seem just as nostalgic and idyllic as the rural landscapes of Monet, Sisley and Pissarro, we can at least by an effort of historical reconstruction see why contemporary spectators might have had problems with them – if only in terms of what they were supposed to be about, and of the aesthetic interest of a subject-matter detached from any social message. But the difficulties of Impressionist landscape remain more elusive, and to make sense of them we have to look more deeply into the intentions of the painters concerned, and the expectations of the art world within which they were required to work.

THE
PHYSICAL
WORLD

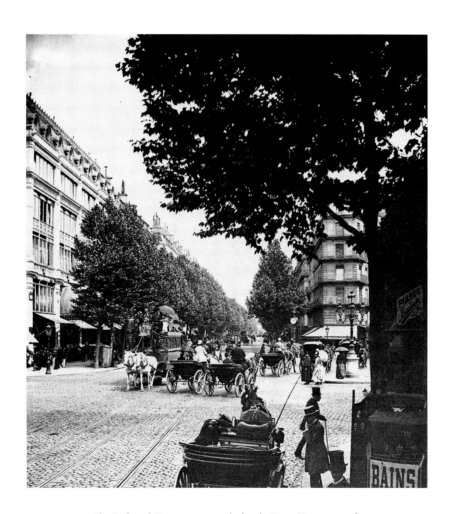

The Boulevard Haussmann, named after the Baron Haussmann, who masterminded the transformation of central Paris (so much disliked by the Impressionists) during the Second Empire.

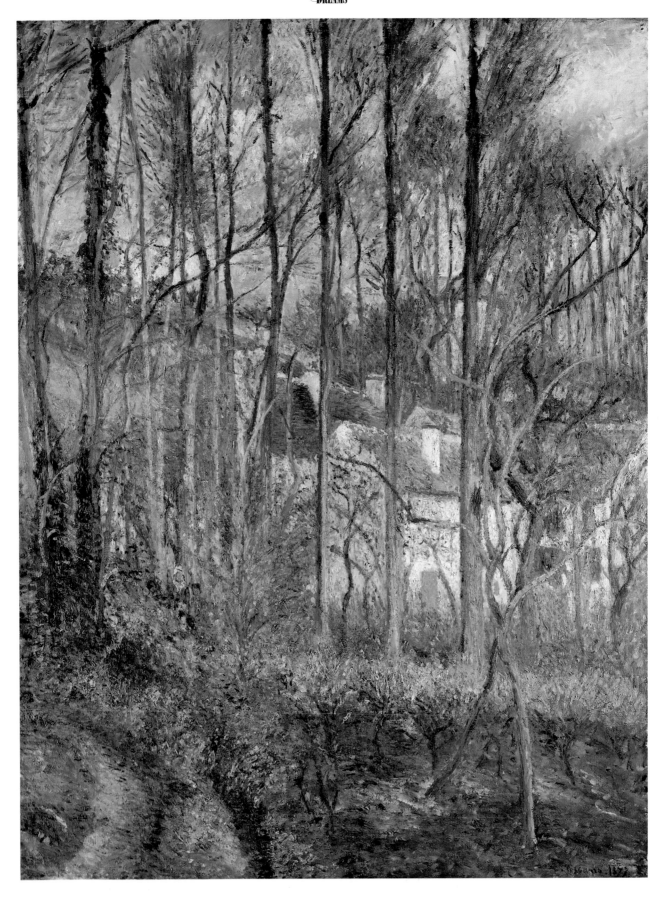

CAMILLE PISSARRO
The Côte des Boeufs at Pontoise, 1877
This was painted when Cèzanne was staying with Pissarro at Pontoise.

18

1

DREAMS
AND DESTINATIONS

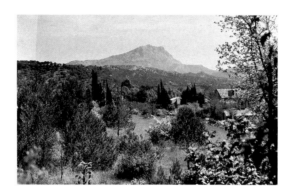

*Contemporary photograph of the Mont Ste.-Victoire, close to
Cézanne's family home in Aix, which became an obsessive
subject for him in later years.*

T IS READILY ASSUMED – TOO READILY, NO DOUBT –
that a landscape does not of itself mean anything.
It may, of course, tell us something about the in-
tellectual and emotional climate of the time at
which it is painted. Why does it suddenly become
interesting in the eighteenth century to paint
mountains, whereas the seventeenth century's in-
terest in townscapes dies away after Canaletto? The growing
attraction of the Sublime and the Picturesque, obsessively
defined and redefined by aesthetic theorists in the eighteenth
century, clearly has a lot to do with it: what we are witnessing
is a shift in sensibility, as the Age of Reason gives way to the
Romantic Movement. But the point about this sort of signifi-
cance in painting is that it is supposed to be largely uncon-
scious: the subjects which appeal to the painter and/or his
public (hopefully both) change as sensibilities change, and
there is seldom any unequivocal answer to the question which
comes first, the art or the theory? Probably, we assume, they
come together, both mirroring in different ways the slower,
deeper, more instinctive changes in the collective
psyche.

In other words, we 'read' landscape, if at all, for what the
painter cannot help putting there rather than for signs that he
has a conscious programme, a clearly understood iconography.
Hence the assumption that when Impressionists concentrated

on landscape, it was as a means (one of many) of escaping from
meaning in a paraphrasable, literary sense of the term. Tradi-
tionally we admit certain exceptions to this. When, for
example, a recognizably industrial building occurs prominent-
ly in a nineteenth-century landscape we notice it and presume
that, if the age is not making through the painter some point
about industrial romanticism or its converse, then the painter
certainly is. By extension, we may then find significant the
absence of such indications that nineteenth-century northern
France was an important and increasingly industrial society: we
progess from asking why Monet sometimes did paint industry
to asking why for the most part he did not.

But the idea of reading landscape can be carried much
further than that, and must be if we want to get at the Im-
pressionists' real intentions. Was their devotion to landscape,
we may ask, the result of an unselective devotion to 'reality',
and a desire to catch it just as it is on canvas? Or were they
actuated by some programmatic intention of painting only par-
ticular kinds of landscape in particular ways in order to fulfil
an idea of what a picture should be, or for that matter what a
country – specifically, France towards the end of the nine-
teenth century – should be? And was this devotion to land-
scape entirely a disinterested romantic gesture, suitable for the
artist as outsider, flying in the face of conventional fame and
fortune, or could there possibly have been some basic motive

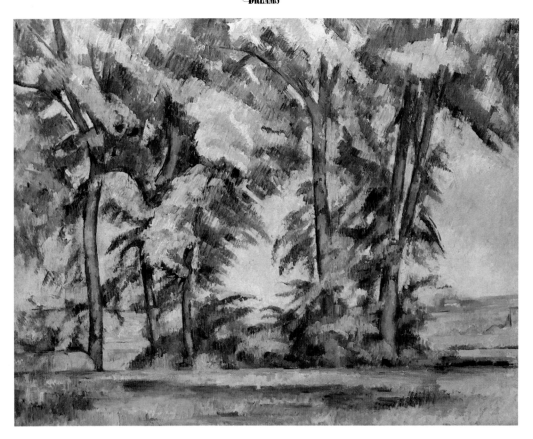

PAUL CÉZANNE
The Jas de Bouffan, 1885-7
The Jas de Bouffon was the estate owned by Cézanne's father on the outskirts of
Aix-en-Provence; he frequently painted the house and grounds.

of financial gain in it all? To work out the answers, we must first look back a little at the position of landscape in French art earlier in the century.

It is frequently asserted that 'pure' landscape was very low in the hierarchy of artistic genres when the Impressionists appeared on the Paris art scene towards the end of the 1850s, and even into the Third Republic when they had their first group show. But this is in fact far from being the case. Though naturally most of the major public commissions were for historical, allegorical and religious subjects – and this remained true until the end of the century, with the enormous number of murals required for the new public buildings of Paris before and after the Commune - the situation of easel painting was very different. During the First Republic and Napoleon's Empire history painting stood highest, while next to that there was always a market for portraits. But landscape too was recognized, both in the form of historical landscape – which was essentially a landscape with something historical or mythological happening somewhere in it, rather as in the much-admired paintings of Claude – and rural landscape, which simply depicted real scenes without human figures playing any central role at all. In 1800 an important book by the painter Pierre-Henri de Valenciennes was published, entitled *Eléments de Perspective Pratique*, which recommended artists to seek subjects in their own native environment, sketch them on the spot (for

later studio working-up into proper paintings, of course) and so express in properly romantic fashion the adventures of their soul in direct response to nature.

In 1817 an official Prix de Rome for landscape was added to those for the more traditional genres, and the following year Jean-Baptiste Deperthes published his *Théorie du Paysage*, which elaborated and systematized Valenciennes's ideas on landscape and added the strangely egalitatian note of approval that landscape was easier for the uneducated to respond to than, say, history painting, because no preliminary knowledge was necessary for its interpretation: the evidence of the eye was enough. One might wonder why that mattered, in the early days of the restored monarchy, when most painting was seen and bought by the old rich among the surviving aristocracy and the rising, but still educated *nouveaux riches* of the bourgeoisie. But anyway Deperthes helped to plant the idea that landscape did not need to be read and understood in the way that other forms of painting did: instinct was adequate. He also handed on Valenciennes's assertion of the importance of on-the-spot observation in the inspiration of the landscape, and an even older notion that, while high finish was necessary for the historical landscape, a pure, rural landscape could be left much rougher. Both of these ideas helped to create the climate of opinion in which the Impressionists first began to paint.

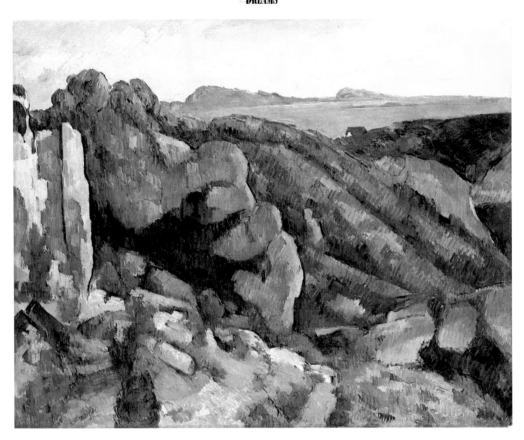

PAUL CÉZANNE
Rocks near Estaque, c. 1884
Cézanne's mother had a house in Estaque, a village about 30 km from Aix,
where he took refuge from conscription in the Franco-Prussian War. He often painted there later.

Nor was there any doubt about the unstoppable advance of the landscape in France during the first half of the nineteenth century. While in the limelight the battle was raging between the followers of Ingres and the followers of Delacroix – neither of whom was noticeably interested in landscape – landscape was quietly gobbling up an ever larger proportion of the market. By mid-century it was even seriously challenging history painting as the kind most patronized by the state. The Salons were thick with landscapes, and though painters such as Courbet, Millet and Corot were felt to be a little aside from the official circles of the Salon/Académie establishment, even when they were not deliberately excluded, they still were commercially among the most successful painters of their day, and all of them were exponents of the rustic landscape – centrally in Corot's case, very importantly in Millet's and prominently even in Courbet's. Moreover, the Barbizon School of painters, a group of Parisians who took to the woods south of Paris in the 1840s in search of back-to-nature inspiration, had already traded successfully on the growing taste (of an increasingly uneducated picture-buying public) for landscape.

It was therefore not such a wildly fantastic notion in the 1860s that landscape painting might be the readiest route to fame and fortune. The Impressionists were certainly not revolutionary in their wholesale adoption of landscape painting; arguably they were more so in the precise direction they chose

to take it. But which direction did they choose to take it? One view is that – as befits associates of Emile Zola, who were early championed by him in print (in 1866, when he was only twenty-six, Zola wrote the first really enthusiastic account of Manet in a newspaper called *L'Evènement*, and continued to write enthusiastically until the 1880s) – the Impressionists aimed at naturalism and objectivity. By this interpretation, their landscapes sought quite deliberately to eliminate the subjective, adventures-of-the-soul element in landscape, and depict it just as it was, without modification, artificial colouring or the infusion of their own emotions experienced on the spot. Like most such formulations, this seems to be simultaneously true and not true.

One should, perhaps, be on one's guard in that this 'impersonality' aspect of the Impressionists' work has been most popular as a concept in the period of Andy Warhol and the critical ascendancy of the mechanical in art. And naturalism anyway is not precisely the same thing as impersonality: the literary Naturalists, Zola in particular, certainly set out to convey a message and a view of life which were arrived at in a highly subjective way: they might claim to be depicting life whole and uncensored, but in fact their selective faculties were working all out, as they would always have to be to produce a shaped work of art. The parallel with Impressionist painting does not hold good, any more than any parallel between the verbal and the

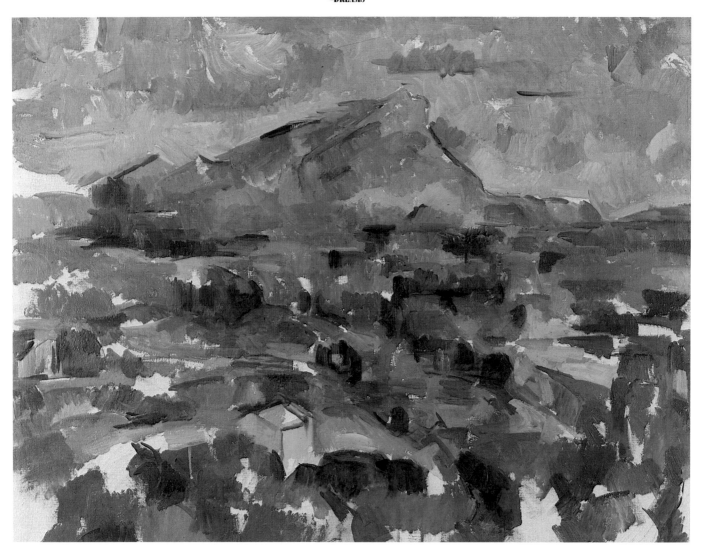

PAUL CÉZANNE
The Mont Ste.-Victoire, 1904-5
*One of Cézanne's latest and most austere views of the mountain near Aix, a
subject to which he constantly returned.*

visual arts. But it is clear that the Impressionists did exercise their powers of selection (arrived at subjectively) in what they chose to paint and what they did not. Indeed, the very idea of painting an 'impression' necessarily entails an element of subjectivity, for the painter's eye is not a camera, passively recording whatever it is pointed at, but a constantly manipulated passageway between outer and inner reality, the former always modified in some way to conform with the latter. Only what impresses you personally can create an impression: we see what we want to see.

But, the argument may be pursued, should we understand that the Impressionists were interested primarily in recording, however selectively, what they saw, or were they more concerned, like the literary Naturalists, with constructing a coherent vision from what they saw, a vision perhaps of an ideal, a world which made sense? And what sense did they want it to make: a heaven, or a hell, or something between the two; the

country as they felt it had been, saw that in part it still was, and would like it to remain? In Britain at the same time there was growing the notion of Merrie England, a sort of pre-industrial golden age which both the High Toryism of Disraeli and the idealistic socialism of William Morris held up for different reasons as an ideal sadly endangered by the forces of modern life. Something akin was abroad in France, a similar nostalgia for times almost past, allied with a mistrust of materialistic progress. This seems to have been, if we may judge from the Impressionists' selection of landscape subjects, very much where their art started from.

This concept of an ideal does not necessarily preclude precise and accurate observation: if one believes that something approaching the ideal still exists, it is desirable to seek it out and record its remains as accurately, vividly and – in view of its evanescence unless something is done to preserve it – attractively as possible. For this reason the spirit of place is after all

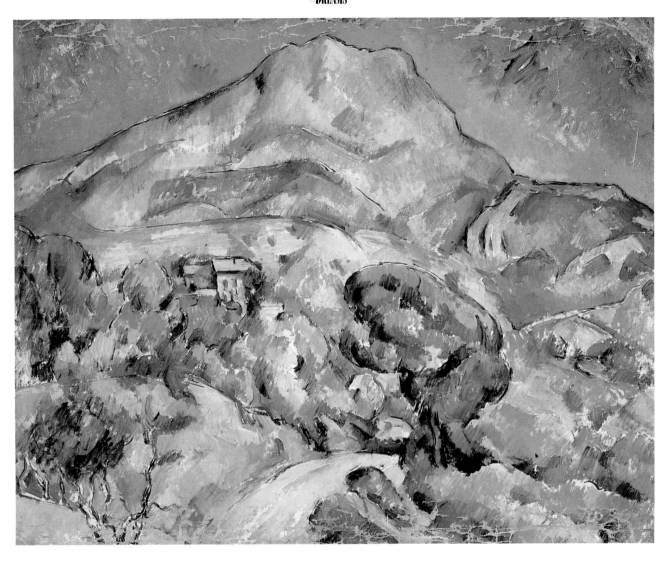

PAUL CÉZANNE
The Mont Ste-Victoire from the South West, 1890-1900
One of the more bare and monumental examples of Cézanne's views of the
mountain near Aix which preoccupied him greatly in his later years.

important to the Impressionists: their world as they see it, and want others to see it, is very much a matter of particularities. The same could be said of the English Pre-Raphaelites, whose early aesthetic was entirely based on recording minute particulars, as far as possible on the very spot where they were to be observed. In the Pre-Raphaelites this leads to an hallucinatory and undifferentiated intensity of detail, with everything in sharp focus: in that sense theirs is an art of the mind rather than the eye, a synthesis of everything they know is there rather than an observation of what any human eye can physically see at one time.

If this is reminiscent of one kind of drug experience, the preternatural clarity with which opium-eaters see everything (it may be significant that several in the Pre-Raphaelite circle were quietly addicted to laudanum), the typical Impressionist 'impression' offers the soft-focus view of the happy tippler, or the short-sighted man who takes off his glasses for relief.

The Pre-Raphaelites were interested in finding the permanent within the temporary; the Impressionists looked for the temporary and ever-changing as it played over and modified the permanent from moment to moment. This meant that they had to be specially interested in the properties of light: light as it created colour, light as it indicated volume, light particularly as it endowed the bare facts with atmosphere. Much of the spirit in a particular place resides in the special quality of its light. And it was certainly this that the Impressionist landscape sought to capture rather than mere topographical accuracy. In the era of the Impressionists the universal craze for photography ensured that virtually every inch of the Ile de France and the area between Paris and the Channel coast was recorded by the camera; subsequently, many photographers have had the idea of following in the Impressionists' footsteps to record continuity and change in the scenes they painted. As a result, we have many records, or alternative witnesses if you will, of

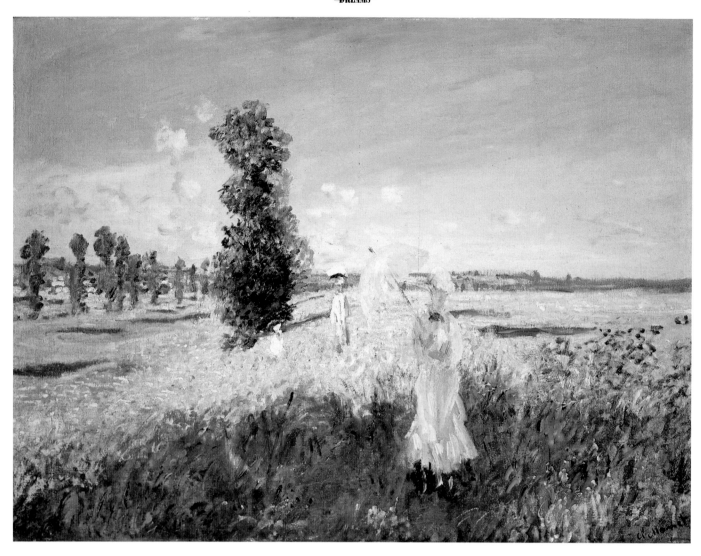

CLAUDE MONET
The Walk, Argenteuil, c.1875
In earlier years Monet painted a number of pictures of figures prominent in
landscapes. After 1890 the human element virtually disappeared from his work.

the facts from which they started. We all know that the camera can lie and constantly does, but at the same time photographs do provide a sort of control, and we can see for ourselves that Impressionist painters often rearranged, if only slightly, the raw materials of landscape to make a more satisfactory composition. Or, sometimes, they pointed to a significance in a landscape, by interpreting and changing the emphasis.

We have two chances to observe these processes in the work of the Impressionists: the period from 1871 to 1878 when Monet was living and largely painting in the small suburban town of Argenteuil, a few miles down the Seine from Paris, and the periods from 1866 to 1870 and 1872 to 1883 when Pissarro spent considerable amounts of time each year in or near the riverside town of Pontoise, on the Oise just upstream from where it flows into the Seine, a few miles northwest of Argenteuil. Both of these places were chosen, for a variety of reasons no doubt: cheapness and country air combined with closeness

to Paris would count for a lot. Finally we do not know — because probably the painters themselves did not know for sure - whether they were chosen mainly for their qualities as subjects for painting, or because Monet and Pissarro happened to be there. Not that it matters all that much: the fact remains that they were painted, frequently, from a great variety of viewpoints, during a period of rapid change, and so provide us with an excellent opportunity to gauge the painters' attitudes in their choice of subject, and what they made of it.

Monet is in certain respects the most mysterious of the major Impressionists. He seldom spoke about his artistic intentions until late in life, and then not very helpfully. He has consequently been regarded as the least intellectual of the group, the most completely sensuous and instinctive. On the other hand, his silence does leave it open to read his work any way one wants, and there has never been any lack of critics to discover a programme, or series of programmes. As early as 1868

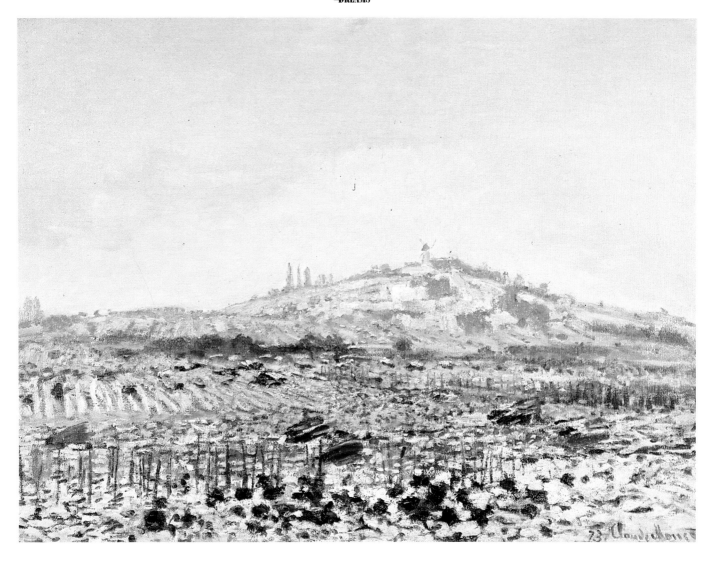

CLAUDE MONET
The Mill at Orgemont, 1873
This picture, also known as Vineyards in the Snow, *shows Monet turning his back on the fast-growing town of Argenteuil
and looking north towards the old mill, originally known, oddly enough, as the Moulin de la Galette.*

Zola observed that Monet seemed interested in landscape only when it held clear evidence of human intervention; total wildness did not please him. And given that a number of his very earliest known paintings are of factories, and he showed a continuing fascination with railways, it has also been suggested that from the start he set out with the deliberate intention of being a modern painter, painting modern life.

This ambiguity is very relevant to his period in Argenteuil. It has recently been demonstrated that he was by no means poverty-stricken when he went there; indeed, by the general standards of the town he was quite prosperous, and soon moved himself and his family from their first, rather simple, home to a distinctly grander property. He went there, presumably, because he liked the place, and in this he was not alone: living just outside Paris, in what were in effect dormitory suburbs (Argenteuil was only twelve minutes from Paris by train), was quite a bourgeois fashion in the 1870s. What we

seem to see during the seven years of Monet's residence is a progression from liking to disliking, a change of attitude which may derive from changes in the town or changes in the painter, or possibly both. At any rate, it seems to be more of an intuitive process than a conscious modification of political or aesthetic attitudes.

Certainly at the outset Monet does not seem to have been disturbed by the evidences of increasing industrialization in Argenteuil. Factories, figuring prominently in many of the very earliest paintings Monet did in the Argenteuil area, appear to be accepted without question as part of the landscape, neither particularly desirable nor particularly undesirable: they are just there naturally, closing the vista along *The Path through the Vineyards* (1872) or occupying as accepted a place as the nearby church spire in the view from *The Promenade along the Seine* (1872). In at least one case, that of the iron railway bridge opened in 1863, Monet clearly found positive attractions in

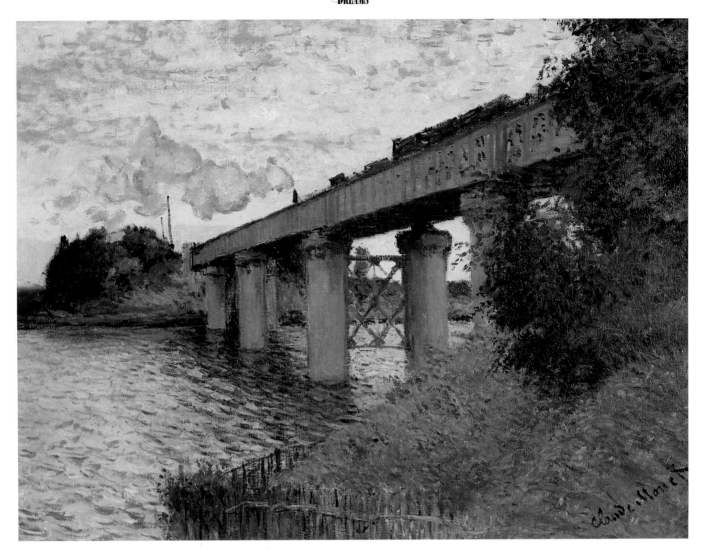

CLAUDE MONET
The Railway Bridge at Argenteuil
The new bridges at Argenteuil, considered an eyesore by many, seem to have
appealed to Monet, who frequently painted both the railway and road bridges.

what other residents persisted in finding repulsive, inartistic or at best inadequate visually for the prominent place it occupied. Monet must have liked it, for he painted it frequently, and often made it the central feature of his paintings, as in *The Railway Bridge viewed from the Port* (1873), where it is given almost an heroic presence.

Though Argenteuil undoubtedly became ever more built-up and industrial during Monet's residence, it was not so extensively transformed that someone who liked it in 1871 would no longer recognize the place he had liked in 1878. Nor were the changes that did take place unexpected and unpredictable. It therefore seems certain that these years saw a more radical change in Monet than in his surroundings. It is noticeable that Monet's output of paintings, very sizeable in the first four years, fell off considerably in the last three. Also, that his chosen subject-matter gradually shifted from the urban, accepting and even glorifying the industrial (to this extent Monet hardly

seems to be objective and anti-romantic in what is supposed to be the typical Impressionist fashion) to the rurally idyllic. More and more he painted the sailing boats on the Seine, with little evidence of the modern world apart from the occasional new house on the bank, or concentrated on his own garden, being enjoyed by members of his own family. Again, a passion for gardens was widely noted at the time as a leading trait of the urban bourgeois, eager to become at least suburban and longing to acquire some of the characteristics of the country gentleman.

The last pictures painted in Argenteuil, such as *Argenteuil: the Bank in Flower* (1877), return again to the town and its industry. But now there is something hectic about them: they become almost Expressionistic in their intensity, as though Monet himself felt and expressed the stiflement of encroaching urbanism and looked on industry itself with something approaching hostility. Whereas the composition of the earlier

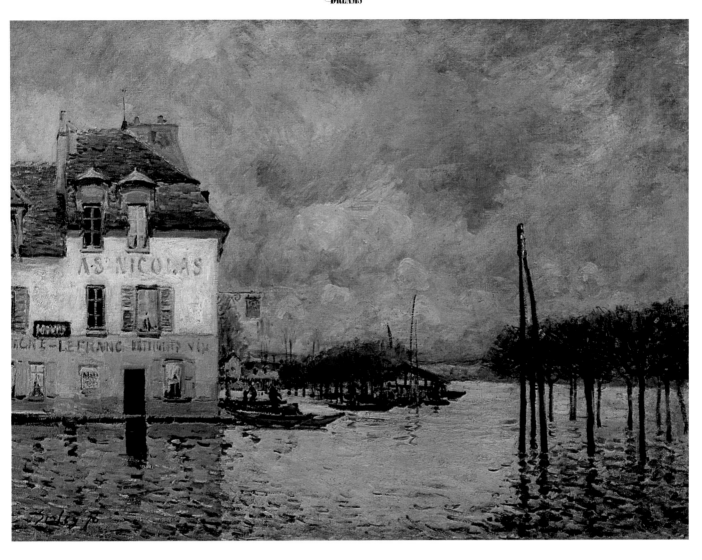

ALFRED SISLEY
The Floods at Port-Marly, 1876
One of Sisley's most famous paintings, catching to perfection the greys of the sky
and their reflection in the flooding waters of the Seine.

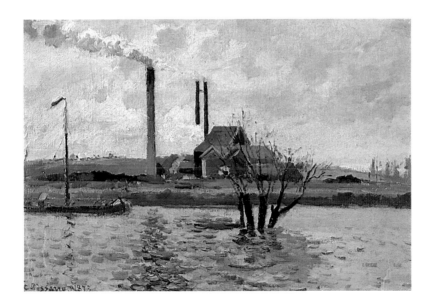

CAMILLE PISSARRO
L'Usine de Chalon et Cie à
Pontoise, 1873
The factory near his home seems
to have fascinated Pissarro,
perhaps as much for its shape as
for its industrial associations.

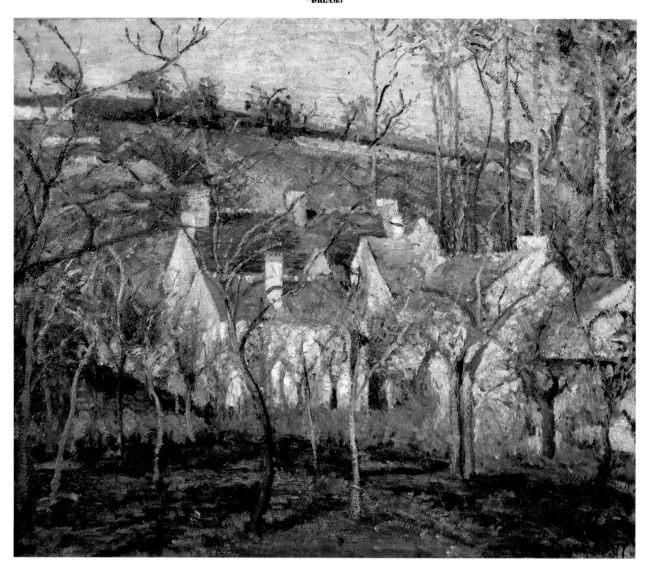

CAMILLE PISSARRO
Red Roofs, Corner of the Village in Winter, 1877
Another Pontoise painting by Pissarro done at the time of his closest association
with Cézanne whose influence is here perceptible.

paintings from riverbank or vineyard seems to draw the specta-tor into the picture, and pull his eye towards the evidences of modern life, now the construction of the picture seems to symbolize rejection and exclusion. Not for nothing was Monet looking for somewhere much more rustic to live and paint: a path which led him immediately to the village of Vétheuil, and finally to Giverny, where he could literally cultivate his garden and let the modern world he had once found so exciting pass him by.

Pissarro in Pontoise must have encountered the same sort of change in a less acute form, in that Pontoise was further away from Paris, smaller than Argenteuil and more definitely a sur-viving country town rather than a dormitory suburb. All the same, the most spectacular change in the locality during Pissar-ro's time was a further encroachment of industry: the local fac-tory, a distillery of alcohol from sugar beet, had been built by the Oise in the early 1860s, but in 1872-73 it was considerably

extended. Pissarro seems to have been fascinated by the build-ing, and in 1873 did a series of paintings which treat it as the most prominent feature. Though Pissarro was much more given to verbal expression than Monet, especially through his abundant later correspondence with his son Lucien, we do not really know exactly what his attitude to the factory develop-ment was. We may guess from his strongly leftish, anarchist politics that he had a passionate sympathy with the factory workers, and it does seem from his paintings that he found the Pontoise factory by no means visually objectionable. There is, however, much evidence from contemporary photographs that he dealt with the subject in a very liberated fashion, departing widely from documentary accuracy and rearranging, adding or subtracting to obtain a more expressive composition than was actually offered.

This series apart, Pissarro painted at Pontoise as though he was in the unspoilt countryside – which, in practice, he was.

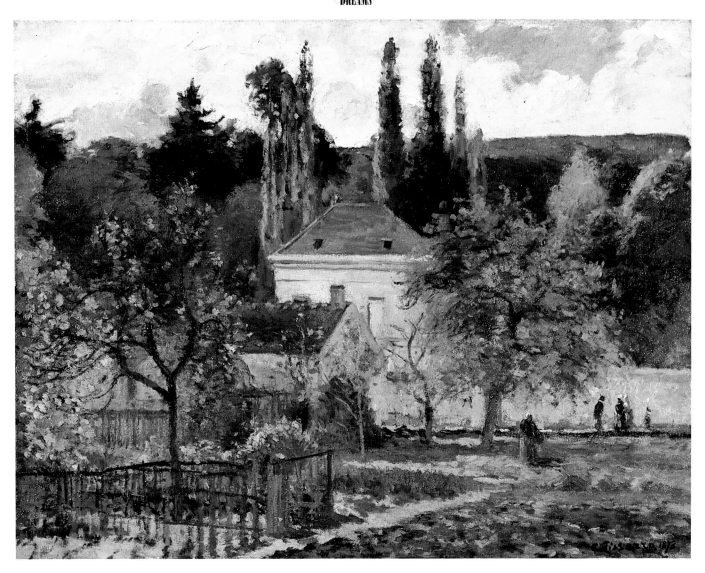

CAMILLE PISSARRO
The Hermitage, Pontoise, 1873
The subject is a substantial property, known as the Bourgeois House, in the rue
de l'Hermitage, Pontoise, an area where Pissarro frequently found painting subjects.

His intentions appear to have been as far as possible from the didactic or anecdotal: he is interested in the play of light and shade, the shapes that hill and valley, bridge and water, woods and buildings make in combination, and if the shapes in front of him are not quite so satisfactory and expressive as they should be he is not averse, here too, to a bit of judicious rearrangement. In this respect his attitude to a factory is not notice- ably different from his attitude to a haystack. And like all the Impressionists – this perhaps is finally what is meant by their 'detachment' or 'objectivity' – he never loses sight of the fact that whatever his personal interest in the raw material of his painting, what he is primarily doing is constructing satisfactory pictures. Relative to that, documentary accuracy has a very humble place among his priorites.

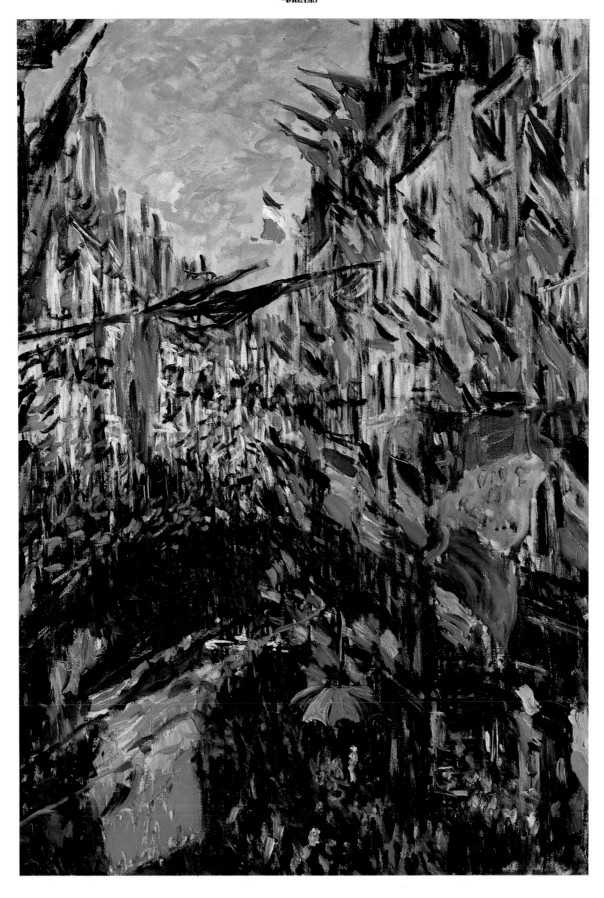

CLAUDE MONET
Rue St Denis, Holiday of June 30, 1878
Monet was clearly fascinated by the play of the flags and hangings at this Fête.

2

CITY STREETS

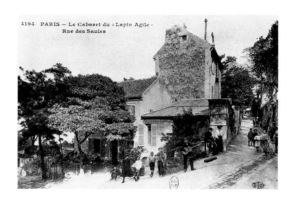

The Lapin Agile (later the Cabaret des Assassins) was a cabaret
in the more countrified part of Montmartre which attracted
artists among its mixed clientele in the 1890s and 1900s.

EVERAL OF THE MAJOR IMPRESSIONISTS WERE Parisians by birth; all, at the crucial period, were Parisians by choice. Manet and Degas were born in Paris to well-to-do bourgeois families (in Degas's case with aristocratic connections); so was Sisley, whose father was an English businessman long resident in Paris. Even Monet, though brought up in Le Havre, was born in Paris, the son of an out-of-work seaman. Pissarro left the West Indies for school in Paris when he was twelve, subsequently returning to live in the capital when he was twenty-five; Cézanne, born in Aix-en-Provence, tried to enroll in the Ecole des Beaux Arts at the age of twenty-two, and settled in Paris the following year; Renoir, the son of a tailor, was born in Limoges and moved to Paris with his family when he was three; Berthe Morisot, born in Bourges, came to Paris with her family when she was fourteen. In the circumstances, it is not surprisng that Paris should bulk large in the work of all of them (except Cézanne) during their early years as professional painters.

To understand what this means, it is important first to establish what Paris meant to them. One thing is quite clear, however one interprets its effect, and that is that the Paris in which the Impressionists grew up, or to which they first came, was in the throes of becoming a modern city. In 1848, when the monarchy was finally swept away, Paris was still in many respects a medieval city, with narrow winding streets and buildings clustered close around the river which bisected it. Within ten years all that had changed, or was in the process of changing. The man with the grand design which brought the transformation about was Baron Haussmann, who set out to create for Napoleon III a capital city which would be the most modern in the world, would have its ancient centre renewed, its old industries moved to the outskirts, its network of narrow streets replaced by grand boulevards and avenues and would, incidentally, be rendered virtually revolution-proof because of the difficulty of barricading the grand new thoroughfares. (As the Commune demonstrated, in this last respect Haussmann's plans fell rather short of their intentions.) Painters of Paris in the 1860s were inevitably, whether they liked it or not, painters of a modern city, and so of modern life.

But did they like it? Haussmann's Paris, like the Second Empire in general, embodied the triumph of the bourgeoisie. The most prosperous segments of society, those for whom the new order worked most advantageously, were the businessmen and the speculators. In the anti-Haussmann, anti-Napoleon III writings of the time, the images constantly recur of the new Paris as a front, an elaborate theatrical pretense behind which the real, unscrupulous business of making money and continuing autocratic power could be pursued while the populace was distracted and bought off with an unending round of beer

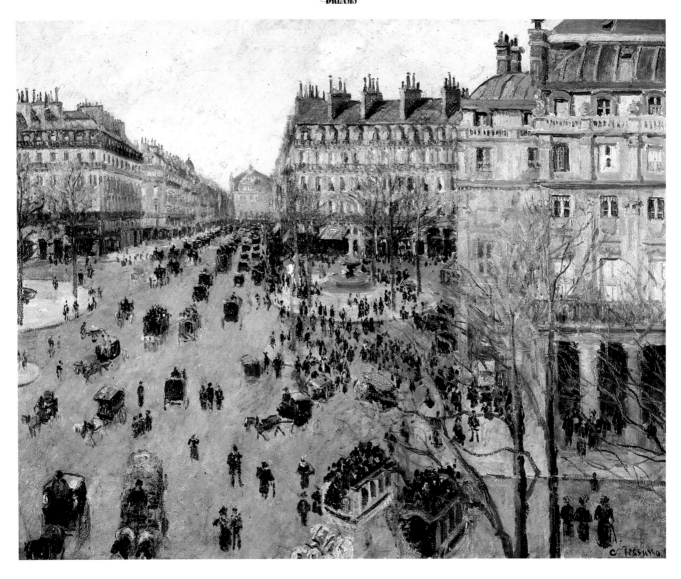

CAMILLE PISSARRO
La Place du Théâtre Français, 1898
In 1897 Pissarro took a room in the Grand Hotel du Louvre, near the junction of the Avenue de
l'Opéra and the Rue Saint-Honoré, and spent nearly six months painting the views from its windows.

and skittles. Depicting the face of the new Paris did not necessarily mean that one accepted it at face value, or implicitly endorsed its standards. It was possible to be for it all; it was possible to be steadfastly against it; it was possible to be in two minds; it was possible to withdraw into assumed objectivity. The one thing one could not really do, in Paris, was to ignore it.

Unless, of course, you just happened to be Paul Cézanne. Though Cézanne was regularly in Paris (with frequent returns home to the south) throughout the 1860s, there is hardly any direct evidence of the fact in his painting. One might perhaps find indirect evidence of the proximity of metropolitan flesh-pots in some of his strongly sexual fantasy pictures of those years, but there seems to be little in them that a powerfully erotic young man could not have thought of for himself in Aix, even if he had come to Paris to acquire the technical ability to express his ideas in paint. And when he was not painting directly out of his own imagination, Cézanne in these early

years was working mainly on portraits and still-lifes, interspersed with the occasional Provençal landscape - though there is evidence that many of these owed more to his imagination that to precise observation on the spot. The turbulent and expressionistic Paris townscape *The Rue des Saules, Montmartre* of c. 1867, is an exception, and has nothing really to do with the modernization of Paris, since there seems to be nothing in this unpopulated corner that could not have been the same for a century. Even the later *Paris: the Quai de Bercy – the Wine Market*, which dates from the early 1870s, commemorates a peculiarly fraught moment in Cézanne's life when, at a low ebb in his financial fortunes, his mistress bore him a son and he was living just opposite the subject of his painting – a position he found almost unbearable and proceeded to ameliorate by moving out of Paris altogether.

Cézanne was, to put it mildly, not a very sociable type. But then a painter did not have to be, unless he (or she) wanted to

32

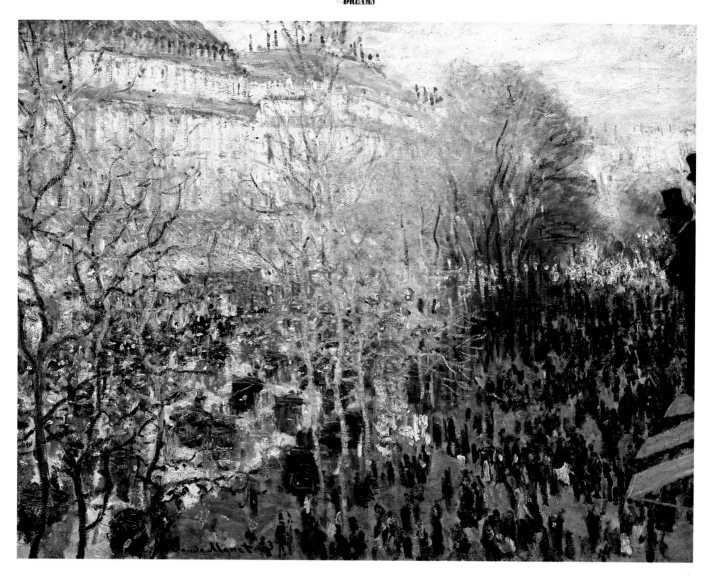

CLAUDE MONET
Carnival in the Boulevard des Capucines, 1873
One of Monet's relatively infrequent studies of street life in Paris, this shows the Boulevard des Capucines
en fête, with the figures appreciated as separate humans rather than part of a pattern.

be. The fact that Cézanne could be in Paris during these crucial, dynamic years and hold himself (or anyway his art) so successfully aloof from it must tell us something about the attitudes of his fellow Impressionists at this time. It must be significant that none of the others ignored the Paris scene so completely. Of course, it must have taken considerable deterination, or a particularity of temperment to do so – especially in 1867, when many of Haussman's major schemes were rushed to a conclusion in time to be celebrated in that year's Paris World's Fair. The fair itself and its buildings figure directly in some important Impressionist paintings, most notably Manet's possibly unfinished *L'Exposition Universelle*, but the effect of a Paris overcrowded with visitors from all over the world and the unmistakable if perhaps not too trustworthy euphoria of the moment was felt by almost all the Impressionists in one way or another. There is something very curious these days in reading the expressions of passionate hostility which the creation of Haussman's Paris occasioned – almost as strange as reading the violent denunciations of Impressionist art during the 1870s, and for much the same reason. This city which is being excoriated and these paintings so categorically condemned are after all precisely what the whole world now conspires to love. How can their evident, immediate attractions have been so drastically dismissed or ignored? The basis of the adverse criticism of Haussman's Paris is, as often as not, financial: those who would have been delighted to get a piece of the action, there being millions to be made by the lucky or canny ones, intensely resented the fact that they had not benefited, and complained endlessly about the favouritism and dishonesty involved in the distribution of benefits. A more reasonable and humane cause of complaint was the summary displacement of the working classes from the central arrondissements to dreary and primitive new slums on the outskirts, but this excited relatively little comment, though no doubt

33

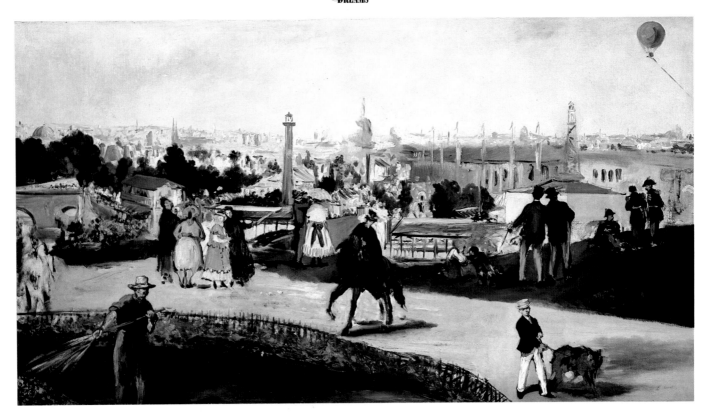

EDOUARD MANET
L'Exposition Universelle, 1867
Manet's panorama (possibly unfinished) shows the buildings of the World's Fair
which so excited the Impressionists for its exotic sights and sounds.

Monet and Pissarro, like other 'reds' of the day, were well aware of it. And then there was a simple resistance to change because it was change, a feeling among the older and more scholarly that the 'real' Paris of their childhoods had been swept away (as of course it had) and nothing that was not sterile, soulless, coldly grand and lacking in human variety put in its place. Where was Paris picturesque or quaint any more?

At least none of the Impressionists seems to have been noticeably interested in the picturesque or the quaint. These qualities in townscape must have been too inextricably associated with historical painting and the sort of antiquarian topographical illustration which they were always eager to reject or move on from. If Paris was the modern city *par excellence*, so be it: they were not likely to be searching out forgotten corners of the old town. On the other hand, it is not so self-evident that they drew their subject-matter from the streets and interiors of the new bourgeois Paris just because, like Everest, it was there. It is easy to assert, as some modern critics have done, that the urban landscapes of Manet and his circle have a moral dimension; but much more difficult to say with certainty just what it is and in what direction it lies.

Take Manet's picture of the World's Fair itself. We may well doubt whether, had it been completed, it would have garnered official approval: it is clearly not an heroic view, erring rather on the side of informality and casualness, despite its considerable

size. On the other hand, it does not seem to be satirical or even critical: there is a certain jollity about it, which stops short of making fun of anything specific. It is, finally, a sort of celebration. As well it might be. The Exposition Universelle was particularly popular, while it lasted, with Manet's own class of educated, well-to-do bourgeois, and since he seems to have had no personal axe to grind in the matter of business favours received or withheld, there is no reason why he should have thought otherwise. At the very least, it was a lively, timely and imaginatively suggestive subject for a painting, and Manet makes the most of it.

He does so, of course, without falling back on anecdote. If we compare the painting with one of William Powell Frith's slightly earlier social panoramas, such as *Derby Day* (1858) or *The Railway Station* (1862), the difference is at once apparent. Frith has in his own way an equal claim to be a painter of modern life: but his way is to pile on the human interest in innumerable little groups of people all doing characterful things or relating in characterful ways. Although the figures in the foreground of Manet's paintings are characterized – the rather surly-looking boy with the enormous dog, the group of off-duty soliders, the two apparently middle-aged bourgeois, seen from behind, as they survey the buildings of the fair in front of them, as in front of us – they are not developed for their own sake, standing out from their context and requiring separate

ALFRED SISLEY
Montmartre, from the City of Flowers at the Batignolles, 1869
Significantly the country-loving Sisley consigns the urban aspects of the scene to
the background, and concentrates on the newly planted saplings instead.

attention for themselves. This, again, is no doubt the detachment which the Impressionists make a virtue for themselves and require in their public. We can find much the same feeling in such closely contemporary and kindred works as Renoir's *The Champs Elysées during the Paris Fair*, which shows many small figures parading in the foreground gardens while in the distance, through the trees, we may glimpse the buildings of the fair itself, or Monet's *The Garden of the Princess*, where the eye is led exorably up from the crowded quai, across the invisible Seine towards the Panthéon, the highest point in the distant skyline.

What all of these pictures do is to evoke the new city without appearing to judge it. But by withholding the judgemental element, the paintings leave us a little confused about how interested the painters were in the city as such. Perhaps they were especially excited by the activity, the vulgar energy, the grandiose vistas. Or perhaps they would have been just as happy painting the countryside or the sea – anywhere where light played over surfaces, and leaves moved and occasionally a puff of smoke or a wisp of cloud moderated the perfect clarity of the scene. For a dedicated urbanite's view of the city one has to turn to a very different painter who, though organizationally central to the Impressionists and their exhibitions, seems in most other ways rather arbitrarily bracketed with them: Gustave Caillebotte. Caillebotte was another painter in the Im-

pressionist circle born in Paris to a prosperous bourgeois family (his father was in the textile business and did well out of the Second Empire, supplying bedding to the French army), and never throughout his forty-five years of life did he have to worry about money or make a living from painting. Indeed, he figures in the annals of Impressionism largely as a patron of worse-off painters and a diplomatic go-between skilled at reconciling warring elements into a coherent exhibiting ensemble.

For all that, he was not an amateur in any but the purely technical sense. He early developed his own style, which was one of hard-edged realism without close parallel among the other Impressionists (though occasionally in his early work a comparison with Manet or Degas may suggest itself), and developed his own area of interest in the architecture of the new Paris and the characteristic types who inhabited it, mainly solid bourgeois and labouring men. Between 1873 and 1880 Caillebotte painted a number of pictures answering to this description, mostly startlingly original. It is clear from his peopled interiors as well as the exteriors and the group of works which show us the street viewed from indoors, upstairs, that he was fascinated by perspective and its conundrums – not an interest shared by any of the other Impressionists except, very occasionally, Degas. And for such a painter, what better than the immense, empty recessions of Haussmann's boulevards? –

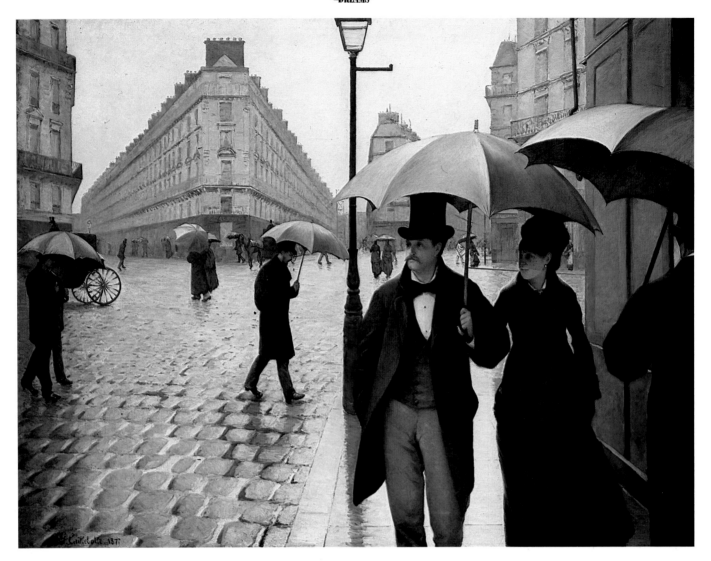

GUSTAVE CAILLEBOTTE
Rue de Paris: Temps de Pluie, 1877
Caillebotte's masterpiece, combining into a large and convincing whole all his
preoccupations with human character and urban geometry.

especially since he came on the scene as a painter late enough to accept them as a *donnée*, without respect of whether they should be there or not.

Caillebotte's finest and most famous work is the vast picture called *Rue de Paris: Temps de Pluie* (1877), which uses the intersection of the rue de St Petersbourg, the rue de Moscou and the rue de Turin in a curious 8-shaped *place* with no name, close to the Gare St Lazare, as the text for an essay on architectural perspective, constructed on a grand scale so that the foreground figures are almost life-size. Still, the anecdote is firmly avoided. These figures, and the others, smaller, scurrying through the rain across the damp cobbles of the middle-distance, are sufficiently characterized to command belief, but not to distract our attention out of the picture: rather they draw us in towards its true centre. Caillebotte's other famous picture, one of two views, of the *Pont de l'Europe*, the great metal road bridge which spans the railway lines just outside St Lazare, was painted a

year earlier, and plays some of the same virtuoso games with perspective, forcing our eye into the picture, past the pedestrians on the pavement and towards the opening between the new buildings in the distance, which is in fact the rue de St Petersbourg (or the rue de Léningrad as it is now) leading directly to the site of *Rue de Paris:Temps de Pluie*. Oddly, the picture suppresses almost all evidence of the extraordinariness of the bridge itself, which is actually a sort of *place* built over the railway, where three major roads intersect in something like a star shape.

But there is little doubt that Caillebotte took an extraordinary interest – extraordinary not only among the Impressionists, but among painters of the period in general – in the precise way that streets intersected and architectural transitions were made – not to mention the elements of city planning visible and readily analysable from above. So much is clear just from the series of views he painted through upstairs windows

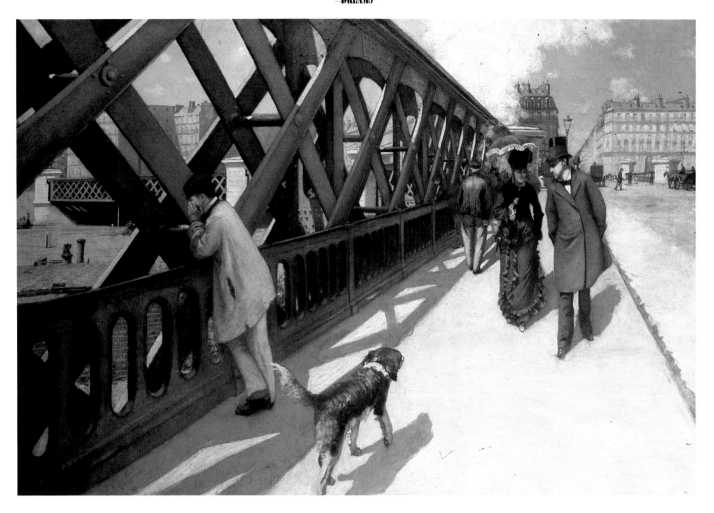

GUSTAVE CAILLEBOTTE
Le Pont de l'Europe, 1876
Another extraordinary piece of perspective, painted just around the corner from Rue de
Paris: Temps de Pluie, *on the bridge over the lines running into the Gare St-Lazare.*

in Paris, starting with *Jeune Homme à sa Fenêtre* (1876), in which a spectator within the picture (Caillebotte's younger brother René) gazes out on to an almost preternaturally crisp, clear, sunlit scene. The form, with variations, is repeated in several paintings of 1880: the *Intérieur, Homme au Balcon, Vue Prise à Travers un Balcon* and *Un Balcon à Paris,* as well as the dramatic view *en plongée* like *Un Refuge, Boulevard Haussmann* and *Boulevard vu d'en Haut,* where all evidence of viewpoint is suppressed, but may be inferred. Even *Peintres en Bâtiment* of 1877, which appears to belong rather to another series, the studies of men at work, also amazes with the seemingly endless perspective of straight streets in which the painters' activities are located.

Though in later life Caillebotte became an enthusiastic suburbanite, devoted to sailing on the river and cultivating his garden, on which he frequently compared notes with Monet, throughout the 1870s he remains the quintessential urban

painter and recorder of bourgeois life in Paris. And for him Paris and its people were a reason, not merely an excuse, as with other Impressionists one often has the suspicion that they are. Pissarro, for instance, did not begin seriously painting Paris until much later – the first series, planned as such and painted from a window in the Hôtel Garnier near the Gare St Lazare, dates from as late as 1893; afterwards he painted series of views from the Hôtel du Louvre, mostly up the Avenue de l'Opéra, in 1898, of the Tuileries Gardens in 1900, of the Pont Neuf and its surroundings later in the same year and of the Pont Royal from the other side of the Seine in the year of his death, 1903. Each of these series was carefully planned in advance, and a suitable vantage point sought and found.

There cannot but seem to be something slightly arbitrary and mechanical about this systematic search for a subject, though that does not prevent Pissarro from occasionally producing first-rate works and reacting with unexpected freshness and en-

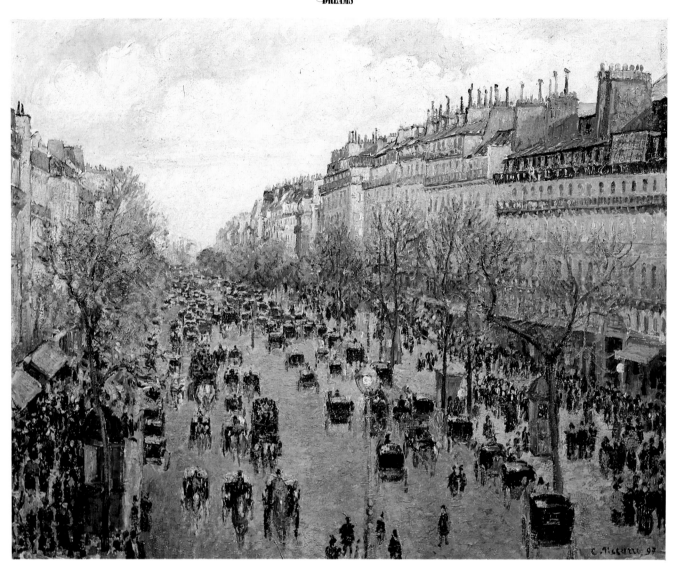

CAMILLE PISSARRO
Boulevard Montmartre, 1897
Early in 1897 Pissarro painted a series of thirteen views of the Boulevard Montmartre at various
times of day and (uniquely in his work) at night. The two paintings on this page belong to the series.

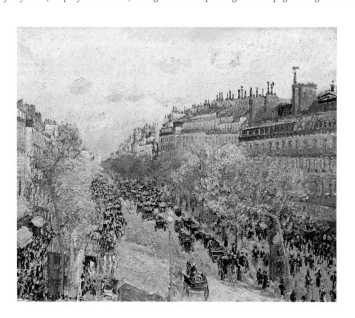

CAMILLE PISSARRO
Boulevard Montmartre with
Setting Sun, 1897

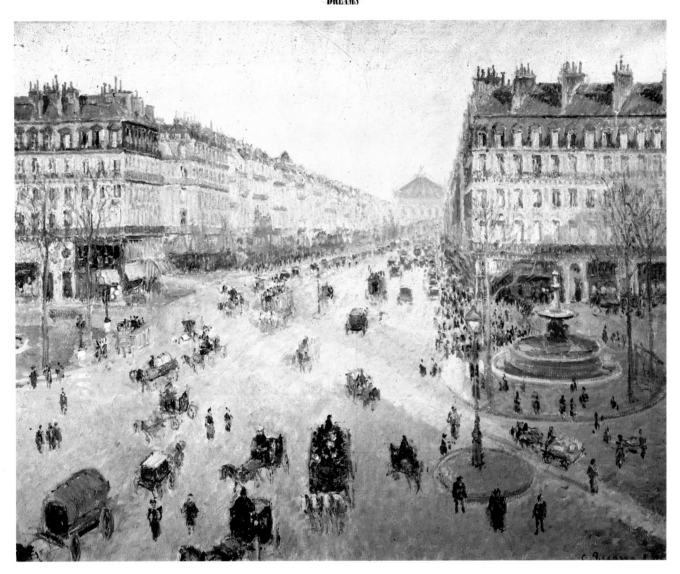

CAMILLE PISSARRO
L'Avenue de l'Opéra, 1898
One of the series of Paris street scenes Pissaro painted from the windows of the
Hotel du Grand Louvre in the Spring of 1898.

thusiasm. Writing to his son Lucien in 1898 he remarks of the views along the Avenue de l'Opéra:

It is very beautiful to paint. Perhaps it is not aesthetic, but I am delighted to be able to paint these Paris streets that people have come to call ugly, but which are so silvery, so luminous and vital. They are so different from the boulevards. This is completely modern.

A reaction, obviously, easier to experience nearly thirty years after the fall of the Second Empire than when Haussmann and his depredations were news. Twenty years earlier, one suspects, Pissarro would have shared the views expressed by Renoir in 1877, when he denounced the new boulevards (shortly after painting them in a glamorous bustle of activity for the Philadelphia Museum's *Les Grands Boulevards*) as 'cold and lined up like soldiers at review', and needlessly destructive of

history. But in the lag of time much of the immediacy and rich ambiguity of the Impressionists' original response has gone, with only a certain distant, elegiac grace to takes its place in these final works of Pissarro.

In principle, the worldly Parisian Degas should have been closer to the centre of things and the spirit of the Paris streets. When we come to metropolitan society, the theatres, entertainments and brothels of the capital it is clear that he was, but this does not seem to have spilt over very much into concern for the external appearance of the city. Indeed, Degas seems to have had little interest in the outdoors at all, except in so far as it was the element of the horses which fascinated him, and in his racing scenes the landscape depicted is generally unspecific and quite remote from built-up areas. During his whole career Degas painted only a handful of pure landscapes, and there is only one of his famous pictures (or was, for it was destroyed in the Second World War) which depicts a recognizable scene in

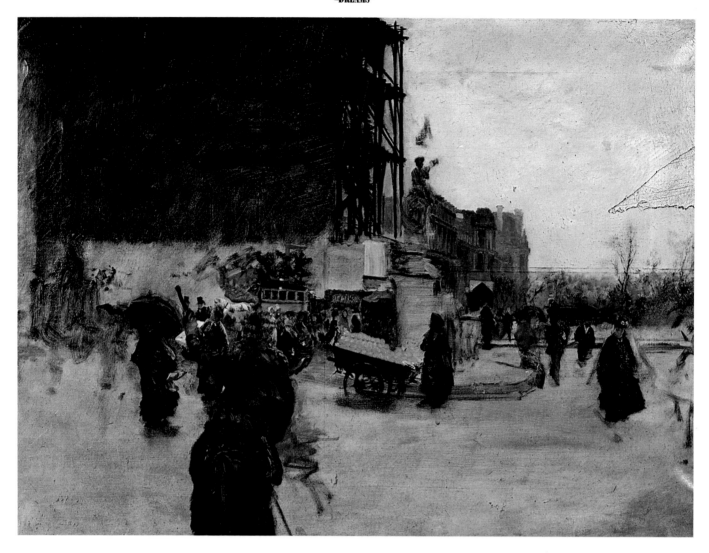

GIUSEPPE DE NITTIS
La Place des Pyramides, 1876
De Nittis was an Italian painter who did his best work in Paris and London, was
a close friend of the French Impressionists and exhibited in the First Impressionist
show in 1874.

Paris: *Place de la Concorde: le Vicomte Lepic et ses Filles* of 1873. Even here, the picture crowds its architecture up in the top quarter of the composition, and the main interest is in the human figures (with dog) arranged in seemingly arbitrary, snapshot-like poses with the Vicomte marching purposefully ahead to the right and the two little girls looking backwards, distracted, to the left. Though the Place de la Concorde itself is a formally arranged space, Degas ignores this by showing as much of it as he does show only partially, and on a diagonal.

Berthe Morisot's interests seem, *mutatis mutandis*, to have been rather similar to Degas's. There are more pure landscapes in her work, and more pictures of people (mostly mothers and children) as non-specific out-of-doors visitors to gardens, parks and such. But again interiors, mostly domestic, predominate, and the evocations of a larger Paris are virtually confined to a group of paintings she did in 1871-72 of Paris seen from the Trocadéro. Only one of these is primarily a landscape, the pan-

oramic (though not large) *View of Paris from the Trocadéro*, which in its composition – a distant prospect from a hilltop viewing-point, with figures in the foreground, a little girl looking towards the view and two women looking away – reminds us a little of Manet's World's Fair picture. The Morisot is historically interesting, in that it gives a clear impression of what this part of Paris, now the sixteenth arondissement, looked like when the Pont de l'Alma was just built. Haussmann's Paris is a distant dream, hardly to be divined, and the golden dome of the Panthéon again dominates all, as the most prominent single building in Paris before the Eiffel Tower and the Sacré Coeur were built. The other paintings in the series, oil and water-colour versions of *On the Balcony*, adopt a similar viewpoint. Yet again the view is dominated by the Panthéon, but here the principal interest resides in the foreground figures looking out over the scene, a young mother in black and her small daughter, with the townscape used merely as a backdrop.

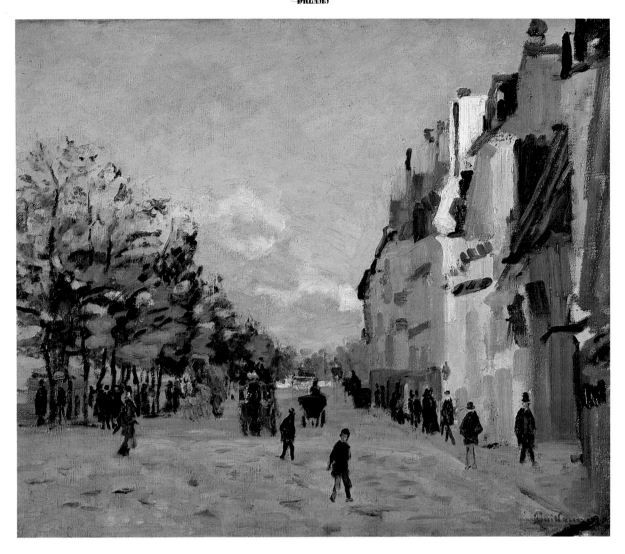

ARMAND GUILLAUMIN
Quai de Bercy under Snow, 1873
Guillaumin was an associate of the Impressionists and fellow exhibitor in
Impressionist exhibitions, but remained more conservative in style. He had a
particular taste for unglamorous semi-industrial scenes.

No doubt the unfortunate academic associations of topo-graphical drawing helped to put off any concentrated and con-tinuing interest on the Impressionists' part in the physical aspect of their city. Also, a lot of it must have been staled for them by familiarity, though this was not necessarily the case with what went on indoors, the social life of the Parisians. Finally it seems to have been left to minor Impressionists and associates from abroad to be really excited by Paris streets and squares, and all the most truly urban aspects of the city. We get more of the physical reality of the architecture as well as the bustle and glamour of the street-life in the paintings of the Italians Giuseppe de Nittis and Federigo Zandomeneghi, or the Belgian Henri Evenepoel, or the Catalan Ramon Casas, than in all the major French Impressionists put together.

This was natural because they were in effect tourists, excited by new sights and sounds and eager to express them all in paint. Even the very serious, dour Van Gogh, who came to Paris in 1886 and became briefly associated with the Impres-sionists, found his own kind of inspiration in the physical appearance of Paris, though in his case it was not the grand boulevards, the pomp and the splendour, but rather the *ter-rains vagues* where the boulevards ran out in scrubby country-side and grimy new working-class suburbs. Even his view of the old *Moulin de la Galette* in Montmartre does not look nostal-gically at this little corner of still-remaining countryside in Paris, but rather seems to view it as a doomed survival, seen across humble allotments. This grim underside also peeps through in Armand Guillaumin's semi-industrial landscapes of the Cité from up-river, such as *Temps Pluvieux* in the first Im-pressionist exhibition and *Quai de la Rapée* in the sixth. Not everyone in the Impressionist circle was ready to accept the Second Empire fantasy of Paris as the whole truth. Yet no one seemed to think that it might be the job of painting – their kind of painting anyway – to denounce it.

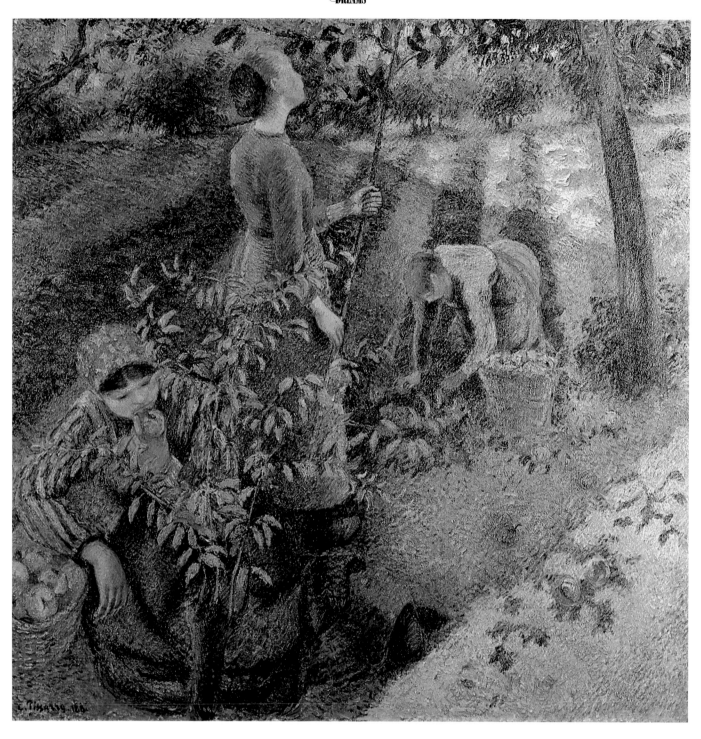

CAMILLE PISSARRO
Apple Picking, 1886
One of Pissarro's most evocative and idyllic studies of works and days in the
countryside, this version of the subject was painted in his Neo-Impressionist phase.

3

RUSTIC PLEASURES

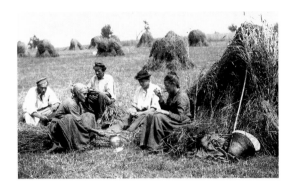

Harvesters breaking for lunch: a photograph of a favourite scene
in Pissarro's painting, dating from c.1900.

IN THE COUNTRY, THE IMPRESSIONISTS WERE ESSEN-
tially day trippers. They came from the city, they
saw and enjoyed,but really only with the edu-
cated townsman's view of things: apart from Pis-
sarro, they give little sign of serious interest in the
countryman and his way of life, the country as a
working society rather than a colourful and
picturesque backdrop. It is significant, and correct, that the
most extensive and scholarly show of Impressionist landscape
in recent times was entitled, in its North American version at
least, 'A Day in the Country', for that really sums up the re-
lationship of 'Impressionism and the French landscape'.

And why should that not be so? There is no rule which states
that painters, even landscape painters, have to be sociologists,
demographers and experts on agricultural procedures. Not, at
least, unless they allege that they are any or all of these things.
On such matters the Impressionists were mercifully silent. And
it is evident that what in one context may seem the fault of
superficiality can be reinterpreted in another as the virtue of
objectivity. It was the very detachment of the Impressionists
from the land and details of its cultivation which enabled them
to depict so clearly what they saw in front of them and attracted
their attention and painterly interest; they had no practical or
symbolic *parti-pris*, like their predecessor Millet or their succes-
sor Van Gogh. Of them might it fairly be said, 'a primrose on

the river's brim, a yellow primrose was to him, and . . . nothing
more.' It hardly matters whether a painter can tell us what kind
of tree he is painting or what sort of crop is being grown in the
field before him, provided he knows what it looks like, its
appearance says something of artistic value to him and he has
the technique to capture or evoke it.

It is, in any case, too easy to speak of the Impressionists as
though they were a uniform group, and as though their atti-
tudes remained consistent and unchanging throughout their
individual careers. We have already seen that during his years
at Argenteuil Monet's attitude to his surroundings, the subjects
he found it interesting to paint, and even to life itself under-
went a considerable change. The same may well be true of
other individual Impressionists. And it is certain that there are
considerable divergences in their attitudes to the countryside,
their interest or lack of interest in the human component of the
landscape. None of the Impressionists cared much for the
wilder aspects of nature, and in the main they confined their
attentions to cultivated land within easy reach of Paris – or, in
the case of the later Cézanne, within easy reach of Aix, where
he was then principally living. On the other hand, it is equally
true that Monet's painterly interest in cultivated land does not
extend to the people who cultivated it: his country landscapes
are usually quite uninhabited.

Pissarro, however, in the years that he was painting, and was

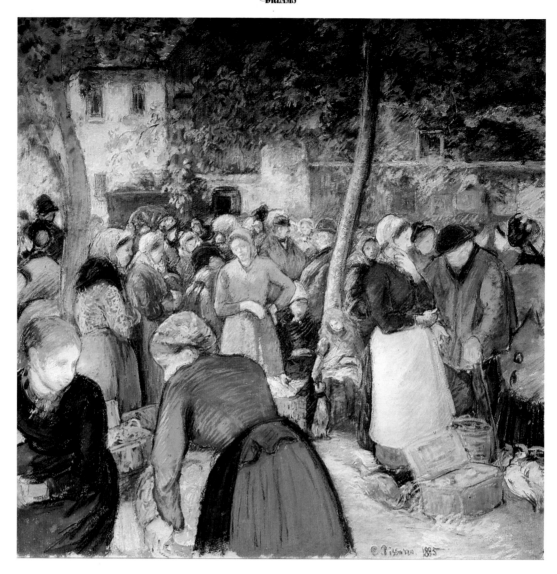

CAMILLE PISSARO
The Poultry Market, Gisors, 1885
This scene of country working women at market, painted (unusually for Pissarro)
in tempera, once belonged to Monet.

the centre of a whole group of painters, at Pontoise, gives every appearance of being as interested in the people as in the place: very rarely are there no human figures in his rural landscapes, and frequently they dominate the overall effect. This surely must have had something to do with his socialist sympathies and his social, even fatherly, nature. It was in any case a trait which remained personal to him. Cézanne for two years early in the 1870s and for three at the end of the decade spent much time in Pontoise as a friend and in some ways a pupil of Pissarro. The two men often painted the same subjects side by side. And yet the spirit informing their work was quite different: as Richard Brettell has nicely observed, in the catalogue of the 1984 exhibition *A Day in the Country*, 'The village, for Pissarro, was at one with its inhabitants. For Cézanne it was simply a group of buildings surrounded by hills and vegetation.' Cézanne was primarily interested in landscape as landscape, a collection of shapes and forms ready for analysis,

taking apart and re-creation in terms of painted surfaces. Of all the Impressionist trippers to the country he was the most truly objective, even to the verge of abstraction.

But all the Impressionists began painting landscape within a certain very distinct tradition, which influenced what they painted and whom they hopefully painted it for rather more than the precise way they painted it. Not only had landscape painting been gaining ground on the other genres in France since the beginning of the century, but with the ascendancy of the painters working in the woods around Barbizon from the 1840s on it was becoming clear that the landscape appealed to a particular class of art-buyers and fulfilled a particular function. The function was one that the painters of the Barbizon School and later the Impressionists were particularly well-fitted to serve: the glorification of traditional French countryside for prosperous townsmen who never had more than a distant, tourist relationship with the country themselves, but felt a sort

CAMILLE PISSARRO
Palines, with Haystacks to the Left, 1873
One of Pissarro's more uncompromisingly grim, grey landscapes painted in the
Pontoise years: little but the ricks, the grey sky, and the solitary human figure.

of chauvinistic pride in it, its settled prosperity and surviving traditional values, and liked to have paintings which reflected and confirmed these views. Catering to such a public was the foundation of the Barbizon painters' prosperity, and it seemed reasonable enough that the Impressionists, despite any differences of painting technique, should hope for a share of the same rich market.

The popularity of this sort of landscape, painted mostly within easy distance of Paris, in the most intensively cultivated area of France, was founded on its comforting nature as a re-inforcer of traditional values and confirmer of traditional myths. Nor did the Impressionists do anything much, in this respect, to rock the boat. The 1870s and 1880s were a period of unparalleled technical advance in French farming, but you would never know it to look at the rustic landscapes of Pissarro or Monet or Sisley or Cézanne. When Pissarro depicts plough-ing or sowing or reaping, it is always done by the most tradi-tional means, by hand and by horse. The new farm machinery of the era never figures in his paintings as something actually in use. In 1876, it is recorded, he painted two farmyard scenes with a new mechanical harvester prominently featured (it had just been acquired by his farmer-friend Ludovic Piette in Brit-tany), but as for becoming an accepted part of Pissarro's agri-cultural landscape, it might just as well have landed from Mars and then departed whence it came.

It is not clear how far Pissarro was consciously perpetuating a myth, or recording the vanishing past rather than the con-quering future. Certainly he was presenting just such a picture as his potential clients would like to see, even if for various reasons, partly aesthetic and partly organizational, he never managed to capture that market so successfully as Monet with his Argenteuil-based paintings of the 1870s. At least it can be said that within his chosen limits Pissarro was serving some kind of recording function: the resemblance between some of his scenes of peasant life and work and some of Millet's paint-ings is hardly coincidental. (Millet before him had tried to avoid the every-picture-tells-a-story syndrome, though some-times he had anecdote thrust upon him, as in the notorious appearance in print form of his famous *The Angelus* under the title, *Burying Baby*.) Certainly Pissarro's titles for his Pontoise landscapes are very precise, as though to reassure potential purchasers that this is indeed a documentary record of this particular aspect, that particular building, a specific field or stream or wood. Possibly he titled his pictures this way because that is the way he regarded them, with a slogging concern for the facts – though as we have seen with his local factory pictures he was quite happy to add, subtract, rearrange and invent for purely pictorial reasons, as well as possibly, some-times, to make the finished picture more palatable to pros-pective buyers.

CLAUDE MONET
Poppies Near Giverny, 1885
One of the earliest paintings Monet did in the area of Giverny, where he had
moved in 1883, and shortly before he began systematically painting in series.

Monet's creative temperament inclined him more towards generalization, and increasingly so as his work progressed. For him, as in the early Hollywood producer Abe Steen's famous piece of advice to the director King Vidor on location shooting, a rock was a rock and a tree was a tree, and one haystack could stand in for all haystacks. Nor did it matter much where this specific haystack was, or whether a buyer wanted to be reassured that these were real haystacks in a real field. To this extent it is tempting to make out a case for Monet as a symbolist rather than a realist: however specific his starting-point, his images are frequently cut loose from concrete reference and left to create their own climate of significance. The haystacks, as we call them (though whether they were actually of hay is not clear, and quite probably was not clear or germane even to Monet), date in any case from later in Monet's career, the series being started in 1890 and exhibited together in 1891. By this time Monet was living in Giverny, and presumably the stacks

were somewhere nearby. But they are never localized in titles. While modern commentators have suggested that the motif was for Monet almost devoid of significance in itself, merely a convenient shape over which the light of different seasons and different times of day could play to almost abstract effect, critics at the time seemed to have no doubt that the stack must carry a freight of quasi-symbolic significance, through its associations with basic sustenance, its design to remain unchanged through the cycle of the seasons, its tokening of strength, security and man's control over his environment. And clearly this must have been how they struck their first buyers (the show was commercially a triumph), inscribing themselves readily in the conservative tradition of glorifying the native soil of France.

Monet had changed since Argenteuil, and continued to change and develop until the end of his life. But the changes were in detail and emphasis, not in essence. And though we

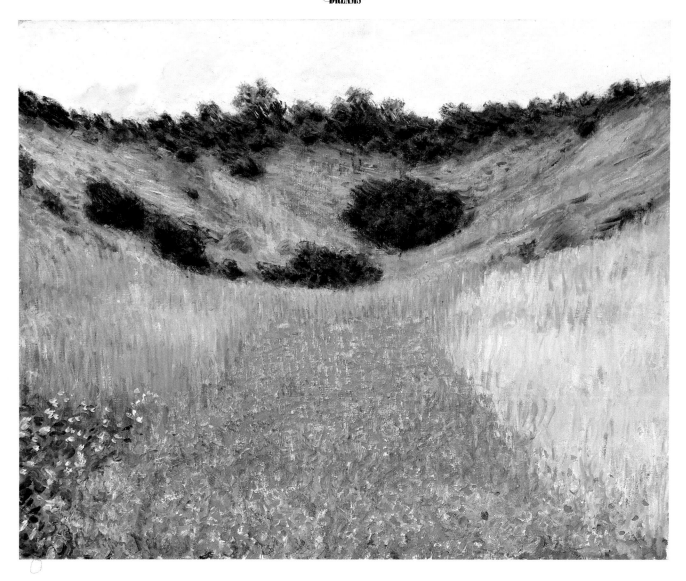

CLAUDE MONET
Poppy Field near Giverny, 1885
Though there is nothing formal or extensive enough to be regarded as a series, Monet's growing interest in the fields
of poppies round about during his early Giverny years prefigures his later serial painting.

may catch symbolic overtones in the haystack paintings, and they may well be there, it is quite likely that Monet was never conscious of them. When he described the process of painting the pictures in a letter to Gustave Geffroy, he made nothing of their subject, merely indicated that it provided a pretext for the creation of 'instantaneity', and at that the *impression* of instantaneity, not the fact, which was naturally impossible, however fast and fluently he might paint on the spot. It is likely that he felt much the same during his Argenteuil period. Although the effect of the landscapes painted in the country-side round Argenteuil is much more solid than that of the later work, so that one has the feeling that they are depictions of a specific place, there is little feeling that the place mattered much on a conscious level. His formal explorations seem to have been paramount in his own mind, and if we think we see a modification of attitude, from happy acceptance to ultimate rejection, in regard to the place itself, that can

hardly be more than a hypothesis, like any psychological interpretation of art.

Whatever interpretation we finally put on the landscapes of Monet's Argenteuil period, they remain quite clearly the work of an outsider, a visitor to the scenes they portray, rather than of a participant in the local life – of the town, let alone of the fields. Perhaps not exactly a day tripper, or if so a peculiarly unfortunate one, in that so many of his painting days seem to have been grey and overcast. Not that he seemed to mind very much: a dull, subdued light was light nonetheless, and could bring out all sorts of subtleties in the colours of nature. Snow was even better. Monet was fascinated by snow and its possibil-ities of reflection, introducing light into a scene from unaccus-tomed angles. This was just as well, as during the last forty years of the nineteenth century there were few years which did not see significant snowfalls in northern France. The winters of 1867-69 were particularly hard, and again there were very

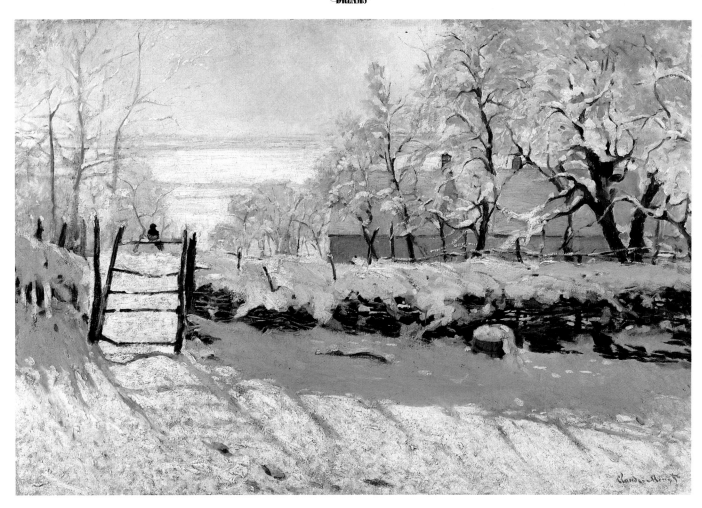

CLAUDE MONET
The Magpie, 1868-69
One of Monet's most brilliant virtuoso depictions of the effects of the sunshine on
snow – a subject he had much chance to study in the hard winters of the late
1860s.

severe winters in 1874-75 and 1879-80, captured on canvas by many other painters of the day beside Monet. Snow was part of the predictable round of the year, and the habit of painting by seasons, recommended by all the classic authorities on landscape, was too deeply ingrained to be dismissed out-of-hand. Moreover, Monet's supposedly extraordinary hardihood in the face of extreme temperatures, his uncompromising determination to paint out of doors in all weathers, was becoming part of his own personal myth, propagated by the newspapers and reassuring to those who worried unduly that to paint in an Impressionist fashion was too easy, insufficiently disciplined and arduous to justify high prices.

What we do know of Monet's painting procedures includes the intensity of his search for landscape motifs which would instantly 'speak' to him. He would take himself off to a new location and explore endlessly and minutely, in the hope of finding the real, right thing.– entirely on the reasonable basis

of 'I'll know it when I see it.' He had certain ideas about himself: he did not take to excessively luxuriant landscapes, being, he said, 'really the man for isolated trees and broad spaces'. We must assume that he explored the Argenteuil area carefully before settling himself there, and appreciated to the full its variety of terrain and its general sparseness. Indeed, it seems very likely that a particular advantage of Argenteuil and, even more, Pontoise, was much like that of such favoured film locations as Durango and Almeria: they have within easy reach – generally no more than a short walk, in fact – many different sorts of country scenery, so that the landscape painter, if so inclined, can paint almost any kind of domesticated nature to his heart's content. While both Argenteuil and Pontoise were partially industrial, and were rapidly becoming more so, they were not so beset with factories and worksites that these could not be avoided by editing out. Which is just what the 'objective' Impressionists frequently did,

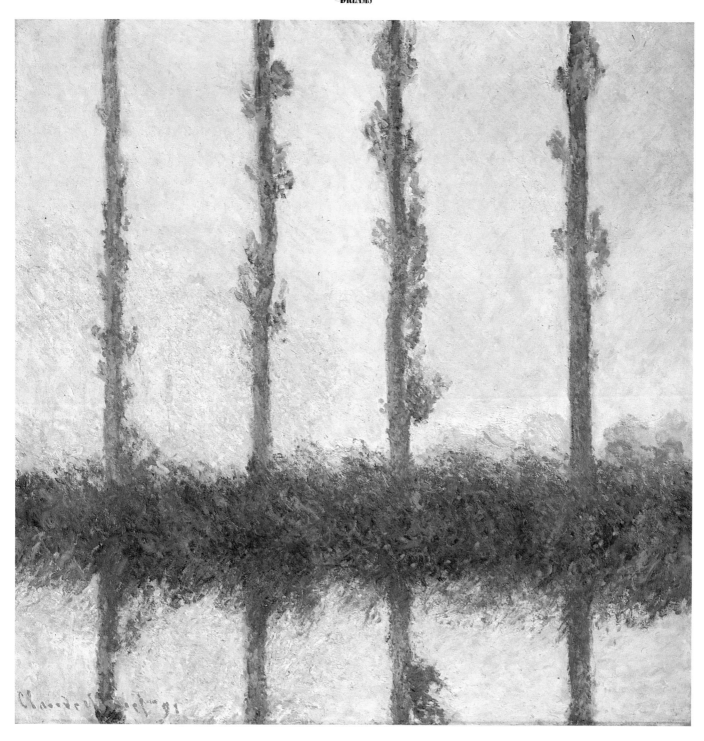

CLAUDE MONET
The Poplars, the Four Trees, 1891
Among the most stark and geometrical of the series of poplar pictures Monet
painted near Giverny around this time, the Four Trees seem to point forward to
Jackson Pollock.

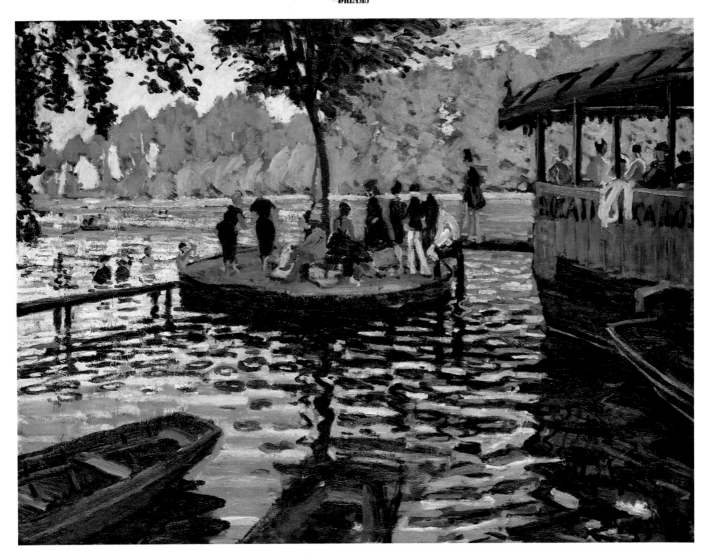

CLAUDE MONET
La Grenouillère, 1869
Using a subject more favoured by Renoir and Caillebotte, Monet makes it over in
his own way by reducing it almost to abstraction in the play of ripples in the
water.

in the interests of harmony, prettiness and preserving pictorially the status quo.

When they got into trouble with the critics – which was frequent in the 1860s and 1870s – it was rarely on grounds of their subject-matter, at least where landscape was concerned, but entirely because of the style in which they treated it. The grounds were two, separate but interconnected: the garishness of their colour and the incoherence of their brushwork, and the way they actually applied paint to canvas. Brilliance of colour was the way they principally differed, even at a casual glance, from their successful Barbizon predecessors. The Barbizon painters mostly painted in dark, old-masterish colours, with heavy impasto, and had a particular affection for thickly wooded areas as a subject for pure landscape. Monet, Pissarro and Sisley tended to prefer open country, but were referring in their work to nowhere more exotic that Barbizon to the Parisian connoisseur's experience – even less so, in fact, since they were often painting not only countryside in easy reach of Paris, but the kind of suburban landscape in which many prosperous Parisian bourgeois lived. In other words, they were calling upon their public to refer what they saw in paintings back to, and compare it with, their own common experience.

This is principally where the colours of Impressionism were a stumbling block. The Impressionists seem genuinely to have assumed that if they could see all those colours in a landscape, then anybody could: it was simply a matter of looking. In this they were optimistic or naive. If they despaired of conventional people for seeing only what the conventions told them ought to be there, they seem to have failed to recognize that they themselves in a sense did the same: it was simply the conventions that were different. Until the mid-1880s, when Seurat and the Neo-Impressionists or Pointillistes started to put Impressionist conceptions of colour on a more scientific basis, Monet, Pissarro and others were apparently little interested in scientific

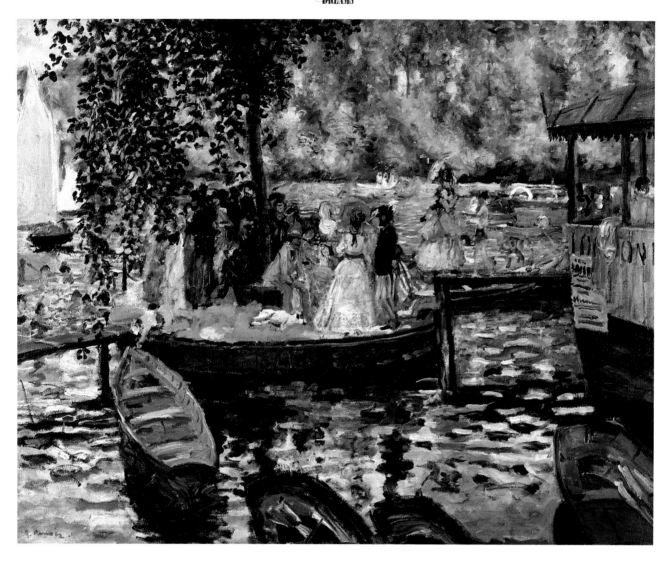

PIERRE-AUGUSTE RENOIR
La Grenouillère, 1869
Superficially similar to Monet's view, and painted at the same time, Renoir's
emphasizes the people more than the scenery in this favourite Impressionist
resort.

theory on colour: they believed that all that was needed to see as they saw and paint as they painted was to look at what was in front of one without prejudice and preconception. All that was necessary was to free the eye from the tight control of the mind. If contemporary spectators could not do this, it was their problem rather than that of the Impressionists.

Nevertheless, they were proceeding according to some loosely defined principles. They saw colour as an alternative to modelling, and generally realized that this came about in two ways: one, that modelling in a surface was conveyed to the eye principally by the way that light played over it; and then that the quality of the light actually changed the colour: an object which was in itself uniformly coloured actually appeared to be different colours in light and in shade. From here it was no great leap to applying some very elementary theory of complementary colours, such as had been understood perfectly well by many of the Renaissance masters, and arriving at the

Impressionists' notorious mauve shadows, which, for the life of them, most of the Impressionists' early critics could not see for themselves. All of these ideas applied particularly to the Impressionist landscape, based as it was on the luminous quality and constantly shifting light of the sun in nature, out-of-doors and uncontrolled. The Impressionists' reputation as realists (if not their pretentions to being realists) told against them particularly here, since as they were handling subjects familiar to all their public, anyone without claim to special expertise could easily say, 'But this is not accurate; it just does not look like that.'

The obvious answer – 'To you perhaps not, but it certainly does to me' – was not readily applicable in the context of an appeal to empirical experience. Had the Impressionists gone about things in the traditional academic way, by propounding a new theory and then working according to it, they might not necessarily had found life any easier, but at least the grounds of

51

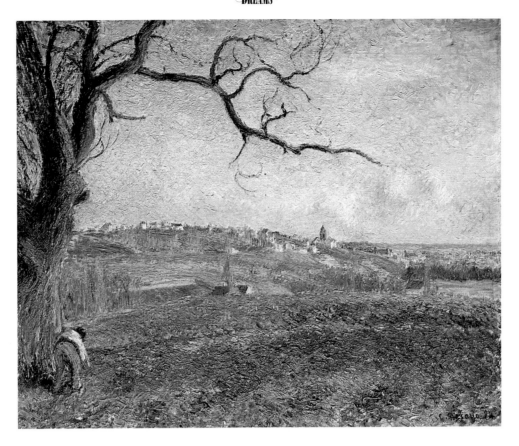

CAMILLE PISSARRO
Pontoise, 1884
Among Pissarro's last paintings of Pontoise, his home for the better part of
eighteen years: a suitably bright, if distant, prospect.

argument would have been more comprehensible. And they would perhaps not have been so widely accused of technical incoherence. No doubt this would still sometimes have occurred, because some of their works *were* technically incoherent. While fundamentally they were advocating adherence to a new set of conventions in the artistic rendering of visual actuality, they had not at first worked out what these conventions were, and so had not worked out a consistent visual language for what they wanted to convey. It is easy for us now to overlook this: we are so used to the Impressionists that our eyes simply glide comfortably over the rougher passages in their paintings; we can just relax and enjoy.

But if we put ourselves back into the position of a contemporary faced with, say, a typical Pissarro landscape of the Pontoise period, our reactions shift considerably. We cannot relax, step back and take in the overall effect: we are so busy trying to read the language of the painting brushstroke by brushstroke, assuming that each one must mean something clear and consistent, that each must be a sort of shorthand for which there is a universally applicable key. Sometimes the paintings read well enough according to this rule; sometimes they do not read at all. And for us it is still deeply worrying if we do not know precisely what is being depicted: what that patch of red is likely to be, and whether, whatever it is, it is nearer or farther away than that quite recognizably depicted

screen of saplings. Pissarro's method at this time was completely intuitive, and sometimes it was more clearly and completely realized than at others. Monet later claimed that even in the 1860s there was method in what he did, that he was knowingly 'running counter to accepted conventions' in his experiment with rendering light and colour. Pissarro seems to acknowledge that he was not by the degree to which he was bowled over by the new theories of the Neo-Impressionists around 1886, which finally gave an explicable structure to what he had intuitively felt.

If this lack of theory, or application of the wrong theory (complete documentary naturalism in the depicting of nature), was the great stumbling block for early appreciators of Impressionist landscape, for Cézanne, in his later landscapes of the country round Aix, the appearance of a too intellectual approach was equally a problem. Aix and the Provençal countryside around it are fairly far removed from the vicinity of Paris and the possibility of day trips. On the other hand, they are Cézanne's equivalent of the Ile de France for Parisian painters: what just happened to be on his doorstep, and had been easily familiar to him from childhood. For most of the Impressionists and their followers, a move outside the more accessible areas of northern France, even in a period of rapidly improving transport throughout France, betokened some kind of deliberate reaction against or rejection of Paris and its in-

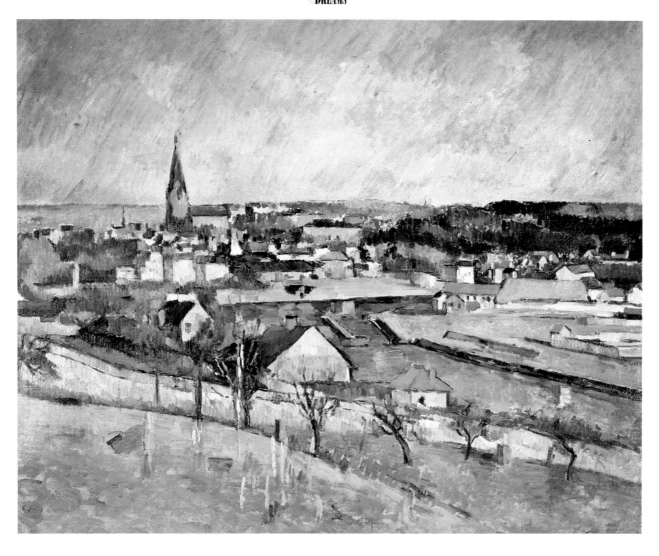

PAUL CÉZANNE
The Village, 1879-82
This view of an unidentified village is probably somewhere in Northern France,
despite the dry, brown, southern colouring of the surrounding country.

fluence, of everything urban. Cézanne's withdrawal from Paris, though evidently occasioned to some extent by the harsh criticism he had received from Parisian critics, also had a lot to do with the basic economics of his life (in 1886 he married and his father died, leaving him with a quite considerable private income) and had, above all, more positive than negative reasons artistically: as Cézanne himself said, 'Were it not that I am deeply in love with the *configuration* of my country, I should not be here.'.

Separated as he was from Parisian art circles, and no longer needing to make a living from painting, Cézanne exhibited less frequently and understanding of his later work was slow in coming. What initially turned commentators off, and then, after his death in 1906, particularly turned them on was the unmistakable theoretical basis of his landscapes. He was in-

terested in the configuration, the structure, of his local landscape, and this meant observing the way light fell on it as a way, primarily, of reintroducing modelling into painting, rendering volume with precision. Once the public had got used to the unconcern of Monet and, to a lesser extent, Pissarro, with the weight and volume of objects, their dissolving of outline into an indeterminate haze of strokes and dots of colour, it was hard to look at paintings which aimed again to create an air of monumental unchangeability. Only with the conversion of Picasso and Braque to Analytical Cubism a year or two after Cézanne's death did his rigorous, studied, profoundly unexotic paintings of 'his' mountain, the Mont Ste-Victoire, and the severe cubes of houses around Aix come again to make their own sense: a sense which was taken at the time to be against all that the first Impressionists had stood for.

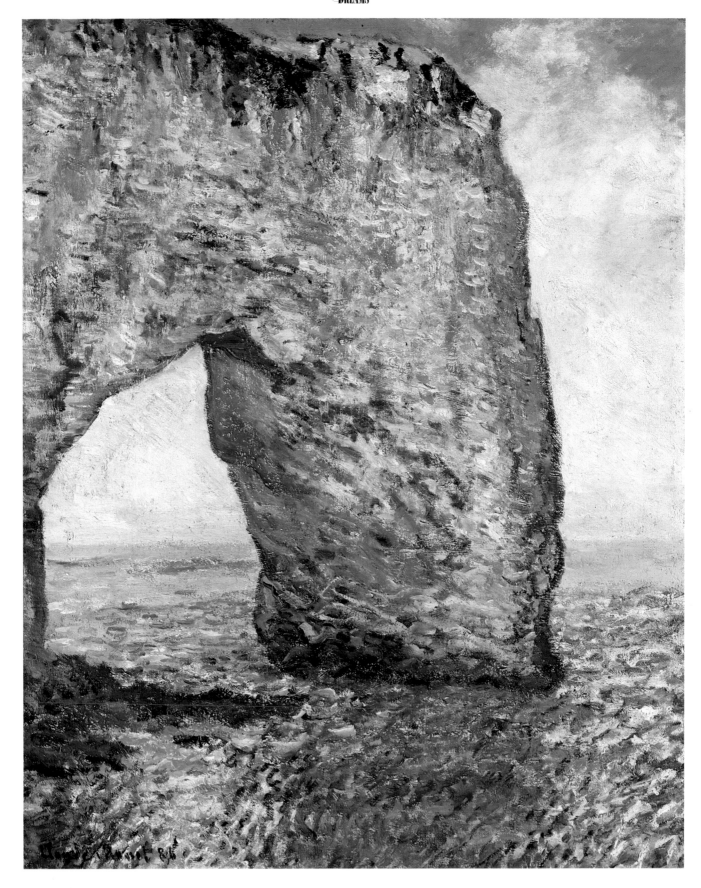

CLAUDE MONET

The Manneport, Etretat, 1886

This extraordinary rock formation was a subject to which Monet reverted quite frequently.

4

THE LONELY SEA
AND THE SKY

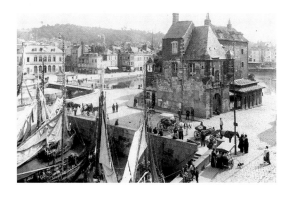

The fishing port of Honfleur on the Channel coast was much
favoured as a painting location by several Impressionists,
particularly Monet, whose family had a house there.

FTER THE SUBURBANIZED COUNTRYSIDE OF THE
Ile de France, the nearest coast, that of the
English Channel resorts, was a natural exten-
sion of interest for Paris-based artists. For
them it also had the convenience of proxim-
ity; for their public the subjects they could
find there had, especially after the great surge
of seaside tripping in the 1850s, all the charms of familiarity. A
painting of Deauville or Trouville or some such resort could be
regarded as a memento of a visit, and a chance profitably to
compare the artist's view of it with one's own. Coastal subjects
had been popular, and had had their own enthusiastic
audience, at least since the time of Louis Francia and William
Parkes Bonington at the beginning of the century. More re-
cently specialists in the genre like Eugène Boudin, a senior
friend of the Impressionists and much admired by them, had
made a very profitable corner for themselves. To venture so far
in search of painting grounds was not, for the first Impression-
ists, exactly a daring and novel thing to do.

What the Impressionists admired in Boudin, and had learnt
from him, was his mastery of what was called *peinture claire*,
that is to say, painting light with a predominantly light tonality.
Boudin had evolved his own version of this, partially from
close observation of certain later Dutch landscape painters'
practice, and even more from his own observation of the wide

pale skies and pale sandy beaches of the Channel coast, and
how a cool, clear light played over them, caught up from the
ripples of the waves and thrown from below as well as above.
His observation was admirable, but his technique was much
more conservative than that of the Impressionists: he still
believed in crisp outlines, and his colouring was a delicate and
precise rendering of what any visiting Parisian could see and
recognize. The Impressionists mostly started from somewhere
similar, and though they carried the dissolution of outline
under the onslaughts of colour much further than Boudin ever
did, they learned much from his observations and the places
where he made them.

Monet, being brought up in Le Havre, in a family connected
with the sea, was the first of the Impressionists to start con-
sistently painting the sea and, more especially, the seaside. But
that was not what he began by doing. As a schoolboy he had a
natural gift for caricature, so pronounced that he could and did
sell his drawings for twenty francs a time. In a local framer's
shop window they were exhibited along with typical small
landscapes by another local resident, Boudin. The older man
encouraged the boy to paint, but impressed upon him the
necessity for proper training – with which in mind Monet was
dispatched to Paris at the age of eighteen. Though he was in-
spired by Boudin's example, he does not seem to have painted
in Le Havre before he left, and by the time he returned on a

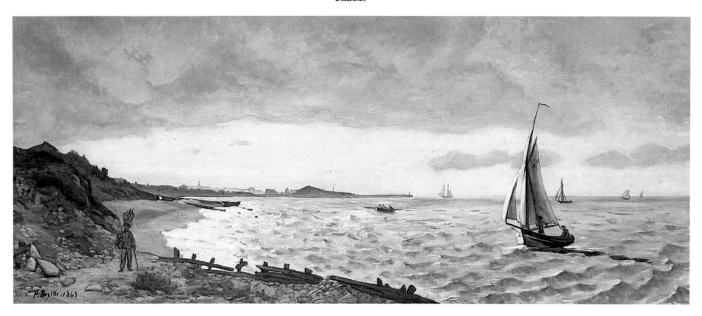

FRÉDÉRIC BAZILLE
The Beach at Sainte-Adresse, 1865
Closely based on a painting of the same scene by Monet, with whom Bazille first
came to paint in the region of Honfleur.

painting trip to the coast in 1864, with his fellow Impressionist Bazille, it was already a Parisian's holiday rather than the return of the native. Monet and Bazille went to Honfleur, no doubt partly because Monet's parents had a holiday house there, and rapidly found more picturesque subjects for painting in the locality than they could conveniently handle.

From the terms in which Bazille wrote of the trip to his mother one may presume that the two young painters were, in a perfectly normal nineteenth-century fashion, in search of the immediately attractive – and possibly saleable – scene for painting: 'As soon as we got to Honfleur we looked around for landscape subjects. They were easy to find because the country is a paradise.' For the moment, what Monet did with these subjects was not so different from what Boudin might have done; a little more roughly painted, but with no evidence that Monet was at this point trying to do anything at all revolutionary. Paintings like *La Pointe de la Hève* and *The Beach at Honfleur*, begun on this trip, seem to have been sketched out on the spot but worked up in the studio, back in Paris. Even at this point Monet was a much more accomplished painter than Bazille, as we can see from comparison of parallel works. But both of them are painting what would be generally recognized as paintable scenes, and probably in Honfleur as much as anything because it had been a favourite location for Barbizon painters in the preceding decade.

At this stage Monet and Bazille were still struggling to paint what was in front of them as accurately as possible. In 1864 Manet too, quite coincidentally, came to the Channel coast to paint, taking himself to Boulogne during the summer. He first appeared before the public in this connection in the improbable guise of artist-as-war reporter: hearing that a battle was likely to take place in the Channel between two American warships (it was the time of the American Civil War), he moved over to Cherbourg and recorded it in a spirited painting, *The Battle of the Kearsarge and the Alabama*, which had considerable topical success when shown in Paris six months later. But his less sensational work of the time was far better. His most notable painting connected with this trip, *Departure from Boulogne Harbour*, is much more stylistically enterprising than anything Monet had yet done. Whether it was done on the spot or painted from memory afterwards, it carries a traditional seascape subject to the verge of abstraction: no evidence of the harbour or of land at all is visible: simply a vast expanse of turquoise sea with strangely shaped black boats with black sails distributed at random on it, and a small steamboat giving off a lot of grey smoke. There is some indication here of Manet's great interest in Japanese prints, and the documentary value of the picture is minimal. It is much closer to Whistler than to anything in French art at the time, and if it were entitled 'Harmony in Blue and Black', or something of the sort, one would

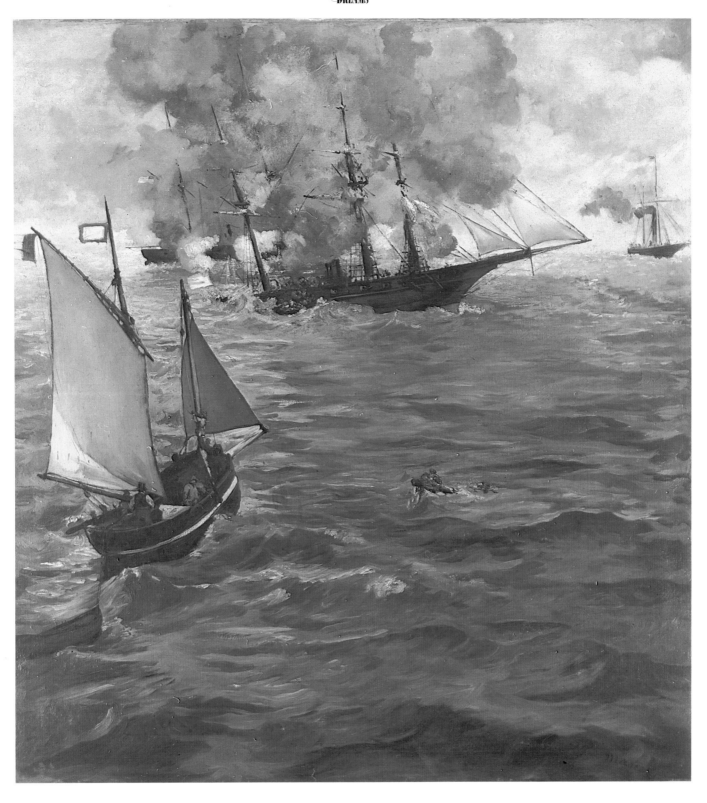

EDOUARD MANET
The Battle of the Kearsage and the Alabama, 1864
An uncharacteristic essay in pictorial journalism for Manet, who just happened to
be on the spot when two American ships, from North and South, engaged in
battle during the American Civil War.

57

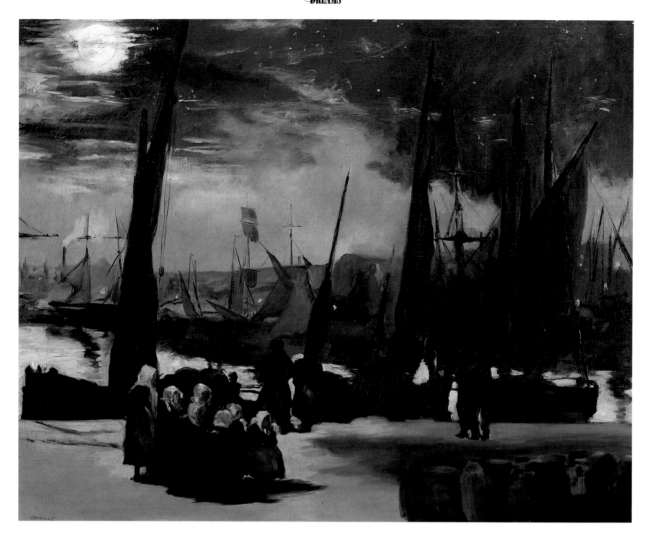

EDOUARD MANET
Moonlight over Boulogne Harbour, 1869
The curious "day-for-night" effect of the painting, probably a studio work from
sketches made on the spot, suggests some early Dutch landscapists, much admired
by Manet.

not be at all surprised. Even Monet's *Seascape, Storm* of 1866, which shows one similar boat against a grey sky and a green sea broken with little white wave-crests, is far closer to a straight recording of things seen than this.

In subsequent years both Monet and Manet returned: Monet was again painting in Honfleur in the summer of 1867, and Manet spent nearly three months in the Hôtel Folkestone by the harbour in Boulogne in the summer of 1869. The 1867 visit shows a considerable advance in confidence for Monet, producing one of his earliest famous paintings, *The Terrace at Sainte-Adresse*, which shows members of Monet's family on the terrace of their Honfleur home with the sea beyond specked with shipping: steam and large sailing ships on the horizon, the typical black-sailed local fishing boats closer to. The human element, always present in Monet's early paintings, is very prominent here, and was even eleven years later singled out by the critic Théodore Duret as a distinguishing feature of Monet's

style: not only was he apparently uninterested in landscapes without evident marks of human intervention, but he also signally failed to show interest in the peasants and farm animals which had so fascinated the Barbizon painters and were still a prime interest for Pissarro. *The Terrace at Sainte-Adresse* is much more vividly coloured than Monet's other seaside paintings of the time – even the sea is given a rather virulent turquoise/Prussian blue – and in the handling of the white dress on the woman with the parasol by the fence one can see the beginnings of Monet's colour researches, making the shadowed side distinctly bluish and also hinting at colour reflected from the brilliant red flowers nearby.

Manet's most familiar Boulogne picture of 1869 is also extraordinary, though in a very different way: *Moonlight over Boulogne Harbour* is a classic Dutch night piece reinterpreted in Impressionist terms. It seems likely that Manet used a dark glass in elaborating the composition, a device frequently

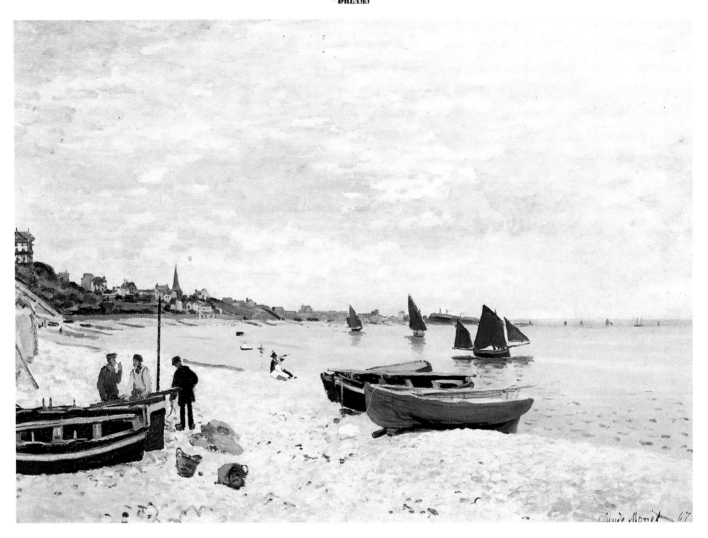

CLAUDE MONET
The Beach at Sainte-Adresse, 1867
Painted by Monet on the spot during a painting trip with Bazille.

employed by the Dutch painters he admired, and rather similar in effect to the day-for-night filters of modern film-makers. The concept of the picture is a lot more traditional than that of *Departure from Boulogne Harbour*, but ironically the making of it into a night scene under the hazy light of a full moon enables Manet to be much freer and less 'documentary' in his handling than he might otherwise have been, leaving the foreground figures, for instance, almost entirely as slightly sinister silhouettes, with only the white of the fish-women's bonnets gleaming spectrally in the prevailing gloom. Also, the scene looks indefinably artificial, very much as a day-for-night shot in a colour film tends to do: sunlight does not become moonlight just by imposing a filter, and this picture certainly savours more of the studio concept than of painting on the spot. (Manet, in fact, took some years to be persuaded of the advantages of *plein-air* painting, and did not take it up until 1874, when he spent the summer with Monet and Renoir at Argenteuil).

Monet continued to visit the region of Honfleur on painting trips until 1870 and the major disruption of the Franco-Prussian War, with the consequent end of the Second Empire. In 1870 he painted a group of his freest, most joyous pictures, centred on the Hôtel Roches Noires on the front at Trouville: in the canvas now in the Musée d'Orsay, which shows the façade of the hotel and its seaside terrace, the emphasis of the picture is mainly on the fashionable figures who people the terrace, evidently bourgeois visitors, rather than on the sea, which is vaguely glimpsed to the left, beyond the railing, and evoked more by the stiff sea breezes which flutter the huge flags on the seaward side of the hotel. Admittedly in the same year he completed and dated a very different picture begun two years before: *The Jetty of Le Havre in Stormy Weather*, where the three-master in trouble with the breakers and the row of men anxiously watching from the breakwater introduce much more of a story-telling element than usual. But here too the human

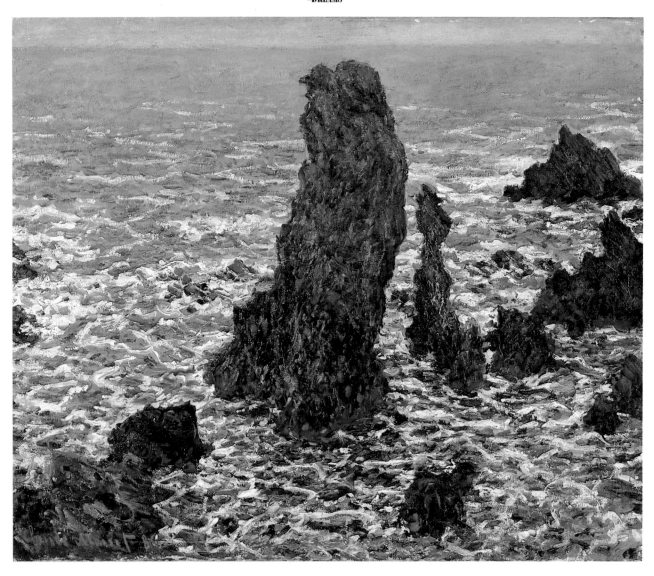

CLAUDE MONET
The Pyramids, Port-Coton, 1886
Another extraordinary rock formation which attracted Monet's attention, rather
further away than Etretat, off the remote Belle-Ile in Brittany.

element seems vital, and there is little sign of strong interest in the sea for its own sake, or even as a favourite painter's pretext.

After the Franco-Prussian War the very idea of comfortable bourgeois holiday-making from Paris seemed for a few years inconceivable – and was apparently equally far from painters' minds. Monet himself was fixed in Argenteuil from 1871, shortly after he returned from his self-imposed exile in England over the period of the Commune, until 1878, and hardly moved far from there in search of other subjects to paint. By 1880 his situation had changed again. He had moved from Argenteuil to Vétheuil, and in 1879 his wife had died. He was consequently much freer to travel, and much more restlessly eager to do so: the very occasional and brief forays to the Normandy coast and to Holland in the early 1870s are suddenly replaced with a spate of travelling, to places outside France, but also a lot more to the Channel coast, systematically exploring for new sights which will inspire him to paint them, and also,

quite freshly, to the Riviera and the very different Mediterranean coast of France. During the 1880s he seems to grow progressively less interested in the human elements of landscape – indeed human figures virtually disappear from his work – and less and less concerned too with the conventional, picturesque sites that would attract the attentions of amateur sketchers. Duret's characterization of him as a painter became irrelevant almost as soon as he had uttered it.

But if Monet was not looking for places that were picturesque in themselves, what was he looking for? It is clear from his letters home that he could not himself formulate this. He simply knew that he had to settle in and get used to a place – unfamiliarity was a hindrance to clear seeing – and then assume a position of 'wise passiveness' in which certain spots would prove to speak to him and others not. As he said himself later on, 'Wherever I found nature inviting, I stopped.' The extent of his journeying in search of inspiration can be gauged

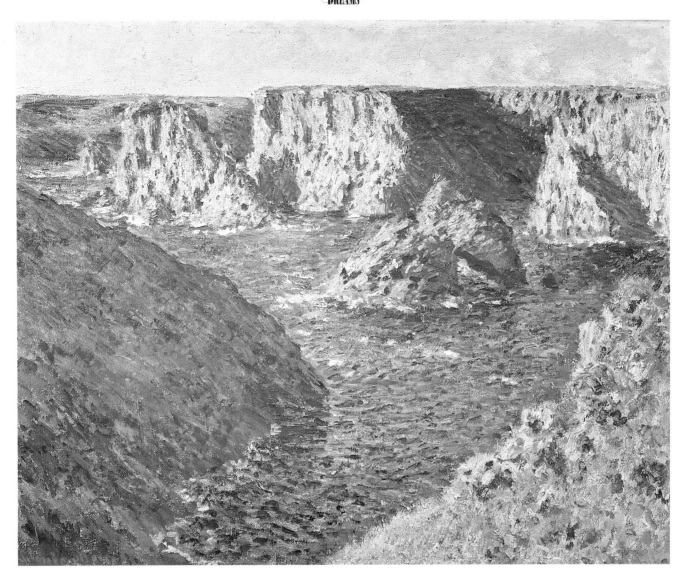

CLAUDE MONET
The Rocks, Belle-Ile, 1886
On his visit to Belle-Ile, Monet at first, while it was sunny, found the place gloomy and
uninspiring, but then when it became stormy he changed his mind and stayed on to paint.

from a brief list of the coastal areas where he painted between 1880 and 1888. In 1880 he was on the Channel at Petites Dalles; in 1881 he spent time in Fécamp and Trouville; in 1882 he explored the coast between Dieppe and Pourville, and having discovered that Pourville was very much to his taste, went back there in the autumn; in 1883 he finally discovered Etretat, where he returned in 1884, 1885 and 1886. In 1884 he also ventured further afield, going painting on the Riviera for the first time, in Bordighera and Menton, while in 1888 he went to Antibes. Between these two southward journeys he went later in 1886 to Belle-Ile, off the coast of Brittany.

The process of finding the right subjects was often long and frustrating. Monet's first reaction to a new place seems nearly always to have been suspicious and unhopeful. When he first arrived on the Riviera he was put off by the luxuriance of the vegetation – this was when he announced that he was really the man for isolated trees and broad spaces – and was worried by

the brilliance of the light, which would need, he felt, a lot of damping down to achieve his sort of colour harmonies. When he got to Belle-Ile, on the contrary, he was overwhelmed by melancholy and what he felt, even in good weather, to be the sinister quality of the place. Even on the Channel coast, with which from his childhood he was more familiar, he often wandered from place to place bewailing the lack of subjects which could appeal to him: on his exploration of the coast between Dieppe and Pourville he drew an almost complete blank until he discovered Pourville itself. During the decade his requirements seem to have become more and more abstract: certainly he was not looking for any place which would be readily recognizable, but rather for the right shape of a cliff against the sea or a single tree in relation to an open panorama.

He did not necessarily avoid famous features which had been frequently painted before: the cliffs at Etretat, with their distinctive arch formation, the Port d'Amont, had been often

61

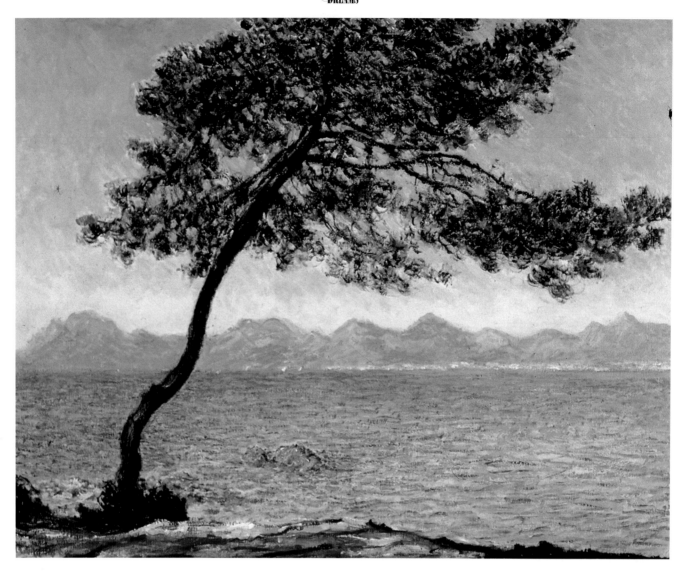

CLAUDE MONET
Antibes, 1888
The clearest demonstration of Monet's statement that he needed only one tree
against the sea, but it had to be the right tree.

painted before, and very famously by Courbet – so famously, indeed, that Monet admitted it was rather daring of him to challenge the earlier master, but determined to do it differently. His approach was not different, at least, in that he turned his back on Etretat the thriving holiday resort, given over in the summer almost entirely to trippers from Paris, and concentrated on the primeval grandeur of the cliffs, as though they were far distant from human habitation. During the whole of the 1880s human figures are almost entirely banished from his pictures, and it is a moot point whether his choice of location had anything at all to do with public reaction to the known rather than the unknown: most probably it was because Monet liked in his few public pronouncements to picture himself as an unworldy artist in the old romantic mould, moved only by inspiration. That seems to have been partly true, but it is not the whole story on this very complex and sometimes contradictory personality.

Anyway, it is obvious that for him making saleable pictures was not more than very loosely linked to picking pre-sold subjects. And for this reason, we can usually minimize the role in his seaside landscapes from this era of the documentary and topographical, or of any realist intent. As the least intellectual of artists, he did not wish or was not able to make up imaginary landscapes, needing always a stimulus received through his eyes to set his faculties working. The bold, abstract shapes of cliffs and the vast glittering expanses of sea were ready made for his purpose – but only when his instincts told him that this was so – and to that extent it did not usually matter very much where he found the right stimulus to creativity, provided that he found it. Sometimes he was certainly looking for a formula – the solitary-tree-against-a-distant-landscape served him for a remarkable number of the pictures he painted in Antibes, such as *Cap d'Antibes, Mistral, La Baie des Anges from the Cap d'Antibes* and, most starkly of all, *Antibes*, which is merely the one

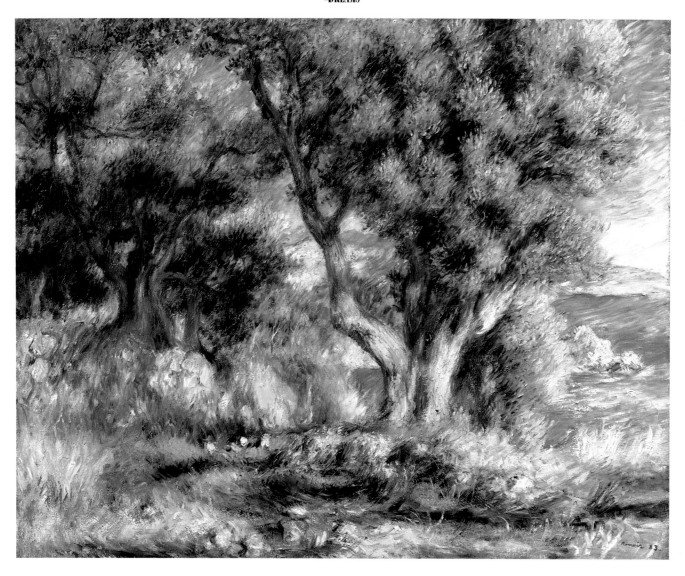

PIERRE-AUGUSTE RENOIR
Landscape near Menton, 1883
Renoir did not make acquaintance with the South until the mid-1880s. When he
did so he really liked it, though it tended to lack the lushness he craved in a scene.

tree slanting up the centre of the picture, with an expanse of water behind it and a row of purplish hills beyond that. One wonders if he really needed to go to Antibes to think up these pictures, but no doubt he thought he did, and once there had to search and search until he found just the right composition ready in nature, a concrete inspiration.

The fact remains that this sort of seaside landscape is unashamedly a pretext for formal explorations. It was possibly the blandness of the south which initially put Monet off quite as much as its luxuriance, though Renoir, who went with him to Bordighera at the end of 1883, with his naturally more expansive, relaxed temperament, took immediately to the area. For Monet the north had the advantage: at least there you had *weather*. Monet was regularly attracted through the years to stormy sea-scenes, and to painting them as fast as possible on the spot. His interest and spirits in Belle-Ile perked up immediately the winter storms began, and he decided to stay on

when other visitors were hastily leaving. In Etretat he painted in all weathers, it being convenient to do so, even from windows on the seafront, which offered a good, unhumanized view of the cliffs. Though for practical reasons Monet preferred to paint from some conveniently placed shelter or cranny in the rocks, there are various accounts of his boldness painting against gales, tides and flying surf. It is impossible to disentangle how far these stormy scenes appealed to Monet as a man, and how far specifically as a painter. Indeed it makes little sense even to try, any more than it would make sense to try to distinguish between his reactions as a painter and as an enthusiastic gardener to his Japanese bridge and waterlilies at Giverny. But at least in view of the discomforts and inconvenience involved in this painting rough, Monet's taste for stormy weather is worth recording as evidence that his approach to his subject-matter was not always an abstracting one of ivory-tower aestheticism.

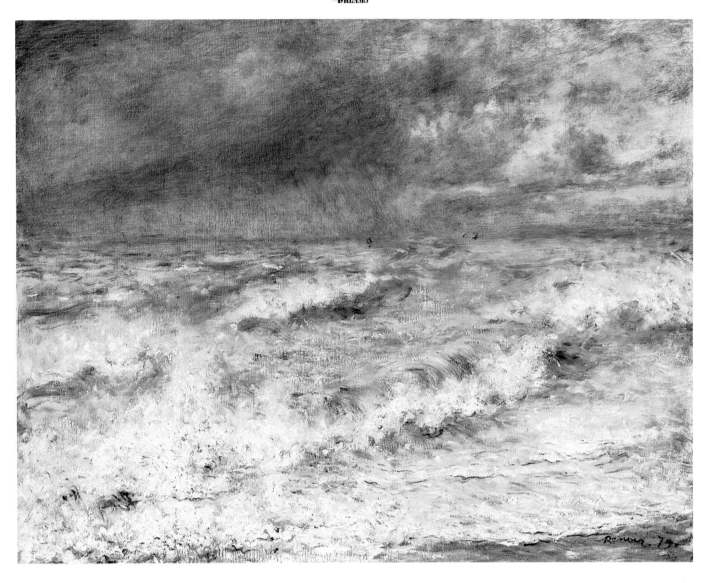

PIERRE-AUGUSTE RENOIR
The Wave, 1879
An exceptional work for Renoir, lacking altogether the human dimension, and
pushing on strongly towards abstraction, years before Monet took the same route.

Of all the Impressionists, Monet was the one most consistently drawn to the sea as subject-matter. Renoir had social connections on the Channel coast, and every year from 1879 to 1885 he stayed for some time, generally in summer, with his friends the Bérards at Wargemont in Normandy. In 1882 he visited Monet in Pourville, and in 1806 he rented a house for two months on the north coast of Brittany, trying (unsuccessfully) to persuade Monet to join him there. Nevertheless he seems to have taken little artistic interest in the sea; even on the Riviera most of his landscapes feature the Mediterranean very little, if at all, and in the north he painted even fewer pictures of the sea.

The main exception, however, is one of his most remarkable works, *The Wave*, painted apparently during his first visit to the Bérards in 1879. This is all sea and sky, with only the tiniest fringe of pinkish beach in the bottom right-hand corner. The scene is as stormy as even Monet could wish, and

the amount of flying spray, whipped off the incoming waves by a strong wind, turns the picture into a virtual abstract, thrillingly unlike practically everything else Renoir ever painted.

The townee Degas is, if anything, an even less likely painter to draw inspiration from the seaside; the most remarkable of the seaside works he did produce is strongly focused on prominent human figures. Quite early in his career, in 1869, Degas spent the summer in Etretat, coinciding there, by a curious chance, with Courbet, who was painting some of his most imposing versions of the cliffs, the ones Monet felt he had to rival. There was certainly no rivalry, conscious or unconscious, between Courbet and Degas: Degas worked only on a small scale, in pastel, making elegantly minimal studies of sand and sea, with sometimes a boat in the far distance. After this he showed no more interest in pure landscape for twenty years, and then in 1890-92 he made a number of extraordinary, almost abstract landscape monotypes. Most of them, in so far as their subject

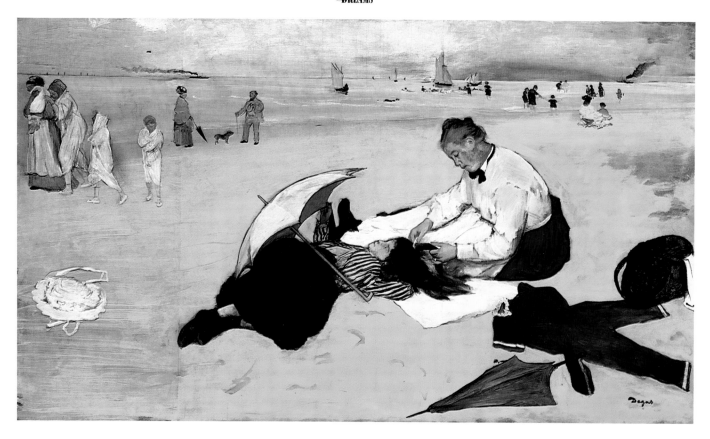

EDGAR DEGAS
Beach Scene, c.1876
One of Degas's most brilliantly unexpected compositions, combining one of his
favourite hair-combing scenes with a cunningly observed Channel-coast landscape.

can be unequivocally distinguished, are inland scenes, but one, a great mass of yellow ochre topped with greeny brown, juts out into what might be the sea. Or again, it might not.

Degas's seaside masterpiece comes somewhere in the middle, dating from around 1876. It is the London National Gallery's *Beach Scene*, which has in the foreground a group consisting of a girl, recumbent and fully dressed (a bathing costume is spread out beside her on the sand) and an older woman who combs her hair. In the background there are paddlers and trippers and towel-wrapped bathers just out of the sea, while on the horizon two steamships, smoke streaming behind them, converge towards the middle of the picture, very like the smoking steamer in one of the 1869 pastels. The atmosphere of the beach is miraculously evoked, and without apparently setting out to do so at all, Degas has provided us, in his own manner, with one of the most vivid glimpses of the Channel coast in the early years of the Third Republic.

At about the same time Degas painted a very different beach scene which also gives us a lively if decidedly strange view of seaside life. This is *Petites Paysannes se Baignant à la Mer Vers le Soir*, which shows three principal nude figures in the foreground, three more partially dressed, in ambiguous space behind them, and in the distance some cliffs, a pier, the sea with ships on it, and the setting sun. The atmosphere here is rather tortured, like a Munch, even though the action appears

to be joyful. It is an enigma which possibly indicates that Degas did not so much like the seaside after all.

With the Neo-Impressionists, those painters in coloured dots led by Seurat and Signac, who put in an appearance in the eighth and last Impressionist show in 1886, we find a new kind of interest in the seaside emerging. In the show itself there were figures on beaches from a couple of unexpected sources – Paul Gauguin's *Les Baigneuses*, in which four rather substantial girls paddle (though one critic, reviewing the show, thought them 'pitiful and sickly creatures') and Mary Cassatt's *Enfants sur la plage*, which shows two chubby children playing with buckets and spades against a hazy blue seascape. And, both here and elsewhere, Seurat and Signac were painting and showing a number of important seaside scenes. Seurat's contributions came from his visit to Grandchamp the previous year. Grandchamp was in fact a rather flat, dreary, featureless township on a rather bleak shore. This suited Seurat quite well, because he often aimed at an effect of monumental immobility and a sort of philosophical calm, such as we find in *Grandchamp, un Soir* and *The Roadstead at Grandchamp*, where the minimal features – a stepped wall, a gatepost – are present as abstract counters against a hardly more *mouvementé* sea with its placid sailboats.

But also included in the Impressionist show was something much more dramatic: the famous painting, now in the Tate Gallery, of the cliff outside Grandchamp called *Bec du Hoc*,

65

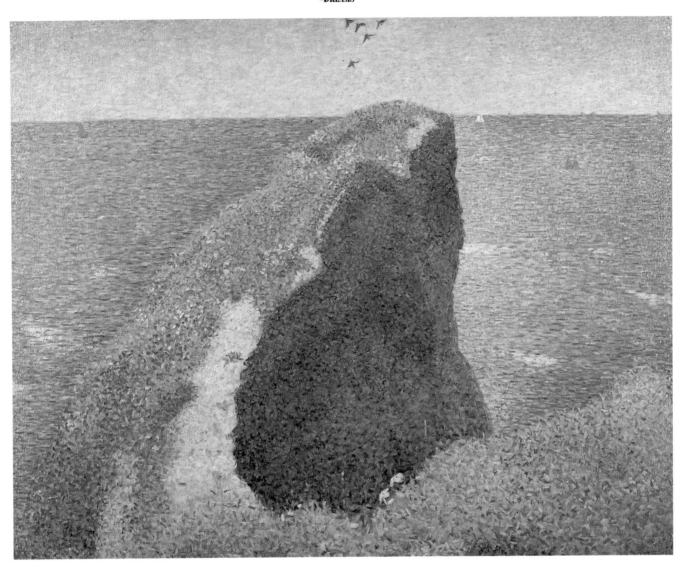

GEORGES SEURAT
La Bec du Hoc, Grandcamp
Ingenious rearrangement of the features (in comparison with a detailed sketch)
adds drama to this meticulously worked-out example of pointilliste technique.

GEORGES SEURAT
Cap Canaille, Cassis

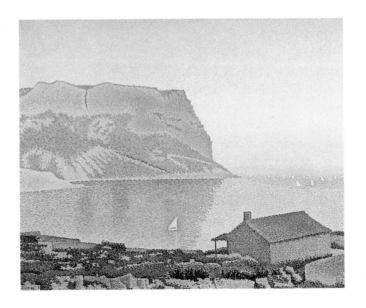

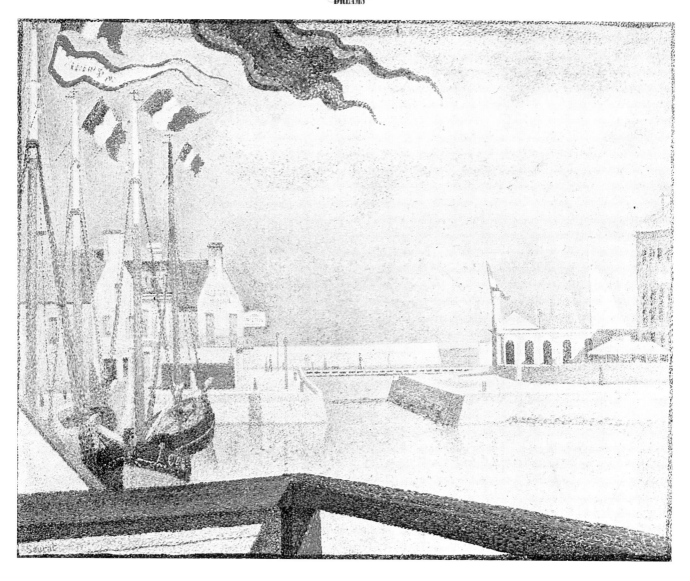

GEORGES SEURAT
Sunday, Port-en-Bessin, 1888
Though the fluttering flags on the left seem to contradict it, the picture as a whole
exudes a monumental calm and timelessness.

which dramatizes the precipitous height of the cliffs by strict geometry and careful ratiocination. For though Seurat was admittedly inspired by some of Monet's recent seascapes, his technique turns its back completely on Monet's bold improvisation, and instead returns to classic textbook procedures, making a sketch on the spot and then rearranging the facts in the studio to produce the most satisfactory visualization of the informing idea in the artist's mind. In this case Seurat eliminates completely from the finished painting the tracts of beach shown in the sketch, leaving the cliff rearing up in solitary grandeur against the calm, distant sea.

Well, it could be that way; it probably would be if the tide were higher or Seurat had placed himself rather further back. But the 'impression' of the sketch has been replaced by something intellectually elaborated, simplified and reconceived away from the scene – painting for painting's sake which wants to create a vivid illusion but recognizes that it is an illusion, that art is only tenuously connected with nature. In the following years Seurat conducted concentrated campaigns of painting relative to the Channel coast – Honfleur in 1886, Port-en-Bessin in 1888, le Crotoy in 1889, Gravelines in 1890. But if Impressionism began, with however many qualifications, as a triumph of nature over art, this was a triumph of art over nature. Nature was back in its place once again.

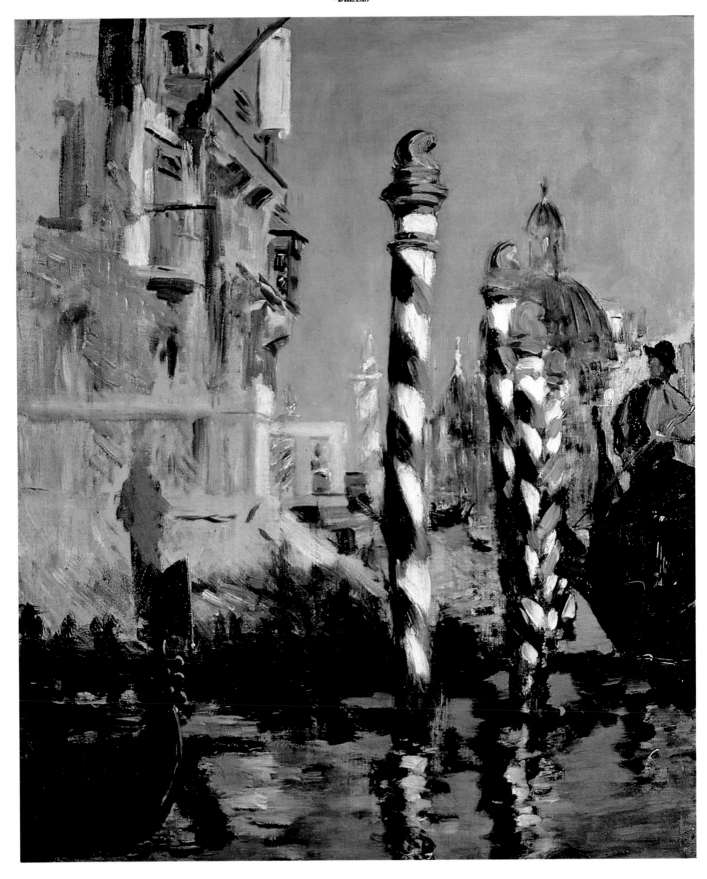

EDOUARD MANET
The Grand Canal, Venice, 1875
In 1875 Manet went to Venice with his painter-friend Tissot. He had recently come to
see the point of painting on the spot, and brought back some of his liveliest landscapes.

5

THE PLEASURES AND PAINS OF ABROAD

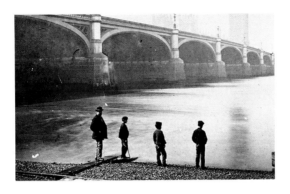

Westminster Bridge, oddly, became for the Impressionists one of the most significant landmarks of London, partly no doubt because it naturally featured in views looking west towards Parliament.

THE IMPRESSIONISTS DID NOT ALWAYS TRAVEL for pleasure.Some of their earliest wanderings, in fact, had their origin in uncomfortable political necessity. Perhaps 'necessity' is slightly overstating the case, since the flight of Monet and Pissarro to England in 1870 was to escape the discomforts and possible dangers of the Franco-Prussian war, rather than because of any specific political persecution either might undergo. Both, of course, were very left-wing by general Impressionist standards, but even so we do not know exactly what was the attitude of either to the radical Commune which took over Paris after the siege and the armistice – possibly sympathetic, but since neither was around to be directly involved, there was no danger of reprisals after the Commune was put down.

The periods spent in London, however, were to be quite significant for both artists. For Monet it was the occasion of his first seeing the Thames and the Houses of Parliament, and so of the first painting of a subject which he was, much later, to make peculiarly his own. Pissarro responded with particular freshness and vividness to the undistinguished areas of south London, like Norwood and Sydenham, in which he found himself, painted some of his best pictures and also established a connection with London, cemented when his eldest son Lucien settled there in 1890, for what was to be the rest of his life. Not only that, but on a purely business level, it was in London that both Pissarro and Monet met the dealer, Paul Durand-Ruel, thereby starting a chequered but in the main beneficial business relationship.

Degas also travelled a great deal for other than painterly reasons. Indeed, he would have been very unlikely to travel in search of new subjects to paint. As we have seen, he was very little interested in landscape, and in fact had decided principles on the painter's deliberate search for varied subject-matter. In 1872 he wrote (significantly from New Orleans) to the Danish painter Lorenze Frölich back in Paris: 'Nothing but a really long stay can reveal the customs of the people, that is to say, their charm – instantaneousness is photography, nothing more . . . I want nothing but my own little corner where I shall dig assiduously. Art does not expand, it repeats itself.' He was in New Orleans with his brother René who had settled there nine years earlier, their mother belonging to an old Louisiana family; we do not know exactly why Degas went – possibly on impulse to visit unknown relations and see his mother's birthplace for himself – but it was certainly not to look for new subjects to paint.

While in America, however, Degas did do a number of portraits of his Louisiana relatives, and also painted several members of his family at their place of business, where they traded in cotton. Though this was local, an office was hardly very ex-

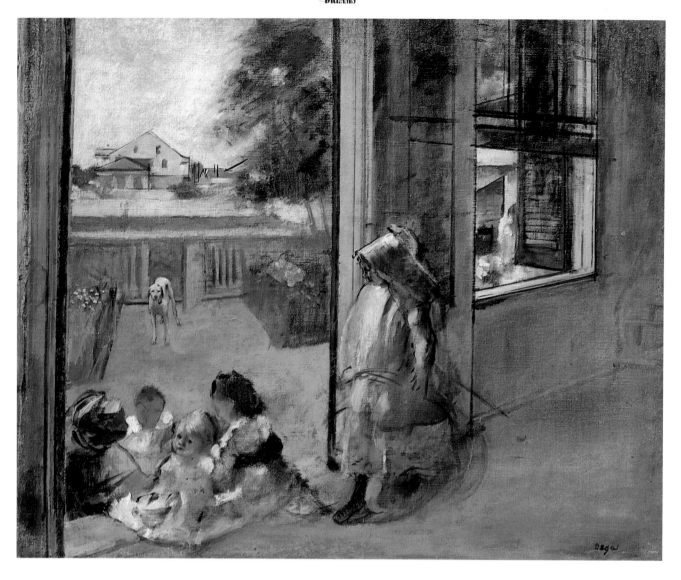

EDGAR DEGAS
Cour d'une Maison (Nouvelle-Orleans) 1872
The only one of Degas's New Orleans pictures which includes a recognisable
exterior, this is almost perverse in its sedulous avoidance of local colour.

otic, and in fact in only one of his paintings from this visit, that known as *Cour d'une Maison (Nouvelle-Orléans)* do we get any outside view at all. This very strange and striking painting was shown in the second Impressionist exhibition of 1876, along with the *Portrait dans un Bureau*, and shows a group of children playing in a doorway, with outside a very bare-looking garden and, across the way, another simple white-painted house. The curious thing about the painting is that it sedulously avoids what all travellers remarked on in the New Orleans scene – the lushness of the vegetation and the rich sub-tropical colours. It is almost as though Degas in New Orleans was doing everything possible as a painter (short of ceasing to paint) to disguise the location from himself and his public.

His frequent visits to Naples, from 1856 to as late as 1906, were for the most part equally devoid of artistic purpose. Degas's father came from Naples, where his grandfather still lived in Degas's youth, along with a large number of relations.

Degas's first visit to Italy, which began when he was twenty-two, was extended for three years, and as well as including several visits to the family in Naples involved a lot of the artistic sight-seeing which would be normal for a cultivated, comfortably-off young man: visits to Rome, Florence, Siena and so on, forging friendships with fellow artists (notably the Symbolist Gustave Moreau), copying old masters and sketching bits of local colour (Roman beggar-women, the crowds at St Peter's, a corner of the Borghese Gardens). He even painted some formal landscapes: a view of Naples, and a Roman view apparently taken from his studio in the Piazza San Isidoro. But even at this period his real interests were elsewhere. After the death of his grandfather in 1858 he made many more visits to Naples, but entirely on family matters and usually connected with the complicated settlement relative to his grandfather's estate, which because of certain provisions in the will was not finally sorted out until 1909.

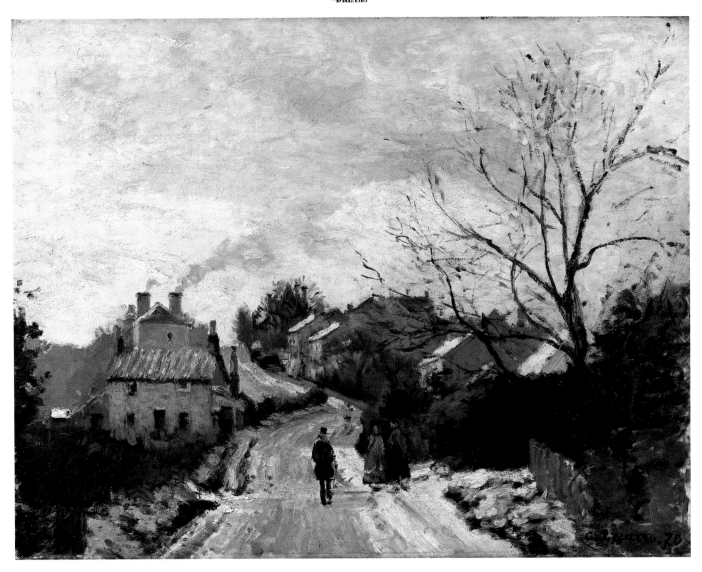

CAMILLE PISSARRO
Lower Norwood, Effect of Snow, 1870
While Pissaro had exiled himself in London over the Franco-Prussian War, he
was living out towards Sydenham and painted the everyday scenes round about.

Most of Degas's other travelling was of the same kind, visiting sick relatives in Switzerland or going (unwillingly) to an exhibition in Brussels. His imaginative relationship with England was of rather a different order. He finally discovered London in 1871, but had been referring to England, studying English painting, reading English literature (though his English never allowed him to communicate easily with Englishmen) and even painting allegedly English scenes, like the *Jockeys à Epsom* of 1860-62, years earlier. Nor does it appear that any real contact he might have with England could compare with or eclipse his youthful romantic fantasy. Really the only later trip undertaken for art and pleasure seems to have been that to Spain in 1889 with his Italian painter friend Boldini. And this could hardly have been briefer: he arrived in Madrid on 8 September, went straight to the Prado, took in a bullfight in the afternoon, and by 18 September he was in Tangier, advertising his intention of returning to Paris immediately via Cadiz and Granada. There

seems to be no evidence of this journey anywhere in Degas's work.

It is curious that Degas, with such a cosmopolitan family background, should have mistrusted exoticism so passionately as a motive force in art. It is perhaps equally curious that Pissarro, whose background was if anything even more exotic, should have achieved some of his greatest successes outside France, like his 1871 pictures of *The Crystal Palace* and *Lordship Lane Station, Upper Norwood*, largely by ignoring altogether whatever exotic element they might contain. These scenes of suburban London are painted in just the same spirit that he painted Louveciennes immediately before his flight to London and Pontoise immediately afterwards: same weather, same trees, much the same sort of building, all painted with the same technique. It is only the labels which tell us we are not in France: and in fact *The Crystal Palace* is the only one of the London paintings from this visit which depicts a readily re-

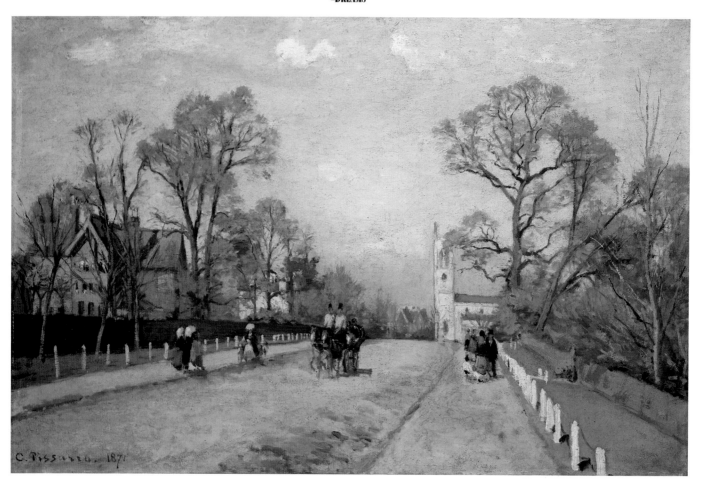

CAMILLE PISSARRO
The Sydenham Road, 1870
*Another of Pissarro's paintings of the totally unremarkable suburbanized country-
side of South London, given a certain exotic glamour by his foreign eye.*

cognizable building, so that we are aware in any way that we are outside France.

This attitude, presumably, was built into Pissarro's background and history. Born, after all, in St Thomas in the West Indies to a Franco-Spanish family of practising Jews, and sent to school in France, he had then returned to the Caribbean to join the family business and spent more than two years as a businessman of sorts in Caracas. Therefore in a sense France was as exotic – or as unexotic – to him as anywhere else. In his personal attitudes he was a paradoxical character. He was a convinced anarchist in politics, but at the same time passionately patriotic about France. Despite his hostility to the Empire, he was therefore deeply distressed when the Franco-Prussian War broke out that, being a Danish national (St Thomas at that time was a Danish colony), he was not able to volunteer to fight for France. In England he already had relatives (his half-sister Emma, who died in 1868, had been married to the London

businessman Phineas Isaacson, and had five children), and his links with the country were to be strengthened when his eldest son Lucien, also an artist, settled permanently in London in 1890. Even on his first visit he made himself quite at home, later remarking, 'Monet worked in the parks, whilst I, living in Lower Norwood, at that time a charming suburb, studied the effects of mist, snow and springtime.' Which, he might have added, he could have done anywhere.

came to Paris from the West Indies when he was twelve, to school, and returned to live Apart from a brief trip to Belgium and Zeeland in 1894, all the rest of his travelling was to England. His first return was in 1890, when he went to London with the Neo-Impressionist painter Maximilien Luce, to visit Lucien, who was also a convinced exponent of Pointillisme. The year was at nearly the end of Pissarro's own involvement with Pointillisme, and in the most familiar of the paintings he did on this trip, *Charing Cross Bridge, London,* one can already

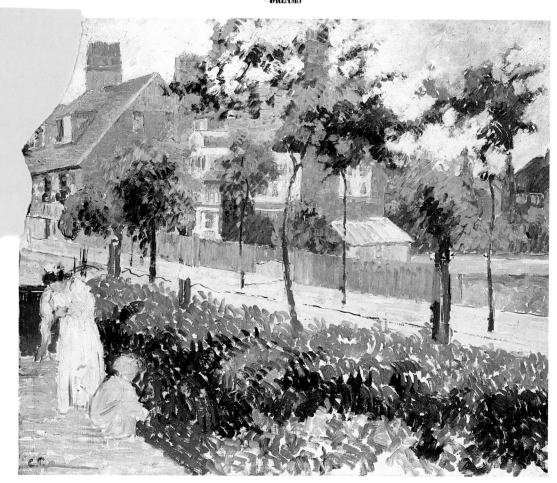

CAMILLE PISSARRO
Bedford Park, 1897
On later visits to London, Pissarro was staying in rather grander areas and
circumstances, since his son Lucien, also an artist, had set up in the Aesthetic
enclave at Bedford Park.

see him moving slightly away from the systematic use of dots of colour, a process which at best he found unduly slow and painstaking. However, the subject here, with the absolutely flat, geometrical railway bridge across the picture about a third of the way up, and behind it the Houses of Parliament's collection of strong, detached verticals in the centre, make it a perfect subject for Neo-Impressionist immobility – in strong contrast to Monet's hazy, iridescent handlings of the same subject from a higher viewpoint starting nine years later.

For his next trip, in 1892, Pissarro deliberately planned to do 'some very free and vigorous things in London'. In the event he painted about a dozen pictures during the trip, of which eleven were concerned with themes and scenes from the immediate vicinity of Kew Gardens. These show that Pissarro had retreated even further from a detailed application of Neo-Impressionist principle, and at the same time had anticipated, by his interest in the urban scene, the direction his painting was to

take in the rest of the 1890s, when in Paris he would become an urban Impressionist of a new type, much more interested in the architecture and topography for their own sake than any of his town-based fellows had been in the 1860s. Even if he did not regard London essentially as an exotic location, probably the movement to another place shook him up just sufficiently to permit him to *reculer pour mieux sauter*.

Among other Impressionists Manet and Sisley travelled very little, and left little pictorial evidence of their travels. In each case there was one memorable and productive trip. Manet went in 1875 to Venice in the company of his friend the society painter Jacques-Joseph Tissot. Manet may have gone there with the deliberate intention of finding something new to paint, because though he had for long held himself aloof from the idea of painting directly from nature as advocated by Monet, Pissarro and other Impressionists, just the previous year he had undergone a sort of conversion while painting with Monet in

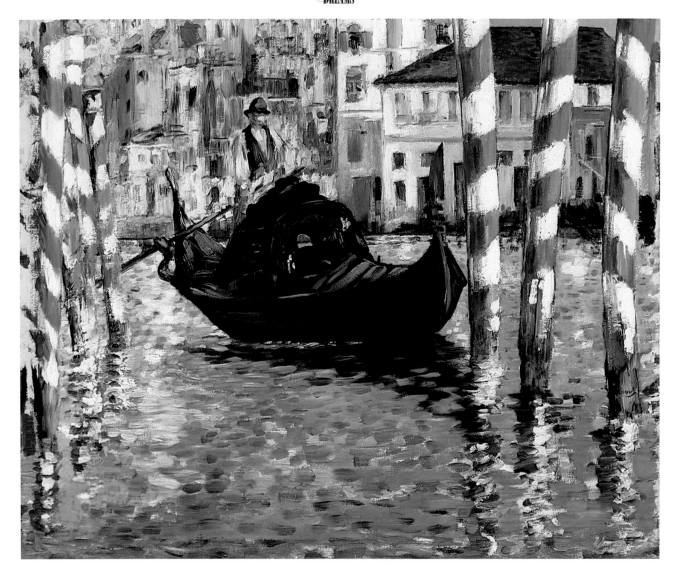

EDOUARD MANET
The Grand Canal (Blue Venice), 1875
Another painting from Manet's 1875 visit to Venice with Tissot, again showing the influence
of plein-air work: allegedly this and that on p.68 were both painted in the last two days.

Argenteuil during the summer. He never felt any great interest in landscape for its own sake – most of his *plein-air* Argenteuil subjects were of people out of doors – but in Venice he was inspired to paint some dashingly fluent impressions of the scene, such as *The Grand Canal, Venice,* in which the dazzling Italian sunlight reduces the architecture in the background to a golden-pink blur of shapes barely indicated, and the pale blue of the sky becomes a richer, deeper blue when reflected in the waters of the canal. Although it looks at first glance like the work of an instant, noting down just what happened to be in front of the artist, on examination it proves to be an unusually intricate composition with the play of near and far emphasized by the placing of boldly striped poles receding just right of centre and the gondolas on either side brusquely chopped off by the picture's frame.

Sisley's major painting trip abroad was not in principle so foreign to him, since it was merely the land of his fathers. In 1874 Sisley went to England for four months with his friend and patron, the singer Jean-Baptiste Faure. There does not seem to have been any particular purpose for the visit: Durand-Ruel had shown Sisley's work in London in 1872, and again in 1873 and 1874, but he was regarded as a new French painter, despite his English antecedents, and had had no special success such as might justify a visit to exploit the English market. But Faure was rich and paid Sisley's expenses, and no doubt a change of scene did not come amiss.

At first Sisley probably stayed with Faure in Brompton, but his time near the centre of London is commemorated by only one painting, a hazy view of the Thames with St Pauls. Soon he moved out to the vicinity of Hampton Court, and worked very consistently in that area for the next three months. *The Regatta at Henley* dates from this time; it is one of Sisley's most animated and joyous works, dominated by the feeling of a powerful breeze which flutters the large flags (almost all the

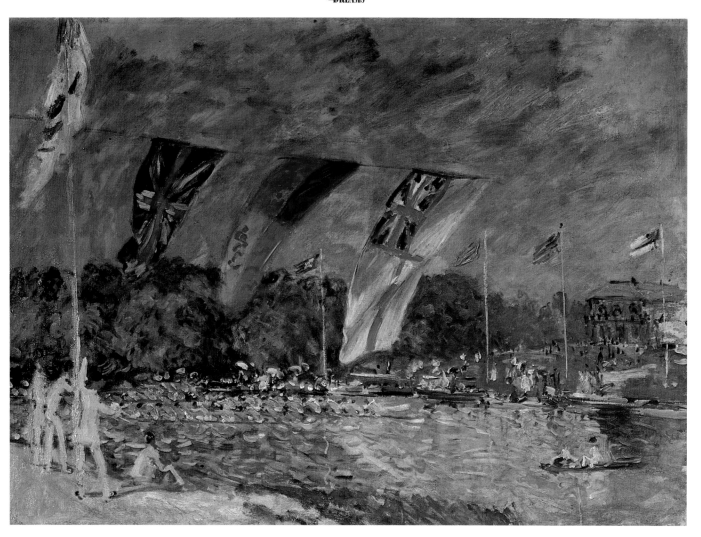

ALFRED SISLEY
Regatta at Molesey, 1874
Sisley went to England for four months with his patron Jean-Baptiste Faure, and
painted mostly around Hampton Court; this is the liveliest result.

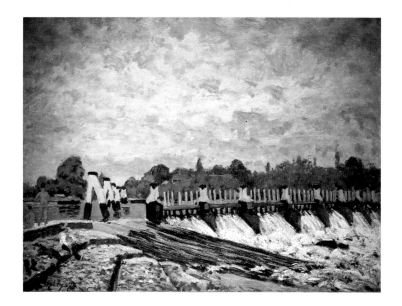

ALFRED SISLEY
Molesey Weir, 1874
More sober but no less compelling
is this view of the weir near
Hampton Court.

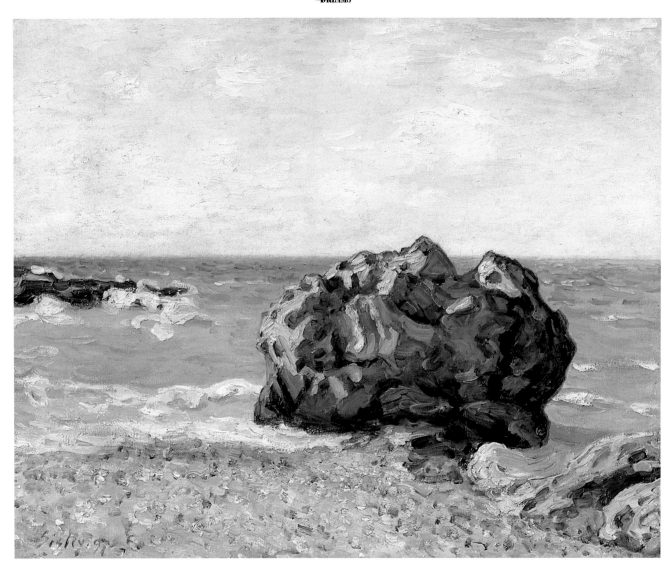

ALFRED SISLEY
Langland Bay, 1897
On his last visit to Britain Sisley visited Cornwall and Wales, and left this
unusually stark, almost abstract image of the Cornish seaside.

Impressionists seem to have had a passion for flags) across the middle of the composition. It is not known whether Sisley was in touch with relatives in England (he retained his British nationality throughout his life); such contact might explain the otherwise curious choice of Hampton Court as a base of operations. He must have been very comfortable working there: at least fifteen paintings from this trip are known, all of the highest quality. Six of them went into Faure's collection, probably in some sort of return for his patronage. Sisley's only other known trip outside France, also to England (and Wales), was in 1897, and occasioned some fine and grandly simple landscapes.

The role of travelling in the paintings of the two other major Impressionists, Monet and Renoir, is curiously spasmodic, and seems to have more to do with impulse than anything else. Renoir went abroad for the first time in 1881, having seemingly had no particular urge to go before, and probably not the

necessary finances readily available either. But in 1881 he suddenly took himself off to Algiers, perhaps partly to celebrate the beginning of a new agreement whereby Durand-Ruel began to buy paintings by making regular payments to Renoir. A visit to North Africa was at that time by no means a rarity for French artists, since this was the heyday of conscientiously picturesque Orientalist painting. But Renoir, though he certainly responded to the warmth and colour of the place, and worked prolifically during the six weeks he spent there, was not apparently very drawn as a painter by the more evidently exotic aspects. Almost all of his paintings were of landscapes – hills and sunlit sea – that could well have been in the south of France, and even the painting called, rather fearsomely, *Paysage d'Algerie: le Ravin de la Femme Sauvage* proves to be of a rocky, sparsely grown valley with no real distinguishing features: even its wildness is illusory, since we are told that by the next year it was heavily built up, with a tram running right down the middle.

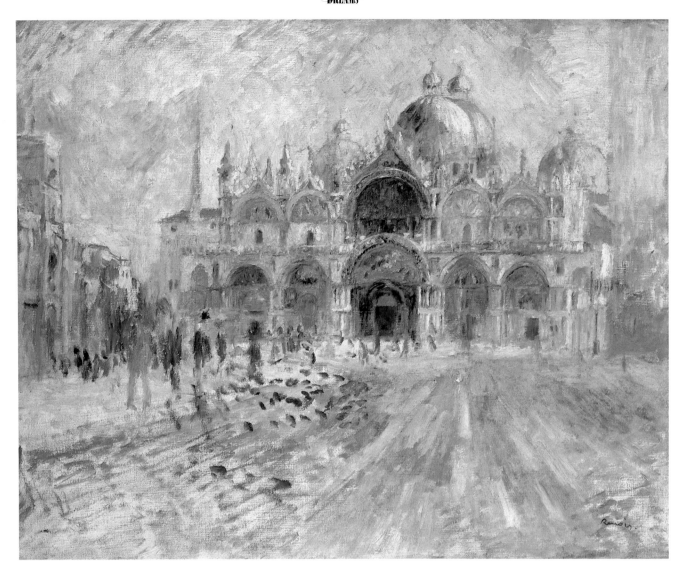

PIERRE-AUGUSTE RENOIR
Piazza San Marco, 1881
When the stay-at-home Renoir began travelling in the early 1880s he was
particularly struck by the brilliant light and colour of Venice.

There is, however, one exception: the painting called *La Mosquée*, or *Fête Arabe*, which seems like a serious attempt to depict some of the native life of the country. It is not, though, quite clear what is being depicted in this picture crowded with figures: it is no doubt a town with a mosque in the background, but the happening is perhaps more likely to be secular than religious, maybe the performance of a group of wandering musicians. It seems likely, in any case, that the first trip to Algiers confirmed and reinforced things that were already happening in Renoir's art – a picturesque interest in imaginary Oriental subjects, several of which, like *Femme d'Alger* of 1870, he had painted long before he had ever experienced the reality and an increasing luminosity in the painting technique, rather than new revelations. The following year he returned, ready to get closer to the people – he had had trouble finding models the first time – and a number of glowing pictures of Arabs on camels, driving donkeys and so on resulted, despite difficulties

with local spectators of his efforts which he was still complaining of to Vollard years later.

Between the two trips to Algiers Renoir had been to Italy for the first time ('I have suddenly become a traveller', he wrote to Mme Charpentier, 'and I am in a fever to see the Raphaels.') He went to Rome, and duly admired Raphael's frescoes, feeling that in them Raphael had 'dedicated himself to the antique, to grandeur and eternal beauty', as well as visiting Florence and Naples, where he saw the painted remains of Pompeii and Capri. He also met Wagner, and got him to agree to sit (briefly) for a portrait. In Italy he painted a wide variety of pictures, many of which show no evidence of where they were done, such as the still-lifes and even the large and lurid *Baigneuse*, painted he said in strong sunshine on a boat in the Bay of Naples, which began him on a new course of luminous, sensuous nudes inspired by his mistress, soon-to-be-wife Aline Charigot, who was spending time with him in Italy. The most

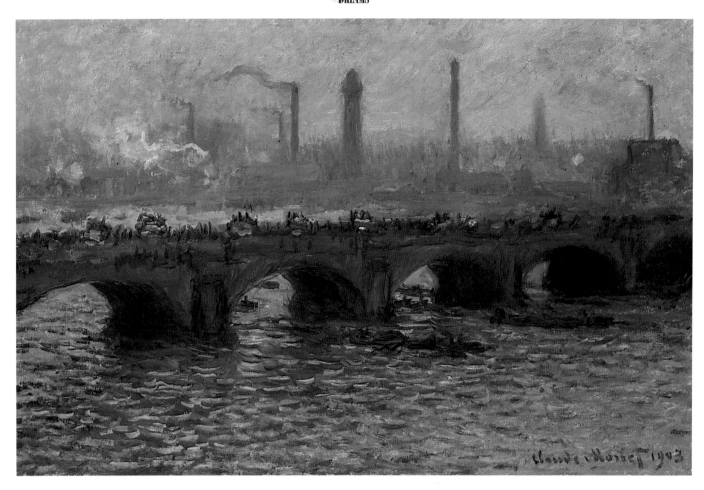

CLAUDE MONET
Waterloo Bridge, Grey Weather, 1903
Painting in London from a window in the Savoy, Monet did not always turn his
attention towards Westminster, but also looked east to the grey industrial
landscape.

tangibly Italian of his paintings are a group of Venetian land-
scapes, mostly of extremely famous tourist attractions, such as
the Piazza san Marco, the Grand Canal and the Doge's Palace.
There were sometimes deliberately left very sketchy and must
have been regarded at the time as obviously saleable, at any rate
to those collectors who would buy a typical Impressionist land-
scape.

During the rest of the 1880s Renoir did not go further out-
side France than Jersey and Guernsey, but in 1892 he set out
again for a real art tour of Spain, specifically Madrid (where he
was inspired by Velazquez at the Prado) and Seville, and in
1896 he made a similar trip with Caillebotte's brother Martial
to Germany, to see and hear Wagner opera at Beyreuth. How-
ever, such a concentration of Wagner proved little to his taste
and before his planned four days were up he moved on to
Dresden to see some art and be bowled over by a Vermeer and
a Watteau in the museum there.

It is perhaps surprising, for someone of Renoir's Impression-
ist history, that what seems almost always to have interested
him most in foreign parts was not the new locations or stimuli
from nature, not even the unfamiliar human types, but the art
he was able to see only in foreign museums. He told Vollard
that when he went to London in 1883 (it is presumed – no defi-
nite record of this trip seems to exist), he was mainly struck by
the Turners, though he soon recognized how almost everything
worthwhile in them came from Claude, whom fortunately he
could also see abundantly in London collections. His trip to
Holland in 1898 was primarily to visit a major Rembrandt ex-
hibition in Amsterdam, which he wanted to see largely because
in Madrid his companion Gallimard had driven him mad by in-
stantly saying when he admired a Velazquez, 'But I prefer Rem-
brandt'. Even in Munich, where he made his last foreign
journey in 1910, what he retained most vividly was a Rubens,
Head of a Woman, in the Alte Pinakothek.

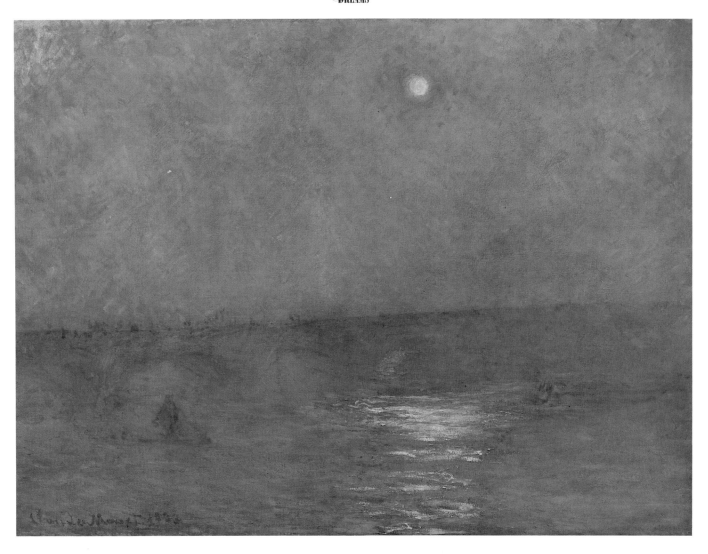

CLAUDE MONET
Waterloo Bridge, Sun in Fog, 1903
Another of the series on Waterloo Bridge, this time more colourful and tactfully
shrouded in a London pea-soup fog.

Now at least Monet, when he travelled, reacted to the places he went. Though when first in London he did discover Turner, it was what we now think of as the proto-Impressionist Turner of *Rain, Steam and Speed* rather than the neo-Claudean Turner Renoir so rapidly saw through. And in general, even if Monet did possibly pick up a few ideas from the Turner of his choice, it was primarily London itself which grabbed his attention and which somehow he stored away for future use.

Once back in France, via Holland, in 1871, he began to retreat into France and into himself – perhaps not finally such disparate retreats.

Almost first of all he returned to his childhood home, Le Havre, and painted two paintings, *Impression: Sunrise* and *Impression: Setting Sun (Fog)*, one of which (though after a lot of recent argument it is still not quite sure which one originally bore the *Sunrise* title) set off the scandal of Impressionism when a hostile critic applied the label to the

whole group. Then he settled in Argenteuil and, literally and metaphorically, cultivated his garden.

Apart from one or two brief forays into Holland, he did not leave France again for fifteen years, until in 1886 he went to The Hague for eight days at the invitation of a patron in Holland, with the very specific project of painting the nearby tulip fields, something he could appreciate even at a distance as a readymade subject for him. This was desirable because, as we have seen, even in France he found the business of finding suitable new scenes to paint long, wearisome and fraught with uncertainty. He might indeed react directly to places, but the reaction was not necessarily quick or easy. This did not make him a ready traveller: when he went uncharacteristically to Norway in 1895 it was in response to an invitation to visit his stepson, and many of the paintings he started there were still in his studio, unfinished, at the time of his death. He probably hoped or intended to work them up to the requisite finish in

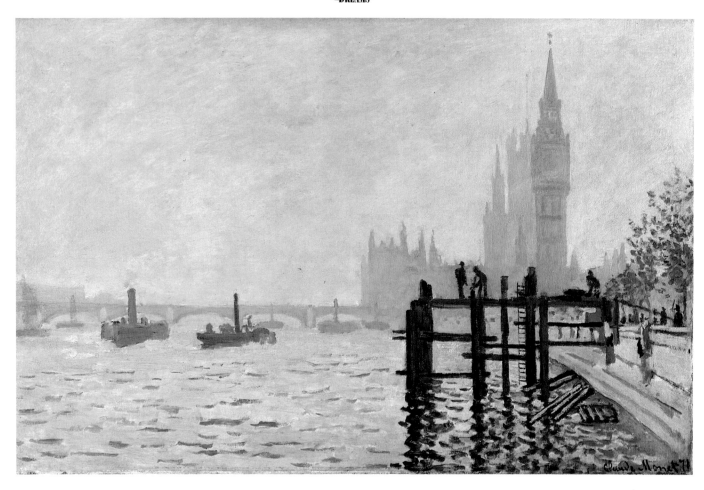

CLAUDE MONET
The Thames and the Houses of Parliament, 1871
A product of Monet's first visit to London, this is obviously a much more sober,
almost documentary version of the subject he later transfigured.

CLAUDE MONET
The Houses of Parliament,
Effect of Fog, 1903
More than thirty years later,
Monet saw Parliament like a
fairy palace, with the sunlight
playing irridescently through
the heavy London fog.

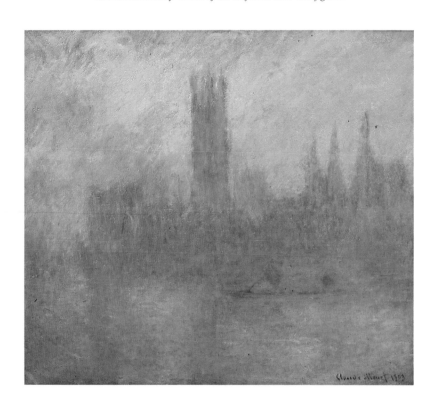

80

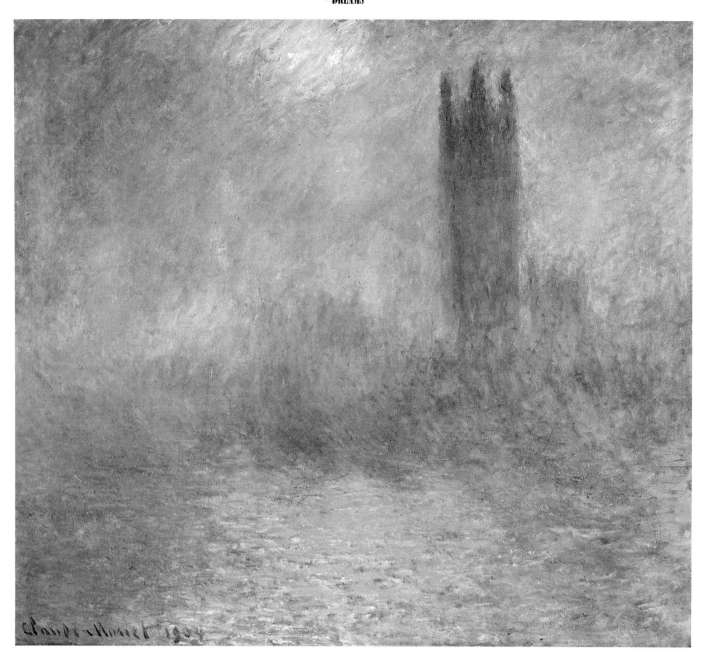

CLAUDE MONET
The Houses of Parliament, Sun Breaking through Fog, 1904
Among the most brilliantly coloured of all the Westminster series, with the golden
sunlight bursting through the purple haze to dazzling effect.

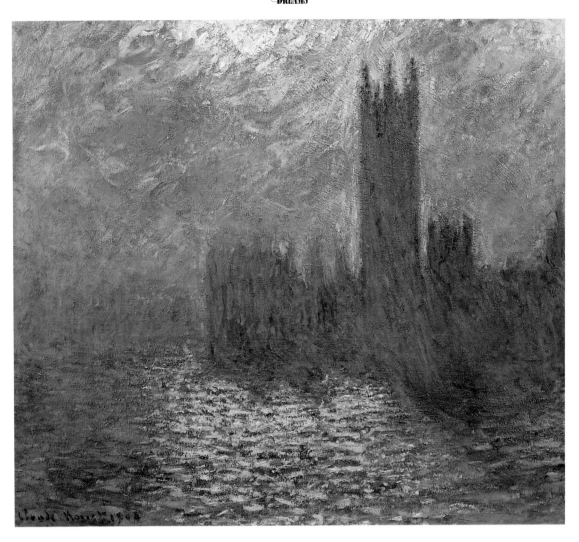

CLAUDE MONET
The Houses of Parliament, Stormy Sky, 1904
The most tempestuous of all the Westminster paintings, with the sunlight gleaming
menacingly on the apparently rough waters of the Thames.

his studio, much as he had done with the tulip paintings nearly a decade earlier. By this stage in his career a visual experience from the outside world was necessary to get him started, but that was often all it did on the spot: the rest of painting was sifting through his impressions and working them from confusion to artistic unity. The effects of light he wanted to catch were so evanescent that it could hardly be a question of merely recording them, but of experiencing, analysing and re-creating.

This fleetingness of impression was one reason for Monet taking to serial painting, working turn and turn about on different versions of the same subject, in different lights. This began formally around 1890 with the haystacks painted around Giverny, but ever since the early 1860s he had done, less systematically, various versions of the same subject or groups of variations on a theme. The most coherent series of the 1890s was that devoted to the façade of Rouen Cathedral which he painted in 1892 and 1893 and exhibited as a group at Durand-

Ruel in 1895. Other series were painted even closer to home: the poplars, the early mornings on the Seine, and the pictures of his water garden at Giverny which he began in 1899. But in that same year London – very much the London he had painted and remembered from nearly thirty years before – also became the subject of a series. Or three series, since there were three main viewpoints, all from a balcony of the Savoy Hotel on the river Thames between Waterloo and Hungerford (Charing Cross) Bridges, and running by 1904 to over a hundred canvases.

In 1870 Monet had painted a misty-gold impression of the Houses of Parliament, seen from ground level somewhere on the Embankment west of Charing Cross. It is an attractive, atmospheric, quite straight-forward image. Thirty years later he was reworking virtually the same image – as Degas said, art does not expand, it repeats itself – though with significant differences and a different end in view. This time the Parliament

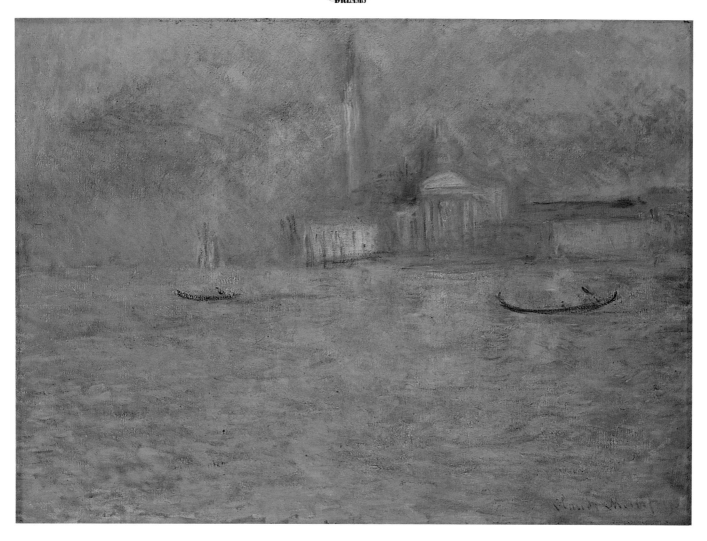

CLAUDE MONET
San Giorgio Maggiore, 1908
Monet's last trips abroad, before he settled fulltime in Giverny, were to Venice in
1908 and 1909, productive of some of his most luminous studies in light and mist.

building was seen from higher up, usually ignoring the Hungerford Bridge and sometimes reducing Parliament itself to a near-abstraction, a magic tower rising through the rainbow coloured mist – or more likely smog, though that was not a concept of the period. London was then one of the smokiest cities in the world, and the famous pea-souper fogs which lent romance to the worlds of Sherlock Holmes and Jack the Ripper alike were also the inspiration of many of Whistler's Thames nocturnes.

One could see these London paintings of Monet as reflections on industry in the modern world, but it would surely be perverse to do so (less so in relation to one of the other London series, in which the view is south-eastward, over the unlovely industrial south bank of the Thames beyond Waterloo Bridge).

What they really do, even if painted on the spot in front of what they purport to depict, is to ease Monet's way to the ultimate abstraction of the last water-lilies. Compared with the London paintings, the pictures of Venice he painted in 1908 are relatively conventional: though the magic of Venetian light and haze are gorgeously caught, they remain depictions of world-famous tourist sights, never becoming as liberated as many of the London series from the trammels of representation. It is ironic in a way that, when Monet tackles a subject which most clearly derived from the modern world and the side effects of industry, he should be in effect further than ever from the sphere of practicalities, more lost in an enchanted world of his own creation, an insubstantial pageant in which reality has left not a wrack behind.

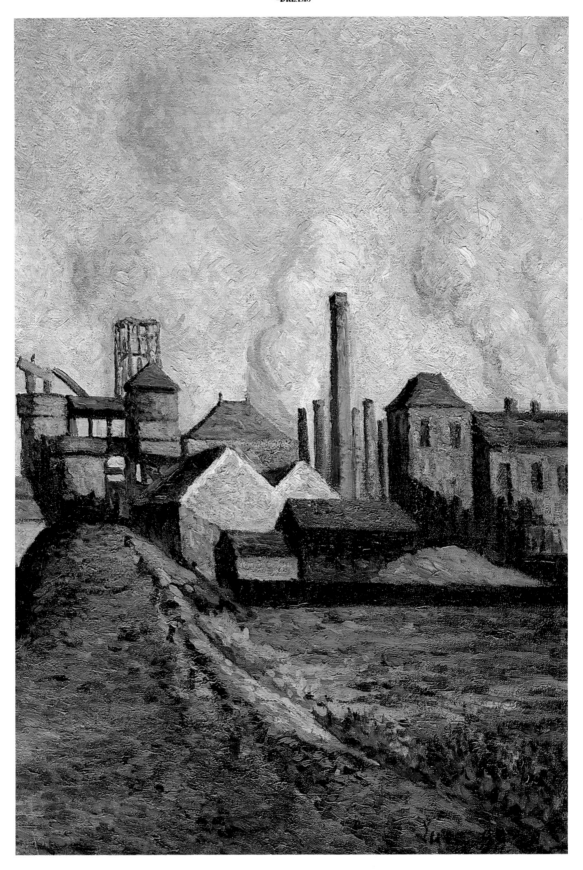

MAXIMILEAN LUCE
The Factory
Luce was the only Impressionist to be interested in the industrial scene.

6

ART AND INDUSTRY

*St Ouen: L'Aumône. This contemporary photographic shows
industrial traffic being towed along the Oise just near Paris.*

THE IMPRESSIONISTS WERE MODERNISTS: EVERY-
one was agreed upon that from the start.
Artistically they took up a revolutionary
stance - they were against the Salons, the
academies and the established academics,
and they came in for praise or condemnation
(mainly condemnation) precisely because
that was understood to be their position. Their rebel status,
partly forced upon them but partly chosen, was frequently
assumed, then and now, to mean that they must be, as Baude-
laire dubbed the very different Constantin Guys, 'painters of
modern life', and in a sense they were, some of them, some-
times. It depends, of course, on what you mean by modern life.

Whatever their individual origins, all of the Impressionists
had become townsmen, and were well aware of the life lived in
Paris and the urban environment. Although Manet and Degas
retained many of the attitudes and assumptions of their class,
they had to an extent dissociated themselves from the *haute
bourgeoisie*, not least by the very act of becoming artists. But all
of them moved in Paris society where they went to theatres and
bars, and from time to time at least painted what they observed
there. And part of their purpose, in the beginning anyway, was
to mirror it as exactly as possible on their canvases. But every-
body's vision is partial, and the artist's perhaps especially, so
the question of selection does assume some importance.

It is in a way helpful, in a way confusing, to note that the
first-generation Impressionists were closely contemporary with
the literary Naturalists, and were personally acquainted with
some of the leading figures, particularly Emile Zola, whose
novel *L'Oeuvre* (1886) concerns a mad painter, one Claude
Lantier, a character apparently based in many respects on a
combination of Manet and Cézanne, with more than a dash of
self-portraiture by Zola himself. Zola and the other Naturalists
offer a useful stalking horse because in their verbal art we find
quite clearly expressed what the artist's duty to reality should
be. He was supposed to grasp it whole, and document its
ugliest traits with as much detailed concern as its more agree-
able and attractive aspects. And in practice it usually turned out
that the more ugly and sensational elements, those most likely
to shock bourgeois respectability, were those most enthusiasti-
cally pursued. Non-French critics have often suggested that
this is a national inclination: J.C. Squire, for example, held that
The Diary of a Nobody, by George and Weedon Grossmith, as
well as being a classic of English humour, is also a classic of
naturalistic observation, except that the English character in-
clines the writers to see the funny side, while 'the tempera-
ments of the "realists" gave their work a gloomy bias'.

In any case, it is clear at a glance that, however friendly and
personally sympathetic the first-generation Impressionists
might be towards Zola and other literary Naturalists, their own

85

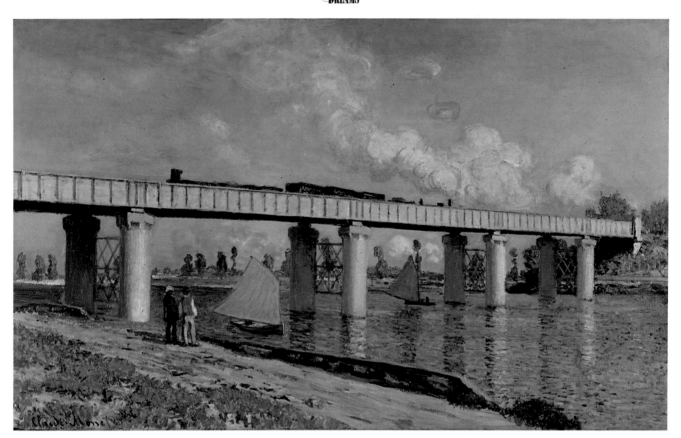

CLAUDE MONET
The Railway Bridge at Argenteuil
*Monet's attitude to the industrialization of Argenteuil shifted during the seven
years he lived there, but his affection for the railway bridge remained intact.*

aesthetic inclinations took them in a very different direction. True, when they include clothed human figures in their work they are wearing modern dress, and if a street scene or an interior is evoked it is recognizably contemporary. But it could never be said that they present us with a 'slice of life', true particularly to the grimmer aspects. Even Degas's brothel scenes are abstracted and drained of any specific social significance in a way that Lautrec's are not. The Impressionists, consciously or unconsciously, choose very carefully what they look at and paint, and it is nearly always the most agreeable aspect. And it certainly seems that the most agreeable aspect, for them, very seldom involved much explicit recognition that in their time France was becoming an industrial power, and that visual evidences of this were all round Paris and northern France, almost inescapably.

One or two of the major Impressionists, from time to time, seem to have been moved by, at the very least, the possibly decorative aspects of industry. Monet is an interesting case in point. It is very difficult to decipher what, exactly, his attitude to industry and its visual traces on the landscape was. His left-wing politics, especially as a young man, seldom seem to have been expressed in his art. But then that sort of anecdotalism or political point-making would be very remote from what the Impressionists in general, or Monet in particular, thought painting ought to be about.

There is one extraordinary image which seems to provide evidence to the contrary: *Les Déchargeurs de Charbon* of 1875, painted at Asnières. Monet himself observed that it was '*une note à part*' in his work, and it is certainly the only painting by him that has this particular kind of human interest. It is superficially a riverside scene, like many others by Monet, with a bridge in the background, occupying the top of the composition, and a view beyond, through the arch. But this time, in the foreground there are these mysterious, rhythmically disposed figures on what appear to be planks placed across the slippery quay. They are the men unloading coal from the slow-moving river barges, and they leave with loads on their heads or return with the empty baskets reversed, like some strange kind of hat, to collect more. It is a cheerless scene, in the bluish-grey half-light, and in this one painting Monet is very definitely interested in the nature of the work, its hardness, delicacy and precariousness.

Otherwise we have to fall back on interpreting, or maybe over-interpreting, the various canvases in which Monet uses smoke, steam or smog for decorative effect. These fall into slightly diverse categories as regards the directness of their reference to the presumed source of these effects. The series of London river views are, as we have seen, only by implication examples of industrial romanticism at all, since the notoriously smoggy atmosphere of London, glamorously transfigured by

EDOUARD MANET
The Gare St-Lazare, 1873
About the nearest Manet ever came to acknowledging the industrialization of
France in his time, this painting is located very close to his Paris studio.

the iridescent play of light, was rather taken for granted, like a manifestation of nature, appreciated or not by visitors entirely according to taste. It can certainly not be maintained that Monet was making any point about pollution in these pictures.

The paintings which feature railways and trains also vary. Many of the views around Argenteuil show a train in the distance, often crossing the railway bridge. It is usually a very small and incidental part of the scene, and if it has any particular association for Monet it is probably as a convenient way for the townee to arrive at more rustic pleasures. The cycle of paintings of the Gare St-Lazare around 1876-78 is closer again to industrial reality: at least we are made conscious of the engines as giant, powerful machines, and we are quite clearly shown where all the smoke and the steam comes from. All the same, finally the play of light through the vapours is what most interests Monet. Moreover, it is the sort of semi-industrial image which even the least socially involved townsman would

be likely to encounter and appreciate for its evident picturesqueness, as well as possibly its associations with holiday pleasures in store.

It is interesting to compare Monet's images of the Gare St-Lazare, remote as they seem from making any specific reference to the industrial side of the railways, with the Manet painting of 1873 variously known as *La Gare St-Lazare* or *Le Chemin de Fer*. Both titles point to an important connection with the railway in the subject of the picture, but when we look at it we are in for something of a shock. It turns out to be a portrait of a young woman, book in hand and little dog in lap, looking rather wanly out at the spectator, while beside her we see the back of a little girl who is grasping an iron railing and looking away from us into a declivity through which (we may surmise by the presence of a large puff of smoke) a train has just passed. No more than that: the proximity of the railway is understood by hints and signs, but not directly presented. In fact, Manet's

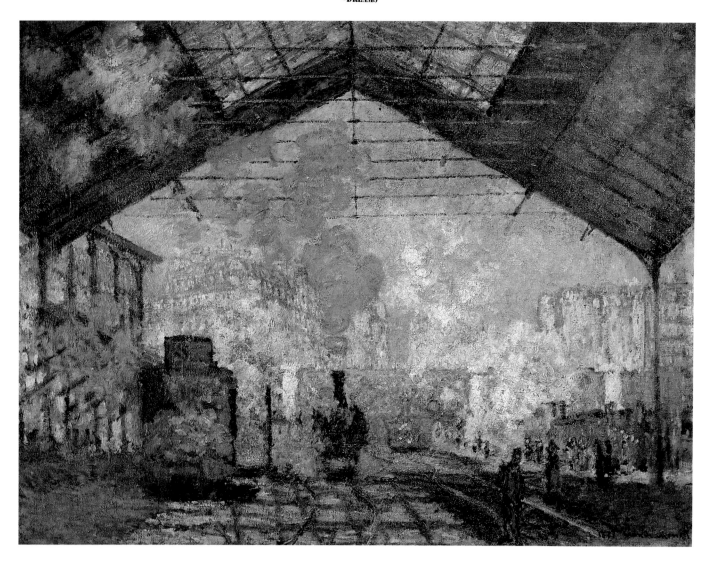

CLAUDE MONET
The Gare St-Lazare, 1877
The most magical of a series Monet made in and around the Paris station, reducing the bald evidence of the
Industrial Revolution to an opalescent play of light and colour through smoke and steam.

studio at this period was in the rue de St-Petersbourg, just a few doors from the railway lines out of St-Lazare, and a contemporary visitor described the constant rumble and clouds of white steam. Clearly Manet could not wholly ignore this immediate evidence of the industrial world just outside his door, but he chose to allude to it only in this curiously detached and indirect way. The picture might well be no different emotionally if it were a parkland scene the little girl was gazing at so intently through the railings.

Manet was not the only Impressionist who painted scenes close to but not quite of St-Lazare. Caillebotte too painted two of his most powerful images on a bridge overlooking the railway just outside St-Lazare, the Pont de l'Europe. Caillebotte was in any case something of an exception among the original Impressionists in that he seemed to have no particular romantic feelings about the countryside, frequently painted town scenes with more regard than any of the others for ren-

dering volume and recession, and also was much more evidently interested in people as subjects, ranging down through society to the manual workers of *Les Raboteurs de Parquet* (1875). Though his pictures of the Pont de l'Europe are hardly more explicit about their relationship to the railway than Manet's, they leave us in no doubt that we are looking at an aspect of industrial society.

For one thing, the loving care with which the bridge itself, its riveted girders of grey-painted steel, is rendered reminds us that it was considered one of the great engineering wonders of its time. Also, there is, in the first *Pont de l'Europe* painting of 1876, not only Manet's indicative puff of steam, but, the subject apparently of the besmocked workman's rapt contemplation, the top of an engine and another complete engine in the distance, and quite sufficient evidence that some kind of marshalling yard is just below. In the second *Pont de l'Europe* painting, though we cannot see much more of the railway itself, two of

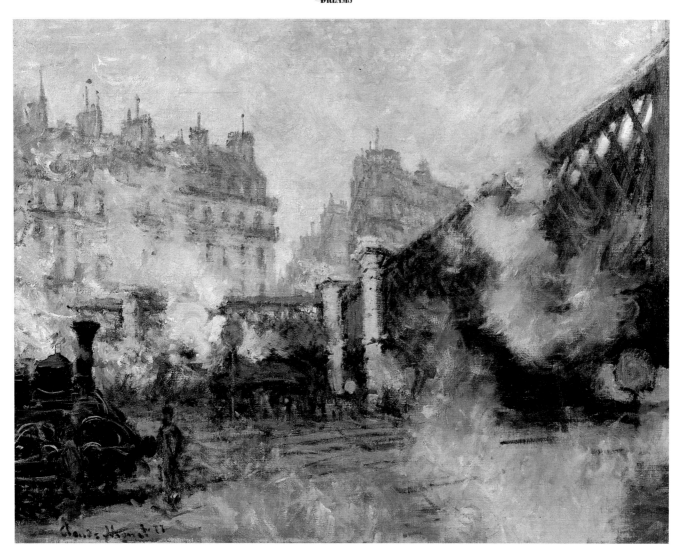

CLAUDE MONET
Le Pont de l'Europe, 1877
The other side of the view memorably painted by Caillebotte, this gives a very clear
idea of what the idlers and passers-by in Caillebotte's paintings were looking at.

three men in it, one in a top hat and one in a bowler, are look-ing away from us and drawing our attention to what they are looking at, represented by a station-shed, a platform, and another puff of steam rising over them.

With most of the other Impressionists who sometimes incor-porated factories (generally viewed from a great distance) into their predominantly rural landscapes, it is not easy even to guess at the frame of mind in which they did it. Cézanne, rather as one would expect, hardly acknowledged the existence of industry in his paintings at all; after all, most of his land-scapes were of Provence, a yet very little industrialized area. There is one exception among his earlier works: *Usines près du Mont de Cengle* of 1869-70, which shows a group of factories with three tall chimneys giving off a lot of smoke, in the middle of what appears to be a typical Provence landscape of bare, green/brown hills and olive trees (Mont de Cengle is a flank of the Mont Ste-Victoire). About the same time he had painted a

watercolour of factories for, of all places, the cover of Madame Zola's workbox, and that is almost certainly a total fantasy trib-ute to Zola's naturalistic-fiction world. The oil painting looks at first glance more likely to be studied from the life, but there seems to exist no trace or record of factories on the site, and this too may well have been an invention in the spirit of Cézanne's friend Zola. Certainly he never tackled such a sub-ject again.

It is also curious, and rather surprising, to find that a group of factory chimneys figures prominently in the background of one of Degas's earliest horse-racing pictures, *Course de Gentle-men avant le départ*, dated 1862, though the chimneys seem to have been added when Degas partially reworked the painting twenty years later. What point, if any, Degas was seeking to make by giving this originally unspecific scene in the open country a sort of suburban colouring, we cannot now guess. He quite possibly just followed an instinct which suggested to him

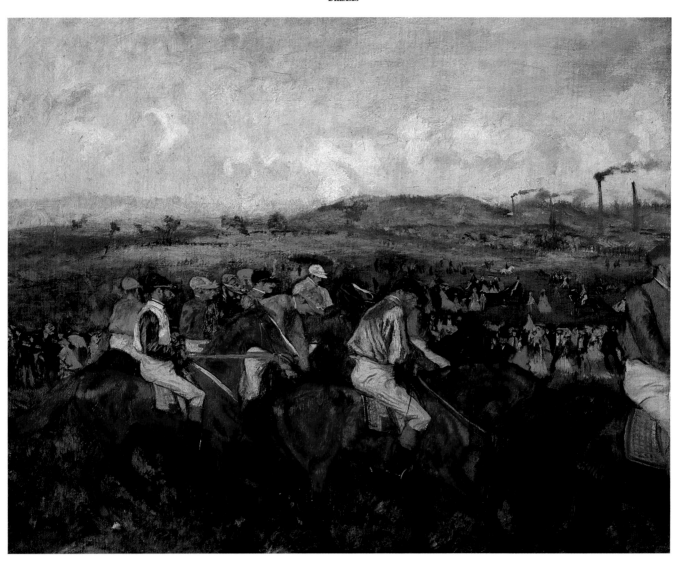

EDGAR DEGAS
Course de Gentlemen avant le départ, 1862/82
Originally this was a simple racing scene in the depth of the undisturbed country; when Degas
worked it over twenty years later, he added the factory chimneys in the background.

that this feature on the skyline gave the picture more interest and variety, as it had done for another picture *Les Courses* in 1872-73, which shows maybe the edges of Paris in the distance, with three smoking factory chimneys, or *Le Défilé* from even earlier (1866-68), which is often supposed to show a race-course at Longchamp, though the conformation of the buildings does not correspond with what is known of Longchamp at the time and it may possibly be an imaginary or synthetic landscape. On the other hand, a recent commentator has taken the surely rather too simple view that Degas's relegation of the factories to the background is a deliberate political statement on his part, indicating that what matters is the 'aristocratic' activity of horse racing in the foreground, and that the factories in the distance are of no importance or interest. If that was really Degas's view, one might counter, why did he go to the trouble of putting them there at all, and even in one painting deliberately adding them? There is not even the obvious dramatic just-

ification present in Degas's 1875 portrait of the industrialist *Henri Rouart devant son Usine*. Sheer decorative effect seems like a more reasonable explanation.

Pissarro's use of industrial motives in his landscapes is not, either, as straightforward and easily definable as one might at first suppose, bearing in mind his famous (or notorious) anarchist sympathies. While he was living and working around Pontoise, we may recall, he reverted quite frequently to the alcohol-extracting factory newly enlarged on the bank of the Oise. In these pictures it is difficult to impute to him either an early version of the present-day environmentalist's concern over pollution or a traditionalist's disapproval of such visual evidence of modern life in a recently 'unspoilt' rural scene. Nor do we get any sense of his attitude to the workers within: heroic fighters for the future or oppressed victims of the capitalist system. Nor, on the other side, is there any noticeable evidence, other than that Pissarro thinks the factory interesting

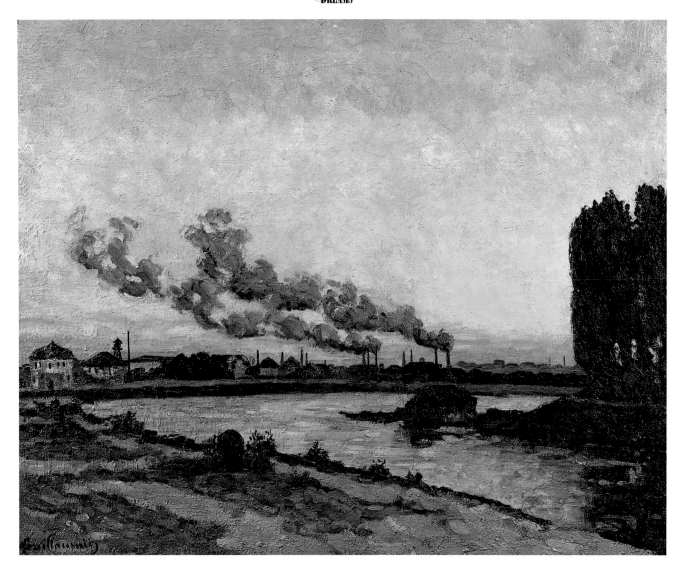

ARMAND GUILLAUMIN
Soleil couchant à Ivry
Though Guillaumin showed with the Impressionists, he was really an older and more
conservative painter whose work hesitates on the edge of full-blown Impressionism.

enough to paint at all, that he is moved by an excitement akin to the sort of industrial romanticism visible in Turner's *Rain, Steam and Speed*, which he had almost certainly seen in London. Pissarro's attitude to the factory seems, in fact, to be as dispassionate as his views of local woods and streams and peasant cottages: it is all there, has an equal right to be there and an equal right to be painted, if and when the artist finds it interesting enough to paint, neither sanctified nor excluded by its modernity or its perenniality.

Of course, such readings are largely determined by the style of painting. During the 1870s Pissarro's style was in general very sober and unexcitable: he seemed most interested in finding an overall balance of tones and unifying the whole painted surface into one satisfactory and coherent harmony. Attempts to see his railway paintings like that of *Lordship Lane Station* from his London period as expressions of industrial romanticism – as it well might be, given that it predates Monet's train

pictures and is one of the earliest Impressionist evocations of the railway era – fall down when we come to assess the tone and emotional climate of the picture.

If we are looking for a really romantic treatment of an industrial theme in Pissarro, we would have to look later, to the middle of his Pointilliste period, when in 1888 he painted *L'Ile Lacroix, Rouen, Effet de Brouillard*. Later on, in the mid-1890s, Pissarro painted several images of a Rouen very different from that implied by Monet's paintings of Rouen Cathedral, a smoky industrial town dominated by gasworks and a very workaday river, though Pissarro, with no sense of incongruity, once described it 'as beautiful as Venice'. But it is in the Pointilliste painting that the full glamour of industry is presented to us. Again it is the gasworks, with its towering single chimney belching forth smoke, which dominates the scene, but here it is dissolved into a haze of pink, beige and gold dots as the sun filters through the mist. This is the perfect example of an effect

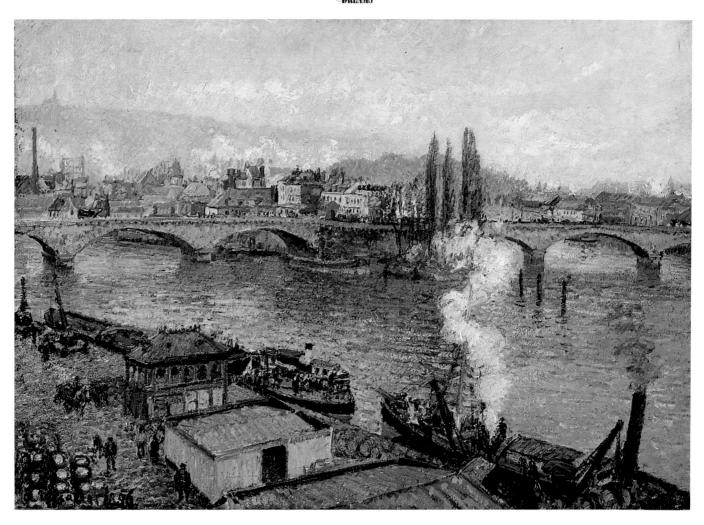

CAMILLE PISSARRO
The Stone Bridge at Rouen, dull weather, 1896
Pissaro seems to have had a liking for the grimmer industrial side of Rouen, which he described
as as beautiful as Venice. This painting is from his second painting trip there in 1896.

which, people think, would be quite beautiful if one could forget what it was. It *is* beautiful, as is the yellow smoke in Antonioni's colour film *Deserto Rosso*, even while it kills the birds, and Pissarro presents it so. Has he done so only by dint of forgetting what it is, or in full awareness of the ambivalence?

The Impressionists' general lack of interest in the industrial scene, or possibly their deliberate turning of a blind eye to it, had by this time received some critical comment. The strongest statement was in Huysmans' predominantly sympathetic review of the 1880 Exposition des Indépendents:

Then, if some of the artists we are discussing have, here and there, reproduced episodes of contemporary life, what artist is going now to render the imposing stature of the factory towns, will follow the path opened up by the German Menzel, going into the immense forges, into the railway sheds which M. Claude Monet has already attempted, it is true, to paint, but

without managing to detach the colossal size of the locomotives and the stations from his uncertain abbreviations: what landscape artist will render the terrifying and grandiose solemnity of the lofty furnaces flaming in the night, the gigantic chimneys crowned at the summit with pale fires? The work of man in manufacture, in factories; that modern fever presented by the activities of industry, the magnificence of machines: all this is still to paint, and will be painted provided that modernists really worthy of the name agree not to diminish themselves, mummified in the eternal repetition of the same subject.

It was a clarion call, fated in the main not to be taken up. It is true that the Neo-Impressionists sometimes found industrial landscapes to their liking, or at any rate to their purpose, since the tendency of industrial buildings to take hard, unadorned, geometrical shapes suited very well the monumentalism and immobility sought by these painters in their works. A painting

92

PAUL SIGNAC
Les Gasomètres, Clichy, 1886
Shown in the eighth and last Impressionist exhibition, this painting takes a frankly industrial
scene, and transforms it into a sunny abstraction of reds, browns and greens.

by Paul Signac included in the last Impressionist exhibition in 1886 illustrates this very well: *Les Gasomètres, Clichy* is just what is says: a picture featuring the gaunt outlines of the framework within which rise or fall the actual gas tanks, and in the middle a totally undistinguished group of buildings, maybe something to do with the gas company, maybe adjacent working-class dwellings, and anyway remarkable pictorially only for their vibrant red roofs, set against the blue/pink of the sky and the scrubby patch of bare earth before. Not by normal standards an alluring prospect for a painter, but Signac contrives, largely by ignoring the associations of the buildings and treating them simply as shapes, to produce a canvas in which, as a contemporary critic said,

The colours palpitate and the burning sun shimmers, making the atmosphere vibrate. And all of this strikes the eye without hurting it, in precise evocation, in an hallucination of memory that does not try to reinforce or multiply the sensation by an artist's trick, as Seurat does.

Which is perfectly fine, but very far from the sort of dynamism and excitement called for by Huysmans from the new industrial art he advocated.

However, there was among the Neo-Impressionists one who seemed to set himself precisely the goals Huysmans had set before painters *en masse*. This was Maximilien Luce, whom we have already encountered going to London with Pissarro at the time of Lucien Pissarro's wedding in 1890. His background was somewhat similar to Renoir's: only where Renoir was apprenticed at the age of thirteen to a porcelain painter, Luce was apprenticed at the age of fourteen to a wood-engraver, and worked as a commercial engraver until in the early 1880s the spread of photo-engraving began to put wood-engravers out of business.

MAXIMILIEN LUCE
Streets of Montmartre, 1887
Luce here, in accordance with his left-wing politics and interest in working-class life, deliberately
depicts one of the grimmer, slummier aspects of Montmartre, rather than the countrified artists'
playground.

He had been painting in his spare time for about ten years when, in 1885, he discovered the work of Seurat and was converted completely to Pointillisme and the scientific division of colours. In 1887 his work created a mild sensation at the Third Salon de la Société des Artistes Indépendants, and as a result he got to know Pissarro, father and son, Seurat, Signac and others from the Impressionist circle.

Politically, like Pissarro, Luce was a committed anarchist, and in the 1890s he was imprisoned for political activities. Probably because of this, and of his own career in a basic working-class trade, he took much more evident interest in the industrial scene than any of the other Impressionists and Neo-Impressionists: not only a rather abstract artistic appreciation of some industrial shapes or recognition that a distant plume of smoke could be an attractive feature on the skyline of

an otherwise traditional landscape, but also an actual emotional excitement derived from the subject-matter in itself. Inevitably the results are ambiguous in their political message. We cannot know unequivocally without external documentation whether a scene such as *Hauts Fourneaux, Charleroi* is supposed to open our eyes to the apocalyptic beauty of the furnaces at full blast, or arouse our indignation of behalf of the men who work them, or both, or neither. But as deeply satisfying pictures of a specifically modern phenomenon, Luce's many paintings of slag heaps, furnaces, buildings sites and factory chimneys make a unique contribution to the Impressionists' highly selective record of the world about them. While most look rather askance, if at all, at the world the Industrial Revolution has made, Luce looks it full in the face, and is excited and inspired by what he sees.

THE SOCIAL WORLD

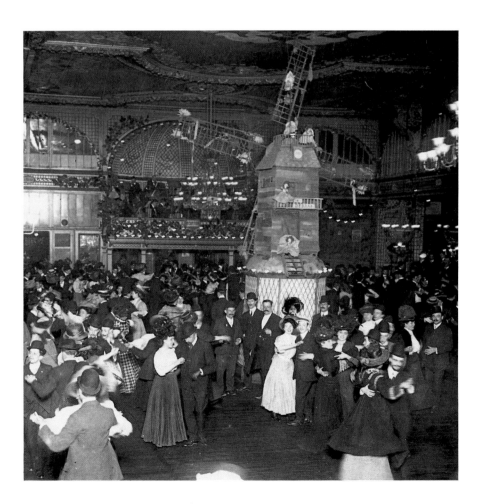

The Moulin de la Galette, as depicted in one of Renoir's most famous paintings was a favourite artists' resort. This is a ball around 1900.

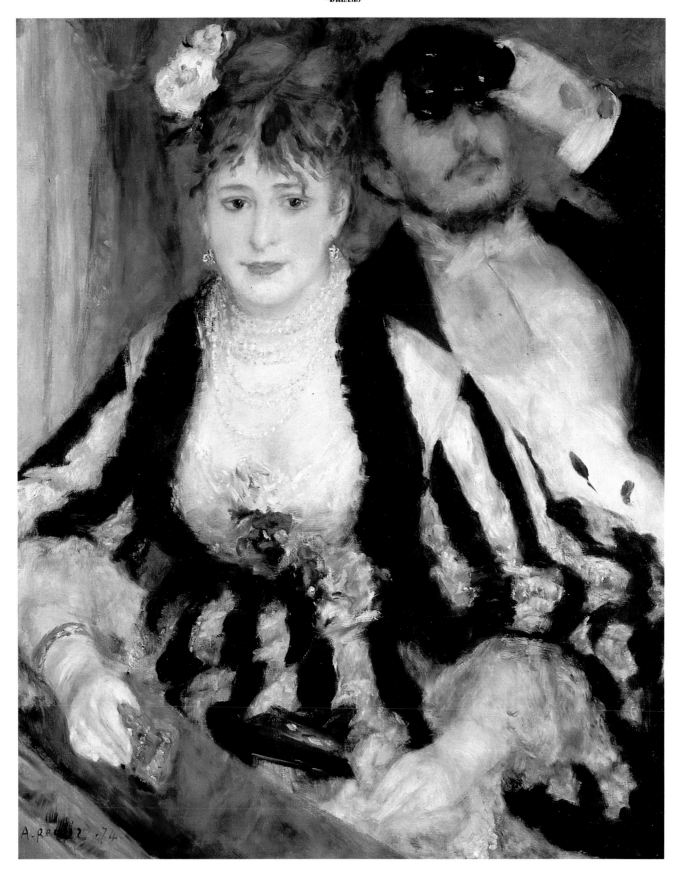

PIERRE-AUGUSTE RENOIR

La Loge, 1874

The working-class Renoir, by 1874 well on his way up the social scale, seems in this famous painting to be
expressing some of the outsider's wonder at the sheer glamour and luxury of a night at the theatre.

7

FASHION AND
LE BEAU MONDE

The major race-tracks in and around Paris were a favourite place of resort. The smart set set at Longchamp, c. 1900.

MONG THE IMPRESSIONISTS, MANET AND DEGAS belonged; Renoir emphatically did not; the rest were indeterminate, shaped by the details of their background, swayed by their political convictions. Basically, apart from Renoir and, later, Luce, they were all bourgeois, though of various standing from the *haute bourgeoisie* of Manet, Degas and Morisot through the middle-range business classes of Bazille, Pissarro and Sisley, down to the lower-middle-class shopkeepers of Monet's family. Cézanne, of course, stood rather apart, as the son of a Provençal banker-turned-land-owner who never really belonged to Paris.

This means that, whatever their personal attitudes towards the Second Empire and its grand bourgeois society, or the even more bourgeois Third Republic that came after it, there was no reason for most of them to feel even slightly uncomfortable in Paris society. On the other hand, they did not have to like it, and obviously by the very fact of becoming artists they had in a measure cut themselves adrift from their class and taken on a colouring of bohemia. This was not necessarily any more than a temporary phase: art students were willy-nilly bohemian, but successful artists were as likely as anyone else to achieve worldly honour, financial success and a welcome in even the grandest salons. Some of them deliberately sought this way to acceptance: Manet, in particular, was convinced that the only

way was to avoid categorizing oneself as a rebel and to continue to storm that bastion of the establishment, the official Salons. Although he finally won official acceptance with the award of the Légion d'Honneur in 1882 it was too late for him to benefit very much from it, since he died the following year. But thereafter gradually one after another of the Impressionists who survived became rich and famous and sought-after.

Even so, not many of the Impressionists concerned themselves very much with society. It was of great interest to some of their personal associates: Manet's friend Tissot's painting was largely concerned with 'vulgar society'; Degas's friend Alfred Stevens made a fortune from painting rich and beautiful society ladies looking even more rich and beautiful than they did in life. As the century wore on younger men, like the American John Singer Sargent and the Italian Giovanni Boldini, specialized in glamorous portraits of the celebrated or merely rich pillars of the new society. But of the Impressionists proper only Manet could really count as a painter of society and Degas sometimes too, though usually incidentally (as in some of his racing pictures, for instance); he really preferred, if he was going to paint bourgeois society at all, to depict the menfolk at work, the women shopping.

Renoir, oddly perhaps, did some pictures of society people in a theatre audience – the most famous of such pictures is *La Loge* – but more usually he preferred a slightly more bohemian

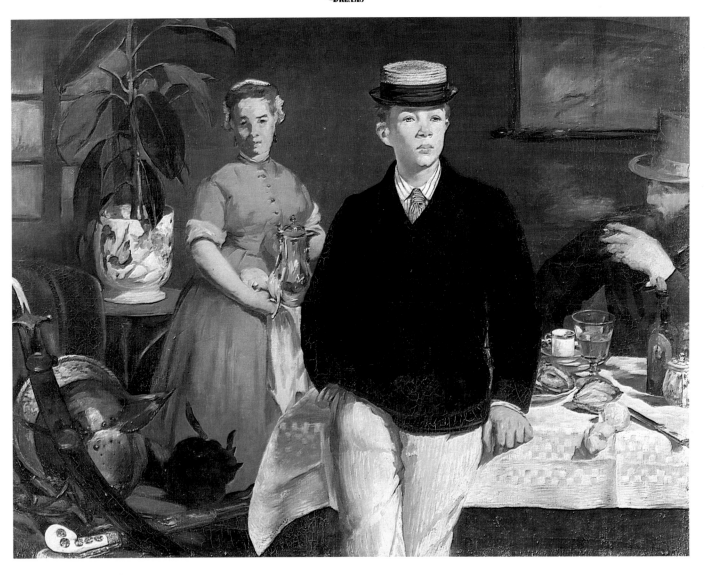

EDOUARD MANET
Le Déjeuner, 1868
*A rather mysterious picture, not at all clear about the relation of the three figures to one
another. We know at least that the boy is Leon Leenhoff probably Manet's illegitimate son.*

stratum of Paris society. Pissaro scarcely touched on this area of subject-matter at all. Sisley remained faithful to landscape, but for an occasional still-life. Caillebotte gives some idea of society in his street-scenes and interiors, but the social side seems relatively unimportant to the true purpose of his paintings. Cézanne's early work, from his first Paris years, had more to do with working out his own passionate complexities than with observing society around him – one or two of his most 'social' looking paintings are in fact based on published fashion plates of the period – while his later work is, in its different way, just as abstracted from society. And Monet, though he was far from apolitical, as a painter gave little evidence of concern with society with either a capital or a small 's'.

Even with Manet, the term 'society painting' is relative. Is, for example, *Le Déjeuner sur l'Herbe* about society or bohemia or what? It has been pointed out many times that its composition is based largely on an engraving after Raphael, the subject being 'The Judgement of Paris'. All reference to the myth has however been suppressed, and the idea of the men fully dressed and the two women nude or very lightly draped was Manet's own. In a sense, the question of whether what we see represents a couple of artists relaxing in the woods with their models, or a couple of outwardly respectable men of leisure with ladies of what we may presume to be easy virtue, is finally irrelevant. Manet must have been conscious when he elaborated the composition that he was throwing out a social challenge by purely artistic means: the question was not so much in the 'story', if any, that could be extracted from the picture, as in its unequivocal situating of nudity in a contemporary context, without any of the get-out clauses of the mythological nymphs and goddesses inescapable in academic art at the time.

In other words, Manet was exposing a certain kind of artistic hypocrisy and double standard, as he was to do even more directly in his *Olympia* the same year (1863), where what could

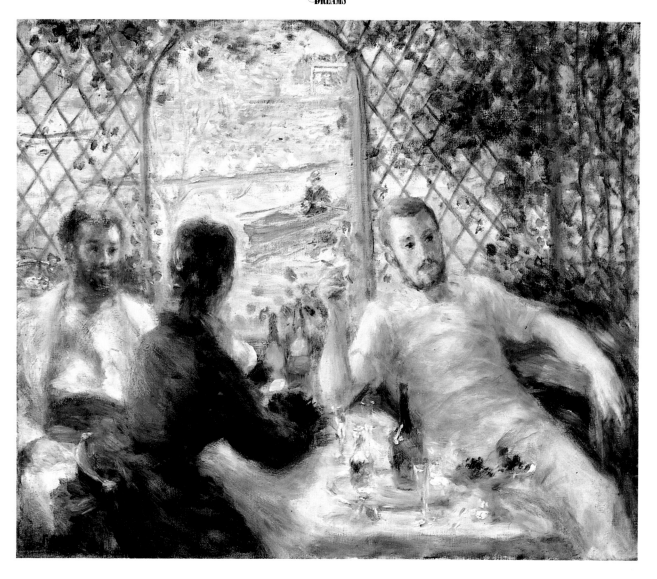

PIEFRRE-AUGUSTE RENOIR
The Oarsmen's Lunch, 1881
*Around the time that he painted his very famous picture of his fellow oarsmen lunching by
the river (p. 103) he also made this simpler study of a slightly different group of friends.*

be a perfectly acceptable academic nude if placed in a vaguely idealized classical landscape is undermined or redefined by being located instead in a modern-looking interior and provided with a clearly contemporary black attendant. Though this may not require us to do any special thinking about its social implications, it inevitably set visitors to the Salon of 1865 twittering over whether it must necessarily represent a fallen woman or a *grande cocotte*. This, of course, was because art-lovers of the time were used to looking for the story that every picture was supposed to tell, reading telltale signs like the bouquet the maid holds and displays (from whom?) or the fact that the woman is still wearing slippers and jewellery. Half a century later, Proust's Oriane de Guermantes remarks (seeing it in the Louvre): 'Nowadays no one is shocked. It looks like something by Ingres.' But if that was so, even in 1907, it was entirely because the Impressionists had meanwhile brought about a shift in sensibility.

No innocent in such matters, Manet was certainly aware of the social subtext in these pictures – though whether his intention was critical or exploratory is less sure: probably we should see it in terms of the 'objectivity' which was to become a hallmark of the Impressionists in general. Interestingly enough, we have in two early paintings by Cézanne a far-from-objective gloss on these two Manet paintings: Cézanne's *A Modern Olympia* (1869-70) and *Le Déjeuner sur l'Herbe* (1870-71) – the earliest of several variations on the theme – must be primarily actings-out in paint of his own tormented imaginings, but as Laurence Gowing has noted, 'It was Manet's spontaneous notation of his provocative subjects that led Cézanne to conceive the picture as an emotional imagining enacted in paint,' and what he brings out into the open in his pictorial references to Manet must correspond to something that others apart from himself were at the time driven to speculate on. In Cézanne's *Le Déjeuner sur l'Herbe* everybody is fully clothed, but the whole

CLAUDE MONET
Le Déjeuner sur l'Herbe (left fragment), 1866
In 1865 Monet undertook an ambitious figure composition,
probably in conscious emulation of Manet's famous work
of the same title. The final painting deteriorated and was
dismembered by Monet himself.

image of four men and three women (not to mention a dog)
having a picnic is invested with a brooding intensity and
prickly discomfort that seem to re-create for us in a more acces-
sible form the sort of emotions the public of the 1860s felt in
front of Manet. *A Modern Olympia* is even more direct: in
Cézanne's version the nude on the couch is curled up in an
almost foetal position, and as well as the dusky attendant there
is now imported into the picture another fully-clothed mascu-
line figure, a spectator who might be a surrogate of the painter
or might be the 'pasha' of the alternative title, which rubs in the
erotic and mercantile associations hinted at in the Manet.
(These are even further emphasized in Cézanne's second ver-
sion of the subject in the Musée d'Orsay, where the attendant is
apparently sweeping off the covers with a theatrical gesture to
display the woman to what one must inevitably call the client.)

In the case of *Le Déjeuner sur l'Herbe* there are other stalking-
horses which take us in the opposite direction. In 1865 Monet

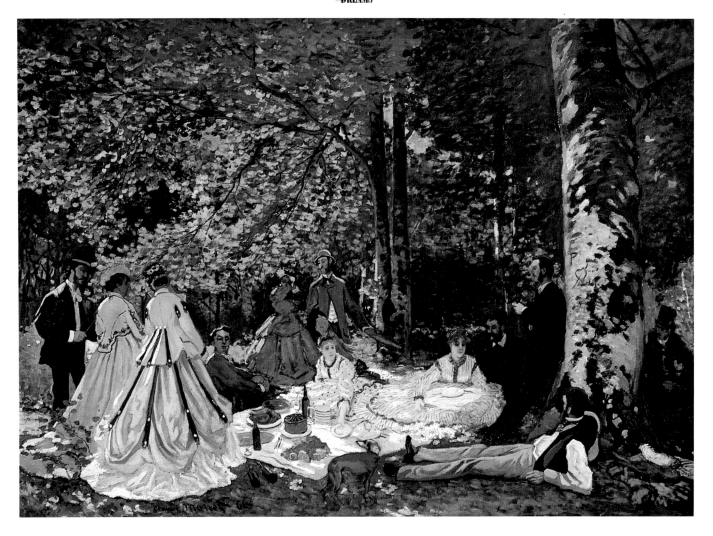

CLAUDE MONET
Le Déjeuner sur l'Herbe (study), 1865
Before embarking on the full-size work, Monet made this complete study for the composition
of his Déjeuner sur l'Herbe, *which gives some idea of its scope and ambition.*

painted his own ambitious version of the theme, which survives now in a quite highly finished sketch of the whole compositon in the Pushkin Museum, Moscow, and two large fragments from the completed work, dismembered by Monet himself after it had deteriorated in the damp. This is as near as Monet ever got to painting society: it depicts a group of seven men, five women (and a dog) standing, sitting or lying around a picnic laid out on the ground in a sunlit glade of the woods. The composition was carefully worked out in advance, and elaborated almost entirely in the studio (with Monet's fellow-Impressionist Bazille posing for at least four of the male figures in the picture). All the people in it are fully dressed, and there is no conceivable challenge to propriety; this is, one imagines, very much society as it would like to be seen. These are clearly sophisticated Parisians on an outing to the country but bringing all the urban appurtenances with them. They are apparently not so grand as the people who figure in Manet's

paintings, and the rendering is quite literal, without any ironic reverberation. It is tempting to equate the painter with the unobtrusive, respectful man-servant crouched behind the tree on the right; he is suitably impressed, and he knows his place.

Elsewhere in Monet, society is present, if at all, as an adjunct of landscape: *L'Hotel des Roches Noires à Trouville,* for example, clearly depicts a stamping-ground of the well-to-do, but the pictorial interest is much more in the evocation of a certain kind of breezy day by the Channel, suggested especially by the way the gigantic flag in the foreground is flapping, than in the tiny, sketchy figures on the terrace. Even the few portraits, like the *Madame Gaudibert* of 1868 and the famous *La Japonaise* of 1875-76, with its fancy-dress Occidental woman surrounded by Japanese fans, suggest solid bourgeois values rather than social grandeur. Though Monet began a notch or two further up the social ladder than Renoir, his attitude does not appear so very different from that of Renoir in *La Loge* (1874), where

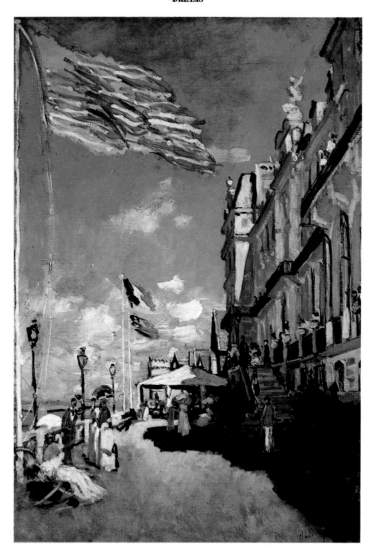

CLAUDE MONET
The Hôtel des Roches Noire, Trouville, 1870
One of Monet's most vivid seaside evocations, this implies the presence of the sea by
the light reflected from sea and sand and the breeze which flutters the flags.

the painter seems to be unequivocally impressed by the remote glitter and glamour of the man and woman in the box, seen as it were from the gods. Renoir is clearly much more at home with the socially mixed revellers at the *Bal au Moulin de la Galette* (1876) or the participants in the *Déjeuner des Canotiers* (1881).

What we miss in Monet and Renoir, but find in Manet and Degas, is a strong, unselfconscious awareness of style, of fashionability as a precise social index (or as precise as could be achieved). Renoir's lunch-party or his dancers are essentially classless – or rather, like Renoir himself at this stage, they belong to one or other of the new, undefinable classes which grew up in the Second Empire and continued to develop during the Third Republic: independent, upwardly-mobile office-workers, shopgirls and the like who at least had enough pay and time off to be able to go on *parties de campagne* or go drinking and dancing in some of the innumerable bars and

cabarets which had sprung up in Paris since 1880. Despite the traumatic interruption of the Franco-Prussian War and its aftermath, with first the siege of Paris and then the dramatic months of the Commune, when the workers of Paris attempted to set up their own communist/anarchist form of government and were bloodily suppressed, the old class structures were being progressively eroded. The bohemian world of the artist, to which most of the Impressionists belonged earlier in their careers, had been romanticized and formularized by Henry Murger in *Scènes de la Vie de Bohème* (1851), and its importance in the Parisian imagination certainly had something to do with the erosion. But it was only one among many unsettling factors as the bourgeois monarchy of Louis Philippe was succeeded (after a brief spell of republicanism) by the bourgeois empire of Louis Napoleon, and that by the bourgeois apotheosis of the Third Republic.

One can get the exact flavour of this new middle-class ascen-

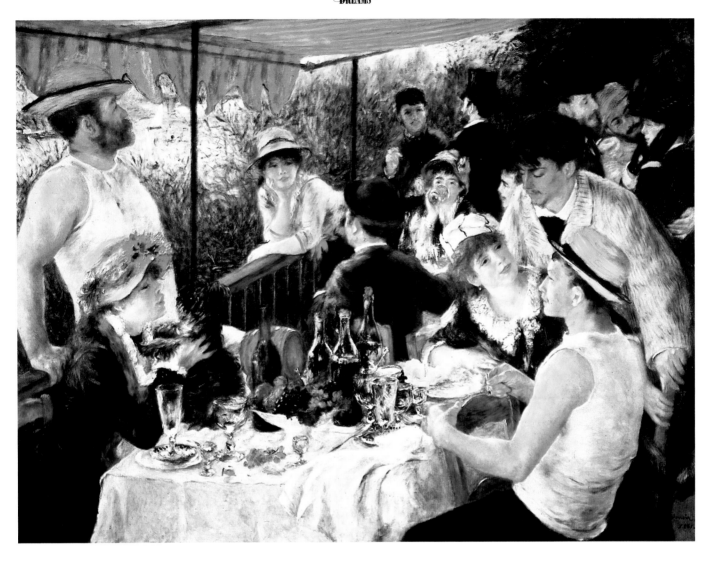

PIERRE-AUGUSTE RENOIR
The Oarsmen's Lunch, 1881
*One of Renoir's most totally sensuous, relaxed views of a day's pleasure by the river, though
the intricacy of the composition and its size indicate more artifice than strikes the eye.*

dancy in the street scenes and interiors of Caillebotte. Again, a key work is *Rue de Paris: Temps de Pluie,* which is set, like Caillebotte's two contemporary *Pont de l'Europe* paintings, in a new, socially nondescript area near the Gare St Lazare (where a number of artists, including Manet, had their studios). The people seen in it, all soberly dressed and carrying umbrellas against the wet weather, are clearly prosperous and bourgeois, more solid than stylish. Similar figures recur on the Pont de l'Europe, where the man in the top hat and the woman in a frilled black dress, carrying a parasol, are surrounded by more humble folk in the first picture; in the second a man in a top hat shares an interest in the railway with a man in a bowler, while another top-hatted figure hurries past. One could imagine the kind of domestic life these people might lead even without the evidence so vividly supplied by Caillebotte's interiors, such as *Déjeuner* (1876), with its elaborately equipped table and heavily furnished room, in which a man and a

woman (son and mother, presumably) partake of a curiously listless meal.

This is a mood piece (and a thoroughly unsettling one at that), but it is also minutely documentary, as is Caillebotte's portrait of his brother Martial *Jeune Homme jouant au Piano* of the same year, which seems to be less about the making of music, or the person making it, than about the claustrophobic patterned wallpaper, the elaborately flounced curtains, or the highly polished woodwork of the piano which bespeaks a more than adequate supply of domestic help in the background. Caillebotte's two related *Intérieurs* of 1880 share the odd atmosphere of these paintings, but sharpened into what has been read by some critics as criticism of the upper-middle-class depicted. In each we are shown a man and a woman (husband and wife presumably, for in the detached manner of the Impressionists we are not told) living together but separate in the same environment. In one the wife is sitting reading a news-

103

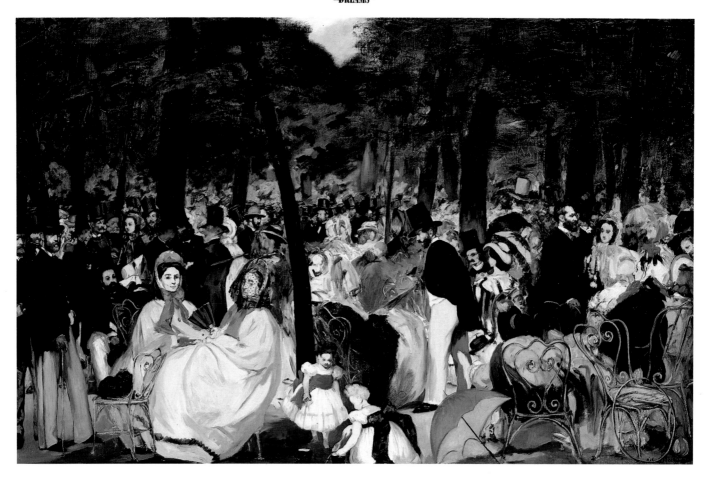

EDOUARD MANET
Music in the Tuileries Gardens, 1862
This broad, almost theatrically presented social panorama gives a vivid impression of the circles
in which Manet moved: among those shown are Manet himself, Baudelaire and Offenbach.

paper in the foreground, and the husband is lying reading a book at the back; in the other the man sits in a chair reading a newspaper while the woman gazes out of the window. There seems to be nothing which unequivocally indicates an unhappy marriage or breakdown of communications in either; married couples do not always need to be acting out togetherness in order to be happy. But in the second especially there appears to be a suggestion of hostility and defiance in the poses of the two figures, and one is reminded that Caillebotte himself never married. Of course, he never ceased, either, to be a member of the prosperous *haute bourgeoisie*.

If this is what society painting entailed for the less than very grand, it is probably not surprising that most of the Impressionists were not particularly interested in it, except in the rather special case of domestic scenes with women and children. At least in Manet and Degas we are given a more immediately attractive vision of the fashionable world. Manet has

two aspects as a society painter: one is visible in the panoramic scenes such as *La Musique aux Tuileries* (1867) and *Bal Masqué a l'Opéra* (1873-74), in which we see a large number of fashionable people relaxing – in the first families out to listen to open-air music in the gardens; in the second mainly men in top hats and evening dress, with a few ladies (or at any rate women) in black masks among them. Both pictures seem at once to present and exploit the stylishness of the scene and subtly to undercut it with, especially in the *Bal Masqué,* disconcerting juxtapositions of respectable and disreputable, while both are give a touch of ironic distance by their construction in the manner of a stage picture, within which the people are performing rather than living. The *Musique aux Tuileries* takes on an added dimension when one realizes that Manet himself, Baudelaire and other friends from the dandyish set in which he moved are clearly depicted, as a kind of nod to insiders.

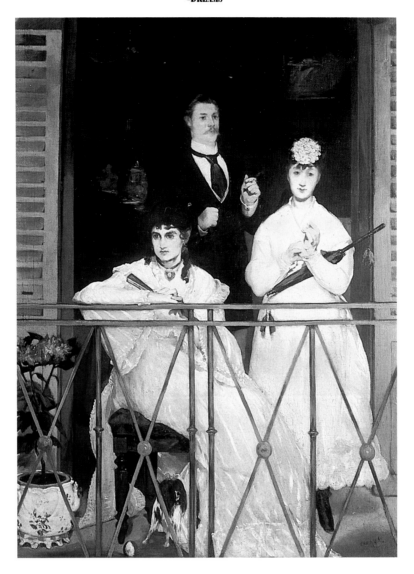

EDOUARD MANET
Le Balcon, 1868-9
*What looks like a portrait group of a family is actually a subject-picture with no literary
signficance: the sitters are friends of Manet, including Berthe Morisot, seated.*

The other side of Manet's work as a society painter has more to do with what is implied rather than what is directly expressed. What is intended may be a portrait, single or group, but what emerges is more of an insight into a certain class and a certain attitude to life. What we take, incorrigibly prone to subject-reading in pictures, as the family in *Le Balcon* (1868-69) is in fact a carefully constructed group of Manet's friends: two Impressionist painters, Antoine Guillemet and Berthe Morisot, and the future wife of the painter/sculptor Pierre Prins. We cannot guess what these clearly prosperous, stylish people are doing on the balcony – they are looking in different directions, for instance – and we cannot see much more of the interior behind them than a reassuring gleam of pictures and ceramics. It is all expressive of *luxe, calme* and a certain degree of *volupté:* we certainly are not given to interpret the characters' lack of togetherness as a social criticism or even as a hint of narrative. Other Manet paintings of the same period have the same kind of mystery: the strange *Le Déjeuner* again features three apparently unrelated characters: the boy leaning against the lunch-table in the foreground, the man seated smoking on the other side of the table and the standing maidservant with the coffee-pot. It seems that the picture evolved gradually from a simple studio scene; it also seems that the boy, Léon Leenhoff, may have been Manet's son. It does not make much difference whether he was or not: the picture is curiously impersonal, or 'objective', and creates an oddly casual effect, which is part of its fascination. The boy in particular seems to have a cool confidence, bordering on impatience: a clear, if no doubt unconscious, statement about his class and upbringing which would not be quite the same in a painting by, say, Caillebotte.

We do find the same slightly imperious quality, though, in the work of Degas. It is obviously present, for instance, in the now lost but much-reproduced *Place de la Concorde,* in the way the artist Vicomte Lepic strides calmly towards the edge of the

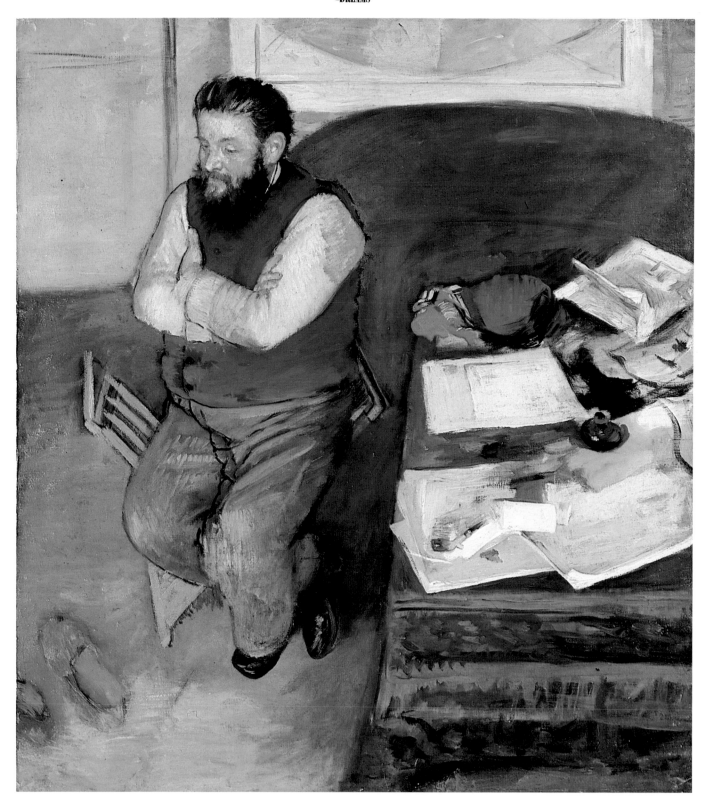

EDGAR DEGAS
Portrait of Diego Mertelli, 1879
*Martelli was a Florentine writer and art critic, who became a close friend of Degas. The portrait shows Degas's
extraordinary originality, both in its asymmetrical composition and the ways he indicates Martelli's character and work.*

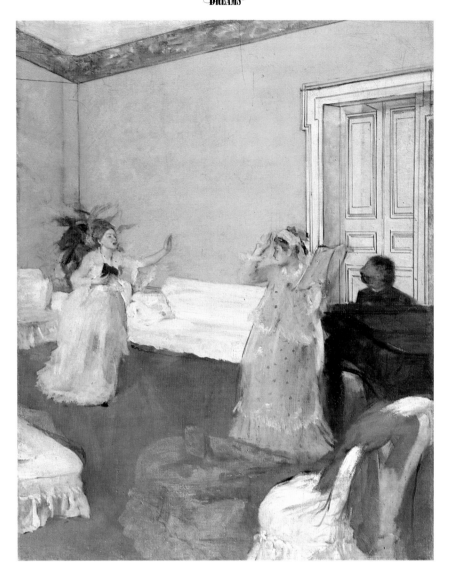

EDGAR DEGAS
La Répétition de Chant, 1872-3
This dramatic scene was almost certainly painted by Degas during his stay among his
American relations in New Orleans, which possibly explains its theatrical quality.

picture, smoking, sure of himself, confident that his dove-grey coat and black top-hat are immaculate, and that his daughters, wherever their eyes may be wandering, will follow where he leads. In other paintings the hauteur of the people is the more telling for being taken for granted. Frequently the backgrounds of Degas's interior portraits are reduced to corners of uncommunicative rooms, lined with books maybe, as in that of *Edouard Duranty* (1879), or just showing a nondescript sofa and a littered table, as in that of *Diego Martelli* (1879), or backed by the impedimenta of an artist, as in that of *Jacques-Joseph Tissot* (1868). To find pictures by Degas which more clearly express a sense of the elegant fashionable life, we have to look to one or two of his horse-racing pictures, notably, *Aux Courses en Provence* of 1869, where, exceptionally, the fashionable visitors are more emphatically presented than the jockeys, the horses and the race itself, or to such an exceptional picture as *La Répétition de Chant,* so dramatic and exotic in its pre-

sentation of a domestic song-rehearsal that some commentators have suspected it dates from Degas's stay in New Orleans, 1872-73.

But if these pictures do tell us something about fashionable life at their period, it is only indirectly. Degas is himself sufficiently established to take all this for granted, and is himself more interested in his excursions into borderline social territory: backstage at the ballet, among the jockeys, observing working girls at work – milliners, laundresses – or in the brothels. Probably in the end an admiring outsider like Renoir can tell us more – or foreigners like the two Italian Paris residents and adherents of the Impressionists, Giuseppe de Nittis and Federico Zandomeneghi. Zandomeneghi in particular, a close friend of Degas, handled rather similar material, and concentrated for much of his career on painting pretty women, often bathing or drying themselves but also in more social situations which give a clearer idea of their social standing – in

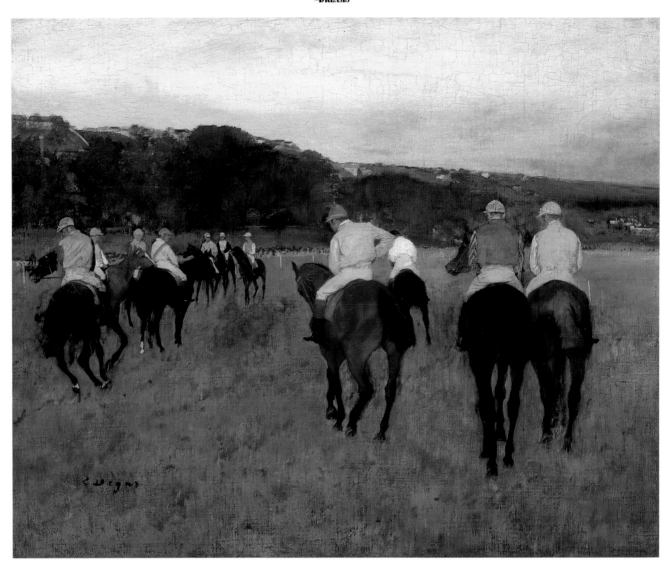

EDGAR DEGAS
Race horses at Longchamp, 1871
One of Degas's most poetic racecourse scenes, owing largely to the unusual twilit lighting,
which gives the vivid colours worn by the jockeys an almost phosphorescent glow.

restaurants or theatres, gossiping or fussing over flowers, sitting in the park or even, in a couple of images dating from 1896, riding bicycles, dressed in bloomers.

But it is when the Neo-Impressionists Seurat and Signac appear on the scene for the last Impressionist Exhibition in 1886 that we encounter a new kind of society painting. Signac in particular recolonized the area of the bourgeois domestic interior, and seems in some cases to be taking up where Caillebotte left off: two paintings especially appear to have a close relationship with Caillebotte's works: *Le Petit Déjeuner* of 1886-87 is almost a direct reworking of Caillebote's *Déjeuner,* ten years before, and *Un Dimanche Parisien,* with a wife looking out of the window and the husband seated, turned away to stoke the fire (1890), looks to have a more coincidental relationship with Caillebotte's *Intérieur,* again of just ten years before. Both of the Signac paintings make whatever critical content there may be in Caillebotte more explicit, and indeed

tempt one to postulate a story, or at least a genre situation, more imperatively than almost anything we can think of in the Impressionist circle since Degas's *Intérieur* of 1868-69 – 'my genre picture', he called it - which is so provocative along these lines, with the man leaning against the door, the bed, the pool of lamplight and the woman in her shift, turning away, that it was long known (without authorial authority) as *The Rape.*

Whereas these pictures seem to lead us away from Impressionist detachment, Seurat's *Un Dimanche à la Grande-Jatte,* painted in 1884 and the sensation of the 1886 Impressionist show, is in a sense the final masterpiece of Impressionist detachment, carried to an extreme of hieratic immobility, as well as leading unmistakably right on to something new. It is undoubtedly a social painting, showing a cross-section of the middle classes taking the air on an islet in the Seine just downstream from Paris. But more than that, it is an essay in the analysis of light and colour, the reduction

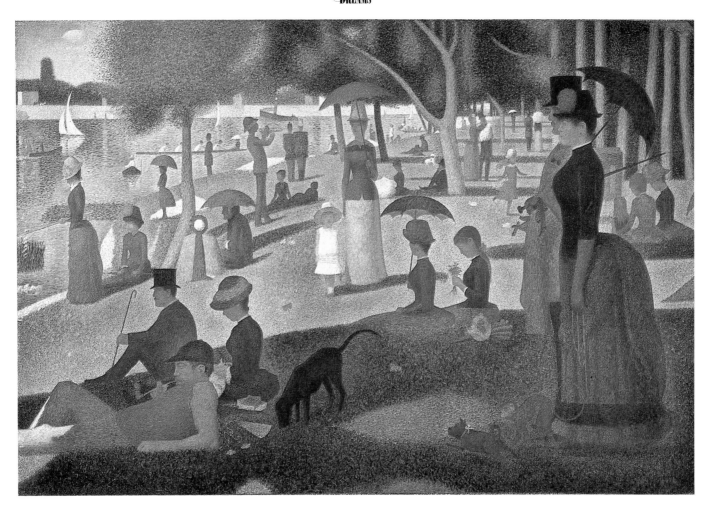

GEORGE SEURAT
Un Dimanche à la Grande-Jatte, 1884-86
The sensation of the last Impressionist show in 1886, and the painting which established
Pointillisme or Neo-Impressionism in the eyes of the world.

of definable subject to almost abstract patterning. Even this can call out the story-telling instinct in some spectators – Stephen Sondheim was compelled to reconstruct the 'narrative' element of the painting in *Sunday in the Park with George*. But first and foremost it is a manifesto painting, belonging crucially to art history, and not to social history at all.

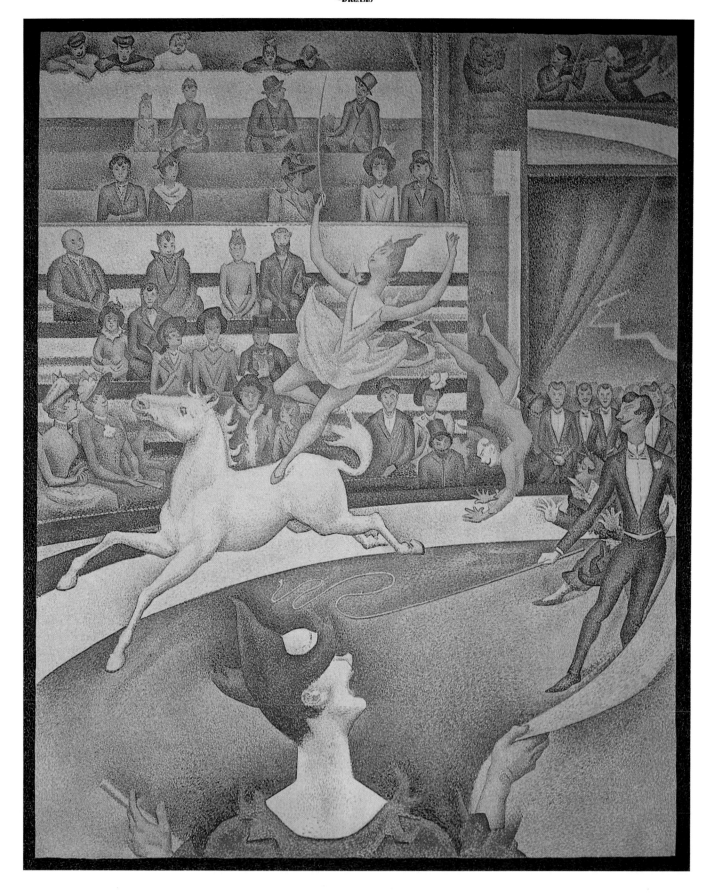

GEORGES SEURAT
Le Cirque, 1990-91
An astonishing application of the finnicky procedures of Pointillisme. Seurat's last major painting.

8

THEATRE AND THE DANCE:
LA VIE DE BOHEME

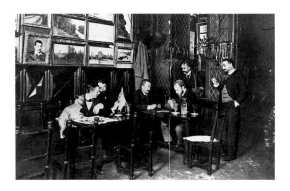

Le Chat Noir was a favourite meeting-place for artists towards the end of the 19th century.

FOR MOST PEOPLE THE IMMEDIATE IMAGE SUM-moned up by the word 'Impressionist' is not of landscape but of people: the inhabitants of that social no-man's-land represented by the bohemian world of the artist, with its cafés and dancehalls, its circuses and spectacles, its riverside excursions, its contacts with theatre and ballet. This is understandable: the more human the face presented by art, the easier it is for the vast majority to react to and fix it in their minds. And many, though not all, of the Impressionists were characteristic products of their age, situated in their early careers somewhere between the innocent diversions of Murger's *Vie de Bohème* and the slightly more suspect – at any rate more attitudinizing – preoccupation of the decadents with showgirls, *femmes fatales* and scarlet sin. Of course, as artists trying to make their way in a chancy profession, they worked hard and frequently recorded the fact. But at the same time they believed in having a good time whenever possible. They had their mistresses, who often in due course became their wives, they went out on painting trips together, they boated, they smoked and drank, they sat up arguing in bars or hung around in the places where what pre-Raphaelites called 'stunners' were traditionally to be found – stage doors, milliners, laundries. And as often as not they recorded it all in paint.

Or at least, some of them did. Even the most serious deigned from time to time to paint one another painting. Renoir painted Monet painting in his garden at Argenteuil, Manet painted Monet painting on a boat on the Seine. Sargent painted Monet painting in the open air. Manet painted Eva Gonzalez painting, at her easel, though in noncommittal surroundings which might or might not be her studio, or anybody's. Pissarro and Cézanne painted each other, Van Gogh and Gauguin painted each other (though after both had ceased to be Impressionists). Tissot painted (with rather nightmarish and un-Impressionist clarity) a number of painters and their wives lunching outdoors at Ledoyen's restaurant in 1885; Degas had painted Tissot in a studio nearly twenty years earlier, but clearly Degas's studio not Tissot's, with the artist represented as gentleman visitor, his profession no more indicated than that of the stolid, top-hatted bourgeois in Tissot's painting. Degas also, around 1879, painted a most curious and mysterious portrait of his painter-friend Henri Michel-Lévy in a studio with paintings, brushes and palette and, slumped at his feet, a lifesize female lay-figure dressed in pink, which (or who) also figures in one of the sketched-in paintings on the wall.

But these paintings were tributes to friendship rather than tributes to art. Though the Impressionists by no means always lived up to their ideals of total *plein-air* painting, most of their paintings involving the actual process of painting are set in the

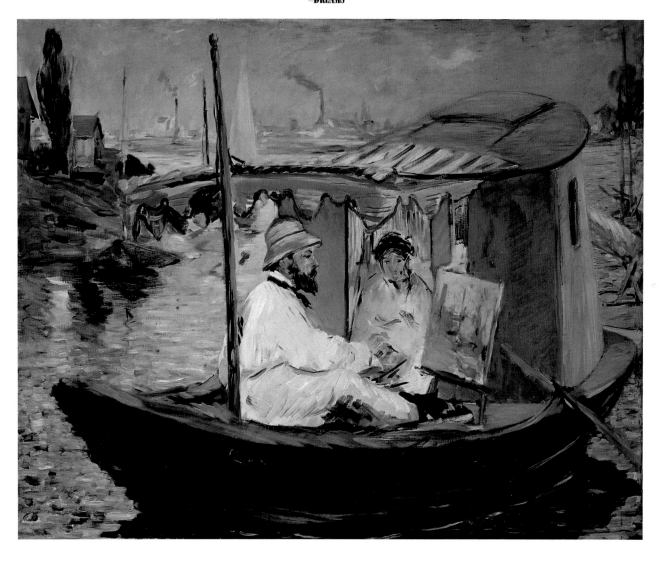

EDOUARD MANET
Monet in his Floating Studio, 1874
One of the paintings which marked Manet's conversion (primarily through Monet) to the idea of on-the-spot
painting in the open air; in the summer of 1874 he spent time painting with Monet and Renoir at Argenteuil.

open-air and seem like an extension of chummy communal painting trips, retaining something of a holiday atmosphere. The much advertised mistrust of or lack of interest in studios does, however, mean that there are no Impressionist equivalents of Courbet's grandiose work *L'Atelier du Peintre,* with its idea of an almost ceremonial visitation of the artist's studio, and consequently of painting as both hard work and an almost sacred duty. Art-making in Impressionist painting always manages to look easy, informal and fun. Just another part of bohemian life, in fact, or something (in Manet or Degas) that a gentleman may engage in, but only dismissively and unobserved.

Several of the Impressionists have left behind vivid indications of the easy-going bohemian life of which such painting activities may be taken to be a part. Renoir is responsible for several of the best-remembered. Who, for instance, has never seen his *Bal au Moulin de la Galette,* a sun-dappled evocation

of dancers and drinkers in what was already the last open-air dance-hall of its kind in Paris when Renoir painted it in 1876? (Notable, even here, is a touch of that nostalgia for things as they used to be which recurs throughout Impressionist landscape.) The usual legends have gathered round this, one of the most famous of Impressionist paintings: especially that Renoir painted it with incredible speed, entirely on the spot. In fact, it is clear that he worked hard over elaborating the composition, which was much more complex than anything he had attempted before, went to some trouble to assemble the models from among his bohemian (mostly painter) friends, and produced studies and alternative versions, while Renoir told Vollard that he was urged on to do the painting by a painter friend, Franc-Lamy, who had found in Renoir's studio a sketch of the Moulin de la Galette he had done from memory, and who figures among those depicted in the painting itself.

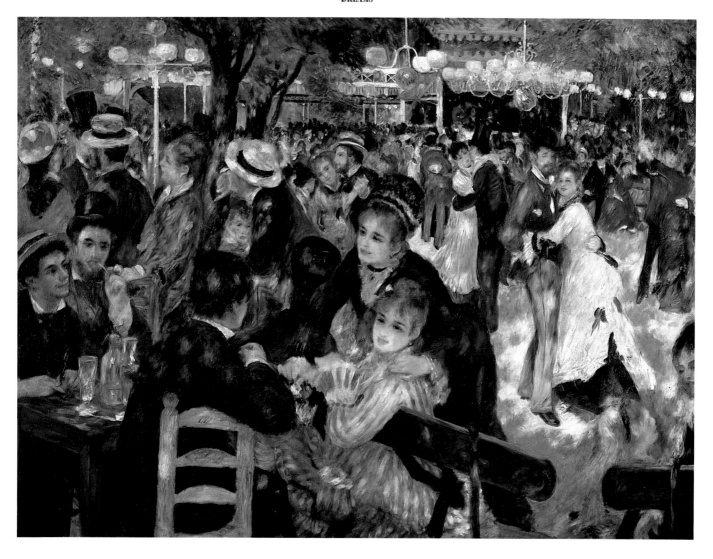

PIERRE-AUGUSTE RENOIR
Bal au Moulin de la Galette, 1876
Most famous of all Renoir's large set-pieces, this panorama of bohemians at play was probably not painted
on the spot, but from sketches made there. A smaller replica brought a record price for a Renoir in 1990.

The painting has sometimes been compared with Manet's *Musique aux Tuileries,* which is also an open-air panorama crowded with figures. But Renoir's painting lacks entirely the theatrical quality of the Manet, suggesting that everyone in the picture is playing a role in a stage setting seen head-on. Renoir's composition is at once more intricate in fact and more informal in effect, with its strong diagonal setting the people sitting at tables on the right apart from those dancing in the middle distance to the left, and its cutting-off of figures and objects at the edges to suggest that this is merely a slice of life which goes on out of sight to either side. The impression that the Renoir gives, despite its hidden geometry, is of a liberated, classless society which no longer has to play a role, as do Manet's *haute bourgeoisie,* but can simply relax and enjoy itself: the perfect model of the carefree bohemian life painters are supposed to lead.

A very similar effect is created by Renoir's other famous evocation of bohemian life, a sort of companion-piece to the first, *Le Déjeuner des Canotiers,* which he painted mostly in 1880. Again, the composition is complex yet informal-seeming, with a strong diagonal emphasis, and again the models are drawn from among Renoir's bohemian friends. The place represented is one which Renoir often visited and painted, the terrace of the Restaurant Fournaise, on an island in the Seine at Chatou, and the lunch is one such as the enthusiastic oarsman of Renoir's and Caillebotte's circle often took part in. The year before Renoir painted his picture the journalist Gustave Goerschy described a very similar scene in *La Vie Moderne:*

The meal is tumultuous; the glasses are filled and emptied with dizzying speed; the conversation goes to and fro, interrupted by the clatter of knives and forks which perform a terrible dance on the plates. Already a rowdy, heated intoxication rises from the tables, all filled with the debris of the meal, on which the bottles quiver and shake.

113

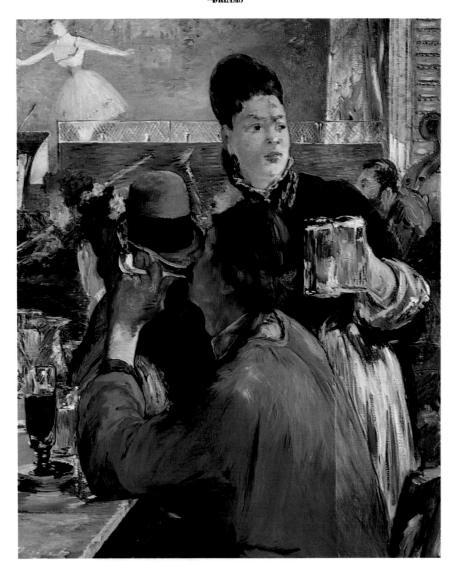

EDOUARD MANET
Coin de Café-Concert, 1879
Most ambitous of a series of pictures Manet painted towards the end of his life
of drinkers, entertainers and barmaids in the popular café-concerts of Paris.

No doubt even for artists, even for Impressionists, life was not always so riotous and carefree. But if Renoir was indeed, as has been supposed, elaborating his compositon partially in response to Zola's call, in his review of the 1880 Salon, for Impressionists to paint detailed, considered studies of modern life, he succeeded brilliantly in producing an image which retained the correct Impressionist detachment from implied story-telling and at the same time created an unforgettable impression of a summer's day, a good time, and a temporary escape from the cares and pressures of a structured everyday society.

This lack of apparent structure played an important part in the attractions of bohemia and the demi-monde, the world of the café-concert, the bar and popular restaurant, of art school, the theatre, and especially the behind-the-scenes society of show and sporting people. In such company, most of the conventional society distinctions were for the moment minimized or annihilated: the aristocrat and the rich bourgeois could take a holiday from their respectable responsibilities, the aspiring working class could find there a way onwards and upwards, the ruined and dissolute, on their way down, could find a refuge and a kind of anonymity, and those, like artists, who did not have any clearly defined place in the social structure could live there happily until external forces pushed them either upward or downward. During the heyday of Impressionism, this was the case with most of the artists in the group, at any rate while they were living in Paris, and it is not surprising that this world of flux, of the indeterminate, so appropriate to the styles of painting, does often and vividly appear in their work.

Ultimately the special department occupied by the ballet and its dancers became the personal preserve of Degas: though other painters might from time to time be taken with the glitter of the opera and ballet audience, he was the only one who felt driven exhaustively to explore what went on backstage, and the

114

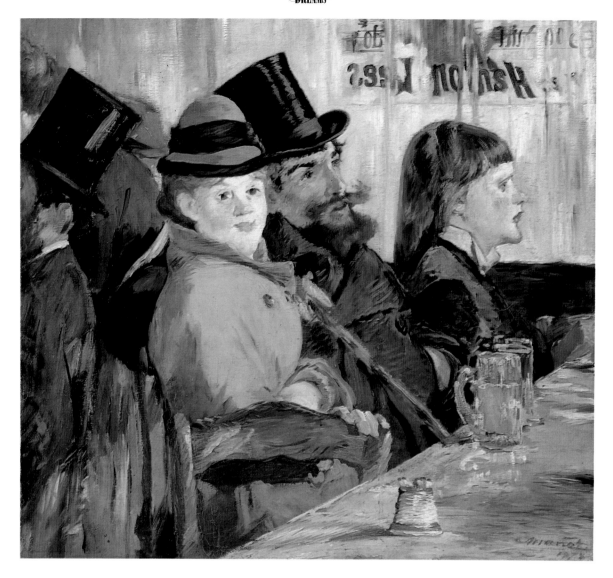

EDOUARD MANET
In the Café, 1878
A simpler bar scene, though still featuring the dissociation between the principal characters,
the swells, the working men and their girls, which sets the tone of the series.

whole professional life of the dancer (female, that is). The life of the café-concert, the dance hall and the bar was much more accessible to anyone who did not lead the life of a hermit. In the later 1860s the Café Guerbois was a regular and important rendezvous for the young Impressionists to meet and drink and argue about art. After the interruption of the Franco-Prussian war they tended to be more geographically scattered, but to an extent the Café de la Nouvelle Athènes in the Place Pigalle took the place of the Café Guerbois. All the same, it is evident that, whatever their personal participation in café society, most of the Impressionists did not find much artistic inspiration there: the most assiduous recorders of this scene were Renoir, by birth and upbringing a natural member of bohemia, and Degas and Manet, on the other side, grand enough to be comfortable slumming there.

Slumming was in many senses the operative word. It was another sort of nostalgia to assume that the café-concert, with

its working-class performers and coarse, direct songs and humour, was still a basic, no-frills kind of working-class entertainment. In fact, even more than its slightly later English equivalent the music-hall, the café-concert was patronized in the Third Republic largely by 'tourists': aristocrats with a touch of *nostalgie de la boue,* and, even more, respectable middle-class men and women (much the same as those who now patronize the drag cabarets of West Berlin) who went with a slight, conscious sense of daring for a hint of (by this time minimal) danger. What more natural than that the most acute observers of all this should be Degas and Manet, and a generation later an actual aristocrat, briefly touched by Impressionism, Henri de Toulouse-Lautrec?

Perhaps the more socially secure you are, the more comfortable you are slumming. Certainly Lautrec seems to have had no difficulty, nor, apparently, did Degas. In Manet one always senses a touch of reserve, as of an outside observer, though this

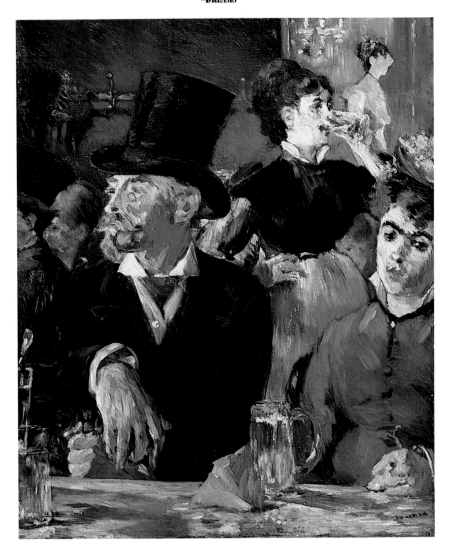

EDOUARD MANET
Café-Concert, 1878
The gentlemen looks one way, the girl wistfully another, the barmaid
has a quick drink and somewhere the entertainment goes on.

no doubt had more to do with his personality than his social standing. It is curious that in any case all of Manet's café paintings and drawings seem to date from the last four years of his life, 1877-1882, reaching their climax in his last major painting, *Un Bar aux Folies-Bergère,* exhibited in the Salon of 1882. It is recorded that in the autumn of 1881 Manet, already ailing and seeking to counter rumours of his artistic decline, was particularly active socially in Paris, visiting friends, eating out and spending time in bars, but if the evidence of his sketches is anything to go by, he had been sitting drawing in bars for the previous three or four years. Clearly what interested him was the outsider's role of unobtrusive observer and recorder. The bars and their clientele were a source of information which might be used other than directly: very much as the novelist may keep his ears open in the pub for snatches of dialogue. (Henry Green said that he had to give up writing novels when he became too deaf to overhear conversations in pubs.)

It seems certain, in any case, that Manet conceived his paintings with a café setting as a series, begun with his Zolaesque picture of the courtesan *Nana* (of which more anon), which would depict striking characters and types of the Third Republic. For the purpose of these paintings he equipped his studio with a typical bar table of cast iron with a white marble top; and naturally, whatever thumbnail sketches he might make on the spot, all the pa.inings, consonant with Manet's usual practice, were constructed in the studio. The table first makes its appearance in *La Prune* (1878), which depicts a rather melancholy young woman, sitting alone with a *prune a l'eau de vie* in front of her and holding an unlit cigarette. She is clearly not exactly a prostitute, but would no doubt welcome an approach from a strange man; the picture is elusive and not easy to interpret. The table is there again in *Café-concert,* painted about the same time. At it sit two separate (very separate) figures, a rather slatternly young woman, smoking a cigarette, with a beer in

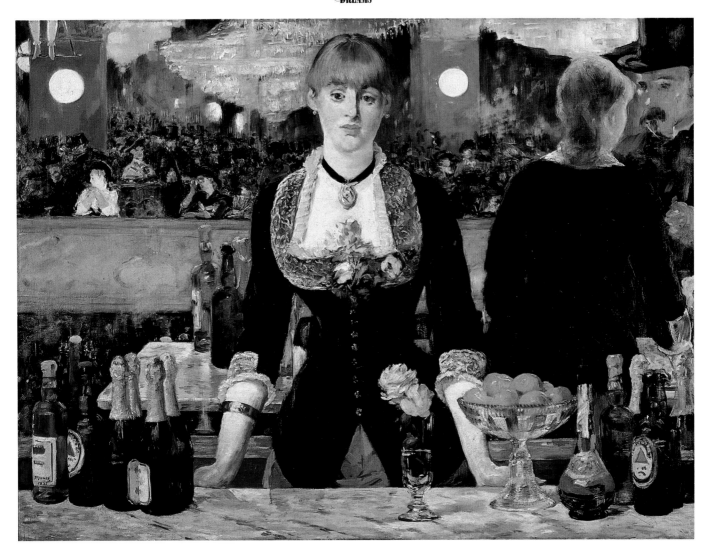

EDOUARD MANET
Un Bar aux Folies-Begère, 1882-3
Manet's last great work, and one of the most famous of all Impressionist paintings. The scene is evidently
constructed in a studio: note that the "bar" is in fact merely a table, as one can see in the reflection.

front of her, and a distinguished-looking middle-aged man in a top hat looking in the opposite direction. Between them and behind, a waitress looking in a third direction downs a glass of beer, while to the right we partially glimpse two working-class-looking people, and in the far back we can see the singer, ignored apparently by everyone, since no one is looking at her, whether she is in fact in front of us on stage, or really behind us, reflected in a mirror.

The table recurs also in *Coin de Café-concert,* where the man with the pipe in the foreground leans on it, ignoring the wait ress serving him with a beer but perhaps vaguely following the performance going on in the background; unobtrusively in *Liseuse,* where a grand-looking woman reads a newspaper, ignoring her surroundings and the coffee-pot (by the look of it) on the table beside her; in the portrait-drawing *George Moore au Café;* and finally, triumphantly, in *Un Bar aux Folies-Bergère,* which is clearly not really a bar at all, let alone at the Folies-

Bergère, but a studio composition in which the barmaid leans on the table pretending to be a bar, with bottles, fruit and flowers in a glass artistically arranged on it. (Apart from its being improbably low, the 'bar' is revealed as a table in the reflection behind the figure.) If all these images from three or four years have anything in common, it is surely an indication of the very opposite of the usual convivial, social connotations of the bar or café-concert: these are places in a city of strangers, where people drink alone or, even in a crowd, fail to connect in any way. Whether we find any sort of autobiographical significance in it, the melancholy is unmistakably there.

Degas has a very different approach in his depictions of similar scenes. Though in many respects he was eccentric, misanthropic (rather, perhaps, than misogynistic, which he is frequently blamed for being) and solitary, he seems to find and imaginatively participate in evidence of companionship and communal experience in the places he chooses to paint. Also,

117

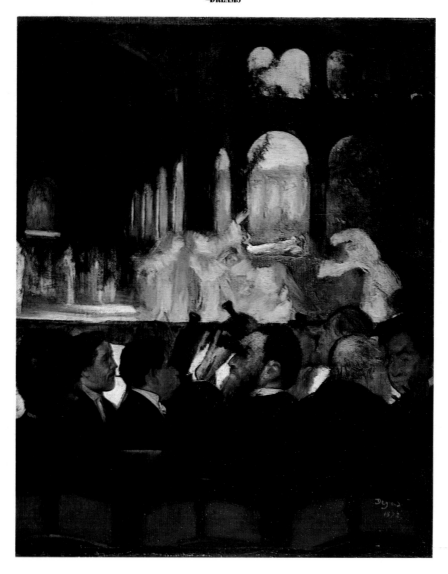

EDGAR DEGAS
The Ballet from Robert le Diable, *1872*
*The earlier of two significantly different versions Degas painted of the same subject, brilliantly
distributing its subject on three levels: the stage, the musicians and the audience.*

he is clearly interested in the performers, both as personalities and for what they do, in a way that Manet apparently is not. The orchestra pit, for instance, is sketchily present in Manet's *Coin de Café-concert,* but Degas is the only one who pays close attention to it. Perhaps because he had many friends among orchestral musicians, he painted a whole series of pictures which insist on the intimate yet separate relationship of the orchestra and those on stage in the limelight. Sometimes, as in *Café-concert* and *Aux Ambassadeurs,* both of c. 1877, the scene is one of popular entertainment, but it may also be the opera, as in the two versions of *Ballet de Robert le Diable* (1872 and 1876), or the ballet, as in the very similar *L'Orchestre de l'Opéra* and *Musiciens à l'Orchestre* (both c. 1870). All the pictures concerned witness to Degas's consuming human interest, probing often into areas that other painters do not reach, as well as his appreciation of work shared and the symbiotic relationship of performers on stage, performers in

the pit and the audience out there appreciating and in a sense participating in it all.

For all his personal aloofness and alleged cynicism, Degas was one of these participants, able to observe with fuller sympathy because he did not have to withdraw himself completely in order to do so. (Nonetheless he remains happily capable of the irony which places centre foreground in the first version of *Robert le Diable* a solitary spectator who is not looking towards the stage at all, but instead has his opera-glasses trained on the first tier of the boxes: it is a joke bred of sympathy and familiarity.) The same with his views of bars. If, as in *Dans un Café,* better known as *L'Absinthe* (1875-76), he shows a man and a woman at the same table but psychologically completely apart, he is making a specific point about the oddity of this, rather than implying, as Manet seems to, that it reflects a general truth. Much more usual is the atmosphere of *Femmes à la Terrasse d'un Café, le Soir* (1877), where the two pairs of women

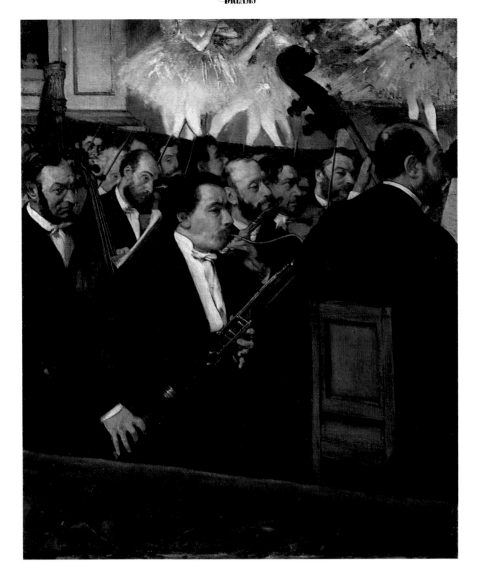

EDGAR DEGAS
L'Orchestre de l'Opéra, c. 1870
Evidently related to "The Ballet from Robert le Diable" (opposite), this concentrates on the musicians, many
of whom were friends of Degas; the face in the box is Emmanuel Chabrier, the composer.

clearly have easy reciprocal relations, or even of *Femme dans un Café* of about the same date, where a very self-possessed woman happily plays patience while waiting (confidently) for something better to turn up. At the cafés-concerts the performers really impose themselves and are taken note of by a reacting audience of more than just the painter – for who can doubt the power of the singer in *La Chanson du Chien* (1876-77) or even more, the extraordinary apparition of *Le Gant* (c. 1878) with the singer at full throttle and the glove itself, black and halfway to the elbow, clothing a hand and wrist held straight up in a strikingly dramatic gesture?

Even the theatregoers in Degas's views of audiences and stage-door Johnnies are thoroughly chatty and out-going. Some such scenes, such as *Ludovic Halévy trouve Madame Cardinal dans une Loge* and *Pauline et Virginie Cardinal bavardent avec des Admirateurs* (1876-77) were actually conceived as illustrations to Degas's friend Halévy's series of humorous sketches *La*

Famille Cardinal, Pauline and Virginie being the two dancing daughters. But in other places Degas also indicates, on his own behalf as it were, that social intercourse is the name of the game. Also, it would seem, as far as his own relations with the ballet girls he painted and drew obsessively from the early 1870s to the end of the century, the only game in town. There has been much argument and speculation over Degas's sex life in general and his relations with the ballet girls in particular. But it seems that, however far he may have been a participant rather than merely a spectator in his brothel scenes, his relations with the dancers were of remarkable propriety. Frequently he got them to pose in his home, but seldom or never in his studio, where impropriety of some sort might be most likely to take place; rather, he would sketch them from life in the drawing-room or have them photographed, then retire upstairs to his studio to construct his paintings out of these basic elements.

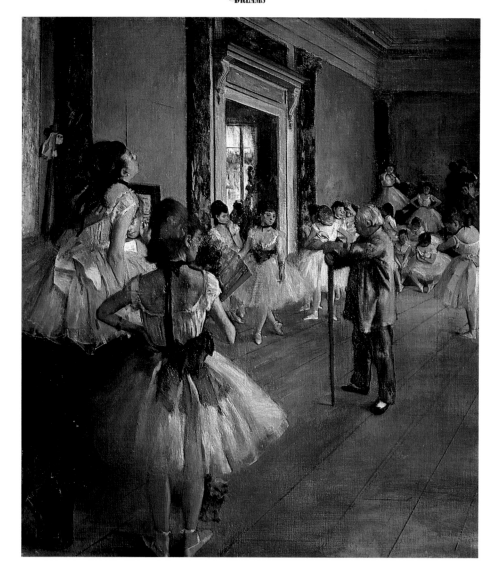

EDGAR DEGAS
La Classe de Danse, 1873-6
One of the most ambitious of Degas's ballet compositions, this was the subject of several
variations. The figure of the dancing-master represents the famous choreographer Jules Perrot.

Not that it matters very much. It is perfectly evident from the works that Degas was interested in the dancers as characters, as part of the theatrical ambiance, and as machines, rather than as *poules* ripe for the plucking. It is true – and surely significant – that never in his art (with the arguable exception of seven drawings of harlequins perhaps from a ballet) do we see a man dancing, and only once or twice, most notably in the various versions of *La Classe de Danse/L'Examin de Danse*, which feature the old ballet master Jules Perrot, do we even see a man directing female dancers. But whatever faint erotic element there may be, it always remains subservient to the mechanics of the dance itself, and the depiction of the dancer as professional. There is an almost infinite variety to be found in the poses and tableaux of the ballet, as well as in the activities of the rehearsal room, and though Degas often uses his individual notations of dancers and poses like counters in some elaborate game, moving them around from composition to com-position, he astonishingly avoids monotony, always coming up with some fresh insight or effect. As late as 1899 he found a new subject, or a variation on an old one, in the shape of a group of Russian dancers in folk costume (female, naturally) that he must have seen somewhere in Paris, and which provides him at least with the material for 'orgies of colour'. And even when – or so he maintained – his eyesight was becoming too poor for him to paint any more he took up modelling dancers instead.

But all this attains a sort of abstraction which takes us far from the bohemian world in which we (and Degas) started. Far even from the Cirque Fernando in which Mlle La La so vertiginously hangs by her teeth in Degas's painting of 1879. But despite his personal fascination – he went to see the lady perform at least four times in January of that year – he turns her feat into a highly schematic composition of complementary colours which makes us forget all about the audience below

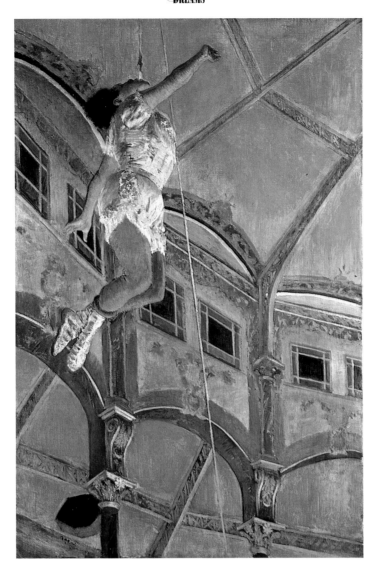

EDGAR DEGAS
Lala at the Cirque Fernando, 1879
Miss Lala was an aerialist who caught Degas's fancy in 1879, when he made an
extraordinary number of consecutive visits to the circus.

and the sights, sounds and smells of the circus. In the late 1880s and early 1890s Seurat, of all people, reverted to the circus and its side shows, the theatre and the café-concert. Curiously, because the challenge for him was to render scenes of sometimes extreme animation – the high-kicking dancers in *Le Chahut* and the intrepid equestrienne and somersaulting clowns in *Le Cirque* – in terms of his finicking Pointilliste style, which was more naturally suited to the breathless immobility of a Sunday at the Grande-Jette. To capture the can-can and the circus in all their squalid glory we need to turn rather to Tou-louse-Lautrec. And in doing so, to abandon Impressionism completely.

121

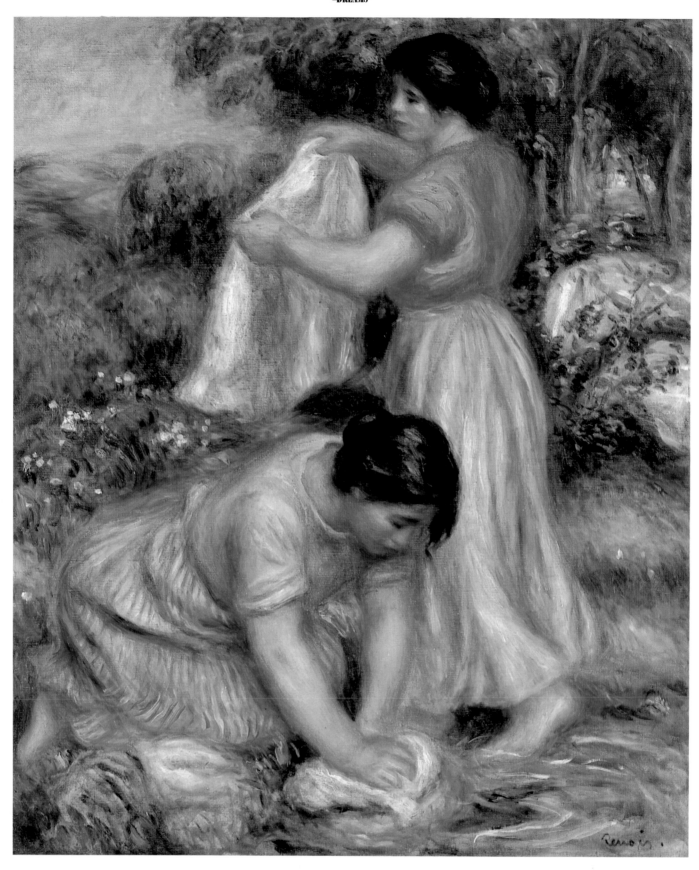

PIERRE-AUGUSTE RENOIR
Washerwomen, 1912
The subject of women washing and bathing was one which haunted Renoir. This
is one of his more broadly executed later reversions to it.

9

A WOMAN'S WORLD

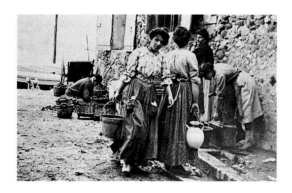

Seaside washerwomen, around 1900: nearer the rough images of Degas than the fantasies of Renoir.

MOSTLY, WHEN DISCUSSING THE ROLE OF women, women's work and the sphere of activity which has traditionally been regarded as a feminine preserve in painting, we have to accept from the start that we are dealing exclusively with masculine views, because almost all the painters concerned have been men. Impressionism, for the first time in the history of art movements, changes all that, for two of the major figures, Berthe Morisot and Mary Cassatt, were themselves women, and there were several women painters also among the Impressionists' constellation of minor figures, followers and hangers-on such as Eva Gonzalez, whom Manet, it will be remembered depicted at her easel. In principle, at least, this should offer a valuable alternative perspective: we can see whether the women painters implicitly accepted traditional readings of their special sphere of interests, and also, if there is a clear distinction between the attitudes embodied in the men's paintings of such subjects and those in the women's.

The world of women in the arts, it hardly needs saying, was generally felt to encompass hearth and home, children, the domestic activities, the gentler emotions of life, and those parts of the public sector which were, almost by definition, the exclusive preserve of women: the hat shop, the kitchen and so on. Huysmans observed (in connection, oddly enough, with the in-

tellectual, unmarried, childless Mary Cassatt) that 'Woman alone is capable of painting childhood . . . only the woman can pose the child, dress it, pin it without pricking it.' Feminism has been oddly ambiguous about all of this, feminist critics dividing between those who reject these as male-devised limitations, and those who embrace them as indicating the true, special nature of women. It is dubious whether either Morisot or Cassatt was even a proto-feminist: to an extent they did not have to be because, initially, they were financially independent enough to escape the first straitjacket imposed on women in a male-dominated world, that of financial dependence. They did not have in any obvious way to fight to do what they wanted to do: they just went ahead and did it.

Given that this was so, it is no doubt significant to observe that both of them confined themselves almost exclusively to what convention indicated was woman's natural sphere. To establish that this did not necessarily have to be so, even then, for the woman painter, we can look to England, where Lady Butler (née Elizabeth Thompson) had already by the mid-1870s established her particular corner in gigantic images of battle; or indeed no further than the Forest of Fontainebleau, where, since her tremendous triumph with *The Horse Fair* in 1853, Rosa Bonheur had been happily and profitably painting away at her equally gigantic and 'unfeminine' canvases of horses and even, after an exciting encounter with Buffalo Bill, the wilder

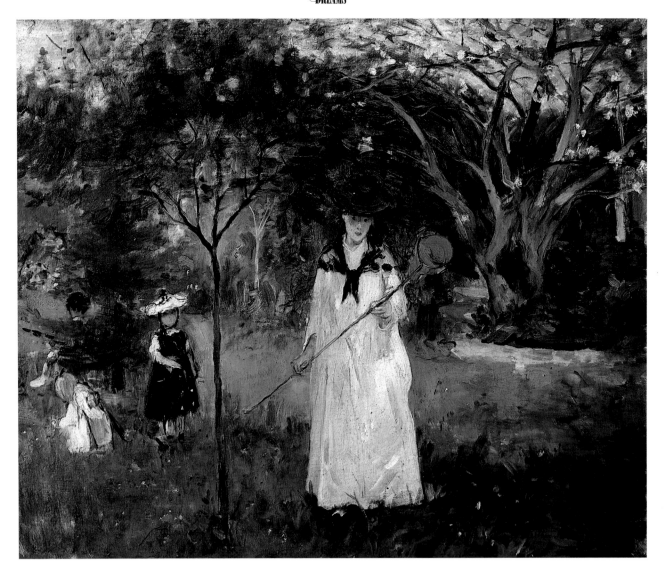

BERTHE MORISOT
The Butterfly Hunt, 1874
One of Morisot's idyllic scenes of mothers and children, out together in a
delicately rendered countryside with little sign of modern life impinging.

side of the West. (Neither of this artists, incidentally, does very well in feminist art history, probably because they are felt to have been playing the masculine game.) In the light of these two remarkable female success stories, however, it is evident that Morisot's and Cassatt's choice of subject matter was indeed choice in the full meaning of the term.

To look at it from the opposite point of view, we might wonder whether the selection of this kind of subject matter was specific to the women artists of the group. To make sense of any answers we might come up with, it is necessary to look first at what is known of the principal male Impressionists' attitudes to women, home and the family. Though they began adulthood as art students, with all the aura of slightly disreputable bohemianism then clinging to that status, particularly in Paris, where the era of *La Bohème* was fresh in the memory, there is remarkably little of sexual passion, sexual turmoil or even sex itself in most of their work.

One can easily accept that such Manet paintings as *Olympia* and *Le Déjeuner sur l'Herbe*, with their brusque mixture of nudity (female) and dress, were considered daring at the time because they flew in the face of certain conventions, social as well as artistic. But that is not the same as finding much genuine sensuality or sexuality in them. Curiously, the major exception among the Impressionists to this view is the young Cézanne, whose painting, up to about 1872, was thickly strewn with evidences of sexual conflict, carrying it almost to the verge of expressionism. There is certainly more real sexuality in Cézanne's curious footnote to Manet, *A Modern Olympia*, than in the relatively staid original. But then, after the first Impressionist show in 1874 he turned increasingly to the exploration of pictorial geometry, and in his later large *Baigneuses* the figures of the female bathers seem hardly different in the degree or quality of their sensuality from his endless views of Mont Ste-Victoire.

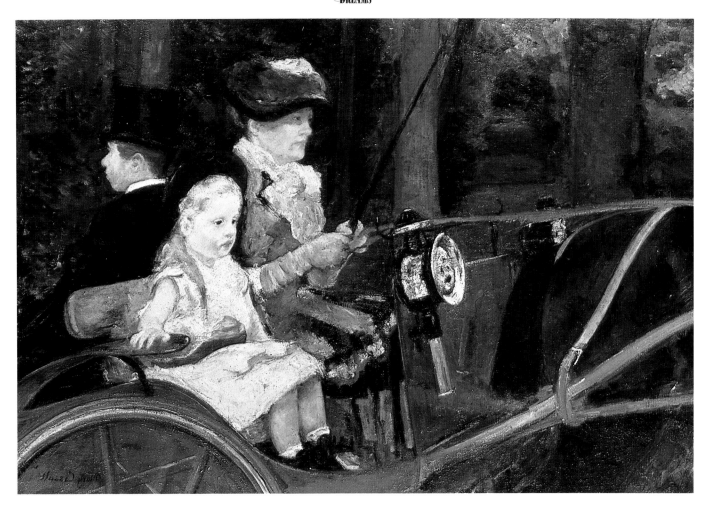

MARY CASSATT
Mother and Child Driving, c. 1879
The vast majority of Cassatt's paintings were figure compositions in interiors, but
here she depicts her sister out with Degas's niece, probably in the Bois de Boulogne.

Elsewhere among the Impressionists, even when young, their attitude to women seems hardly an issue. They mostly married respectably (if a trifle belatedly), had large families and became, willy-nilly, patriarchs. If Renoir seems to have retained an edge to his sexuality longer than the rest, and still in his old age was capable of seeing busty girls from the fields with a sensuously appreciative eye, that did not mean that he was any less an avid observer of the home scene and painter of his own household.

Perhaps more, indeed, for you seldom find Monet, for instance, showing much family or domestic interest in his painting: everything in its place, and art and that side of life for him just did not mix. Even Pissarro, *pater familias* and father and grandfather of painters, seldom turned his painter's eye on a domestic interior, though when what his family did (gathering fruit and such) bordered more nearly on the life of the fields, he was perfectly willing to paint or draw it.

It is ironic that the most exhaustive obsession with women, their ways and their world among the major Impressionists should occur in Degas, lifelong bachelor and reputed misogynist. It is Degas who is fascinated by the spectacle of women in their own domain (witness the frequent paintings of hat-shops), women doing the sorts of menial work which were most often their lot (such as ironing in a laundry), and women in their most intimate moments, washing, bathing, combing their hair. We know that many of the latter scenes were observed in brothels, which might support the male-chauvinist view of his observations. On the other hand we have registered that even his obsessive interest in ballet-girls was seemingly in no way directly sexual, any more than his passion for painting and drawing horses had anything to do with the exterior activities of his life, in which he never rode and never bet.

And if we ignore the circumstances, and how much or how little we know about the lives of the artists concerned, can we

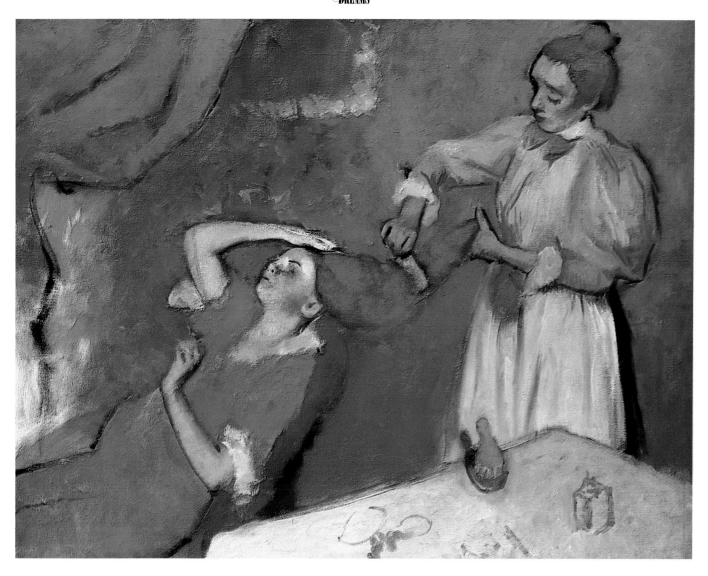

EDGAR DEGAS
Maid Combing a Woman's Hair c. 1898
Among Degas' later paintings this carries his progressive simplification of style to extremes, both in the
sketchiness of the draughtsmanship and in the bold reduction of the colour range.

really see any vital difference between, say, one of Degas's classic images of women arranging their hair and Cassatt's 1886 *Girl Arranging Her Hair*? It must be significant that Cassatt painted this picture in response to a sort of challenge from Degas, who maintained that women could not judge style. Consequently this picture can be reasonably seen as an attempt to meet Degas on his own ground – evidently a successful attempt, since Degas admired it enormously when it was shown at the last Impressionist exhibition and acquired it in exchange for a nude of his own, keeping it until his death. But the fact remains that, even without this history, the subject would be regarded as a very reasonable, indeed a central, woman's subject, one which a woman painter like Cassatt would have had no need of male stimulus to tackle. It would even be pushing things to suggest that her perception of the awkwardness and vulnerability of this girl who is not yet quite a woman is male-inspired. Though once its presence is admit-

ted, it must surely be admitted also that Degas's comparable paintings often have this same delicacy and awareness, even if they had their origin in the brothel. It is a human observation, rather than a sexual, much less a sexist.

Degas can in fact offer an enormous repertoire of similar observations, of women alone or women among themselves. And there is precious little indication in his work of misogyny, whether or not his reputation in life was justified. On the contrary, he seems to be fascinated by women as people, and by what, if anything, sets them apart from men. It is perhaps a more understandable corollary of his unmarried state that he shows little interest in domesticity and family life: when he paints children, for instance, as in the case of his portrait of Hortense Valpinçon (1871) or in such subject pictures as *Cour d'une Maison (Nouvelle-Orléans)* of 1872 or *Children and Ponies in a Park* of 1867, it seems to be usually because they were relatives or the children of friends and acquaintances, rather

126

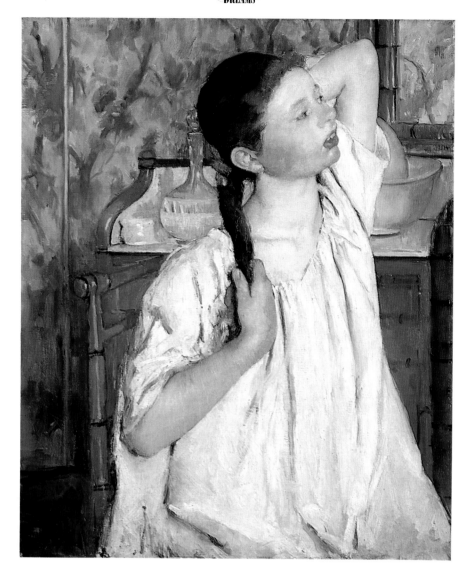

MARY CASSATT
Girl Arranging her Hair, 1886
Much more reminiscent of a characteristic Degas hair-combing scene, this was apparently painted
after a challenge by Degas, who subsequently acquired the painting in exchange for one of his own.

than because he took any interest in children for themselves.

However, we do not know, either, that Morisot or Cassatt was particularly interested in children for themselves. Perhaps, rather, they were a subject readily to hand, and one subject was as good as another. Morisot indeed married Manet's brother Eugène in 1874, and bore him a daughter, Julie; Cassatt, on the other hand, never married, and the children in her paintings and prints are as a rule the children of friends or relatives, notably those of her brother Alexander, whose family visit to Paris in 1880 inspired a number of memorable works. And if Cassatt managed to be a close but platonic friend of Degas for many years, it probably had something to do with her 'unfeminine' independence and intelligence: it must mean something that when Degas depicts her in his work, it is doing something not, it is true, obtrusively unfeminine, but from the gender point of view noncommittal: i.e., visiting the Louvre and looking at pictures or antiquities.

Manet quite frequently used his friend and eventual sister-in-law Berthe Morisot in his paintings, though as a rule (in *Le Balcon*, for example) in the sort of neutral way he might have used any model, as a presence rather than playing a role or observed at some activity from her own everyday life. In her own right as a painter Morisot sometimes produced 'pure' landscapes, often of the edges of Paris or by the sea, but most of her most typical work concerns women and children, hearth and home. First it was the children of her friends and their mothers, but soon after the birth of her daughter Julie in 1878 her own family understandably became her principal preoccupation. Technically her work has often been compared with Manet's – again understandably, given their closeness, but even before Manet's death she was finding her way towards a more independent and superficially more 'Impressionist' style, especially in her pastels and watercolours, which became more and more broken up into indicative dabs of colour. This made her

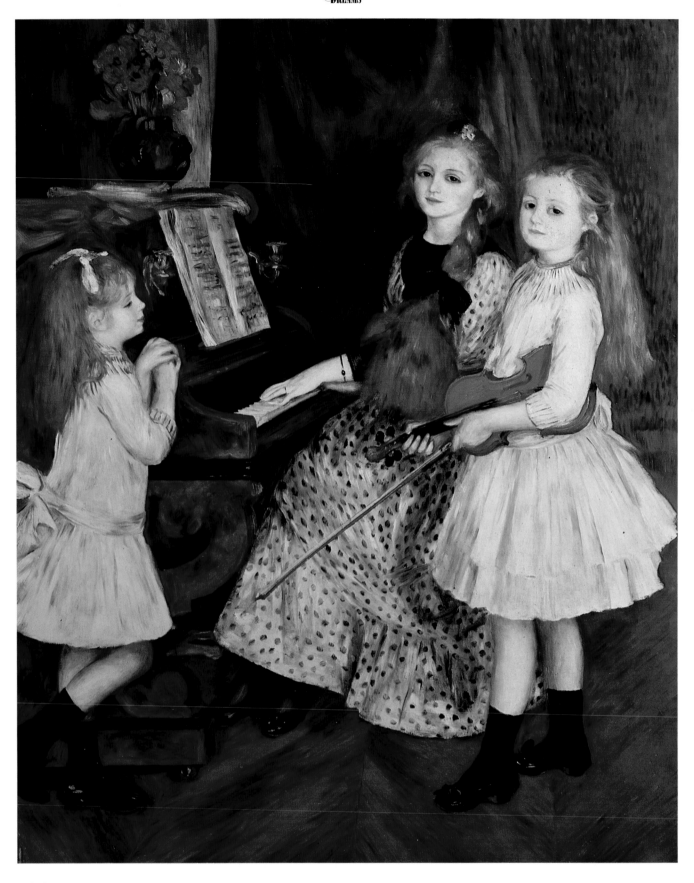

PIERRE-AUGUSTE RENOIR
The Daughters of Catulle Mendès at the Piano, 1888
Another obsessive image for Renoir was that of girls making music, playing or
round the piano. Here the theme makes a good excuse for a sort of family portrait.

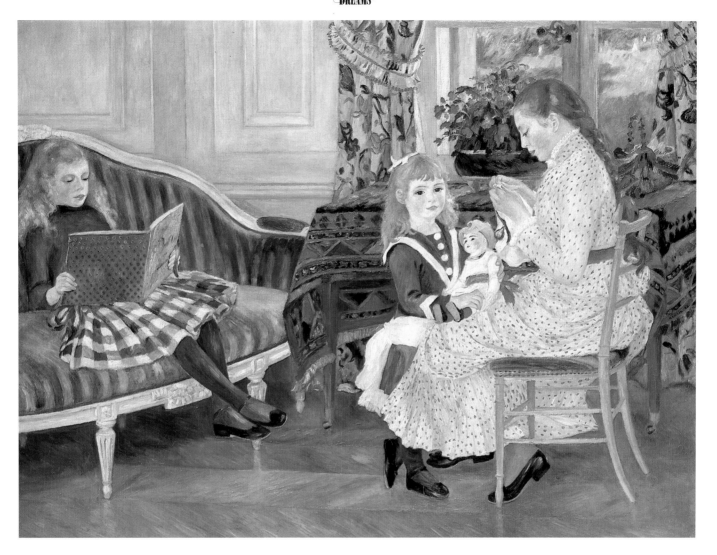

PIERRE-AUGUSTE RENOIR
L'Après-midi des Enfants a Wargemont, 1884
The idea of painting the three daughters of his patron Paul Berard at leisure in the North Coast
country house gives rise to an uncharacteristically cool-toned, hard-edged image.

style seem more feathery, delicate and therefore, Rosa Bonheur notwithstanding, 'feminine'.

It is perhaps mainly on shaky and arguable criteria such as these that her work has been adjudged feminine – though no one seems to label, say, Vuillard, who often employed the same sort of style on the same sort of domestic subject, as feminine, let alone Renoir, some of whose work also superficially resembles Morisot. It is certainly true, though, if we pursue the comparison with Renoir, that Morisot's women are more individualized and less wilfully voluptuous than Renoir's. But Renoir in any case throughout most of his later career deals in stereotypes: virtually all his women and children have the same features (which, in the case of his own children, we know from photographs that, alarmingly, they did) and it seems to be a personal limitation rather than a by-product of male chauvinism. In any case, after the early 1890s it becomes more and more difficult to see Renoir's endless procession of piggy chil-

dren and great blubbery nudes in terms of anything but kitsch, a failure of taste rather than of vision. He seems to have been unable or unwilling to follow up the possibilities inherent in such colder, crisper paintings of the early 1880s as the touching portrait of Charles and George Durand-Ruel, the teenage sons of Renoir's dealer, and his luminous and clear-cut *L'Après-midi des Enfants à Wargemont*, a picture of the three daughters of his patron Paul Bérard respectively sewing, reading, and playing with a doll, according to descending order of age, from fourteen to four.

If we are looking for something which might be regarded as feminine in style, provided we knew nothing of its origin, this last painting could be it. With its strongly graphic style and virtual elimination of chiaroscuro, it is not so distant in style from the colour prints Mary Cassatt was making after 1890. At a further remove of time and place, we may be reminded of the Swede Carl Larsson's picture-books of his own house and chil-

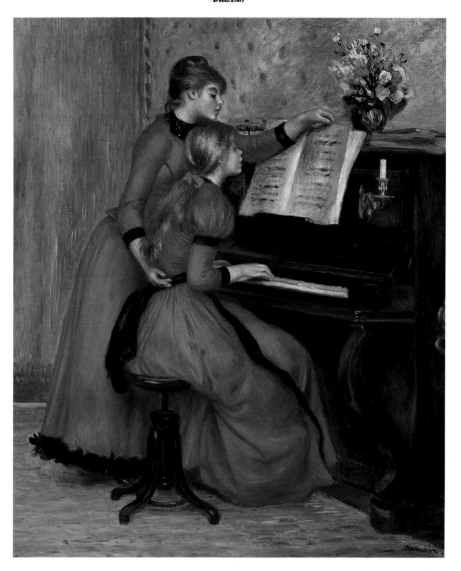

PIERRE-AUGUSTE RENOIR
The Piano Lesson, c. 1889
A relatively early version of the girls-at-the-piano theme so favoured by Renoir,
prefiguring the crucial work commissioned by the French State in 1892.

dren. Renoir's many paintings of women, girls and children during the 1890s, either in interiors or in an idealized, soapy countryside, are mostly devised to look like glimpses of his own home life. But though some of them are undoubtedly just that, like the *Déjeuner à Berneval*, which shows two of his children and the maid/companion/nanny Gabrielle all crammed uncomfortably into a holiday chalet near Dieppe, many of them are, rather, fancy compositions which mix his children with professional models and friends according to some preconceived programme.

At least Morisot's domestic scenes seem to have a little more reality, and a touch of that asperity which is another aspect of Impressionist detachment. Whether it is the *Le Berceau* of 1872, a remarkably clean, unsentimental picture of a mother looking at her sleeping child, or one of the deceptively casual glimpses of household chores being done, like *La Salle à Manger* (1880), or one of the later pictures of a now teenage Julie sitting fond-

ling a greyhound (1893) or playing the violin (1894), the effect is created with a certain justness of tone, a lack of excessive emotion, which perhaps one is not too far off the mark in regarding as truly feminine – as of one who is in daily touch with the realities they record, rather than seeing them as most men would, if at all, through the rose-tinted spectacles of indulgent distance.

Something of the same quality of feeling (or lack of it) can be sensed in Mary Cassatt's technically very different *Une Tasse de Thé* of 1880, where there is a teasing but clearly non-narrative ambiguity in the situation of the two women taking tea from a silver tea-set in a richly furnished room; some of Degas's pictures of his men friends, such as *Jeantaud, Linet and Laine* of 1871, work on one in the same sort of way. But then so do some of his domestic pictures of women, such as the picture of his aunt and cousins, apparently in mourning, *La Duchesse de Montejasi et ses Filles Elena et Camilla*, where a balance, or rather a

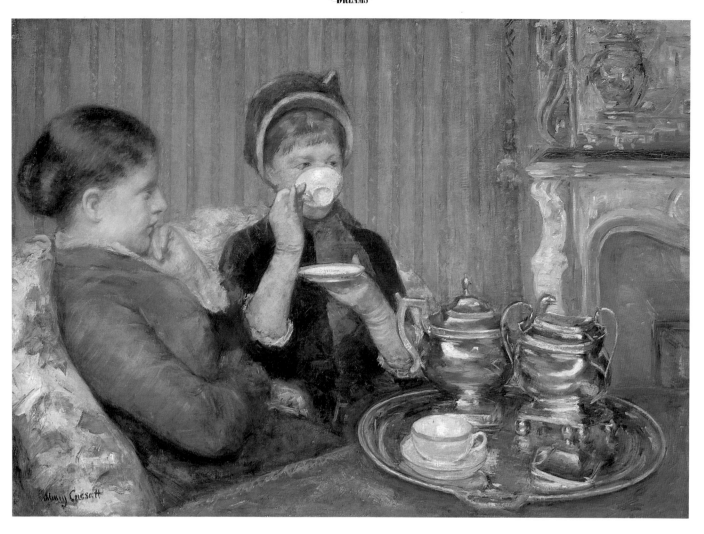

MARY CASSATT
Five O'Clock Tea, 1880
Verging on the genre picture, this mature Cassatt sets the viewer wondering
what the "story" may be, as very few Impressionist works do.

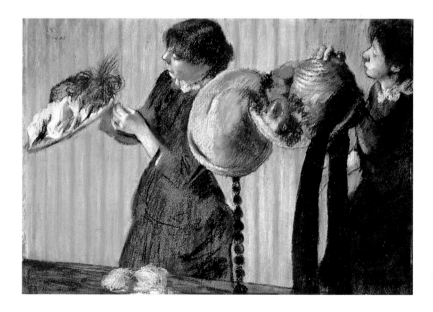

EDGAR DEGAS
The Milliners, 1882
One of Degas's more abstract
studies of life at the Milliner's,
this seems to be most
interested in the rhythm set up
between the two human figures
and the three hats.

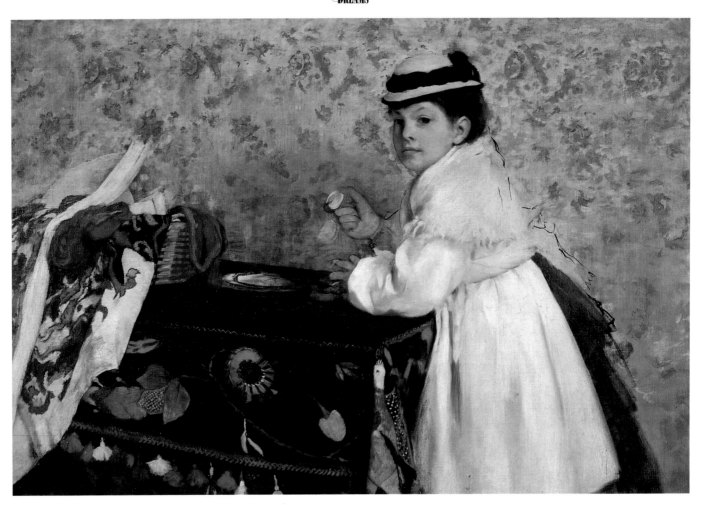

EDGAR DEGAS
Hortense Valpinçon, 1871
A daring off-centre composition (one of Degas's most "Japanese") and the wide expanse of figured golden wallpaper,
together with the acuteness of the child portraiture, puts this among Degas's most challenging works.

hierarchy, of power is subtly suggested by the poses and spacial relations of the figures.

Degas, indeed, is in general such a crisp, incisive, sympathetic but unromantic portrayer of women that, from internal evidence, he might be a woman himself. Though he seems from time to time to take an interest, out of his boundless curiosity, in the details of domestic management, he has perhaps not enough easy first-hand knowledge to support that assertion. But portraits like *Madame Jeantaud* [wife of a friend] *devant un Miroir* (c. 1875), or *Victoria Dubourg* (1865-69), wearing a plain brown frock and sitting forward alertly in a plain wooden dining-room chair, or the amazing, off-centre *Femme accoudée près d'une Vase de Fleurs* (1865), where the unknown woman, dressed for outdoors, seems to be caught waiting in a hallway, have the clear advantage of dealing with their subjects as people rather than in some stereotypical way as women. And Degas brings a similar skill and sharp observation to the paint-

ing of children, either alone like the cool-eyed *Hortense Valpinçon*, aged about nine (1871), or with a parent, as in *Henri Rouart et sa fille Hélène* (c. 1877) and *Henri Degas et sa nièce Lucie Degas* (1876). His paintings of scenes in hat-shops – women trying on hats, milliners trimming hats – which seem to have exerted a short-lived fascination around 1882, also have a degree of formal distance and a precise, unsentimental perception of the relations between customer and staff which make one forget completely that the little *midinette* (work-girl) was traditionally a prime target for the sexual attentions of the unattached man-about-town.

Perhaps Degas's position as a lifelong, childless bachelor actually helped him towards a degree of objectivity – though it must be said that he has also been the subject of unfavourable feminist criticism, accused of patronage and exploitation. Another lifelong bachelor Impressionist, Caillebotte, is also interesting in this regard. He painted many more men than

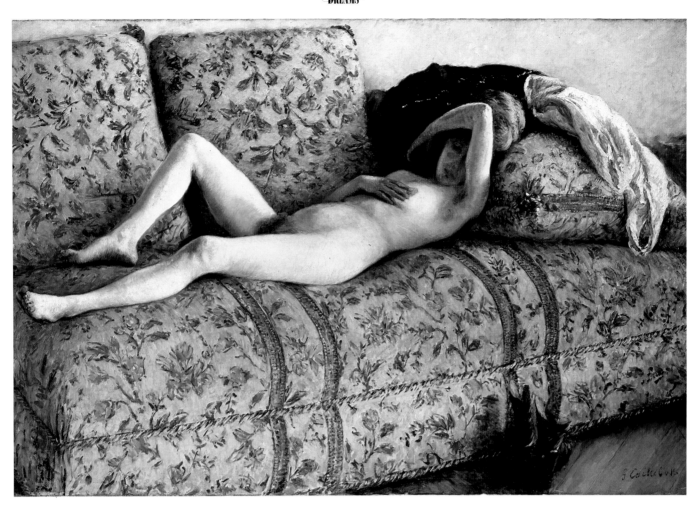

GUSTAVE CAILLEBOTTE
Nu au Divan, 1880-82
Equally daring, in its very different way, is Caillebotte's firmly Naturalist nude, with all the
evidence (clothes, boots) that she has just undressed and is not assuming a formal pose.

women, but most of his pictures of women have some special qualities and, in their period context, oddity. *Femme à sa Toilette* (1873), an exquisite harmony in pinks, lavenders and grey-greens, with the skirt the woman is about to remove a bold expanse of black, is a remarkably informal, domestic-looking scene, delicate and tender in its undramatic observation of a quiet moment in life (the woman is withdrawn, private, concentrating on the task of unfastening her crinoline skirt).

Caillebotte's later *Nu au Divan* (1880-82) seems at first glance a complete contrast. A naked woman lies resting on an elaborately flowered divan, shading her face with one arm and touching her breast with the other hand. Her clothes lie crumpled on the cushion under her head; her boots stand neatly on the floor. She does not seem to be just a model resting, and her plentiful supply of pubic and armpit hair belongs to no contemporary artistic convention. On the other hand, it does not seem to be an erotic, or even a voyeuristic, picture. Though nude, the woman retains her privacy and her personal integrity. Is it a female nude such as a woman painter might paint? Hard to say. But the existence of these pictures by Caillebotte, like Degas's female portraits, at least makes it clear that in the question of the Impressionists' artistic attitudes to and relations with women none of the answers are as straightforward as we might at first expect.

133

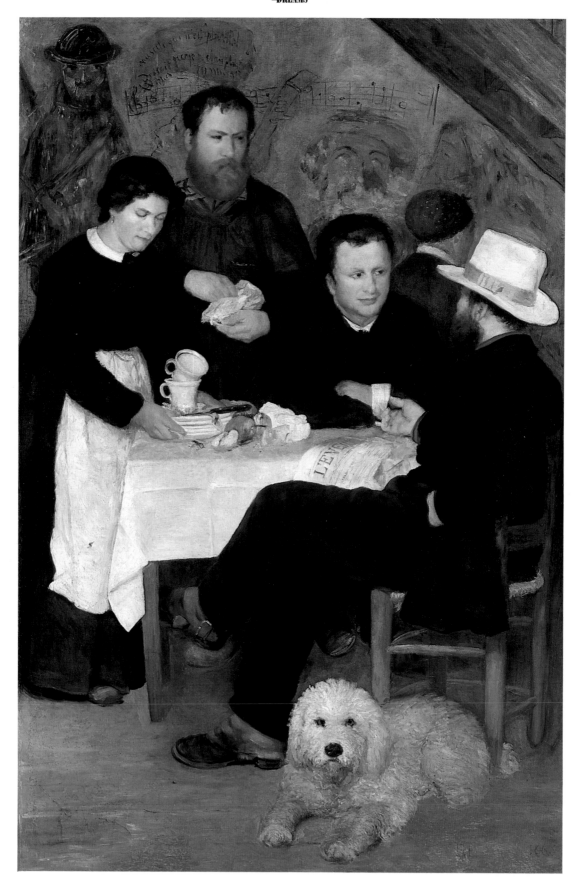

PIERRE-AUGUSTE RENOIR
Cabaret de la Mère Antony, 1866
Renoir's first full-scale composition, commemorating happy days of his youth at the inn in Morlotte.

10
WORKERS
AND OTHER ANIMALS

*This Paris fish-shop around 1925 can have changed little since
the days of the Impressionists.*

R EMARKABLY FEW IMPRESSIONISTS SHOWED
much painterly interest in the working man,
and hardly more, surprisingly considering
the traditional erotic possibilities of the *midi-
nette,* the laundress and such, in the working
girl. Partly, it may be suspected, this was an
artistic rather than a social discrimination.
The plight of working people had been much exploited in mid-
century art, offering as it did many opportunities for affecting
genre scenes sentimentalizing over the lives of the deserving
poor or summoning up *grand-guignol* melodrama from the
doings of the criminal classes and their eventual retribution.
Often it was picturesque local colour, deriving perhaps from
the mightily popular Murillo's studies of cheeky peasant lads
and the more sober eighteenth-century genre tradition of Char-
din, Greuze and their followers. But there was also a thriving
school of more seriously crusading social realists in French
painting (coming to its climax in the highly influential Jules
Bastien-Lepage) which depicted hard times in a more minute,
unsparing fashion and intended thereby to urge on social
change. But sentimental or sententious, such painting was
always closely linked with the story-telling element in painting,
and that was something that the Impressionists wanted nothing
to do with.

This attitude clearly separates them from Zola and his school
of literary Naturalists, even though they were personally
friendly and were often bracketed in the criticism of the time.
The Naturalists, after all, were in the business of story-telling,
and if they wanted to tell a different story in a different way,
that did not invalidate the whole basis of their art as usually
practised. But the Impressionists felt it possible to approach
reality in painting without entangling it in the paraphernalia of
the picture that tells a story. This did not mean, necessarily,
that the lower classes so extensively (and sometimes luridly)
depicted in Naturalist writing were totally barred to them as
subject-matter, but most of their then normal associations in
art were anathema to the Impressionists. If they found a scene
of working-class life visually interesting and so worth painting,
of course they would do so. But the fact remains, not many of
them did.

This is particularly evident, and extraordinary, in the case of
Monet. As we have noted, Monet in his early days was so left-
wing in his political allegiances that he found it advisable to
leave the country at the time of the siege of Paris and the Com-
mune. But you would hardly ever guess it from his painting.
The image, already discussed, of *Les Déchargeurs de Charbon,*
plying their awful trade by a gloomy Seine around 1875, is vir-
tually unique in Monet's work, and a strong visual interest in
engines, smoke and steam never seems to imply any interest in
those who drive or service them. Pissarro, the other left-wing

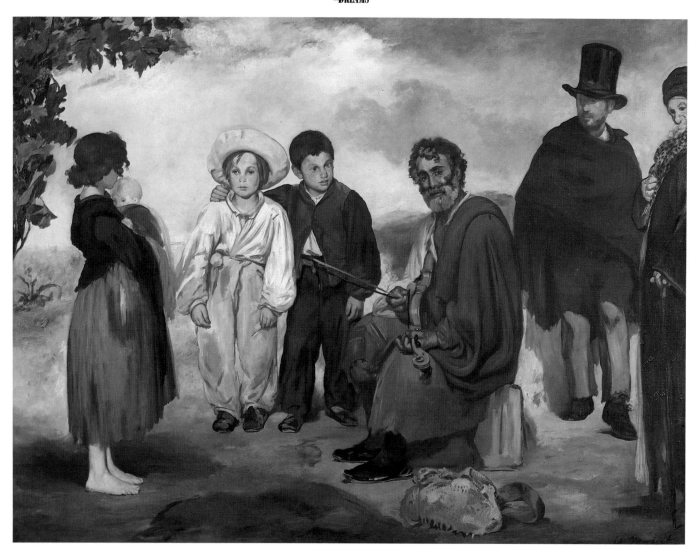

EDOUARD MANET
Le Vieil Musicien, 1862
*A typical example of Manet in his early career knowingly elaborating images from pre-existent art to make
his own. This painting is particularly close to paintings by Velasquez and the two Le Nains.*

extremist of the group, does a little better in this respect, though entirely in a rural context. He made a number of prints for a collection entitled *Turpitudes Sociales* (1890), but the approach is allegorical, and that is about as near as Pissarro comes to the everyday life of the urban worker.

In the country, however, he is fascinated by the *Travaux des Champs*, title of another portfolio of prints. He is particularly drawn to the spectacle of peasant women working, even in the most basic occupations like milking and cutting cabbages. In this he goes a bit further than his great predecessor Millet, who also frequently depicted sowing and reaping and gathering in. Nor are Pissarro's peasants particularly idealized – often they are gawky, awkward and uncomely – though the Impressionist technique, especially in its Pointilliste phase, does tend to endow its subjects with a sort of halo of glory. Perhaps Pissarro's fascination with real peasants doing real things is best appreciated in his many pictures of country markets, which he

painted and drew over and over again: the poultry market at Gisors in 1885, the pig market at Pontoise in 1886, the chestnut seller at Pontoise Market in 1881, and a diversity of individual traders or groups of stalls through the years.

Since Manet was one of the most conscious, among the Impressionists, of artistic precedent, and the least willing to break with it, we might expect, especially given his devotion to Murillo and to Spanish painting in general, that he would offer more studies of the working class in terms of genre painting than anyone else in his circle. And so, in a sense, it proves: though Manet does minimize the anecdotal element, he has a number of pictures which call heavily on this particular tradition. Especially relevant, perhaps, are his large group *Le Vieil Musicien* of 1862 and individual studies like *Le Gamin au Chien* of 1860-61 and *Philosophe* of 1865-66. The trouble is that these pictures are so redolent of their origins in Spanish painting, even in specific Spanish paintings (the 'Gamin' in Murillo's *The*

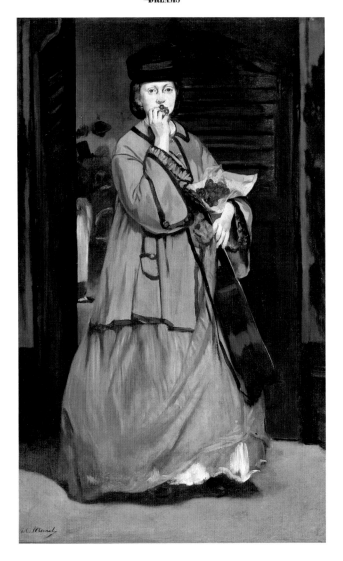

EDOUARD MANET
The Street Singer, c. 1862
An early tribute to the Naturalist ideal by Manet.
This picture arose from a chance encounter in the street.

Little Beggar-boy, the 'Philosophe' in Velazquez's *Menippe*) that we lose all sense of direct observation from the life, these beggars and urchins are so evidently constructs of the studio. The *Vieil Musicien* is also oddly abstracted: it is hard to guess what is going on, since none of the five discrete figures around the seated street musician seems to be about to listen or to have just listened to his music (there is in fact a separate canvas, called *Buveur d'Absinthe,* which simply lifts out and isolates the curiously posed standing man in the tall hat on the right) and the whole thing looks more like one of Manet's deliberate essays in dissociation than a picture which tells us anything specific about life.

The effect of Manet's *La Chanteuse des Rues* (1862) is rather different; we know that it arose from a particular street encounter of Manet's, when he observed a singer emerging from a low bar carrying her guitar, and though the woman herself refused to pose for him (he used one of his favourite professional models instead), the immediacy of the image is palpable. It resides partly in the briskly sketched background of the bar behind, glimpsed through the half-open door; but more specially it comes from the very exact depiction of the woman's clothes, which seem to be intriguingly fashionable for one in her position. Likewise, her ambiguous facial expression, with a handkerchief held to her lips, encourages the spectator to look for a story: has this woman only recently fallen on hard times, is this her first, unsuccessful attempt to make money by singing in the streets, and so on? It shows Manet as a traditionalist in that he permits us to ask these questions, and a modernist in so far as he refuses even to hint at an answer, leaving the picture as an observation of life, passed on for its own inherent value.

In the second Impressionist exhibition in 1876 there were three canvases in particular which called down the wrath of the critics, for reasons which seem to have been largely social, if not political. One of them was the most boldly silhouetted of

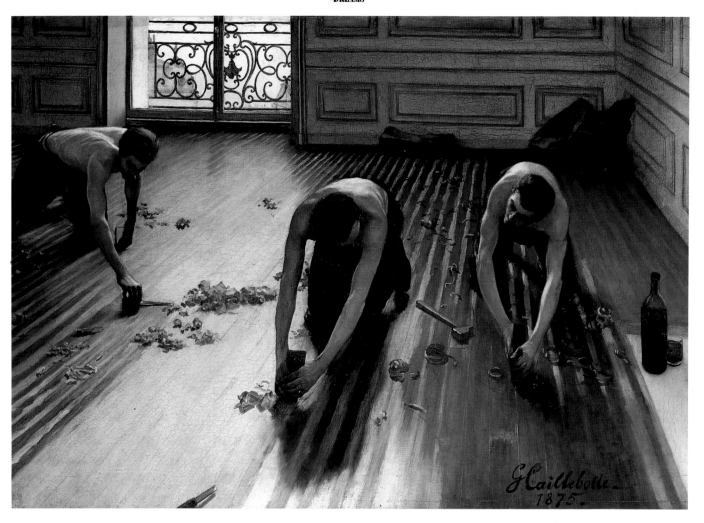

GUSTAVE CAILLEBOTTE
Les Raboteurs du Parquet, 1875
An extraordinary combination of working-class realism, very rare among the
Impressionists, with a meticulous regard (even rarer) for the geometry of a picture.

Degas's *Blanchisseuses:* the other two were related paintings by Caillebotte on the subject of *Raboteurs de parquet,* the men who scrape down the wooden floors of new buildings to smooth and regularize the surface. We do not, apparently, know any details of Caillebotte's politics, but on the score of these paintings he was accused of Zola-esque Naturalism and of practising 'democratic realism', which sounds vague but possibly subversive. For whatever reason he chose the subject, it seems unlikely to have carried much political significance for him. Rather, in line with his other work, it is most likely to have been for the intricate formal possibilities of the composition, with its sharply-sloping perspective of half-scraped floorboards, and the extraordinary foreshortening of the crouching figures this entailed in the larger painting, and the odd insights of character and the realistic detailing of the smaller. It has been suggested also that the floor-finishers were chosen as a pretext for a modern version of the classical male nude or semi-

nude, but given the minimal amount of torso the men's poses permit us to see, this seems unlikely.

The fact remains that Caillebotte seems to be the only important member of the Impressionist circle who took any real interest in the detailed observation of men working. And not only if they were picturesquely stripped to the waist; his *Peintres en Bâtiment,* painted the following year, are all fully and decorously dressed in long painters' smocks, and are hard at work painting and decorating a shop front (or in one case stepping back from the ladder to review the handiwork), while the long straight street stretches back almost to infinity (again one recalls Caillebotte's special interest in problems of perspective). It is clear from pages of sketchbook studies that Caillebotte studied all his figures carefully on the spot, possibly supplementing this by getting models to pose in the studio. The final picture (preceded by a detailed oil sketch) is so evidently considered and so meticulously finished that one

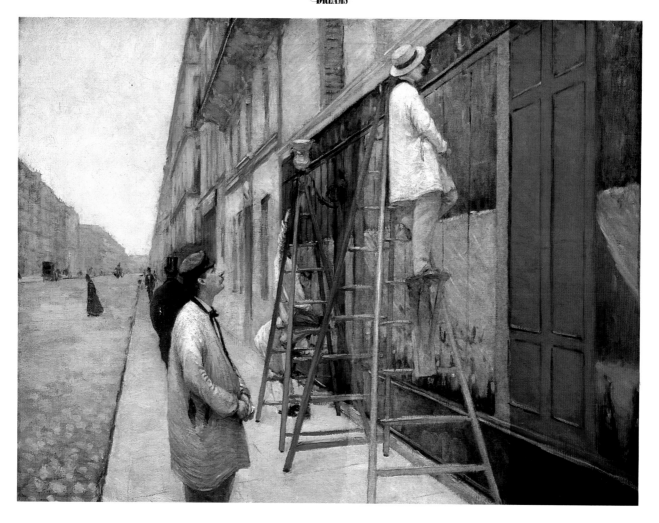

GUSTAVE CAILLEBOTTE
Peintres en Bâtiment, 1877
A characteristic Caillebotte study of rigid urban perspectives is made the setting
for another characterful examination of working men plying their trade.

never suspects it of being *pris sur le vif*, but at the same time it achieves a balance rare in Impressionist painting between realistic human observation and the fall of light and harmony of colour.

On the whole, when other Impressionists took note of workers working, it was generally as a fairly distant and unobtrusive part of the landscape, as in Sisley's *Scieurs de Long*, included in the third Impressionist exhibition of 1877, which shows a large tree-trunk raised on a wooden scaffold to be cut across the grain, the sawyers themselves being quite unimportant and in no way personalized. Workers of any kind played even less a part in Cézanne's turbulent early fantasies, and are not to be glimpsed anywhere in the vicinity of Mont Ste-Victoire. The preoccupations of Berthe Morisot and Mary Cassatt are impeccably middle-class, not extending even to female workers, with whom they must certainly on various occasions have come into contact.

Unexpectedly, things perk up a bit in the latter stages of Impressionism. Seurat, in his life the superficially impeccable bourgeois (even his carefully hidden working-class mistress and their illegitimate child could fit into that pattern), was nevertheless more interested in men involved in manual work than almost any of his immediate predecessors. Sometimes men involved in country pursuits like hoeing and mowing, but more often, as befits an artist of predominantly urban preoccupations, they are doing the usual jobs of city streets, breaking stones, sweeping, rag picking, selling fruit from a stall. These were mostly the subjects of his early drawings, done around 1880-82, but even towards the end of the decade, when he was well embarked on his major paintings, he kept his eyes open on the city's streets, as drawings of roofers and workmen on scaffolding attest. They are clearly based on observation, even if (one supposes of anything so calculated) executed entirely in the studio.

MAXIMILIEN LUCE
Coffee, 1892
A working-class domestic interior, painted in the Neo-Impressionist style by the
movement's most committed left-winger and social realist.

Among the Neo-Impressionists, there is also the exceptional figure of Maximilien Luce, whom we have already encountered in relation to the Impressionists' attitude to industry. In Luce's many pictures of slag heaps, factory chimneys, building sites and such the figures, though present, are subordinate parts of the design. But he also produced many vivid images of men at work, or the home life of the worker, where the people are the centre of interest. In 1884, for example, he painted *Le Cordonnier*, which shows a cobbler working on some leather while a lad (an apprentice, presumably) looks on, all in a tiny, rather improvised-looking loft workshop. Paintings of the 1890s such as *L'Aciérie* and *Ouvriers devant une Forge*, make the most of the flames, the smoke and the unearthly lighting of the steelworks, but also give us a clear picture of unidealized but somehow heroic workers in them. And paintings like *Le Café* (1892) use a Pointilliste technique to unfamiliar purposes by showing a humble domestic interior, woman sweeping in the background

and working man in his shirt-sleeves making coffee by a grate in the foreground. And once Luce had settled on his subject-matter and his style, he stuck with it, evolved but not radically transformed, as late as *Les Maçons* in 1929.

Well, we know that Luce was an enthusiastic Communard (he painted several important political pictures commemorating the martyrs of the Commune) and considered a dangerous enough radical to be imprisoned for his political beliefs as late as 1896. Degas's political attitudes are much more ambiguous and contradictory, and no doubt changed as he got older. He has been thoroughly excoriated for his anti-Dreyfus stand in the 1890s, and dismissed as an an anti-Semite of the extreme right (though we forget that Renoir, despite his origins and early radicalism, shared Degas's views on Dreyfus). This reputation, combined with his separate (and possibly less justified) reputation as a misogynist, unsettles ideas about the attitudes which inform his numerous paintings of working girls. Do they

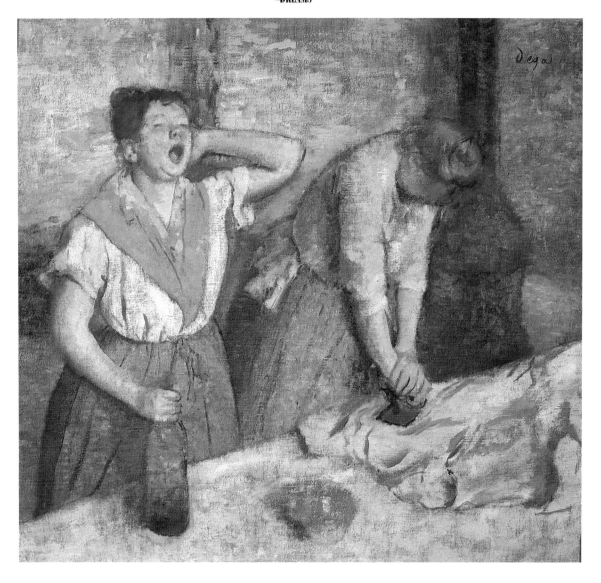

EDGAR DEGAS
Les Blanchisseuses, c. 1884-6
One of Degas's most unsparing, least glamorised studies of working girls; no one
could claim that this is an erotically predatory handling of the subject.

have anything to do with politics, other than sexual? Are they exploitive works of a woman-hating (or -despising) male chauvinist? Is it possible that such a man as we conceive Degas to be could have any genuine, disinterested sympathy for the working classes? (Also one might ask, artistically speaking, whether any of this matters: what surely does matter is the urgency of the inspiration, not where precisely it is coming from.)

We do, in fact, have some evidence of Degas's own attitudes. For example, he once said to his friend Halévy, 'I like to see the families of the working men in the Marais. You go into these wretched-looking houses with great wide doors, and you find bright rooms, meticulously clean. You can see them through the open doors from the hall. Everybody is lively; everybody is working. And these people have none of the servility of the merchant in his shop. Their society is delightful.' That does not sound either hostile or patronizing. And one could apply these remarks to his pictures of laundresses quite as readily as to his

projected series on bakers. Except, of course, that he did numerous pictures of laundresses, and never got beyond a vague planning stage with the bakers. Was this because the laundresses were sexually interesting to him and the bakers not? Possibly, but is clear that any erotic element in the laundress pictures is very rapidly subsumed in (1) Degas's insatiable interest in the processes of washing and ironing, and the ways they are physically expressed; and (2) the formal challenges posed by all this and the task of making it into satisfactory compositions.

In other words, his interest is disinterested, founded apparently on human sympathy but shorn of the anecdotal. In much the same way Degas could be interested in the shapes of a horse race, the combinations of horse and rider, without necessarily riding himself or having any reason to care who came in first. The subject of laundresses and ironing women certainly preoccupied him for a long time (if not quite so long

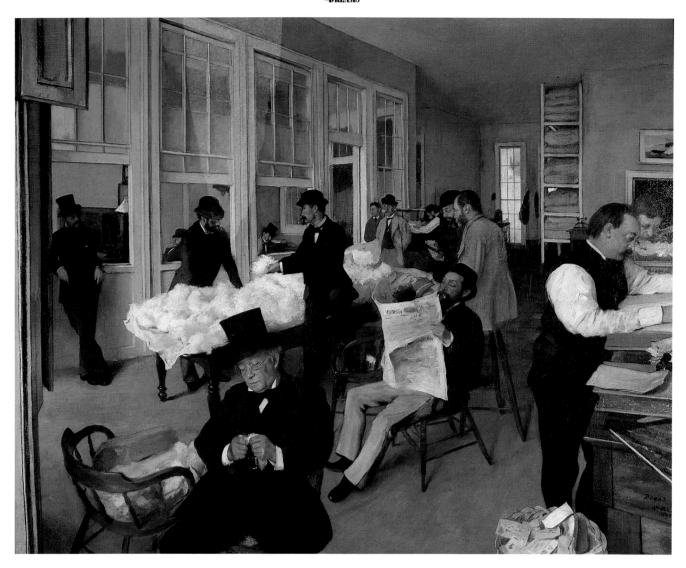

EDGAR DEGAS
Portraits in an Office (New Orleans), 1873
The most substantial product of Degas's family visit to New Orleans, this shows a number of
relatives and people involved in the family business (cotton) working in the local office.

as the horse races): he seems to have begun the series around 1873, with the *Blanchisseuse (silhouette)* which was so loudly complained about and mocked in the Impressionist show of 1876 (where at least none of the critics seems to have suspected a dubious sexual motivation). Soon after, Edmund de Goncourt saw some laundress pictures in Degas's studio, and attributed their existence to the popularity of the Goncourts' novel *Manette Salomon*; Zola later said that some of his descriptions of the laundry in *L'Assommoir* (1876) were based directly on Degas's pictures. These close connections with literary Naturalism could hardly have failed to be marked at the time of the second Impressionist exhibition, and no doubt coloured the tone of comment. By no means nonplussed, Degas was still painting women ironing in the mid-1880s, the date of his most familiar image (existing in several versions), where one woman yawns with a bottle in her hand while the other is bent over her iron. And as late as 1892 or later the theme still recurred. What

it meant for Degas at any time we can now hardly begin to guess, but the power of these pictures as an image of labour makes them unique in the whole annals of Impressionism.

In English paintings of the period a taste for sentimental images of the poor frequently went with a taste for sentimental images of animals. Pictures of either which were not sentimental existed too, but had much more difficulty finding a public (though one wonders about such brutal scenes of the chase as Landseer's *Otter Hunt*) and the sentimental kind were paramount in fixing public attitudes. Things were not so different in France, though the French never seem to have been so crazed about animals as the English. Nonetheless, if the Impressionists avoided working-class subjects largely by reaction to the orthodoxy of the day, it is quite likely that they showed on the whole little interest in animals either because they did not want to be confused with Rosa Bonheur, or because they thought that the market for animal subjects was quite suffi-

142

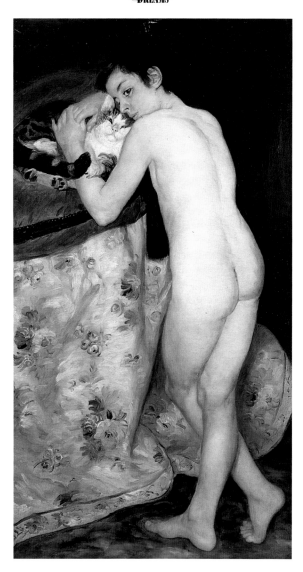

PIERRE-AUGUSTE RENOIR
Young boy with a Cat
An early, cool-toned nude remarkable for the prominent position
of the cat and the physical type of the boy.

ciently catered for by the small, domestic-sized sculptures of Barye and other sculptors known, from their specialization, as *animaliers*. Whatever the reason, apart from the horses which play an important part in Degas's work, animals are for the most part conspicuous by their absence from Impressionist paintings, or at any rate from a position anywhere near centre stage.

In an English *Le Déjeuner sur l'Herbe* there would surely be a dog around somewhere, but not in Manet's, nor in Monet's, and in Cézanne's only a decidedly disreputable pooch gazing with improbable eagerness at what appears to be an orange, all the food apparently on offer. There is a rather strange-looking hearth-rug dog being walked in Manet's *L'Exposition Universelle de 1867,* he has a number of pictures loosely connected with bullfighting and one of a dancing bear, and the *Jeune Dame en 1866* is accompanied by a grey parakeet perched on its stand. But it seems that if Manet liked animals at all his devotion was

reserved for cats. The cat playing with an orange in the lower right-hand corner of *Jeune Femme couchée en Costume Espagnol* (1862) immediately has an individuality and vitality of its own, and the numerous studies of cats Manet made around 1868, perhaps in connection with the poster he designed that year for Champfleury's book on cats, or the etching *Le Chat et les Fleurs* of 1869, do seem to witness some personal and specific interest.

Whether or not Degas loved people, there does not seem to be any reason to see him as one of those who substituted animals for people in their affections. Of course, the horses are there, endlessly, in the horse-racing pictures (they would, after all, have to be) but they do not always seem to be all that closely observed. In *Aux Courses en Provence* of 1869, for instance, the tiny horses racing in the background seem to come from early English racing prints rather than direct observation: their legs are stretched straight out simultaneously before and

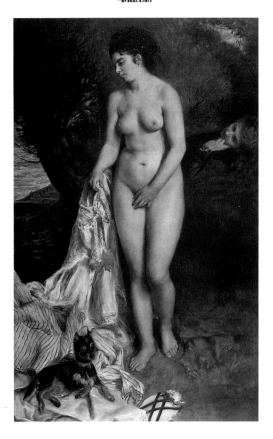

PIERRE-AUGUSTE RENOIR
La Baigneuse au Griffon, 1870
An early attempt at a full-length female nude, looking back to
Courbet as much forward to Renoir's mature style.

behind in a way which is physically impossible for a real horse in real motion. Later Degas learned more about the believable depiction of horses, but it never seems to have been central to his purposes: he is quite as interested in the jockey as in the horse, and more interested still in the ambiance of the race meeting, the extraordinary patterns that horses and riders keep forming and reforming against the green grass. In the end, like his dancers and his washerwomen, they become counters in the game of art, drained of any except purely formal significance – though that, since Degas is a master and an obsessive, remains enough to keep us enthralled. There is a dog in the New Orleans *Cour d'une Maison,* but in general horses are the only animals Degas pays any attention to, and even there the degree and nature of the interest are questionable.

Caillebotte, now, has an extremely characterful dog striding out all by itself across the Pont de l'Europe, and Zandomeneghi, as well as featuring sundry lap dogs as appurtenances of his fashionable ladies, offers an extraordinary dog in his *La Terrace* of 1895, a small puggy type seated in an open space among the tables of the open-air café, right in the centre of things and evidently with no doubt whatever of his right to be there. Berthe Morisot's daugher Julie had at one stage a pet greyhound which appears with her in various pictures,

but not really characterized much more than the violin she is playing in other pictures of the same period. Renoir does not go much on animals either: they are oddly lacking in a lot of pictures where one might expect to find them – domestic interiors with his own family, say, or days of fresh air in the rain and the sun. On the other hand, there are rather prominently displayed dogs in some group portraits, such as the early *Cabaret de la Mère Antony* (1866) – a very woolly-looking white dog – and the mature *Portrait de Madame Charpentier et de ses Enfants* (1878), which should also add *et de leur Chien,* a Pyrenean/St Bernard type large and docile enough for the little girl to sit on. A dog even appears, signalled in the title, as a vital part of *La Baigneuse au Griffon* (1870); the dog seems to be poised uncomfortably between the real and the quasi-heraldic, in the same way that the picture hovers somewhere between the 'classical' academic nude and the more realistic, modern kind Renoir was subsequently going to develop. Farm animals occur here and there in Pissarro, but accorded no particular significance.

Animals returned to painting in a big way among the Post-Impressionists, and in artists of slightly later generations, such as Bonnard. Why this curious gap exists among the Impressionists we can only speculate. But gap undoubtedly there is.

THE INNER WORLD

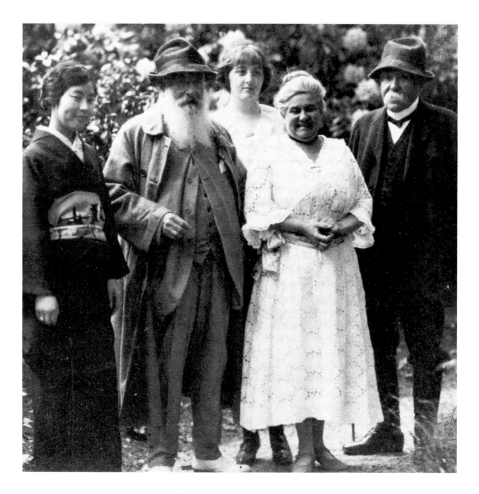

Monet with his wife Blanche Haschedé and the statesman Clemenceau, as well as a niece and a Japanese visitor.

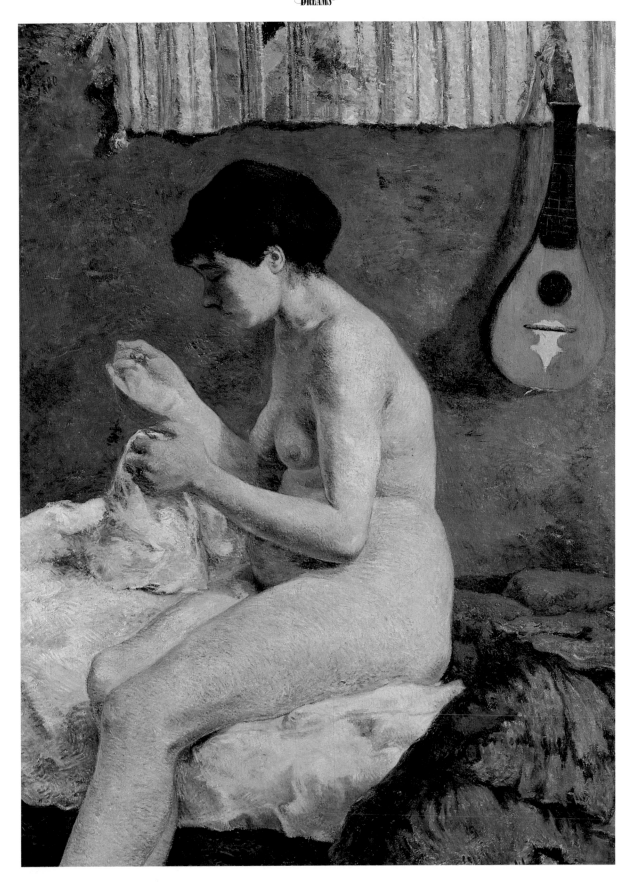

PAUL GAUGUIN
Naked Girl Sewing, 1880
Shown in the Impressionist show of 1881, this was the first of Gauguin's works to receive significant acclaim.
It is in his early, fully Impressionist style, though with perhaps more hints of the more angular style to come.

146

11

FLESH AND FANTASY

Before he started using the camera himself, Degas used to pose pictures for others. This is taken at Menil-Hubert, c. 1885.

WE HAVE ALREADY TOUCHED, MARGINALLY, on the ever-interesting subject of the Impressionists and sex. But it really has to be classified under 'The Inner World', because, though we may be able to document in some detail what they did and whom they did it with, the only really interesting and significant part is that which must remain speculative and beyond quantification: what it meant to them and how that psychology expressed itself in and coloured their art. Most importantly, it can be a key to the imaginative life of those who often appeared to have no imaginative life, or at any rate made it a point of honour that any imaginative life they might have should have as little as possible to do with what they painted. Even while aiming at 'detachment' or 'objectivity' there are some points at which no one can hope to be completely objective and detached; it is valuable to observe where these points lie, and speculation about the boundaries may cast a helpful light on to other dark areas.

It can be said immediately that the sex lives and sexual interests of most of the Impressionists were pretty straightforward and conventional. They mostly went through their student days in the expected fashion, pursuing barmaids and models, acquiring mistresses and in due course, depending on class and personal inclination, marrying the mistresses and set-

tling down or keeping the mistress and her children (if any) as a sort of half-recognized alternative family. Monet and Manet are perfect examples here. Monet set up house in his mid-twenties with his mistress Camille Doncieux, had his first child by her before their marriage and the second child after. She died in 1879 and in 1881 he set up house with a second mistress, Alice Hoschedé, who was married to someone else. She lived as Monet's wife and looked after his children; her husband died in 1891, and she and Monet married in 1892. Alice Monet died in 1911, after living with Monet for precisely thirty years. There is virtually no specifically sexual content in Monet's painting at any stage in his career, and we must presume that he was the type of man designed by nature to be happily monogomous: his continuing relationships seem to have fulfilled all his sexual and practical needs, and freed his mind for matters which were more important to him, like the way the light fell on a haystack or the façade of Rouen Cathedral.

Manet approached things rather differently. He travelled as far as Rio de Janeiro when he was seventeen, while his family was ineffectually trying to manoeuvre him into the navy, and his sexual initiation must have taken place about then; in the same year he met Suzanne Leenhoff, a young Dutch woman who was giving piano lessons to him and his brother: she became his mistress, and when he was twenty gave birth to a boy,

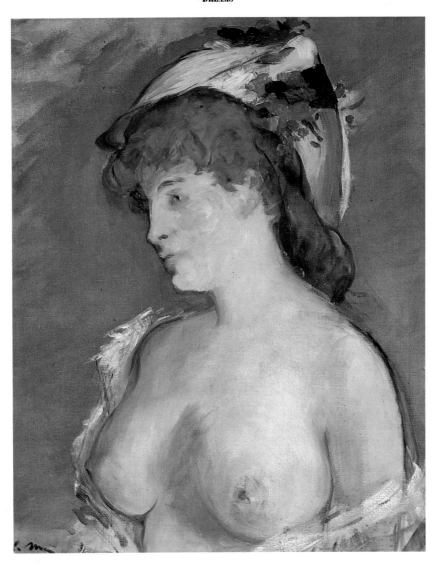

EDOUARD MANET
Blonde aux Seins Nus, c. 1878
Even this relatively late reversion to a favourite theme shows also how "learned" Manet
was as an artist, making clear reference to precedents in Tintoretto and other Old Masters.

Léon-Edouard Koëlla, called Leenhoff, whom Manet always treated as his own son (which he most likely was). He lived with Suzanne and Léon regularly until in 1863, fourteen years after he had met Suzanne, he married her. Through the years he had professional relationships with other women, notably the model Victorine Meurent, whom he painted many times, and the painter Eva Gonzalez, who became his pupil, but it is not clear whether these relationships were also sexual; they need not have been. However, there is plenty of evidence in his work that he had the man-about-town's expected acquaintance with brothels and the sea-coast of bohemia.

Several of his major paintings, most importantly *Olympia* and *Nana* (1877), deliberately challenge conventional sexual mores by clearly depicting courtesans: in the case of the nude Olympia the spectator-client is implied; with Nana, as she poses in her underclothes, we actually see the top-hatted companion seated hard by, eyeing her possessively as he awaits her

pleasure (or his). The subject-matter is overtly sexual, but somehow – perhaps because of a certain built-in ironical detachment – the pictures are not noticeably sexy, even (or perhaps especially) within their period context of titillating salon nudes. Otherwise, it is quite clear that Manet enjoyed drawing and painting attractive women, sometimes exposing their breasts (with good iconographic precedent in Tintoretto), sometimes naked in a bath, but usually fully dressed. But even these paintings are curiously lacking in unconscious sub-text. And his illustrated letters to friends male and female, though they feature sometimes sketches of women's hats or women's legs, seem to be more humorous than excited. In general Manet looks like another variation on the theme of the happily married family man, whose marginal sexual activities, if any, were never important enough to invade and dominate his work.

Pissarro's sex life followed much the same pattern, though if anything slightly more conventional, as one might possibly ex-

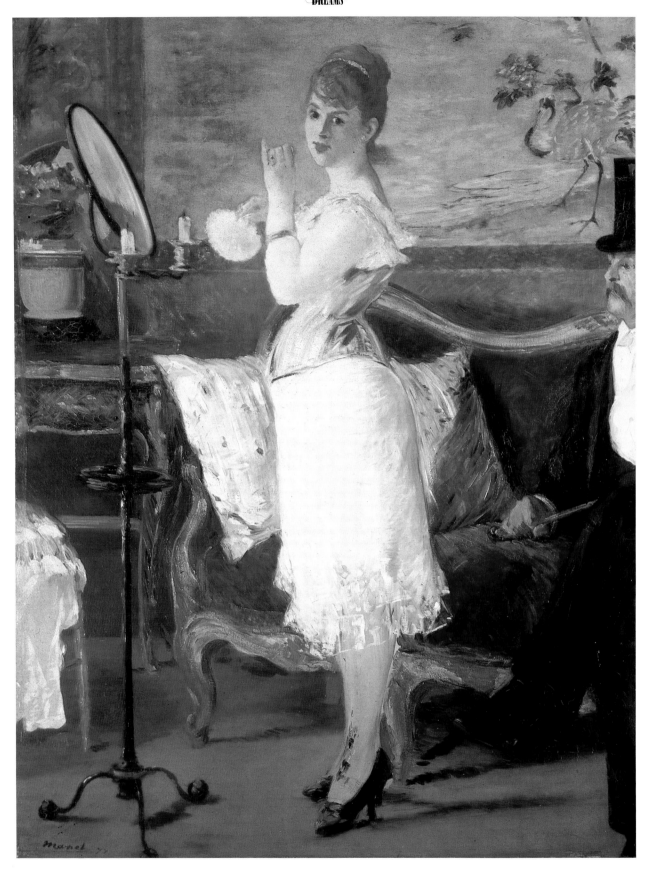

EDOUARD MANET
Nana, 1877
The reference of the title is to the heroine of Zola's Naturalist novel about a prostitute. This
was intended as the first of a series by Manet treating Paris life and the demi-monde.

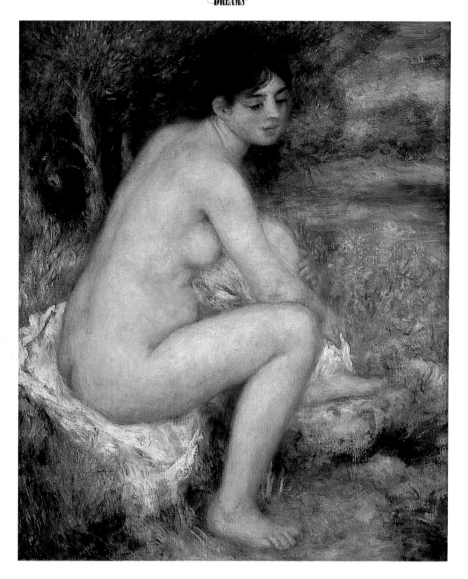

PIERRE-AUGUSTE RENOIR
Nude in the Country
A straightforward nude obviously related to the long series of Renoir bathers –
the model appears to be drying her foot.

pect of a nice Jewish boy: when he arrived in Paris to study art he lived with respectable bourgeois relations, and rapidly formed a liaison with a maid in the family home, Julie Vellay. Together they had three children, two daughters and a son, before they were married (in Croydon, during Pissarro's flight to England) in 1871. From this point at least he was totally settled: the Pissarros had five more children by 1884, and Pissarro assumed what seems to have been his destined role in life as patriarch, father and father-figure to later generations of artists. There is never, even early on, a hint of sexual licence, or even much sexual interest, in his art.

Pissarro's younger friend Seurat, who converted him to Pointillisme in the 1880s, presents a slight variation on this pattern – perhaps only because he died young, at the age of thirty-two. He also came of a respectable, bourgeois merchant family, and kept up the conventions of his class, even after he had moved away from home, dining with his mother regularly once a week

and dressing and comporting himself in such a way that Degas nicknamed him 'the soliciter'. He too had a mistress, Madeleine Knobloch, whom he met around 1888, and in 1890 she bore a child whom he legally acknowledged as his. However, he was so secretive about the whole thing that many of his closest associates did not know of the woman's and child's existence, which was revealed to his family only two days before his death in 1891. Had he not died, he might well have followed in Pissarro's footsteps to a settled, familial middle age. Certainly his painting does not seem to contain any half-concealed wildness which might contradict that assumption.

Passing rapidly over Sisley, the quietest and most respectable of all the Impressionists, we come to Renoir. Even the most casual acquaintance with Renoir's work is bound to suggest that sex played a very important role in his imaginative life and very probably his physical life too. A constant preoccupation, from early on right to the end of his life, is the depiction of lus-

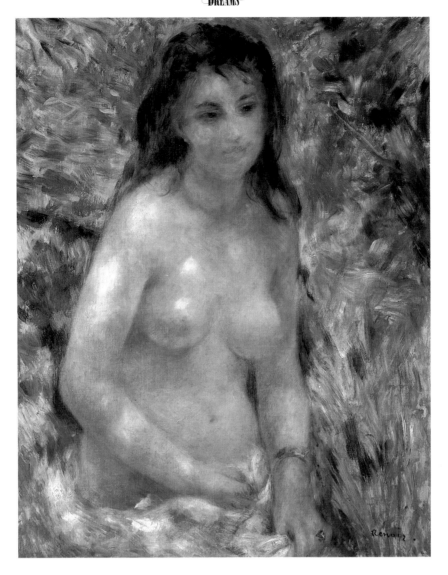

PIERRE-AUGUSTE RENOIR
Study: Nude in the Sunlight, 1874
Shown in the second Impressionist show in 1876, this picture excited some of the most hostile
criticism: the play of light and shade on the flesh was held by one critic to indicate putrefaction.

cious, big-breasted, available-looking young women in states of partial or total nudity. Nothing more complicated than that; and though such pictures were generally saleable, there seems to be no doubt that Renoir painted them primarily because he enjoyed it. Of his own sex life we know for sure that in 1865, when he was twenty-four, he met Lise Tréhot, the sister of a painter-friend's mistress, and cohabited with her until she married an architect in 1872; then in 1880 he met Aline Charigot, with whom he lived and who bore him a son in 1885, before he married her and legitimized the child in 1890. Both Lise and Aline modelled for him frequently, and both appear to conform to his 'type' of the big-boned, well-upholstered peasant woman, blonde or brunette, with a sort of built-in sexy pout. Between and alongside Lise and Aline there was a succession of Annas and Nanas and Ninis, all of much the same physical type, all painted nude or nearly, often as bathers. The most important seem to have been Anna Leboeuf, who modelled for

Renoir between 1875 and her death in 1879, and Gabrielle Renard, a distant cousin of Aline who joined the household as a sort of maid/companion/nurse in 1894 and showed her breasts endlessly for Renoir to paint over the next few years.

It is not clear whether either Anna or Gabrielle was also Renoir's mistress. But it is clear that the erotic appeal they exerted was an important part of his reason for painting them, and an overflowing sensuality is always part of Renoir's artistic stock-in-trade. From the mid-1890s, when Renoir began to paint Gabrielle, the female figures tend to become more and more stereotyped, and virtually indistinguishable. Since by then Renoir was approaching sixty, one may perhaps attribute this to a less and less adventurous older man's retreat into comfortable fantasy. Certainly the later bathers, who became vaster and fleshier all the time, do quite often approach a parody of Renoir's early vision. If one compares most of these pictures with such celebrations of his earlier ladies as the 1868 *En été*

151

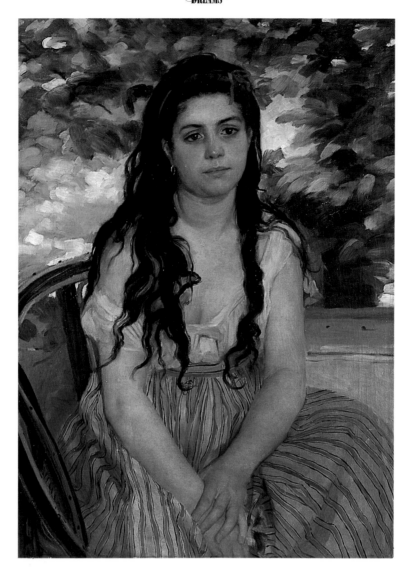

PIERRE-AUGUSTE RENOIR
En Été, 1968
The only painting exhibited by Renoir in the Salon of 1869, this is a portrait of Lise Trehot,
his mistress from 1866 to 1871. The handling is still quite acceptable by Academic standards.

(*étude*), which shows Lise fully clothed (though with ample décolletage) against a leafy background, or the sun-dappled *Etude* of 1875, which shows Anna nude among the boscage, some drifting away from even the most rosy view of reality and into rather masturbatory titillation must be remarked. Also, Renoir's passion for the fleshy, rather than merely fleshly, approaches fetishism: one is reminded of the American cartoonist James Thurber's resigned reply to the question of why his women had no sex appeal: 'They do to my men.' Except that, convention being what it is, if Renoir were to reply that his elephantine nymphs were sexy to him, no doubt an amazing number of men, even today, would concur in that judgment.

Whatever his attitude to sex may have been, Renoir never seems to be in any way tormented by it. Cézanne was a far different case. Turbulent, uncontrollable emotions and erotic torment seem to be the hallmark of all his earlier work, up to the early 1870s. After the Franco-Prussian War, when he returned more and more from Paris to his native Provence, he seems to have resolved a lot of the conflicts in his nature, and erotic themes gradually disappear from his work, except in the arguable form of a series of more and more abstracted *baigneuses*, where the bathing women seem to be treated with thoroughgoing Impressionist detachment, as formal elements in the composition. We can only guess what brought this transformation about. In 1869, in Paris, Cézanne met Hortense Fiquet, who became his mistress and bore him a son in 1872. He continued to live with them, and finally in 1886, shortly before the death of his father, he married Hortense before Church and State, and in the presence of his parents (whereas Manet and Pissarro had, perhaps coincidentally, regularized their unions privately and abroad). It is almost as though he pulled himself together and made himself as far as possible into a respectable bourgeois by a deliberate decision: but if so, the decision seems

152

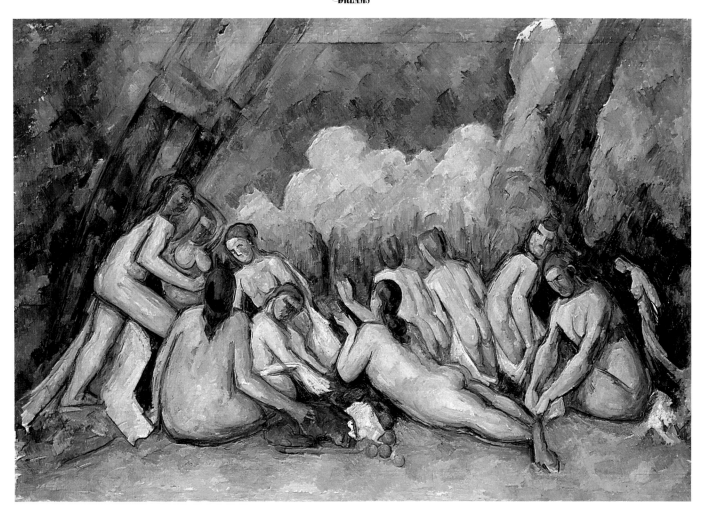

PAUL CÉZANNE
The Big Bathers, 1900-5
One of the latest, grandest and most abstracted of Cezanne's long series of paintings on
the subject of female bathers. What the Cubist learned from Cézanne is clearly apparent.

to have been remarkably successful, and to have left no neurotic after-effects.

If we look back from the works of Cézanne's maturity to the paintings made in Paris in the 1860s, we enter a different world. We know that in his late teens he wrote letters and poems which give full vent to the imagination of the sexually excitable (and no doubt sexually frustrated) adolescent. Recently a very early painting, done apparently when he was about twenty-one, has come to light which carries similar preoccupations to almost pornographic lengths: *Lot et ses Filles*, leaves us in no doubt about the incestuous relationship as fantasized by the painter. All of his early works, even though their subject-matter is normally far more respectable, are painted with the same heavy impasto and have the same almost expressionist intensity. Not that they are necessarily devoid of humour: *L'Apres-midi à Naples*, painted in 1866 or 1867, shows a nude man and woman sprawling on a couch while a scantily

draped black attendant of unclear gender proffers a tray, a pot and cups upon it. The theme is thought to be related to a couple of studies of drunkenness which Cézanne submitted unsuccessfully to the Salon in 1867, but its gleeful grotesquerie forbids any too moralistic interpretation. The paintings of the next few years include several female nudes, *L'Enlèvement,* a rather rough and unidealized depiction of Persephone's carrying-off by Pluto, a *Meurtre* of unresolved violence and an ambitious composition of a nude banquet variously known as *Le Festin* and *L'Orgie.* In 1869-70 come Cézanne's brusque and outspoken comments on Manet's *Olympia,* both known as *A Modern Olympia,* in which a figure suspiciously resembling Cézanne's self-portraits of this period is added to Manet's composition, appreciatively surveying Olympia's wares.

The apotheosis of this phase in Cézanne's career seems to come with two paintings of c. 1870, *La Tentation de St Antoine* and *Pastorale.* The Temptation, suggested no doubt by Flau-

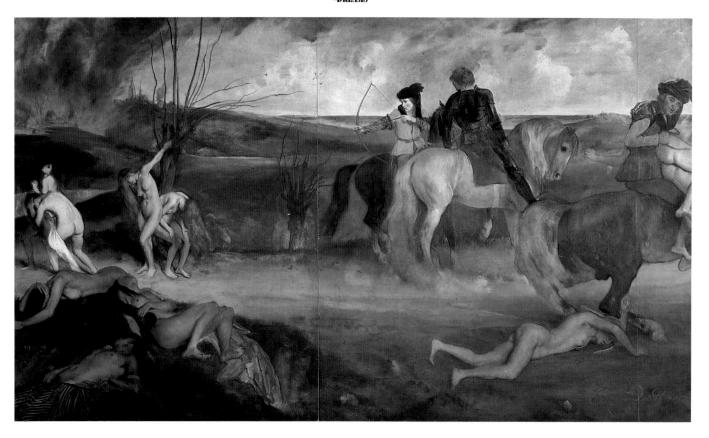

EDGAR DEGAS
Scene de Guerre au Moyen Age, 1865
Among the last of Degas's early historical pictures, this one remains rather mysterious in its oddly
savage imagery (not "justified" by reference to any precise literary source) and its eccentric composition.

bert's book of the same name, which obsessed Cézanne in the following decade, seems to express a generalized torment – the torment of general self-discipline – rather than a direct sexual challenge: the St. Antony is withdrawn right to the back of the picture, and left to wrestle with just one nude tempter, while the other three arrange themselves disquietingly in the foreground. The Pastoral is also very strangely put together: another Cézanne look-alike, fully clothed, lies dreaming at the edge of the water while three hefty nude women seem to be totally self-absorbed and the other two men sit noncommittally by. Is this peace of mind, all passion, if not spent, at least thoroughly suppressed and controlled? That seems, at least, to have been Cézanne's personal, if not necessarily his artistic, goal, and in the gradually evolving scenes of bathers he painted on his return to Aix – sometimes male, more usually female, but never the two together after the Paris painting *Baigneur et Baigneuses* of c. 1870 – we can see him little by little achieving it. For him, whatever life might be about, art was about something else, and his life had to be about art. Monet, in his very different fashion, reached the same conclusion without apparent conflict; Cézanne had to fight the battle out to its hard-won conclusion, and in his art of the 1860s we see him, with almost painful clarity doing precisely that.

The two childless, confirmed bachelors among the important Impressionists were Degas and Caillebotte. Though there have been in both cases tentative attempts to suggest that this was because they, consciously or unconsciously, were homosexual, there does not seem to be any real evidence in either case, or psychological necessity for this conclusion. Degas does not in his painting show any apparent hostility towards women, though it is questionable whether he gives much evidence of direct erotic stimulation by them either. On the other hand, he does not evince any noticeable erotic interest in the men he paints – though some of his male friends are undeniably handsome and dashing, most of them are not, and even in relation to the more attractive subjects there is a decided lack of that sexual magnetism that we find in some of the male portraits by such friends of the Impressionists as Tissot and Sargent.

Tissot's sexual orientation has never, I think, been questioned, but there is surely something perceptibly sexy in his elegantly sprawling portrait of the soldier and traveller Fred Burnaby, the tallest man in the Army, which is one of the most memorable images in London's National Portrait Gallery. And with Sargent (whose sexual orientation has been questioned, if inconclusively) it is instructive to compare his in its time notorious profile portrait of *Madame X* – supremely elegant but quite chilly – with his contemporary portrait of her lover Doctor Pozzi, a palpable focus of sexual energy in his long red dressing-gown.

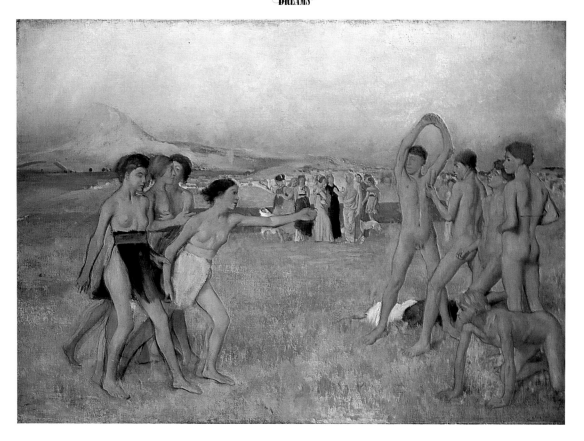

EDGAR DEGAS
Petites Filles Spartiates provoquant des Garçons, 1860-62
A very carefully considered and worked-over treatment of a typical Academic
subject, reinterpreted in Degas's own, very personal way.

In this connection it may be germane to note also some oddities about the only major picture in which Degas depicted full-frontal male nudity, the early *Petites Filles Spartiates provoquant des Garçons* (1861-62). In the final version the genitals of the boy athletes (who are evidently Parisian gamins rather than classical idealizations) are clearly rendered – presumably as a gesture against the coy strategems of the academic nude. (A sketch in the Fogg Museum shows that Degas toyed with the idea of some improbably placed leaves before rejecting any such notion.) But in the preparatory studies of the individual boys the genitals are not even sketchily rendered – they are left out altogether. This, in a period when even clothed figures in painting were frequently studied in the nude to get the anatomy clear, seemed to suggest that Degas suffered from some exceptional self-consciousness in this area. It may be noted, too, that Degas seemed to have no corresponding hang-ups when it came to drawing the genitals of the women he sketched for *Scène de Guerre au Moyen age* a couple of years later. Make of that what you will.

With Caillebotte the question is even more hazy. It seems that the most intense emotional attachment of his life was to his younger brother Martial, with whom he lived and shared his stamp collections until Martial married in 1887. But on the other hand he had a country house at Petit-Gennevilliers from 1882, where he lived with a lady called Charlotte Berthier, to whom he left the property and an income at his death; as pictured in his garden paintings of the 1880s, she does not look like an old housekeeper type. Caillebotte certainly painted men – workers at work and bourgeois at play – more frequently than he painted women, and his men are generally presented in an attractive light. His pictures which are supposed to depict marriage are also supposed to depict unhappy marriages – not in general a subject of much interest to homosexual artists.

Caillebotte is also, apparently, the only Impressionist to paint a major, finished, full-length male nude – at any rate after Bazille's 1868 *Le Pêcheur a l'Epervier,* intended for but refused by the 1869 Salon, which looks like an opportunistic attempt to place an *académie* pose in an unlikely pseudo-realistic context. But Caillebotte's extraordinary painting *Homme au Bain* of 1884 is in fact in certain respects a companion piece to his female *Nu au Divan* painted three years previously, which I have already described. They both have about them a wholly unromantic realism – in the way the discarded clothes are scattered around, for instance – which seems to deny any suggestion of sexual provocation in either case. Again, we encounter Impressionist detachment, though whether as a statement of principle, or a protective device, or both, it is impossible to say.

Caillebotte's man drying himself after a hot tub brings us, ironically, right back to Degas and all his female bath-takers. What, if anything, does the Caillebotte tell us about them? Very

155

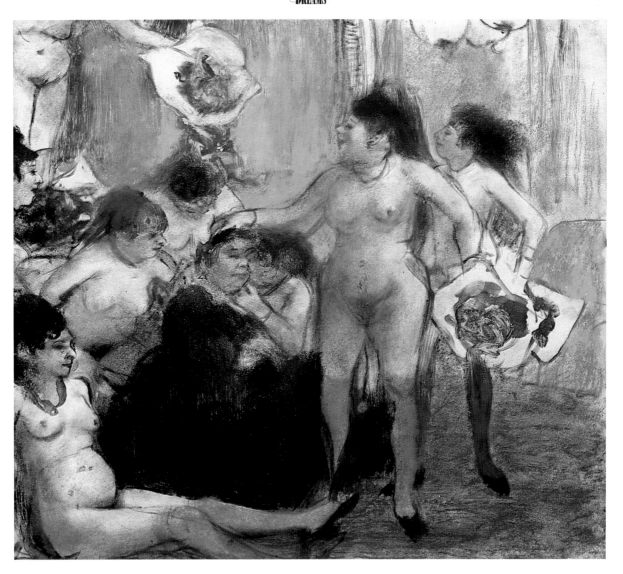

EDGAR DEGAS
The Madame's Birthday, 1876-7
A mong the jollier of Degas's in general very jolly scenes of life in a brothel,
which concentrate mainly on the business and the bonhomie of the situation.

little, no doubt, about the fact of them, but something perhaps, about their spirit. It is to be noted at once that while Caillebotte's bather is a one-off, a single experiment in his work (whereas he quite frequently painted in series, or handled the same theme from various angles), Degas's bathers and related themes, like the women combing their hair, recur frequently over a long period. In other words, they tend overall to lose their immediate connotations as an exceptional subject, and become instead a motif, like the horse races or the dancers or the washerwomen. Naturally one can ask why this motif and not that – what first attracted Degas's attention to the theme of women washing themselves, drying themselves, in the tub or just out of it? If it was merely a formal pretext, why women and not, say, men? Some feminist critics (though not all) have a ready answer for that: because, of course, he was a man, bound to treat women reductively as sex-objects, and the whole process was, to use some of the terms the earliest critics used,

'humiliating' and 'demeaning' – perhaps even more so the further his scrutiny gets from basic sexual excitement, as the women therefore are reduced more and more to objects.

There is a catch to this reading, however. If it is true of the bathing women, why is it not also true of the horses and the jockeys? Maybe it is, but not even animal rights compaigners care enough to remark on the fact. But also, if we remove the subject – or allow that the subject removes itself – from the field of sexual politics, then surely in another way it is also defused. Even if we admit that there was a sexual component in Degas's initial choice of the subject, sometime in the 1870s, can it still be there with full (reprehensible) intensity thirty years later? The bath pictures are particularly important to our study of Degas's motivation because they stand in a sense about midway between the ballet pictures and the brothel pictures, with which they were at first closely associated. What applies to one group may well apply to all. And we have to ask ourselves

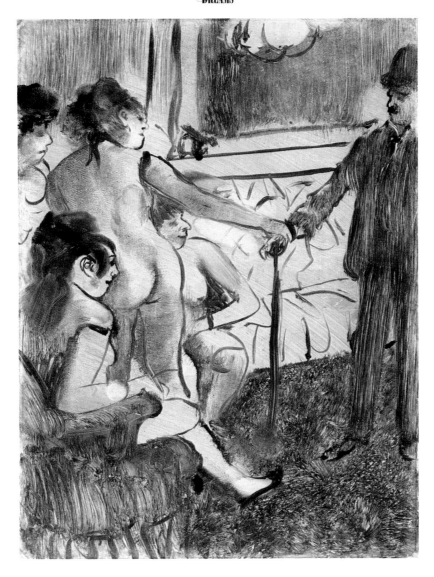

EDGAR DEGAS
The Serious Client, 1876-7
Another cheery scene, in which the girls show off their wares and the potential
customer, in respectable beourgeois dress, solemnly appraises them.

whether, with the bath pictures and ever more with the brothel pictures, we are not letting our own prejudices and received ideas get in the way of clear vision? If we suspect an openly sexual element in them, does that necessarily make them special or automatically remove them into a different class of experience?

To start with the pictures of ballet-girls at work. Most people would think it unduly simplistic to see in them pictures of sexually attractive girls, and look no further for their *raison d'être*. It must be just as important to Degas that they work in the ballet as that they are girls: the ballet, after all, provides a ready-made formalized vocabulary of movement, which already abstracts the participants from everyday humanity. It is this formalized vocabulary which seems particularly to fascinate Degas and provide the material of his art: the girls themselves are rather like machines, or lay-figures on which the artist can experiment, endlessly making and remaking patterns. We do not in any way have to assume that Degas paints these pictures because he had a ballet-girl as a mistress or lusts after ballet-girls in general (any more than we have to assume that Caille-botte lusts after his *raboteurs*.)

From there it is a small step to seeing the gestures and positions associated with the business of taking a bath as another vocabulary of movement, not yet so formalized or formularized as that of the ballet, but susceptible of arrangement and classification. And that seems to be precisely what Degas is doing: certain movements of the figure drying herself fire his creative imagination in the same way that certain movements of the horse in the paddock or on the race-track fascinate him. It is inevitably a matter of subjective response, but given the formulaic provocativeness of the subject-matter – a convention like any other – we might surely not be too far from the mark in seeing the method in Degas's metier as a deliberate reduction of irrelevant sexual responses until the bathers are apprehended

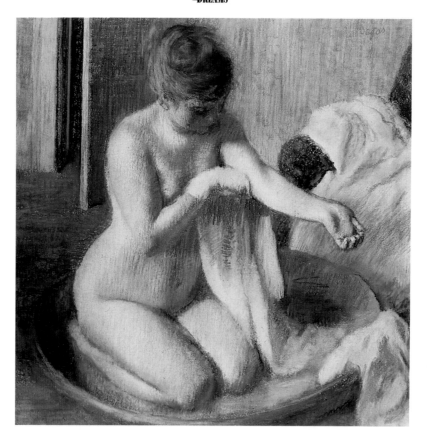

EDGAR DEGAS
After the Bath, c. 1885
Another favourite variation was the combing and dressing of the hair after a bath, either by
the bather herself or by a maid. Again this gives rise to all sorts of formal explorations.

as pure form, pure movement; as objects like the parts of a Calder mobile.

Where does that leave us in relation to the brothel monotypes Degas made probably around 1876-77? Because of their location, it is presumed these must be central to any consideration of the role of sexuality in Degas's work. It has been suggested that he was (perhaps unconsciously) homosexual, and that he was impotent, either throughout his life or in later life as a result of venereal disease contracted in his youth. We are reasonably certain that he never had a mistress after 1870, and that his behaviour towards his ballet-girl models was a model of propriety. So what was he doing, in his early forties, frequenting brothels? Erotic obsession and impotent voyeurism have both been postulated, but in the face of the works themselves neither seems quite right. For one thing they are extremely good-natured, and sometimes downright funny. It seems that a contemporary critic – if Degas did indeed exhibit some of the series in the third Impressionist exhibition 1877 – compared them with Goya and observed that the comparison was precise because 'The Spanish master's horrors of war are no stranger than the loves M. Degas has undertaken to depict in painting and print,' with the implication that they were to be looked on with pious horror or at least careful disclaimers of familiarity. But in fact there is little suggestion of anything but cheerful acceptance in Degas's attitude.

It looks very much as though Degas actually enjoyed the company of the girls, and the atmosphere of the *maison close.* The feeling is much more of Maupassant's companionable *La Maison Tellier* than the systematic degradation of the Goncourts' *La Fille Elisa* or Huysmans' *Marthe,* both of which searing accounts of prostitution had come out in the previous six months. Goings-on in these brothels seem actually (if reprehensibly) jolly. The girls chat, lounge around, pose for serious customers, celebrate the patronne's birthday (nude, with flowers) and sometimes sleep intertwined, for all the world as though they have taken hints from Courbet's famous *Le Sommeil.* But this comparison also shows the difference: Courbet is certainly erotic, with hardly concealed sapphic suggestions: Degas is chummy, comfortable and rather matter-of-fact. Perhaps the key to the mystery is in something he once said to one of his models: 'It's true, I've had the sickness, like most young men, but I have never made love very much.' Everything falls into place if we assume that, dandy, sophisticate and man-about-town as he was, he was not necessarily either homosexual or physically impotent, but merely, like a surprising number of men, not particularly interested in sex. If he had married, at a reasonable age, a woman who would run his house for him, bear him a child or two and supply his (possible minimal) sexual requirements, nobody would have raised the question.

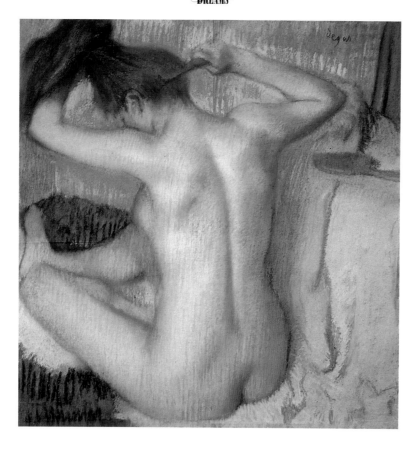

EDGAR DEGAS
Woman Drying Herself, c. 1883
A pastel from the long series in which Degas drew the subject of women taking baths, getting into
them, getting out of them, drying themselves and so on until the subject became just a formal excuse.

But was he also, in some way, kinky? The correspondence of pose between one of the brothel drawings and a study of the much earlier – and much stranger – picture *Scène de Guerre au Moyen Age* (1865) raises as many questions as it answers. On the one hand it tells us that even in a brothel his abstract pre-occupations with particular poses and gestures remained intact. On the other, it does make us wonder in what spirit the earlier picture was undertaken. It does look suspiciously like a sado-masochistic fantasy disguised as respectable history: the allegory (it must be) involves a group of horsemen shooting arrows at naked women in the road and trampling them under their horses' hooves. Misogyny? Impotent fury? Beady-eyed sadism? That way madness lies.

It only remains to glance at the work of the women Impressionists to see if it contains any apparent evidence of sexual motivation. Whether or not the blue-stocking Mary Cassatt had lesbian tendencies, we cannot distinguish anything of the sort in her paintings and prints, even though they are mostly of women and children. Emotionally she seems to have been entirely bound up with her family, and her close platonic friendship with Degas (however that may be read) seems to have encouraged her particularly in that kind of precise, incisive draughtsmanship which of its own accord distances the subject by converting it into self-sufficient art.

Berthe Morisot had great difficulty in persuading her husband Eugène Manet to sit for her even once, and for the most part concentrated on her daughter, her household and her women friends, probably because they were close at hand and easy models to find at leisure. Marie Bracquemond had personal-cum-professional difficulties enough in her marriage with the rabidly anti-Impressionist painter/etcher Félix Bracquemond, and eventually gave up her own art altogether. Most of her works, too, show what was considered at the time to be a self-evident woman's world, undisturbed by sexuality, though her grown-up son Paul in one of her latest-executed paintings has a definite sexual presence. It was not until Suzanne Valadon, who progressed from being a model for Renoir to being admired as a painter in her own right by Degas, that we find a woman interested in painting male nudes (of her own son Utrillo and others), or at least who dared to do so. But then Valadon's mature painting is definitely Post-Impressionist, and so belongs to another chapter in the history of art.

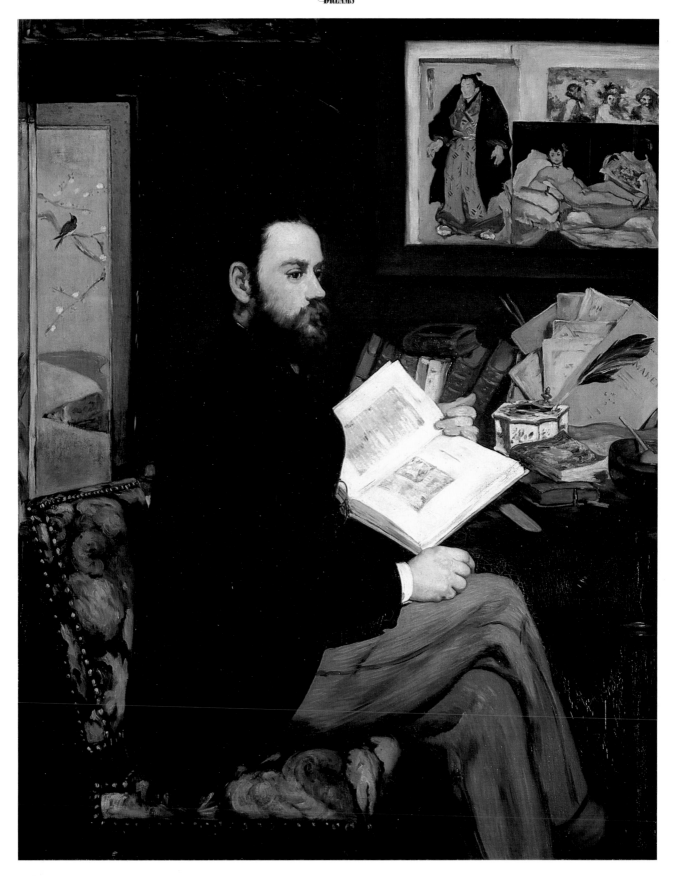

EDOUARD MANET
Portrait of Emile Zola, 1868
Zola, a close friend and supporter of Manet, is shown in his study surrounded by indications of his career as a
writer, his taste in art (including Manet's, to judge by the reproduction of "Olympia") and his personal character.

12

THROUGH OTHER EYES

*This photograph by Dornac seems to show Zola at much the
same period in his life that Manet painted him.*

ISCUSSING MANET'S LATER PICTURES OF
clothed women with just their breasts bared,
I remarked – snidely perhaps – that they had
good iconographical precedent in Tintoretto.
That comment is not so irrelevant as it prob-
ably seems: the Impressionists, for all the
parade some of them made of rejecting the
artistic past, were seldom as ignorant or uninterested as they
wished to appear. They were likely to be aware of precedents
for what they were doing, and to have their imagination
sparked by the work of previous artists (either in emulation or
in deliberate contradiction), and their way of seeing influenced
by what other artists had done or by the recent revelations of
photography. They might wish it to be understood that every-
thing in their work was the product of an unmediated con-
frontation with the subject before them, but as a rule this was
not the case.

The Impressionists, after all, could not but belong to their
period, however much they might consciously react against
their cultural surroundings. As a group, they were friendly with
some of the important figures of literary Naturalism, among
them Zola and the Goncourt brothers. Their own works, and
their attitudes to the depiction of reality, were inevitably com-
pared with the Naturalists – Zola, Huysmans and the Gon-
courts, all of whom wrote art criticism from time to time, were

enthusiastic supporters in print, and some of the Impressionist
milieu appeared, lightly disguised, in Zola's novel *L'Oeuvre*
(1886), not entirely to their pleasure. Sometimes they did
demonstrably undergo literary influences: Degas made illustra-
tions for his friend Halévy's *La Famille Cardinal* – not, admitt-
edly, the height of literary Naturalism, Manet illustrated Edgar
Allan Poe's *The Raven* and Cézanne was obsessed for a decade
with Flaubert's ornate morality *La Tentation de St Antoine,* both
of which seem more appropriate inspiration for symbolists
than for ruthless realists. But by and large, considering the
decidedly literary circles in which they frequently moved, the
Impressionists' art must be admitted to be remarkably un-
tainted by literary concepts and effects.

Not so when we consider their relations with the work of
other visual artists of previous generations and their own day.
It must be remembered that all of the Impressionists were to a
greater or lesser extent academically trained. And a great deal
of academic training at that time consisted of copying the art of
the past and absorbing its messages. Virtually all the Impres-
sionists have left behind masses of student sketches in which
they extracted, to the best of their ability, the essential from
plaster casts, the works favoured by their teachers and the art
as well as other things they saw in their travels. Even if most of
this was consciously rejected afterwards, it was bound to enter
their system in some covert way. In any case, there is no work

161

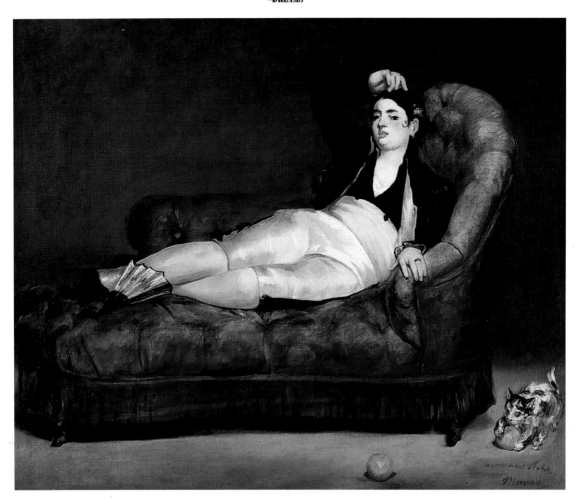

EDOUARD MANET
Jeune Femme couchée en Costume Espagnol, 1862
The pose here suggests Goya's famous paintings of the Maja dressed and undressed – another of
Manet's Spanish enthusiasms – but the cat playing with an orange is a more personal touch.

so inane and despicable that something cannot be learnt from it or something useful found in it. Also, not all the Impressionists adopted, even early on, an intransigently revolutionary stance. Monet and Degas in particular persisted, if only to annoy, in finding good qualities even in Ingres, the favoured bogeyman of the time, and certainly much to appreciate in the art of the Renaissance masters.

Of them all, Manet was the one most soaked in the past, most informed in his awareness of other artists' visions and technique. By now we all know that the main part of the composition in *Le Déjeuner sur l'Herbe* is based on a Raphael design for a Judgement of Paris. But there are other sources beside that: Manet has also carefully examined the *Fêtes champêtres* of Watteau, and no doubt also the *Concert Champêtre* in the Louvre then believed to be by Giorgione and now thought to be partially or wholly by the young Raphael – which was also an influence on Watteau in his day. Far from being a simple

slice of bohemian life as Manet might have known it, the picture emerges, for all its originality of tone and substance, to be a surprisingly learned work, full of reference and allusions that it would have taken an art historian to disentangle fully. We do not know for sure whether Manet wanted or expected them to be disentangled; some of them, one presumes, must have been in the nature of a private joke, but others might incidentally have helped recommend the work by indicating to the timid that the painter was actually situated in an established tradition and clearly conscious of what he was about.

What is true of *Le Déjeuner sur l'Herbe* is also true of many other of Manet's early works, and a surprising number of his late. To begin with, the influence of the Spanish school of painting, then the height of fashion in French artistic circles, is paramount. Some of Manet's paintings look like direct imitations, and are: *Le Gamin au Chien* closely based on Murillo, for instance, or numerous echoes of Velazquez and Goya.

162

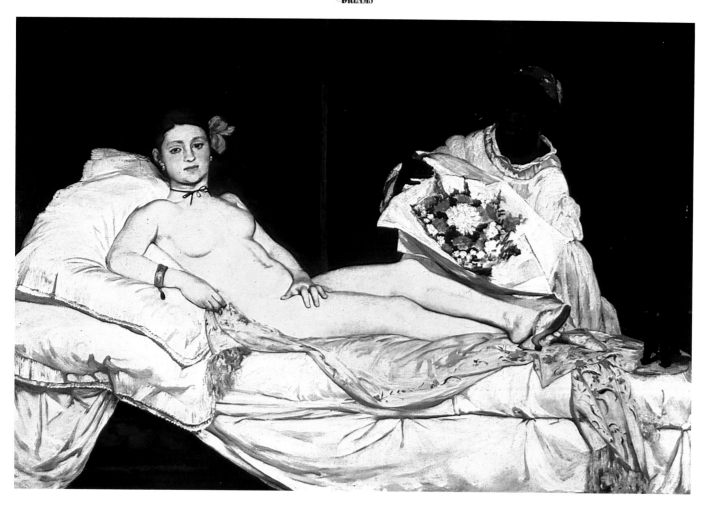

Olympia, 1863
One of Manet's most controversial works when it first appeared in the Salon of 1865 – mainly on moral grounds,
since the nude had no mythical excuse and carried strong suggestions that it represented a modern courtesan.

Others look like it but are not: *Le Chanteur Espagnol*, for example, is actually based more nearly on a Greuze of a mandolin-player than on any precise Spanish precedent. And not only Spanish and French predecessors are laid under tribute: Rubens seems to be the principal source of *La Pêche* (1861-63), Rembrandt may be in the background of *La Nymphe Surprise* (1859-61), and if *Olympia* herself suggests some reference to Goya's *La Maja Desnuda*, she undoubtedly has even more to do with Titian's Urbino Venus.

These little tributes to the art of the past in Manet's work are curious, but not very important in themselves, except for the light they throw on his evolving creative processes. More than any of the other Impressionists, he began as a traditionally formed painter, with the traditional goals of acceptance by the Salons and the academic hierarchy. His refusal to exhibit with the Impressionists was because he mistrusted rebellion as such; later it was because he thought it strategically sounder to try to

take over the establishment from the inside, in a sort of Trojan-horse campaign.

This shift of purpose corresponds with a shift in his approach to the making of art: in 1874 Manet spent some time in Argenteuil, painting with Monet and Renoir, and was bowled over by the possibilities of painting in the open air, directly and spontaneously from what he saw in front of him. He did not thereafter go over completely to *plein-air* painting, preferring to make notes and sketches in streets and bars, and then work them up in the studio (which was actually what even the most intransigent *plein-air*ists like Monet often did, whatever their publicity might suggest), but from that point he more or less threw away his collection of models and precedents, stopped trying to see the subjects of painting refracted through other artists' experience, and concentrated on seeing them through his own. Of course, his knowledge of art history and earlier practice was deeply embedded, but it seems likely that

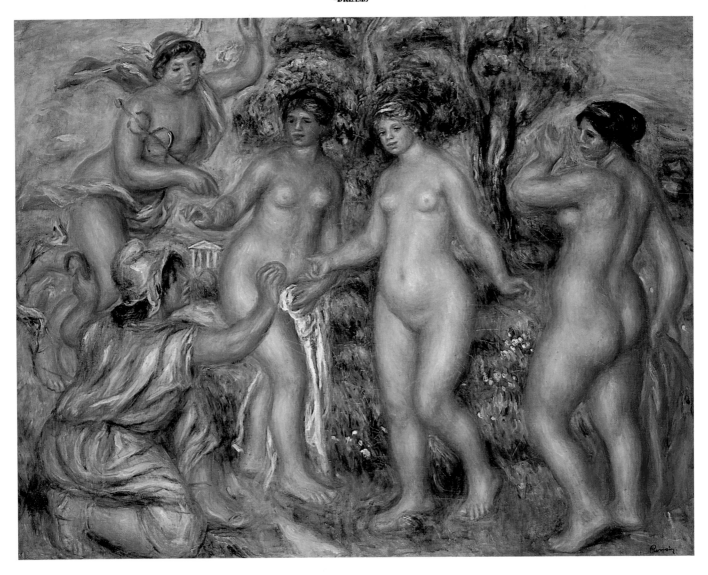

PIERRE-AUGUSTE RENOIR
The Judgment of Paris, 1908
By the time Renoir painted this no clasical excuse was needed for female nudes –
which was perhaps why he decided, mischievously, to provide one.

the connection between the *Blonde aux Seins Nus* of 1878, or even the *Brune aux Seins Nus,* probably painted around 1871, with Tintoretto was quite unconscious, rather than a deliberate attempt at emulation.

The Tintoretto might well have been at the back of Manet's mind anyway as a result of his visit to Madrid in 1865; he would very likely have seen it in the Prado where, like any cultivated traveller, he spent some time. The obvious connection between Renoir's 1914-15 *Judgement de Paris* (or even his simpler 1908 version) and the Rubens treatment of the same subject in the Prado presumably derives from a similar experience, when Renoir visited Madrid in 1892 and was particularly impressed by the works of Velazquez in the Prado. The disposition of the figures and the general composition of the Renoir are too close to the Rubens for it to be entirely by chance, but on the other hand Renoir was not the same kind of intellectual as Manet, and it is clear that he has taken in the superficial appearance of Ruben's treatment without understanding – or probably being at all interested in – the visual rhetoric and the baroque drama on which the painting is based. Undeniably by 1908 the process was entirely instinctive, and what he turned to for inspiration was not the vision of others, but his own hazily erotic dreamworld, where luscious nudes disported themselves timelessly in vaguely classical fantasy landscapes.

If Renoir seems like an improbable painter to be affected in this way by classic art, Cézanne is in certain respects even more so. Not in this case because he was lacking, as Renoir seems to have been, in intellectual equipment, but rather because in his mature years his intellect seems to have been entirely inturned, strenuously arguing out solutions to his own private questions about the rendering of visual experience in paint. Even there, though, it is likely that one will make comparisons, however remote, between the long series of major composi-

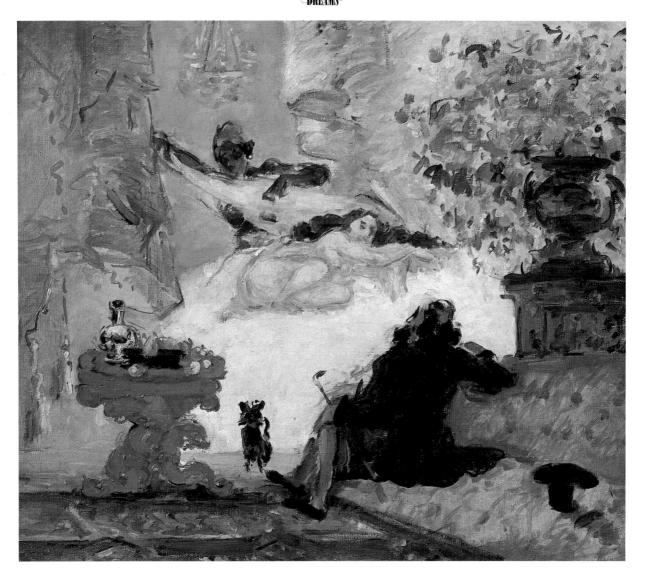

PAUL CÉZANNE
A Modern Olympia, 1873-5
One of two variations that Cézanne painted on Manet's "Olympia", perhaps with ironic intent. Certainly he
makes the implications of the Manet very clear by adding the figure of the observer/client.

tions Cézanne devoted to *baigneuses* – getting more and more abstract through the years – and numerous treatments of multiple nudes in baroque painting. Any lingering doubts as to whether Cézanne would actually have been conscious of these predecessors can be readily dispelled by reference to the sketches he made as a student, which are full of figures and details derived from a study of Rubens, Raphael, Veronese and others. We have also already noted that in his paintings of the 1860s Cézanne at least twice elaborated his own compositions as comments on or critiques of paintings by Manet: in *A Modern Olympia* and in *Le Déjeuner sur l'Herbe*.

But on closer examination, many more of these early works prove to be Cézanne pouring his own unruly imagination into a vessel originally fashioned by someone else, with the inevitable results of disruption, dislocation and general confusion – though since Cézanne was a great artist, at least in the making, his confusion is itself creative, producing new and intensely

personal effects. This is true even when Cézanne is making a direct copy: it is revealing to compare his 1864 copy of Delacroix's *La Barque de Dante* with the two of the same painting made by Manet in, probably, 1854 and 1859. Manet's first version is very sober and respectful, copying Delacroix's technique almost as much as his composition; only in the second, made about five years later, do we get a hint of Manet's own mature style imposed on Delacroix. Cézanne, on the other hand, though he does not take any obvious liberties, at once begins to make Delacroix over, importing his own vibrant sense of colour contrast, his own apparently awkward way of applying paint which yet allowed him to do whatever he wanted to do with it.

More significant, of course, are the pictures in which Cézanne appropriates something from another painter without direct acknowledgement and makes it his own. A striking example of this is (or more precisely was) *Le Christ aux Limbes*

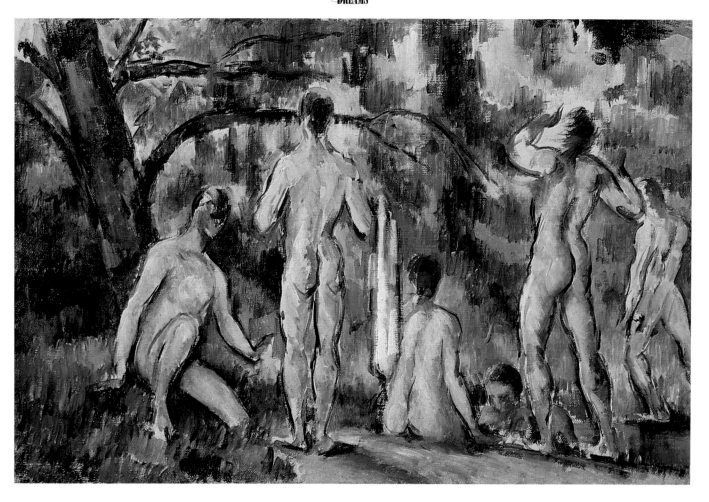

PAUL CÉZANNE
Bathers (Five Men), 1892-4
Alongside his series of paintings of female bathers, Cézanne did an almost as extensive series of male
bathers, though oddly he hardly ever mixed sexes – perhaps to keep any suggestion of erotic intent at bay.

et la Madeleine of c. 1867: 'was' because the two halves, admittedly very strangely proportioned in relation to each other, with the Magdalen seemingly gigantic in close-up on the right and Christ much smaller in the middle distance on the left, have now been separated. The left half of the picture is quite closely based on a picture of the same subject by Sebastiano del Piombio in the Prado, which Cézanne would just have seen in reproduction, while the right half, as far as we know, has many analogues but no precise source. The eccentric combination is of course Cézanne's own.

Another painting of about the same time, *La Toilette Funéraire,* is presented as a contemporary, even a realistic subject, but it is founded on a drawing for an *Entombment* by Fra Bartolommeo in the Louvre which Cézanne had copied as a student. And it is evident that in the colour treatment of his Feast/Orgy painting, as well as in the concept of the banquet itself, there must be some detailed study of Veroneses such as the *Wedding*

Feast at Cana he must have known from the Louvre. Such observations on sources have little to do with aesthetic judgment, any more than the information that in 1871 Cézanne (curiously anticipating Sickert) did a couple of paintings based on popular fashion plates of the time. But it is useful to have chapter and verse for a feeling occasioned in Cézanne's later work that something lies beyond the scene, that an artistic ghost is somewhere present, interposed between the man and his mountain.

Influences undergone in youth are often bizarre and unpredictable. Who would expect, for example, to find the austere Seurat, shortly after he left art school, not only doing a quick copy of Puvis de Chavannes's latest work (which could make sense, since Puvis, though no Impressionist, was hardly either a conventional academic) but producing an elegant variation on the theme most famously handled, at about the same time, in Paul Baudry's kitsch best-seller *Truth Emerging from the Well?*

166

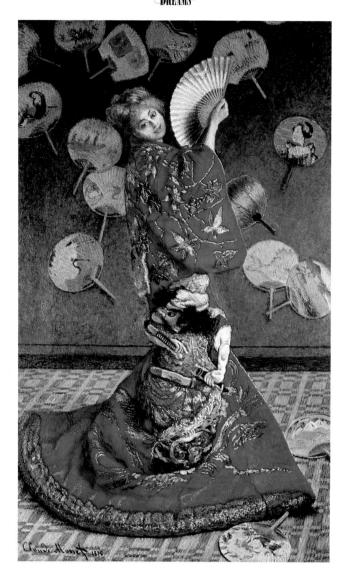

CLAUDE MONET
Japonnerie, 1875-6
*Also known as "The Japanese Woman", this picture is Monet's clearest
homage to Japanese vogue which swept fashionable Europe at this time.*

Baudry was one of the two principal muralists commissioned to decorate the new Paris Opéra; the subject was quite frequent in French academic art of the mid-nineteenth century, but the idea of Baudry and Seurat being in this sort of competition is extremely weird. It is not, on the other hand, so surprising that Caillebotte, in so many ways the odd man out among the Impressionists, should inspire comparisons with the more academic painters of his day, especially the social painters such as Tissot, who was a close friend of Manet and Degas, despite their ideological differences. The gap, clearly, between the Impressionist non-conformists and the successful conformist art of the time is not always as wide as both sides tended to see it.

Where Caillebotte does seem to be working under a new influence, according to a way of seeing things and organizing space previously unknown in Western art, is in what he derives from the study of the Japanese woodblock print. These first made their appearance in Paris around the end of the 1850s

(Monet in later life said he bought his first example in 1856) and very rapidly became all the rage. Collectors were for a while obsessed with everything Japanese: prints, fans, blue-and-white china, lacquer. The spirit is well conjured up in Monet's portrait *La Japonaise,* where a perfectly Western-looking blonde is dressed in a very elaborately decorated kimono and holds a fan, posing against a background scattered with fans. But artists well before that (1878) had begun taking Japanese artistic ideas as represented in the better prints very seriously indeed – Monet amassed a considerable collection of the prints, but so did several other Impressionists, and the influence was felt to some degree by them all. However, as has been said frequently since the critic Ernest Chesneau first said it in the year of the *La Japonaise,* it was not a matter of seeing things submissively through the eyes of the Oriental artist. The prints would only make sense and be of use if they clarified or pushed further some idea a Western artist already had.

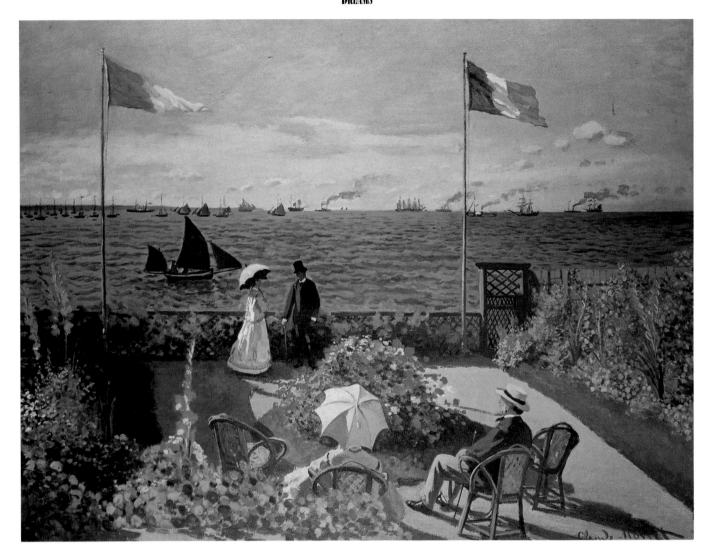

CLAUDE MONET
The Terrace at Sainte-Adresse, 1867
The terrace was in front of Monet's parents' summer house by the sea and here he admittedly imitated
Japanese prints' suppression of evidence of perspective to produce a flat, formalized pattern.

Sometimes the artists recorded the inspiration in rather un-likely places. Left to ourselves, we probably would not think of Monet's painting of his family by the seaside, *The Terrace at Saint-Adresse* (1867), as a particularly Oriental-looking picture, but at the time he called it his 'Chinese painting with flags in it', and when we look more closely we can see that he does strange things with perspective, by constructing his scene in bands which appear to run parallel – the edges of the garden path, the top of the fence, the horizon – and suppressing as far as possible or deliberately distorting the evidence we would expect of recession. And one should not assume, even when there is close similarity between a specific Japanese print and a particular Western landscape, that imitation was the point, but rather that the print liberated the artist's mind and opened his eyes to the possibilities of a landscape which earlier generations would have dismissed out-of-hand as hope-lessly inartistic.

Certainly the Japanese influence worked differently on dif-ferent people. For Monet it liberated his sense of what con-stituted a satisfactory and balanced composition, licensing asymmetry and the crowding of what one would expect to be the focus of interest towards the edge of the canvas. It also in-tensified his interest in the painting as a flat, diffused, dec-orative pattern, which found its logical conclusion in the late water-lily pieces painted in his water garden (itself inspired by Japanese models) at Giverny. For Caillebotte it enabled him to keep his interest in perspective and recession intact, but to push it further, tilting his floors dizzyingly to an unexpectedly high horizon or using the oddities of proportion sometimes created by perspective to real emotional effect (emphasizing, for instance, the smallness and fragility of the boat down in the water as against the solidity of the oarsman on the shore, or re-ducing the pedestrians in the street below, viewed *en plongée*, to curious insects under a microscope) in a way which would

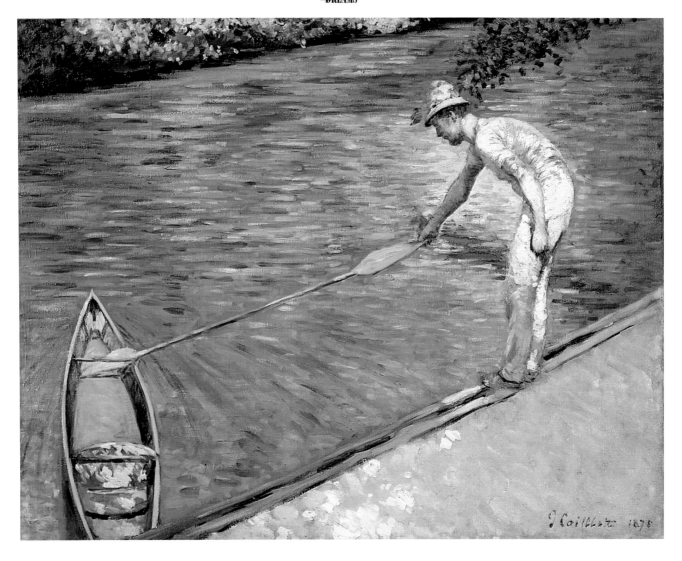

GUSTAVE CAILLEBOTTE
Oarsman pulling in his Boat, 1878
Again, clear evidence of oriental influences in Impressionist painting: the odd, off-
centre composition indicates a close acquaintance with Japanese woodcuts.

have been unthinkable before, when such phenomena, even if observed in life, would have been instantly 'corrected' before being put on canvas.

Traces of this Japanese influence on the Impressionists' way of looking can be seen all over, in practically every Impressionist. But probably the most radical examples are to be found in the work of Degas. Degas had initally a rather similar scholarly approach to that of Manet: he spent a lot of time when young touring Italy copying the old masters, and also underwent a thorough academic art education drawing from plaster casts and studying the techniques of the classics. The main grounds of his violent reaction to all of this seem to have been realistic: he did not like the deadening conventions of the then dominant schools of history painting, and set himself determinedly against them. In this respect, *Petites Filles Spartiates provoquant des Garçons*, in which he dared to treat a traditional type of subject in a wholly modern and realistic way, was one of his most

daring works, flying in the face of the 1860s art establishment – though he later tended to dismiss it as unimportant.

This means that the influence of the classics – apart from the effect his training had in forming his brilliant, incisive draughtsmanship – was almost entirely negative: he worked from them by reaction. The Japanese influence, however, was something positive to put in their place: a refreshing new way of looking at things which at the same time gave definition to something he was already reaching towards. If we look for the exact place when Degas as we know him starts, it must be between his last history painting, *Scène de Guerre au Moyen Age* (1865), and two astonishing portraits, painted at almost the same time, where we seem to enter a different world. And it is extremely doubtful whether either *Portrait de l'Artiste avec Evariste de Valernes*, squashing together its oddly posed figures against and below a challengingly empty background, or *Femme accoudée près d'un vase de Fleurs*, which pushes the

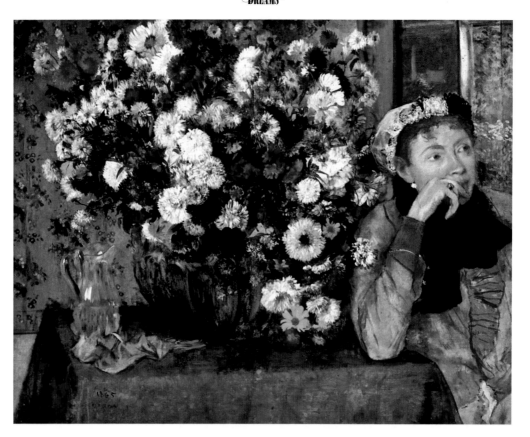

EDGAR DEGAS
Woman leaning by a Vase of Flowers, 1865
*Japanese influence took many forms. In this case Degas's radical rethinking of the whole portrait idea, pushing
the figure over to one side as though the picture is primarily a flower-piece, must owe a lot to oriental sources.*

woman portrayed right over to the right-hand third and partially off the canvas, could possibly have been conceived without influence from Japan. The *Femme accoudée'* is certainly radically different from a Courbet of 1862, *Le Treillis*, with which it has been compared: the Courbet shows a young woman working elegantly on a trellis full of flowers, and lacks completely the delicate balance-within-dislocation of the Degas – and of many a Japanese print.

The boldly asymmetrical and arbitrarily chopped-off were to become inescapable characteristics of Degas's work for the rest of his life, reaching their extreme, perhaps, in the lost *Place de la Concorde*. But that picture has raised another hare to go bounding across Degas studies: the importance to him of photography. For it has been argued that while the Vicomte Lepic's unheeding progress towards the right of the picture and the unconnected spectator cut in half to the left probably owe a lot to Japanese ways of doing things, they could equally well derive from the arbitrary, fragmentary effects of the high-speed snapshot, with its claims and appearance of giving an unadulterated slice of life. True, by the early 1870s the use of photography as an aid to artists was no longer a novelty: for that matter, both Ingres and Delacroix had used it. And by the 1870s technique had developed far enough for this sort of instantaneous street snapshot to be possible. But there seems to be little evidence the Impressionists took much interest in it.

Manet was a friend of the photographer Nadar, who took portraits of practically everybody who was anybody in the Second Empire and the Third Republic. But Manet seems to have seen photography as an adjunct to art primarily in terms of a means of recording art works, aiding in their reproduction, and occasionally as a substitute for a sketchbook. Degas seems to have had much the same attitude. There are photographs of him and his circle, joky or serious, but though there are many examples of his using a monotype as a basis for further work with watercolour or pastel, there does not seem to be (what there well might be) an example of his using a photograph in the same way. And it is remarkable that when he himself took up photography with enthusiasm around 1896 he manifested no desire to catch reality as it flew; rather, he persisted with old-fashioned tripod, plate photography, setting up careful compositions with posed models by artificial light. Many of his photographs were characteristically posed portraits or portrait groups, but there are also pictures of nude models assuming some of the more extreme poses of his late bathers: they are, as it were, photographic reconstructions of his inner vision, rather than inspirations to a new way of seeing things.

Earlier in his career Degas used photographs in his work in a careful, conservative fashion. He could see the potential usefulness of the photograph for recording how someone looked in a way which could subsequently, more or less inventively, be

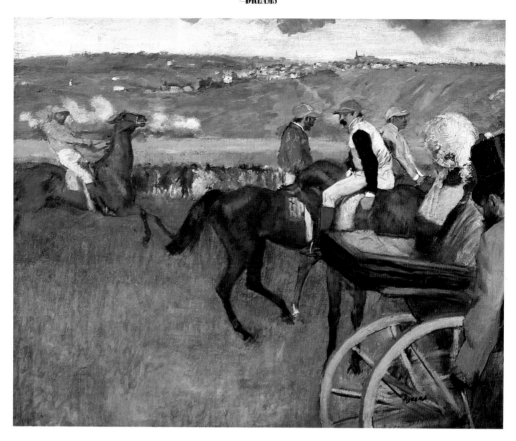

EDGAR DEGAS
A Carriage on the Course, 1877-80
One of Degas's curiously cut-off compositions (particularly the figure of the man to the right)
gives a strong sense of movement, a moment captured from the flux of time.

transformed into a painted portrait. His *Portrait de l'Artiste*, (1863) which shows Degas hat in hand, appears to be closely related to a *carte de visite* photograph, though it is by no means a simple transcription. The portrait of the Princess Pauline de Metternich (c.1861) is even closer to its admitted origin in one of the photographer Disderi's *cartes de visite*, which shows the princess posed and dressed exactly the same as in the painted portrait, but arm-in-arm with her husband, whom Degas has neatly eliminated. This documentary use of the photograph, parallel to the use academic Orientalist painters were beginning to make of photographs of the Middle East (often published in portfolio specifically as an aid for artists who did not wish to visit the locations themselves) is useful and legitimate enough no doubt, though even today the debate continues. But no one then or since could maintain that it was very interesting, or made any important modification to the way the painter might see his subject.

More noticeable, and more productive of creative excitement in the artist, was Degas's reception of Eadweard Muybridge's 1887 photographic book on animal locomotion. We have seen that in his early horse-racing pictures Degas painted galloping horses the way that generations of sporting artists before him had done; the naked eye could tell him no more accurately. In

1872 Etienne-Jules Marey published in Paris his researches into animal locomotion, which brought him to some unexpected conclusions about the movement of horses. This paper inspired Muybridge in California to attempt unassailable photographic proof of Marey's observations, which he actually achieved,in a rather primitive and blurry form. By the time he published his book in 1887 he had improved his technique enormously. Degas was enthralled, and immediately embarked on a whole new series of horse pictures using the new insights he had got from it. But again the use is really documentary: Degas was a great believer in direct observation as the starting point (but only the starting point) of art. Muybridge's photographs were a sort of direct observation of which Degas's unaided eye was incapable, and he used them as he would his own on-the-spot sketches, without hesitation, embarrassment or apology. They changed or extended what we could see – as the Middle Eastern photographs extended what stay-at-home would-be Orientalist artists could see – but it is doubtful whether they really changed how he saw it. Not, surely, to anything like the same degree as the economic graphic style, the bold foreshortening, the elimination of much that Europe had thought necessary since the Renaissance, which he and the other Impressionists had found in the Japanese print.

171

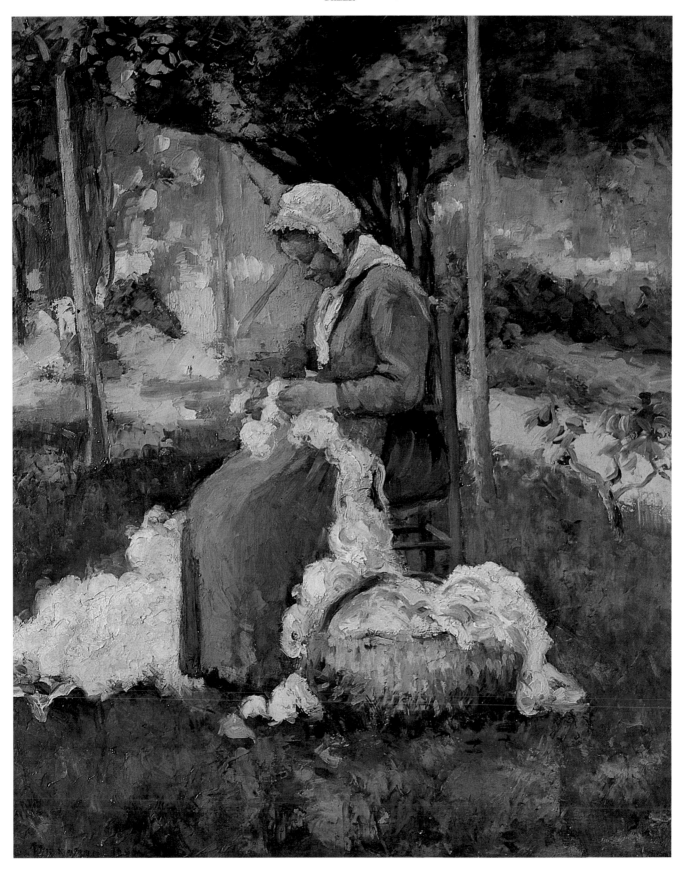

CAMILLE PISSARRO
Peasant Woman Carding Wool
Pissarro many times painted the peasants he lived among in Eragny, usually with little or no
sense of the quaintness many of his fellows found in traditional rural activities.

13

THE HEART OF REALITY

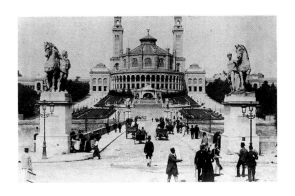

*The Trocadero was built for the 1900 Exposition. It was
replaced in 1937 by the Palais de Chaillot.*

THE SO-CALLED IMPRESSIONIST REVOLUTION IN
French art provoked so much excitement
and attention, then and since, that we forget
that it was not the only revolution going on
at the time. Art in general was in ferment,
and as political changes came fast upon one
another at the end of the 1840s and again,
even more violently, at the end of the 1860s, the artistic estab-
lishment found itself under attack from many sides: the Im-
pressionist side was just the most aggressive and
confrontational. The other two main lines of attack, what we
might roughly call the Realist and the Symbolist, in their way
constituted no less of a threat to the status quo, but on the
whole made less fuss about it and therefore often seemed – and
benefited from the seeming – merely to be proposing a few
minor modifications to the accepted norms, rather than want-
ing to change things completely. As so often, what things were
perceived to be had a lot more effect than what they funda-
mentally were.

The Realists made more of a bang. The great issue in official
artistic circles in the early 1860s, when most of those later to be
known as Impressionists were art students in Paris, was still the
argument between supporters of Ingres, the great Classical
painter, and those of Delacroix, the extravagant Romantic. This
debate, somehow arranged in terms of line against colour, was

a largely technical issue, with little reference to subject-matter.
But subject-matter was also in question. The first *cause célèbre*
was in 1855, the year of the first Exposition Universelle in Paris
on lines laid down by the Great Exhibition of 1851 in London.
This included, naturally, an official Salon of French art. And
the great independent Gustave Courbet had two important pic-
tures rejected (though others accepted). He promptly hit back
by setting up a small wooden 'Pavillon due Réalisme' just out-
side the official building, to show the rejected works, realistic
pictures of his native town, Orléans.

Courbet's very existence as a professional painter was a chal-
lenge to academics: coming from a comfortably placed farming
family, he had failed to get into the Ecole de Dessin at Besan-
çon, a leading provincial centre of academic training near his
home, and was largely self-taught. Moreover, though many
of his subjects came within the confines of acceptable genre
painting, with enough of a story-telling element to capture
the attention of the unspecialized bourgeois public, they also
contained enough cussed, self-advertising realistic obser-
vation, vigorously unidealized, to shock and alarm both the
Classical and the Romantic factions in the establishment.
The grounds of criticism were often formulated as coarseness
and ugliness of workmanship, but essentially it was a matter
of subject – what was fit to be painted and what was not.

This controversy was still flourishing when Manet's *Le*

173

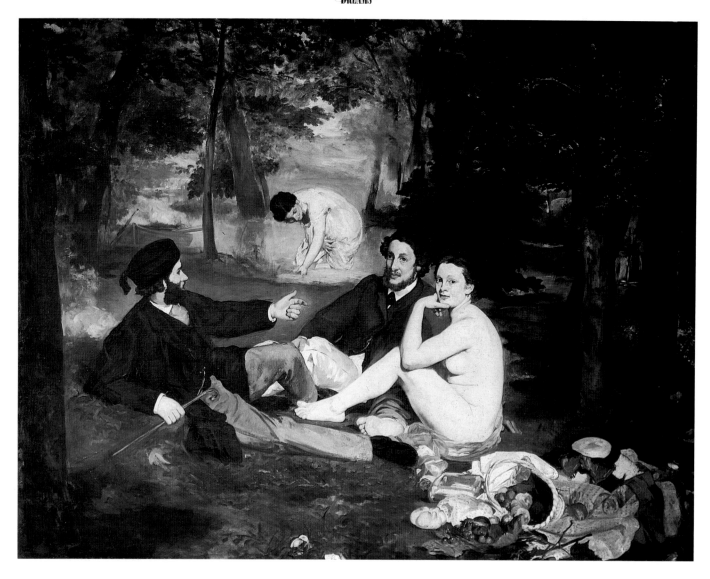

EDOUARD MANET
Le Déjeuner sur l'Herbe, 1863
The first great sensation of Impressionism; the painting which so shocked conventional opinion with its mixture of
men in modern clothes and nude women that it almost single-handed enforced the setting-up of the Salon des Refusés.

Déjeuner sur l'Herbe was rejected by the selection committee of the 1863 Salon. Trouble had been bubbling away for some time about the Salons, what they accepted, what they rejected, and the criteria they invoked. When *Le Déjeuner sur l'Herbe'* was shown two weeks later at the newly set up Salon des Refusés, it attracted a lot of attention, partly because the Emperor himself was known to have found it 'immodest'. The eventual result of the sensation was that the next year Manet's *Olympia,* arguably even more immodest, was accepted by the Salon without demur. The fact remains that the debate was entirely on the question of subject-matter: the critic who opined of the *Déjeuner* that 'the nude, when painted by vulgar men, is necessarily indecent,' admitted that Giorgione had done the same sort of thing in the *Concert champêtre,* but found that the placing of Manet's nude in a realistic modern context, with the clothes of the men unmistakably contemporary, deprived it of the necessary idealizing distance.

The argument about *Le Déjeuner sur l'Herbe* automatically made Manet, and so eventually the other Impressionists, part of the debate on Realism, and the degree of contemporary realism which was admissible in painting. But academic circles had taken to heart the notion that 'if you can't beat them, enlist them'. Delacroix had at long last been elected to the Academy in 1857, and Courbet was finally not so difficult to swallow: one simply had to concentrate on the things (mainly the element of story-telling) his paintings had in common with accepted academic work, and minimize the importance of the rest. Consequently, little by little, most of the Realists working along similar lines as Courbet were absorbed or somehow found their own place (and their own market) within the official system. For example, François Bonvin, a close contemporary and early acquaintance of Courbet, made his way similarly in from the outside (in his case applied-art training), and rendered his brand of unidealized realism acceptable by accom-

PAUL CÉZANNE
Bathers, 1870
*Many of Cézanne's earlier paintings reflected his own inner turmoil, sexual and philosophical. This painting
suggest a temporary respite, with male and female happily together in idyllic surroundings.*

modating it to three recognized genres: the portrait, the still-life and what was known as pious painting – pictures of good works in modern life, showing orphans schooled, the deserving poor fed and the humble religious at their simple devotions. (These last were much favoured for government purchase during the Second Empire, but lessened in popularity in the anti-clerical climate of the Third Republic.) Though some of the challenges offered to convention by the Realists might seem to be technical, involved with the way the picture was painted, in fact they all came down eventually to what the picture was judged to be *about*.

Such points are often lost on us today – we just cannot see what contemporary critics were going on about – because they refer to a way of reading pictures which has now fallen into desuetude: the careful search for moral principle or social judgement in the imagery. If the imagery gave out socially acceptable signals, all might be well: if not, not. It was this sort of reading Manet fell foul of with *Le Déjeuner sur l'Herbe* and *Olympia,* and later on with *Nana.* That he did so seems hardly accidental: he obviously put the messages there deliberately for his critics to decode. He was twisting the tail of the respectable bourgeois, and respectable bourgeois critics, not surprisingly, barked back. In this Manet seems to be confirming his apartness from the rest of the Impressionists, signalling otherwise by his refusal to lend more than moral support to the exhibitions.

For we always assume that seeing subjects in this way, for whatever coded messages they might contain, was no part of the Impressionists approach to the making of art. They certainly said so often enough. But it was so much an automatic part of contemporary response, and must have been embedded in their unconscious. Probably not very deeply in Monet's: he seems to have seen things from the start almost exclusively in purely visual terms, and it is difficult, even with much straining, to extract from any of his paintings anything resembling a message such as the academic Realists might have understood. But when Pissarro paints and draws peasants, in an updated version of the manner his Realist predecessor Millet did, we have to presume he is saying something, however general and minimal, about the dignity of labour: he does not, after all, show them engaged in drunken brawls or rural rape. Cézanne's early paintings certainly tell us something, though perhaps little which can be paraphased in Realist terms: what else they might be telling us I shall come to in due course. Renoir seems to be mostly the pure sensualist, but nevertheless he does paint people, and people in costumes and situations which can be read, whether that is an important part of his conscious purpose or not.

With Caillebotte and Degas we come to something else: the absence of literary content in most of their work seems to come from a deliberate stance of contrariety. They know what specta-

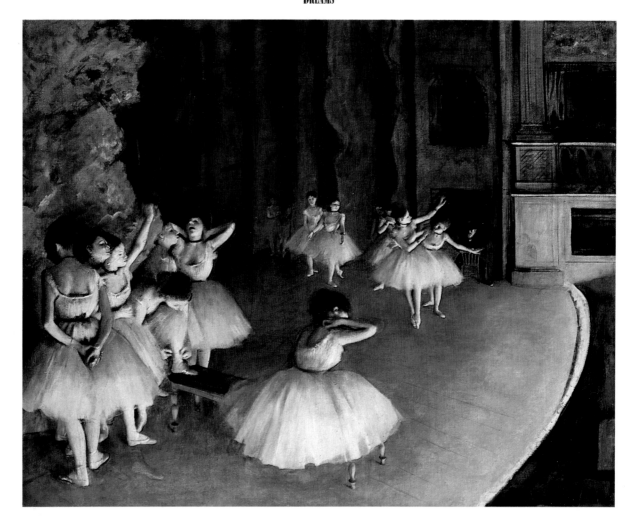

EDGAR DEGAS
Ballet Rehearsal, 1873-4
An almost monochrome treatment of a subject which Degas was to return to, explore and
vary for many years. In this its apparent tranquillity belies its compositional cunning.

tors want and expect, and are deliberately teasing, playing around the expectation in order finally to deny it. For all that, Caillebotte is clearly nearer to a conventional social painter of the day – Tissot, say, or Alfred Stevens – in that while he has reduced the anecdotal element he does not dispense with it altogether. The *Nu au Divan* must be meant to invite questions – What is she doing there? When and why did she remove the clothes that he scattered around? – without in any way pre-empting judgment. We do not know whether we are witnessing 'immodesty' in the order of *Le Déjeuner sur l'Herbe* (is Caillebotte vulgar enough to render his nude indecent?), but Caillebotte at least makes us wonder. Again, the non-communicating couples in his *Intérieurs* are perhaps merely (and no doubt were primarily) pretexts for exploring in paint the oddities and paradoxes of perspective. But if spectators at the time thought they were saying something about unhappy marriage and bourgeois *ennui* (we do not know they did, but they may

have), would they have been totally out of tune with Caillebotte's intentions?

Degas is not so easy to catch in a conventional expectation. His personality and mental processes are the most mysterious of any of the Impressionists. Personal accounts of him, like those of the dealer Vollard or the son of his great friend Halévy, seem to indicate that he enjoyed his own eccentricities and cultivated aloofness as a variation of the dandy persona. Though he began by painting history paintings, one of the things that convention at the time would have had him do as a young painter trying to make his way in the world, he soon abandoned them in favour of something which was assumed at the time to be contemporary realism. But only one painting in his whole oeuvre, the *Intérieur* often known as *Le Viol*, would qualify for his ironically disclaiming description, 'my genre picture'. Many experts regard it as an illustration to his friend Zola's Naturalistic novel *Thérese Raquin*, and so it may be. But if

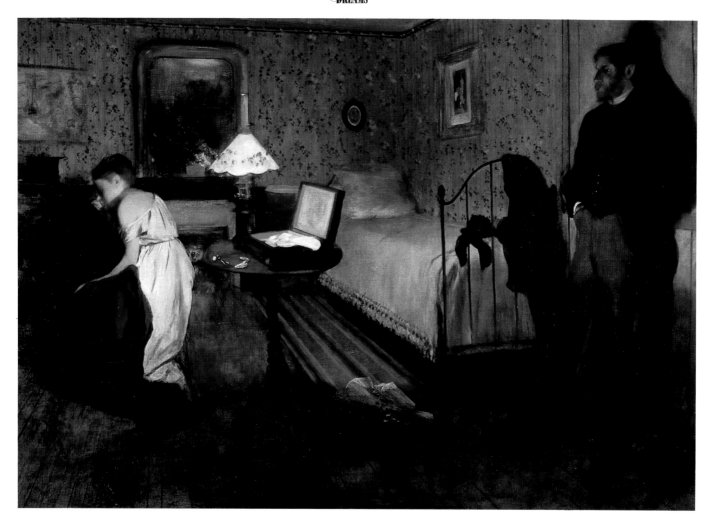

EDGAR DEGAS
Intérieur, 1868-9
Often popularly known as "The Rape", though it is far from clear how the concept applies, this is about as near as
Degas comes to literary illustration. A recent suggestion is that it illustrates a scene in Zola's Thérèse Raquin.

so, the subject has been abstracted to such an extent that its significance remains insolubly obscure. The fact that it has been called *The Rape* (before or after?) both indicates the indeterminacy of the image and confirms that it somehow pushes us towards interpretation or literary paraphrase.

The truth is that Degas's one enduring interest seems to have been formal exploration. With the subjects which recur frequently throughout his career there must have been initially some ordinary human interest, sexual or social, in the subject observed, but then this is gradually lost sight of as the pictures take on a purely artistic excitement of their own, coming to be about patterns of movement and colour and texture, shapes which might be a human body or a rolling hillside, and in at least one case, the amazing *Paysage* usually called *Steep Coast* of c. 1892, has clearly been first one, then the other, and is now indissolubly both. To put it summarily, what we see is a consistent, unstoppable movement from life to art.

So what, then, are these later parts of the major Degas sequences about – if anything we can paraphrase? The example of the landscape which began life as a recumbent female nude perhaps offers a clue: as they get further and further from the immediate notation of observed reality, they seem to take on a symbolic dimension. Degas's dancers are not individual girls in the *corps de ballet*: they represent Dance, and that itself is a medium which speaks in symbols. His washerwomen and women washing themselves became Woman, or the Feminine Principle. And if we feel tempted to delve into the artist's unconscious, we can reassure ourselves with the thought that we are not after all behaving too anachronistically: psychology was a subject of intense interest to the Paris of the 1880s, and Freud acquired his seminal interest in hysteria while staying in Paris in 1885.

But if we are looking for symbolism in French painting during the heyday of the Impressionists, it is not necessary to

177

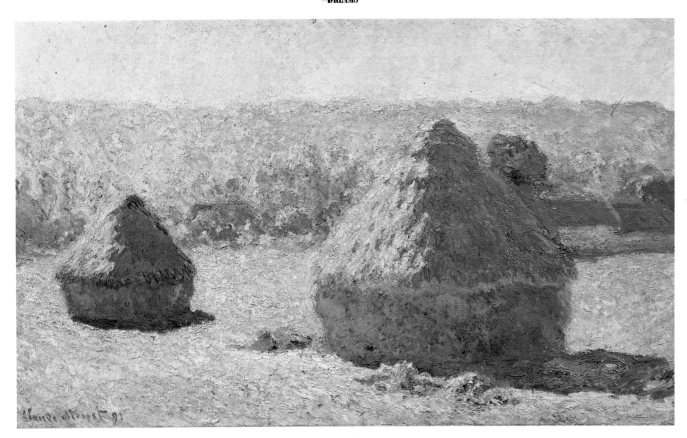

CLAUDE MONET
Grainstacks, End of Summer, 1890
One of the first and most realistically detailed of Monet's great series of paintings
of grainstacks in various lights, at various times of year.

look too closely at the artists' unconscious; their conscious intentions are often sufficiently clear. For this brings us round to the other sort of threat posed, from the 1860s on, to the academic status quo: Symolism with a capital 'S'. Around 1850, when artists thought of or discussed pictorial symbolism, they had in mind a comprehensive vocabulary of accepted equivalences: flowers which mean constancy or fickleness in the much-codified language of flowers; mythological figures which were widely understood to represent abstractions; colours and accessories with circumscribed significances. All this was part of the standard academic painter's equipment. When you saw a nude lady climbing over a parapet in a Baudry painting, you knew she was Truth because she was naked, she held a mirror and she appeared to be emerging from a well. But while the Realists were battering away at the citadels of academe on one side, there were other artists who were doing something new and strange on the other. They were the ones who saw the future of art not so much in the destruction of the academic vocabulary of symbols, as in its extension and loosening up, in the exploitation of an aura of quasi-symbolic association which could not be exactly paraphrased and explained.

There was at this time a whole borderland of art in France which dealt in the alarming, the mysterious and the grotesque. It was marginal because it found much of its exposure in book and magazine illustrations (Doré, for instance) or in the en-

tirely non-academic doodles of inspired amateurs like Victor Hugo. But artists such as Gustave Moreau and Pierre Puvis de Chavannes were more like a fifth column in academic art circles. Using sometimes similar techniques and similar imagery to the marginals, they twisted the established artistic procedures to their own peculiar imaginative ends, little by little cutting symbolism loose from its moorings in formal allegory and letting it drift as far as the imagination cared to take it. They were very little interested in the outside appearances of things, but sought instead their spiritual shape. Where the Impressionists were frequently linked with the literary Naturalists, mostly working in the novel, these other artists were compared with the school of poets who eschewed messages and the narrative, dealing instead with atmospheres and soul-states. Both the poets and the painters came to be known as Symbolists.

From our point of view, the connections between an artist like Monet and the Symbolist poets are much more obvious than those between him and the literary Naturalists. His pursuit in paint of the most evanescent visual experiences takes him right through realism and out the other side. And if one admits that something can feel symbolic without actually standing for anything specific, then surely that is just the feeling we get in front of a series of Monet haystacks, or Rouen Cathedrals, or poplars, or water-liles. They acquire from paint-

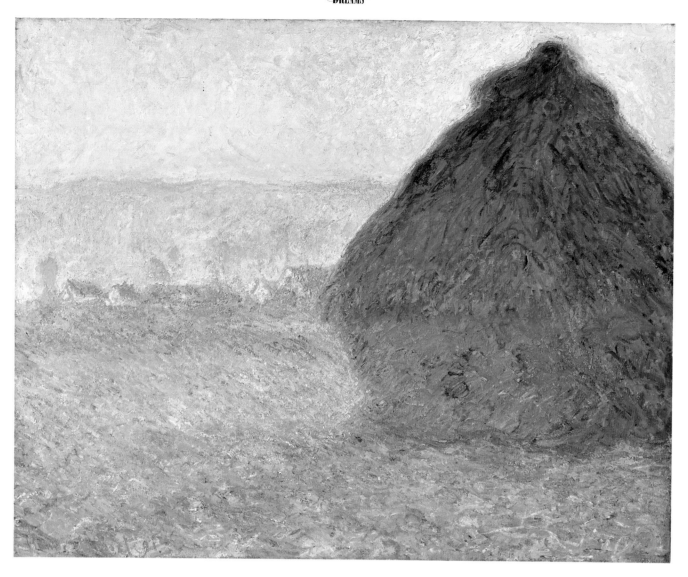

CLAUDE MONET
Grainstack at Sunset, 1890
As the series of grainstacks progressed the colouring became bolder, the brushwork looser and
freer, and the whole effect further and further away from any kind of rural realism.

ing to painting a baggage of miscellaneous, non-specific and probably undisciplined association such as we would regularly find in the descriptive lyrics of the Symbolists. They may not look at all like the bejewelled Salomés of Moreau or the pallid, phantasmal saints and divinities of Puvis, but ultimately the informing spirit is not so different.

And if this is true of Monet, why not of Degas, with his serial works? Why not of Caillebotte? Why not of Renoir? Degas may at first sight seem to be the Impressionist with his feet most firmly planted on the ground, his art most securely grounded in observed physical reality. But in a way this liberates him, so that his mind is free to play with the sort of metamorphosis through which a woman's breast can be covered with foliage and turn into a hillock, rather as Ovid's nymphs and goddesses could enter nature and change form without changing substance. This does not mean, as has recently become fashionable, that we have to look for the kind of moral density in an

Impressionist which comes from the embodiment of social attitudes and a political point of view; psychological density and a web of associations are enough.

Of course, both kinds of interpretation are dangerously liberated from external controls; the pictures can too easily become so many Rorschach tests in which the inkblots are perceived as depicting whatever the spectator's psyche and preconditioning would have them represent. At least in the early works of Cézanne we are left in no doubt about the symbolic force and intent of the paintings: indeed, so powerful is the drive behind them that sometimes they seem to skip forward fifty or sixty years, to the German Expressionists or to the tortured images of Soutine. The impression is of paintings made to carry a weight of significance they can hardly bear, with the palpable excitement they throw off coming from the unresolved conflict between form and content. Or rather, the fact that the form has to be radically reshaped by the content, to

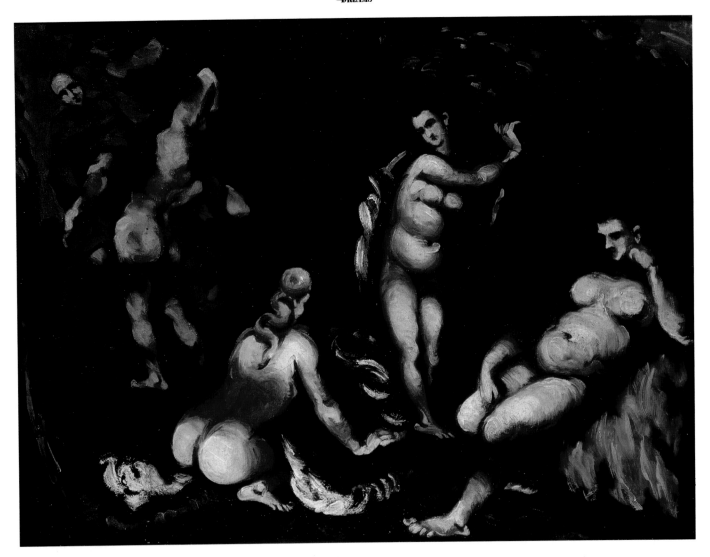

PAUL CÉZANNE
La Tentation de St Antoine, c. 1870
A curiously untempting view of its subject, one might think, but the autobiographical

produce something really unlike anything that was happening anywhere else in art at the time.

Recently there has been some play made of the phallic symbols which surround the lake (or sea) in the dreamlike *Pastorale* and it is no doubt a fair comment; but the conscious intent of this painting and others such as Cézanne's contemporary versions of *La Tentation de St Antoine*, or *Baigneur et Baigneuses* (a naked man attended by three fairly obliging-looking nymphs), seems to be clear enough: Cézanne is giving concrete form to his sexual wish-fulfilment fantasies, more directly still expressed in the relatively light-hearted *L'Après-midi à Naples*, or dramatizing his resolve to resist them. These are Symbolist paintings in much the same way that Moreau's are, and certainly as are many *fin-de-siècle* works on the subject of the *femme fatale*, the martyred poet, and other sadomasochistic themes which become the stock-in-trade of the Symbolist Decadents. They suggest an idea, turn one's atten-

tion in a particular direction, and then liberate the spectator's mind to play among the associational possibilities.

If Cézanne in the 1860s does this overtly, later he hides his hand. But all the Impressionists do the same to some extent, if only because liberating art from the rigid conventions of classical academicism necessarily entailed also laying the responding mind open to free or only minimally controlled association. The Realists stood for control, of a sort, by exercising great care and sobriety in the choice of subject, and so giving the intellect something else to work on. One can construct a neat scenario which leads art from Romanticism to Realism to Impressionism to Cubism to Abstraction. One can construct another which leads art from Romanticism to Symbolism to Expressionism and Surrealism. But then both Surrealism and Abstraction do the same thing: they liberate the unconscious. And this is why one can shuffle the constituent elements and get the same results: see the hallucinatory realism of Caillebotte as a forerun-

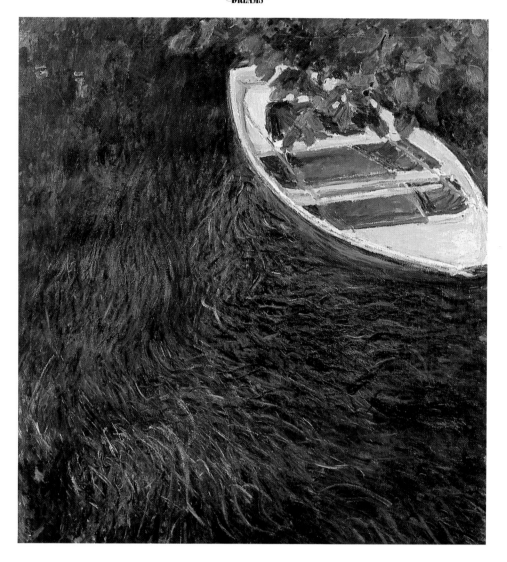

CLAUDE MONET
The Boat, c. 1890
A suggestion of Japanese principles in the composition does not detract from the virtuosity with which
Monet suggests the movement of the water and the burgeoning life beneath the surface.

ner of Surrealism, or confound Moreau's increasingly abstract watercolour sketches with Monet's increasingly abstract water-liles, all tending towards that ultimate unlikely synthesis, Abstract Expressionism.

When you come down to it, it is not surprising that the Academic, the Realistic, the Symbolic and the Impressionist could all coexist, or that, whatever those involved passionately believed at the time, they are not now always readily separable. The Realists shared with the Academics a belief that the artist painted not things as he saw them exactly, but how his reason told him they must be. The Symbolists painted things not as they saw them with the physical eye, but how their inner eye recognized their true, essential nature. The Impressionists thought they were painting exactly what their eyes saw, whether the correcting intellect agreed or not. Everybody ignored the fact that what was really central was the finding of a convention for depriving experience of the dimension of time, in so far as that implied constant change and flux, and reducing the other three dimensions to two. How they approached this problem varied depending on what elements in the equation their instincts told them were the most important, but finally they were all caught in their shared time-frame: as Dali said, 'A modern painter is the one thing, no matter what you do, that you cannot help being.'

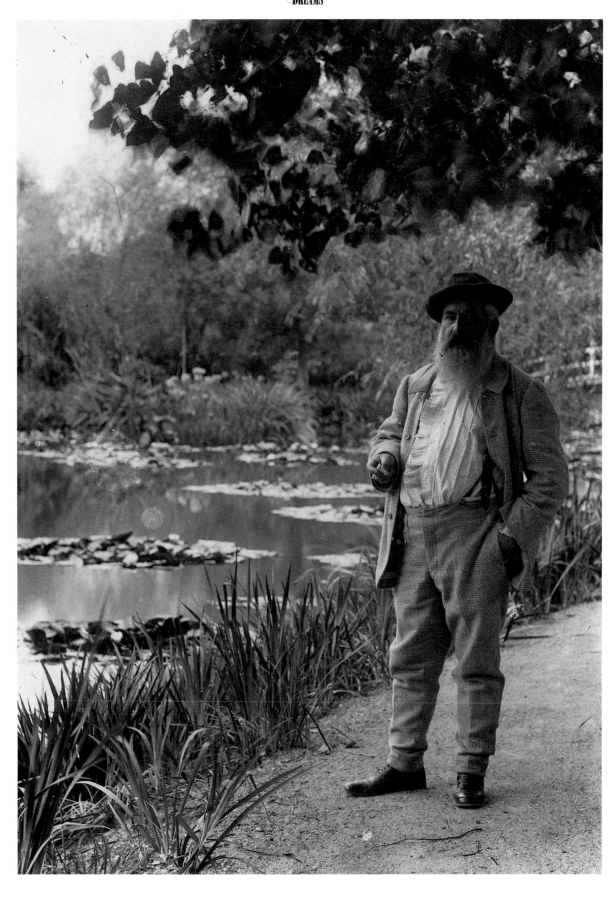

Monet in his famous water-garden at Giverny, the great passion of his later years.

EPILOGUE:

DECLINE AND FALL OF THE IMPRESSIONIST IDEAL

*The Place St Michel around the turn of the century, with trams
beginning to oust horse-drawn carriages.*

INEVITABLY, IN THE FULLNESS OF TIME, A MODERN painter is the one thing, no matter what you do, that you cannot help ceasing to be. If Impressionism, as a movement, took shape and definition from the fact that the individual artists were friends, painted together, and, most important, exhibited together, by the same token it ceased to be a coherent movement when they drifted apart personally and ceased to exhibit together. Impressionism is one of the given elements of art history, and there is no more point in arguing now that, say, Manet, Degas and Caillebotte should not be counted as Impressionists than there is in arguing over, say, whether Shakespeare's characterization of Richard III is true or historically accurate. Even if we say that Manet should not be counted because he did not exhibit at any of the Impressionist exhibitions, there is no changing the definition now. Whatever reservations we may have about it, it remains true that people are what they think they are, if only because they think it. Between 1874 and 1886 the Impressionists thought of themselves as a group and were perceived as a group, and so they were a group.

And it is true that something importantly changed after the eighth and last Impressionist show in 1886. It was even changed *by* the 1886 exhibition, which not only showed Pissarro, Seurat and Signac painting in the Neo-Impressionist,

Pointilliste style – derived, certainly, from Impressionist researches in the rendering of light and colour, but put on a theoretical rather than an empirical basis, which changed its nature – but also included one of the leading figures of the emerging Symbolist movement, Odilon Redon. The pendulum was already swinging away from Impressionist informalism. Increasingly the question was being asked: what did Impressionist art *mean*? By this time it was widely accepted that it did not mean, and should not be expected to mean, the sort of thing that academic or realistic art had always been understood to mean. But, in that case, was its technical meaning, the way it rendered effects of light, the new perceptions it presented of the colours within colour, was this all enough? Like all new movements of thought and taste, it had brought into prominence elements of experience which had previously been overlooked or downgraded. But once that had been done, and been seen to be done, was it not time for yet another turn of the wheel? The Impressionists knew to perfection how to paint the light places, but how could one find a way of looking into the dark?

Particularly the dark places of the human psyche. Outside early Cézanne, there is little in the corpus of Impressionist painting which hints at psychological complexity or profundity. Visual ambiguity there may be – though not so much even of that, once the eye is trained to decipher – but emotional and

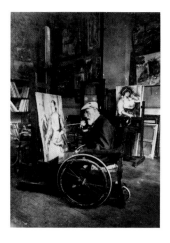

Renoir in his studio, 1914, already
crippled but still painting; he is
working on the portrait of Mme
Tilla Durieux.

Monet showing a patron his second
studio at Giverny, c. 1920.

The board for the Salon des Indépendents, which removed the necessity for the
Impressionists to exhibit as a group.

moral ambiguity hardly seems to be at issue at all. In Caille-
botte possibly, for it is difficult rationally to explain the haunt-
ing quality of his painting. And certainly in Degas, except that
he appears always to be fighting against it, abstracting to escape
the deep discomfort that seems to lie at the root of his work.
There is, of course, nothing wrong with being a happy painter
like Renoir, but once one has noted its advantages one
naturally tends also to notice its limitations. It is surprising,
actually, how rapidly criticism came round to the Impression-
ists. In 1876 the critic of the *Figaro* was able to make humo-
rously heavy weather of the dappling effects of light on the
flesh of Renoir's *Etude* of Anna Leboeuf: 'Would someone
kindly explain to M. Renoir that a woman's torso is not a mass
of decomposing flesh, with the green and purplish blotches
that indicate a state of complete putrefaction in a corpse...'
While he is pushing a point to raise a laugh, it is clear that there
is a real problem of perception here. Even ten years later, no
one was able any more to react in that densely uncompre-
hending way; people's way of seeing things had really been
modified to take account of the Impressionist vision. But once
that was so, did not the work lose some of its savour along with
its controversial quality?

It was here that the Symbolists really came into their own.
Redon, for example, exhibited in the 1886 Impressionist show
fifteen pictures including a *Salomé*, a *Tentation* 'appartient à M.

J.K. Huysmans' and works with titles like *La Désespérance* and
Lune noire. Even something sounding as innocent as *Le Secret*
proves to be one of his agonized, haunted figures, crouched
behind bars. Though some of the criticism was unfavourable to
him – George Auriol said, 'For my part I would trade all of Re-
don and his future work for one simple watercolour by Berthe
Morisot' – it was all playing him off against the Impressionists
proper, who by now were perceived as embodying the safe, the
agreeable, the easy-to-take. Paul Adam observed that, 'His
genius, independent of all schools, bears no immediate relation
to Impressionism', and Henry Fèvre added (approvingly) that,
'In the middle of this frenzied Naturalism of colour, the draw-
ings of Odilon Redon strike a Baudelairean note à la Edgar Poe
of nightmare grimaces where laughter is rictus, at once carica-
ture and horrible.' It seemed that the dark was back in full
force.

On the other hand, there were the Neo-Impressionists, who
sought to reform Impressionism itself by imposing 'scientific'
order on its untrammelled, instinctive reactions. Possibly some
Impressionist painting was incoherent, because experience
itself, taken from life, was incoherent. But frankly, that was not
a good enough reason, and Seurat and Signac were going to
make their elders see the error of their ways – they had already
succeeded with the oldest of the elders, Pissarro. Signac, in his
Apprêteuse et Garnisseuse (Modes), rue du Caïre, listed first

The aged Monet in his studio at Giverny.

Cézanne's spartan studio in Aix-en-Province.

among his eighteen entries, seemed to be challenging Degas directly on one of his chosen grounds, the depiction of milliners and modistes, of which there were two typical examples in the same show. Degas's pictures, which had not long ago seemed so strange and sketchy and incomprehensible, now seemed comfortably familiar: it was Signac's highly formalized composition, with its monumental stillness (even though the *apprêteuse* is caught in mid-action leaning forward to pick up a pair of scissors from the floor), which presented the new challenge and possibly new insight.

Were the major Impressionists aware of or concerned at this turn of taste, this tacit removal of their work from near the cutting edge of art? Not particularly, it seems. Like all successful revolutionaries, they were bound when the time came to become the establishment themselves. Manet had died, and Caillebotte was to die in 1894, when only forty-five. Degas had at least fifteen years of productive work before him, until poor eyesight, increasing crankiness and external upsets to his life would start him retreating into solitude and inactivity. But Monet and Renoir were already well set on the path to riches and adulation; even Pissarro, always the poorest of them, was doing all right; and Cézanne, living out his chosen life in Aix, was gradually to see himself regarded, whether he wished it or

not, as the king in exile, battling heroically with the infinite. They had won their place in the sun, and now it was the turn of another kind of art. This too had been waiting; Redon had been around quite as long as any of the Impressionists, without achieving even the same degree of notoriety and the kind of Symbolism he stood for had its major vogue in the 1890s.

The survivors were not untrue to their ideals: they did not give in to the world; the world gave in to them. From there it was perhaps a logical progression towards their becoming the favourite expensive interior decoration for film stars and others who liked to flaunt their money in a safely cultural way. That was hardly their fault. They had started something, or helped to start something, which their later disciples, like Gauguin, Van Gogh and Toulouse-Lautrec, would carry further, transform and ultimately turn upside down. Until 1926 Monet, the Grand Old·Man of Giverny, continued to cultivate his garden, paint what he made, and then make what he had painted. It was a good life, and an honourable one. By living through so much time he had ultimately escaped it; like the rest of the Impressionists, he had entered history, and made sure by his example that whatever new phases of art might come and go, the world would never be perceived in quite the same way again.

LIST OF ILLUSTRATIONS

71 CAMILLE PISSARO *Lower Norwood, Effect of Snow*, 1870. National Gallery, London.

72 CAMILLE PISSARO *The Sydenham Road*, 1870. Private Collection. (*Christie's Colour Library*).

73 CAMILLE PISSARO *Bedford Park*, 1897. Ashmolean Museum, Oxford.

74 EDOUARD MANET *The Grand Canal (Blue Venice)*, 1875. Shelburne Museum, Vermont.

75T ALFRED SISLEY *Regatta at Molesey*, 1874. Musée d'Orsay, Paris. (*Bridgeman Art Library*).

75B ALFRED SISLEY *Molesey Weir*, 1874. National Gallery of Scotland, Edinburgh. (*Bridgeman Art Library*).

76 ALFRED SISLEY *Langland Bay*, 1897. Kuntsmuseum, Berne.

77 PIERRE-AUGUSTE RENOIR *Piazza San Marco*, 1881. Mineapolis Institute of Arts. (*The John R. Derlip Fund*).

78 CLAUDE MONET *Waterloo Bridge, Grey Weather*, 1903. Odrupgaard Museum, Copenhagen.

79 CLAUDE MONET *Waterloo Bridge, Sun in Fog*, 1903. National Gallery of Canada, Ottawa.

80T CLAUDE MONET *The Thames and the Houses of Parliament*, 1871. National Gallery, London.

80B CLAUDE MONET *The Houses of Parliament, Effect of Fog*, 1903. High Museum of Art, Atlanta.

81 CLAUDE MONET *The Houses of Parliament, Sun Breaking through Fog*, 1904. Louvre, Paris. (*Bridgeman Art Library*).

82 CLAUDE MONET *The Houses of Parliament, Stormy Sky*, 1904. Musée des Beaux Arts, Lille. (*Bridgeman Art Library*).

83 CLAUDE MONET *San Giorgio Maggiore*, 1908. National Museum of Wales, Cardiff.

84 MAXIMILIEN LUCE *The Factory*. Private Collection. (*Christie's Colour Library*).

85 St Ouen: *L'Aumoñe*. (*Roger-Viollet*).

86 CLAUDE MONET *The Railway Bridge at Argenteuil*. Private Collection. (*Christie's Colour Library*).

87 EDOUARD MANET *The Gare St-Lazare*, 1873. National Gallery of Art, Washington. (*Gift of Horace Havemeyer in memory of his mother Lousine W Havemeyer*).

88 CLAUDE MONET *The Gare St-Lazare*, 1877. Musée d'Orsay, Paris. (*Bridgeman Art Library*).

89 CLAUDE MONET *Le Pont de l'Europe*, 1877. Musée Marmottan, Paris. (*Studio Lourmel*).

90 EDGAR DEGAS *Courses de Gentlemen avant le départ*, 1862/82. Musée d'Orsay, Paris. (*Lauros-Giraudon*).

91 ARMAND GUILLAUMIN *Soliel couchant à Ivry*. Musée d'Orsay, Paris. (*Lauros-Giraudon*).

92 CAMILLE PISSARO *The Stone Bridge at Rouen, dull weather*, 1896. National Gallery of Canada, Ottawa.

93 PAUL SIGNAC *Les Gasomètres, Clichy*, 1886. National Gallery of Victoria, Australia.

94 MAXIMILIEN LUCE *Streets of Montmartre*, 1887. Rijksmuseum Kröller-Müller, Otterlo, The Netherlands.

95 Montmatre, Bal au Moulin de la Gallette. (*Roger-Viollet*).

96 PIERRE-AUGUSTE RENOIR *La Loge*, 1874. Courtauld Institute Galleries. (*Bridgeman Art Library*).

97 The Stands & Spectators at Longchamp. (*Hulton-Deustch Collection*).

98 EDOUARD MANET *Le Déjeuner*, 1868. Neue Pinakothek, Munich. (*Scala*).

99 PIERRE-AUGUSTE RENOIR *The Oarsmen's Lunch*, 1881. Art Institute of Chicago. (*Potter Palmer Collection*).

100 CLAUDE MONET *Le Déjeuner sur l'Herbe (left fragment)*, 1866. Musée d'Orsay, Paris. (*Lauros-Giraudon*).

101 CLAUDE MONET *Le Déjeuner sur l'Herbe (study)*, 1865. Pushkin Museum, Moscow. (*Scala*).

102 CLAUDE MONET *The Hôtel des Roches Noire, Trouville*, 1870. Musée d'Orsay, Paris. (*Bridgeman Art Library*).

103 PIERRE-AUGUSTE RENOIR. *The Oarsmen's Lunch*, 1881. Philips Memorial Collection, Washington. (*Lauros-Giraudon*).

104 EDOUARD MANET *Music in the Tuileries Gardens*, 1862. National Gallery, London.

105 EDOUARD MANET *Le Balcon*, 1868-9. Louvre, Paris. (*Bridgeman Art Library*).

106 EDOUARD DEGAS *Portrait of Diego Martelli*, 1879. National Gallery of Scotland. (*Bridgeman Art Library*).

107 EDGAR DEGAS *La Répétition de Chant*, 1872-3. Dumbarton Oaks Research Library & Collection, Washington D.C.

108 EDGAR DEGAS *Race horses at Longchamp*, 1871. Museum of Fine Art, Boston. (*S. A. Dennio Collection*).

109 GEORGES SEURAT *Un Dimanche a la Grande Jatte*, 1884-6. Art Institute of Chicago. (*Bridgeman Art Library*).

110 GEORGES SEURAT *Le Cirque*, 1990-91. Louvre, Paris. (*Bridgeman Art Library*).

111 EDOUARD MANET *Le Chat Noir*. Bibliothèque Nationale, Paris. (*Edimedia*).

112 EDOUARD MANET *Monet in his Floating Studio*, 1874. Alte Pinakothek, Munich. (*Bridgeman Art Library*).

113 PIERRE-AUGUSTE RENOIR *Bal au Moulin de la Gallette*, 1876. Musée d'Orsay, Paris. (*Bridgeman Art Library*).

114 EDOUARD MANET *Coin de Café-Concert*, 1879. National Gallery, London.

115 EDOUART MANET *In the Café*, 1878. Oskar Reinhart Collection, Winterthür, Switzerland.

116 EDOUART MANET *Café-Concert*, 1878. Walters Art Gallery, Baltimore.

117 EDOUARD MANET *Bar aux Folies-Bergère*. Courtauld Institute Galleries. (*Bridgeman Art Library*).

118 EDGAR DEGAS *The Ballet from Robert le Diable*, 1872. Metropolitan Museum of Art, New York. (*Bequest of Mrs H. O. Havemeyer, 1929*).

119 EDGAR DEGAS *L'Orchestre de l'Opéra*, c.1870. Musée d'Orsay, Paris. (*Lauros-Giraudon*).

120 EDGAR DEGAS *La Classe de Danse*, 1873-6. Musée d'Orsay, Paris. (*Scala*).

121 EDGAR DEGAS *Lala at the Cirque Fernando*, 1879. National Gallery, London.

122 PIERRE-AUGUSTE RENOIR *Washerwomen*, 1912. Metropolitan Museum of Art, New York. (*Gift of Raymonde Paul in memory of her brother, C Michel Paul*).

123 Washerwomen. (*Edimedia*).

124 BERTHE MORISOT *The Butterfly Hunt*, 1874. Musée d'Orsay, Paris. (*Bridgeman*).

125 MARY CASSATT *Mother and Child Driving*, c.1879. Philadelphia Museum of Art, Pennsylvania. (*Bridgeman Art Library*).

126 EDGAR DEGAS *Maid combing a Woman's Hair*, c.1898. National Gallery, London.

127 MARY CASSATT *Girl arranging her Hair*, 1886. National Gallery of Art, Washington DC. (*Chester Dale Collection*).

128 PIERRE-AUGUSTE RENOIR *The Daughters of Catulle Mendès at the Piano*, 1888. Private Collection. (*Bridgeman Art Library*).

129 PIERRE-AUGUSTE RENOIR *L'Après-midi des Enfants a Wargemont*, 1884. National Gallery, Berlin.

130 PIERRE-AUGUSTE RENOIR *The Piano Lesson*, c.1889. Joslyn Art Museum, Omaha, Nebraska.

131T MARY CASSAT *Five O'Clock Tea*, 1880. Museum of Fine Art, Boston. (*M Theresa B Hopkins Fund*).

131B EDGAR DEGAS *The Milliners*, 1882. Nelson Atkins Museum of Art, Kansas City, Missouri.

132 EDGAR DEGAS *Mile, Hortense Valponçin*, 1871. Minneapolis Institute of Arts. (*The John R Van Derlip Fund*).

133 GUSTAVE CAILLEBOTTE *Nu au Divan*, 1880-82. Minneapolis Institute of Arts. (*The John R Van Derlp Fund*).

134 PIERRE-AUGUSTE RENOIR *Cabaret de la Mére Antony*, 1866. Kunstmuseum, Stockholm.

135 Fish shop in Paris. (*Roger-Viollet*).

136 EDOUARD MANET *Le Vieil Musicien*, 1862. National Gallery of Art, Washington D.C. (*Chester Dale Collection*).

137 EDOUARD MANET *The Street Singer*, c.1862. Museum of Fine Art, Boston. (*Bequest of Sarah Choate Sears in memory of her husband, Joshua Montgomery Sears*).

138 GUSTAVE CAILLEBOTTE *Les Raboteurs du Parquet*, 1875. Louvre, Paris. (*Lauros-Giraudon*).

139 GUSTAVE CAILLEBOTTE *Peintres en Bâtiment*, 1877. Private Collection. (*Lauros-Giraudon*).

140 MAXIMILIEN LUCE *Coffee*, 1892. Private Collection. (*Lauros-Giraudon*).

141 EDGAR DEGAS *Les Blanchisseuses*, c.1884-6. Musée d'Orsay, Paris. (*Bridgeman Art Library*).

142 EDGAR DEGAS *Portraits in an Office (New Orleans)*, 1873. Musée Municipale de Pau.

143 PIERRE-AUGUSTE RENOIR *Young Boy with a Cat*. Private Collection. (*Christie's Colour Library*).

144 PIERRE-AUGUSTE RENOIR *La Baigneuse au Griffon*, 1870. Museu de São Paolo, Brazil. (*Bridgeman Art Library*).

145 Monet & his family. Musée Marmottan, Paris. (*Edimedia*).

146 PAUL GAUGUIN *Naked Girl Sewing*, 1880. New Carlsberg Gallery, Copenhagen.

147 Degas & Friends. Bibliothèque Nationale, Paris. (*Edimedia*).

148 EDOUARD MANET *Blonde aux Seins Nus*, c.1878. Musée d'Orsay, Paris. (*Lauros-Giraudon*).

149 EDOUARD MANET *Nana*, 1877. Kinstghalle, Hamburg. (*Bridgeman Art Library*).

150 PIERRE-AUGUSTE RENOIR *Nude in the Country*. Musée d'Orsay, Paris. (*Scala*).

A NOTE ON SOURCES

THE MOST IMPORTANT THING FOR ANYBODY INTERESTED IN ART IS THE opportunity to see as many as possible of the original artworks. For Impressionist-fanciers, the last fifteen years, and the passion for giant, blockbuster art exhibitions engendered by the triumphal progress of the Tutankhamen show in the early Seventies, have brought almost an embarrassment of riches – at least for those able to travel. In addition, the catalogues for these shows, increasingly large and lavish, have become the principal means of publishing new scholarship.

The major monographic shows of this type have been those devoted to: Caillebotte (*Brooklyn, 1977*), Bazille (*Chicago, 1978*) Toulouse-Lautrec: Paintings (*Chicago, 1979*), Monet (*Paris, 1980*), Pissarro (*Paris/London, 1981*), Manet (*Paris, 1983*), Renoir (*London/Paris, 1985*), Degas (*Paris/Ottawa/New York, 1988*), Van Gogh à Paris (*Paris, 1988*), Gauguin (*Chicago/Paris, 1988*), Cézanne: The Early Years (*London, 1988*), Zandomeneghi (*Venice, 1988*), Van Gogh (*Amsterdam, Otterlo, 1990*), De Nittis (*Milan, 1990*), Monet (*London, 1990*).

Among the more significant smaller or more specialized shows I have seen devoted to individual artists were: Degas (*Edinburgh, 1979*), Degas: The Dancers (*Washington, 1984*), Degas in the Art Institute of Chicago (*Chicago, 1984*), Degas: The Painter as Printmaker (*Boston/London, 1984/85*), Monet: Nymphéas (*Basel, 1986*), The Private Degas (*Manchester, 1987*), Pissarro (*Birmingham/Glasgow, 1990*).

More general exhibitions of note have included: Post-Impressionism (*London/Washington, 1979/80*), The Realist Tradition (*Cleveland/Glasgow, 1980/81*), A Day in the Country (*Chicago/Paris, 1983/84*), The New Painting (*Washington, 1986*), Lighting Up the Landscape (*Edinburgh, 1986*), Neo-Impressionisten (*Amsterdam, 1988*).

During the same period there has been a plethora of books, general and specific, popular and esoteric. The most useful overall survey remains John Rewald's *The History of Impressionism,* first published in 1946 (Fourth revised edition, 1973). Among the rest, notable in their power to illuminate or irritate or both, are:

T. J. CLARK: *The Painting of Modern Life.* New York/London, 1985.

IAN DUNLOP: *Degas.* London, 1979.

ANNA COFFIN HANSON: *Manet and the Modern Tradition.* New Haven/London, 1977.

ROBERT L. HERBERT: *Impressionism.* New Haven/London, 1988.

JOHN HOUSE: *Monet: Nature into Art.* New Haven/London, 1986.

MARY TOMPKINS LEWIS: *Cézanne's Early Imagery.* Berkeley, 1989.

EUNICE LIPTON: *Looking Into Degas.* Berkeley, 1986.

ELIZABETH ANNE McCAULEY: *A. A. E. Disderi and the Carte de Visite Portrait Photograph.* New Haven/London, 1985.

GEORGE MAUNER: *Manet, Peintre-Philosophe.* Pennsylvania/London, 1975.

JOHN MILNER: *The Studios of Paris.* New Haven/London, 1988.

LEOPOLD REIDEMEISTER: *Auf den Spuren der Maler der Ile de France.* Berlin, 1961.

STUCKEY SCOTT: *Berthe Morisot.* London, 1987.

RICHARD SHIFF: *Cézanne and the End of Impressionism.* Chicago, 1984.

RALPH E. SHIKES and PAULA HARPER: *Pissarro.* New York/London, 1980.

RICHARD THOMSON: *Seurat.* London, 1983.
 Degas: The Nudes. London, 1988.

PAUL HAYES TUCKER: *Monet at Argenteuil.* New Haven/London, 1982.

KIRK VARNEDOE: *Gustave Caillebotte.* New Haven/London, 1984.

INDEX

Figures in italics refer to captions.

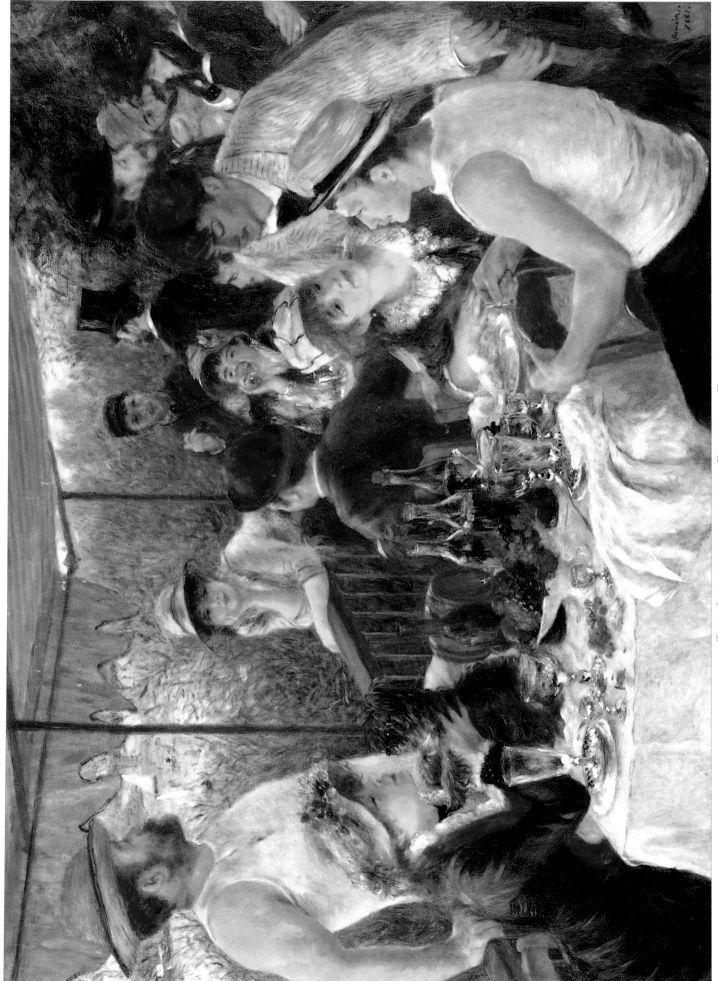

The Luncheon of the Boating Party
Pierre Auguste Renoir

A·HENDERSON — ART

CELEBRATIONS

Pierre Auguste Renoir 1841–1919 French

The Luncheon of the Boating Party 1881 Oil on canvas 129.5 x 172.7 cm

The Phillips Collection, Washington DC

THE ARTIST

Renoir began his painting career at the age of thirteen, applying luscious strokes of colour to porcelain in a factory. This must have influenced his love for perfect beauty and the charming subject. It was his association with Monet and his habit of painting out of doors around the Seine that developed his striking freedom of brush-stroke and lighter palette. He developed a style of dappled coloured light and shadow without any definite drawing. At the height of his Impressionist phase he recorded the casual, sunlit café world of the Parisian, languid riverside scenes and bustling dance halls. Later, he concentrated more on the female nude, entranced with the pinks and pearlescent hues of his models' skin. Renoir hated ugliness, and had a firm conviction that art should be 'pretty' for there was enough sadness in the world already! This belief gave his work a glamorous and attractive air, full of life and lovely people. His women were always attractive and decorative, and, in his eyes, best suited to singing and dancing. As a revolutionary, Renoir was fairly useless! He was torn by a love for the contemporary and the challenging Impressionist style, but harboured a fear of modernity – he even hated sliced bread! (preferring it broken apart by hand). He felt that art should reflect his world, but resented women painters doing it!

THE PICTURE

This picture must have become a symbol of the English dream of France. A sunny day on the Seine, coloured striped awnings, a long lazy lunch with warm red wine, and good company. What more could be asked for? Although painted in the studio, and at the end of Renoir's truly Impressionist period, the Boating Party still retains many of Renoir's sparkling techniques. The composition is casual and deliberately relaxed and unposed, recalling the contemporary photograph and confirming Renoir's intention to be natural. Nevertheless, the scene is well organised, with a careful symmetry between the crowded right-hand side of the picture, and the river divided by the vertical awning pole. The two boating men in white shirts and yellow boaters seem to set up a bare-armed balancing act across the picture, pulling our attention back to the middle. Our eyes are drawn to the exquisite features of the girl talking to her dog. Renoir emphasises her as a focus by giving her brilliant orange flowers on her hat. The way she and the dog are painted is sheer poetry! This is Renoir at his finest, all sugar and spice; but what softness, what astonishing lightness of touch and delicacy of brushwork! The world for Renoir seems flooded with pure joy. Form is suggested but always remains insubstantial, a fusion of colour and light that can disappear like the golden moment he records.

TIME FOR TALK

Talk about parties This picture is the scene of a boating party enjoying lunch. This is an adult affair, but children can have parties too. All pupils have parties of some sort – find out about the sorts of parties that pupils have in your class. Make a class list of favourite types of party, and the sorts of food and drink that you have at your parties. What games do you play?

Talk about Renoir's style Ask the pupils to look at the picture and describe it with reference to the way Renoir has painted. Look particularly at the way Renoir has painted the dog, and the white jacket of the man on the right. He was a great Impressionist painter, along with Monet, Degas and Cassatt. Look at the work of other Impressionist painters; there is a Monet in this pack. Look for similarities in their work. The scenes are of ordinary everyday life, usually people enjoying themselves, celebrating even! The colours are very strong and bright, and were often painted in sunlight out of doors. The brush-strokes are dabbed, dappled and broken, creating the effect of passing light on water or fabric. People are casually observed in conversation, unposed, as if photographed spontaneously. Look for these hallmarks of Impressionism, and contrast them with other painters and styles in this pack and elsewhere.

PRACTICAL STARTING POINTS

● Follow up the discussion on parties with Design-a-Party time! It may not be that time of year, but focus on party-time anyway. List those things that pupils could design and make for a party – hat, mask, wand, place name, printed invitations, printed table-cloths, games, prizes, fancy dress. Has the party got a theme? This will dictate the design ideas, of course.

● Hats can be great fun; there are some good hats in Renoir's picture. Hats can be simple cones, decorated with coloured papers and paint, with flowing ribbons attached. They could be crowns! Cut them out first and keep them flat while you decorate them with foils, tissue paper and paint, then wrap them round the pupils' heads and fix to a perfect fit. Hats can be tall columns, or short, with firecracker-coloured papers spilling out of them.

● Masks are endlessly exciting. Make masks just for the eyes, in card covered in rich fabric, decorated with sequins and glitter. Hold them on with elastic, or with a stick wrapped in gold paper. Make all-over face masks from the corners of cardboard boxes coloured and collaged in aluminium foil and tissue paper.

● Make print blocks from card or styrene sheet, with ideas based on the party theme, and print them on white paper sheets to make decorative table-cloths and napkins.

● Design cakes and drinks, and make them if you can.

● Design original games that involve drawing, or acting, or music.

● Make paintings of the pupils dressed up in their party gear, hats, masks and all! Before you do, go back to the party painter, Renoir, and see how he made frothy, light and delicate effects. Try to use his bright colours and his dabbing brush-strokes on your portraits.

ARTHUR PENN: COUNTY INSPECTOR FOR ART & DESIGN EDUCATION, GLOUCESTERSHIRE LEA

Philip Green Educational Limited 112a Alcester Road Studley Warwickshire B80 7NR England Tel 0527 854711 Fax 0527 854385